A BIG THANK YOU TO ALL MY INDIAN FRIENDS.

THE PHOTOGRAPHS IN THIS BOOK WERE TAKEN WITH A CANON EOS WITH FUJI SENSIA FILM.

EDITOR, ENGLISH-LANGUAGE EDITION: Lory Frankel
DESIGN COORDINATOR, ENGLISH-LANGUAGE EDITION: Brankica Kovrlija

Library of Congress Control Number: 2001093033
ISBN: 0–8109–3475–2

Printed and bound in Italy
10 9 8 7 6 5 4 3 2 1

Harry N. Abrams, Inc.
100 Fifth Avenue
New York, N.Y. 10011
www.abramsbooks.com

Abrams is a subsidiary of

DESERT EVES:
an indian paradise

photographs by hans silvester text by catherine clément

translated from the french by lory frankel

HARRY N. ABRAMS, INC., PUBLISHERS

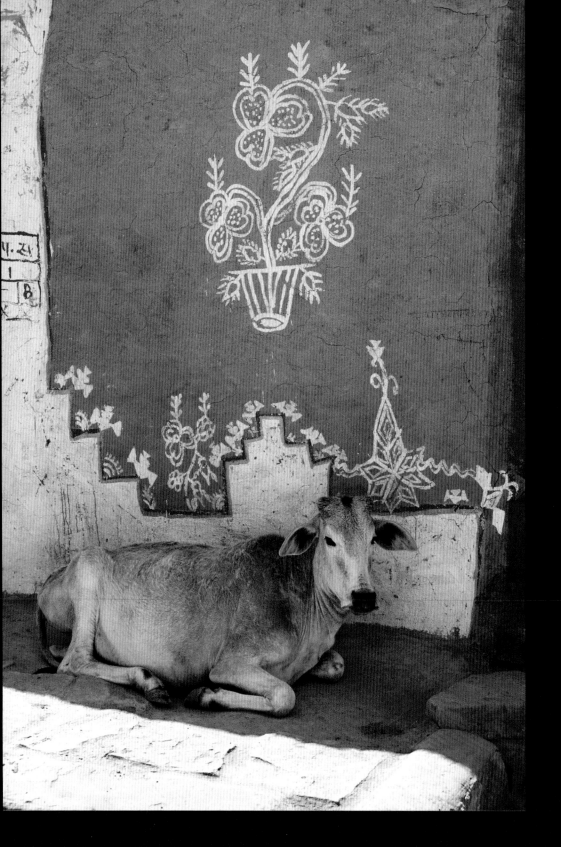

THE SEEKER OF ALLIANCES

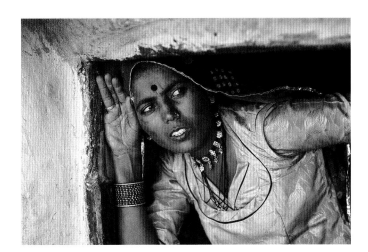

I FASCINATIONS

India "fascinates" the West—this is taken for granted. In Europe and the Americas, whatever our language, we use words that mean "to charm" when talking about India. The India of a thousand gurus, the India of a thousand palaces, the enchanted continent, casts a spell on us. Their women, with their special grace, exert a particular attraction. But, needless to say, we are also drawn by the large oxen of Nagaur, with their long, lyre-shape horns, the bright pink and orange of the women's veils, embroidered with silver stars, the white bangle bracelets they wear high on their arms, and the sky, at once so violent and calm, that overarches all. Since Marco Polo, Europe has been in search of its East Indies.

Some of Europe's empires colonized India, but like all empires, they finally died out. Of the glories of Portugal described by Luíz Vaz de Camões in his *Os Lusíadas* (1572), only some Baroque churches in the state of Goa remain, while the British Raj left to New Delhi the presidential house, train stations, roads, bridges, tea with milk, a bureaucratic model, and one of the twenty-four official languages of the federation. France made a bid for India but did not succeed. Hans Silvester, however, was not born in a country that aspired to control India at all. Although he comes from a border region, the Black Forest, he is German. Of all the possible ways that one can come to love India, Germany almost always chose the best: through scholarship and education. Romantic Germany's view of India is certainly dreamy, simultaneously serious and poetic, but not colonial. Following the Sturm und Drang movement and the Oriental poems of Goethe, Germany sought in India an alliance with the sacred.

The benefit of the sacred is that it boils over the religious like milk on a stove. Unclassifiable, it does not lend itself to being penned in, especially in India, and above all in the desert, much less in a desert in India. The sacred is everywhere, settled on a bird, a shoulder, even a rat. Could a temple with living rats as gods exist anywhere but in the Thar Desert? It is in Bikaner, and its rat divinities, duly protected by stout wire guards, move briskly, as they are well fed. These rats with narrow snouts incarnate the members of a mistreated lower caste, lifted to divine rank by a woman ascetic who compelled the rulers of the kingdom to honor these rodents and to protect them from the birds of prey that might suddenly seize them. This disturbing sacred object has thousands of tails; after a few hours I accidentally trod on the end of one. The rat whose caudal appendage I had stepped on squeaked with indignation. And the pull of the sacred was so strong that I exclaimed, incongruously, to the divine rodent, "Oh! Excuse me!"

To return to the holy ascetic, she who brought about this transmutation herself was represented on icons sold at the temple of the rats as a bearded woman. Reaching this level of surrealism, the mind gives itself up to the bizarre and perceives the sacred in its divine absurdity. In India, it seems, the angel of the bizarre offers surprises at every turn. True sacredness, however, inheres in the seeker of alliances: the infinity of sand, the empty horizon with, for fullness, the pool in the oasis, the camels that drink there. In this book we will not see the *sadhu,* a mendicant ascetic who contorts his body, draws his nourishment from the wind, and sleeps standing on one foot in order to fulfill his relgious vows. All of the animals shown are of the domestic variety, so thoroughly integrated into village life that animality lightly touches humanity for the greater happiness of the species. It would be a mistake to think that animals are treated better than people, which was true of Nazi Germany, which gave to dogs and domestic animals rights to train travel, which was forbidden to Jews. The lively communication between species, represented by divinities with animal faces, exalts the entire universe, to which humanity belongs.

As a photographer, Hans Silvester is neither scholar nor reporter but a loner visiting the desert to rediscover the people. Which people? Those who no longer exist: a people who live a hard life under the harsh light, in a land where spring is rare. Luminous tracks from this eternal people repeatedly rise into view, as in deserts of shooting stars. These are the people of all the Bibles, who live in the joy of wedding festivities. In the age of computers and start-ups, a few extracts of paradise survive. The word *extract* should be understood as applied to perfumes: quintessence. It must be admitted that these surviving paradises have neither running

water nor electricity. Their inhabitants live in the rhythm of daylight and go to sleep when the animals do. No gas stations, no grocery stores; those who live here cook their loaves of bread in a pan and drink well water. That is, the women of these places. Against the light, draped in long veils, their fine silhouettes describe the immemorial figure of the first woman.

Where does Eve live? In the desert. Her native garden no longer grows green as it originally did, consisting instead of sand, brushwood in the wind, pebbles, and thorns. To protect herself from the sun, Eve covers her head, but her waist is bare under the veil and her legs strong beneath the round skirt. And, since she has sinned and wears clothes, she wears jewelry, solid bracelets on her arms, and rings on her ears and feet. At dawn she hurries to light a fire to cook her loaves of bread. In these images, she smells of bread. Eve often carries her latest-born Abel on her hip, and she laughs, her teeth flashing.

Whoever travels across a desert has the opportunity to meet Eve, but nowhere else will she be as beautiful as she is in India. Look at those encountered by Hans, seeker of peace. All of them live in the vast region comprising the Thar Desert, in the heart of Rajasthan State, in the western part of modern-day India. In a strange paradox, these Eves are all Hindus. The Bible is not their sacred book, and their gods are not the figures of books but allied to diffuse inspirations, multiple spirits, badly deformed statuettes, numerous as the grains of sand in the desert. Yet these hardy women are all Eve, for the viewfinder of the seeker of peace defines them thus.

2 INDIA AS A TRAP FOR PHOTOGRAPHERS, EXCEPT FOR HANS

Anyone who has been to India realizes it is an image trap. Point a camera at the same spot for a minute and ten scenes worth photographing present themselves simultaneously. In the city or the countryside, on a riverbank, in the mountains, anywhere, no matter where, the lens will catch a monkey running off, a parrot in flight, a haughty dromedary, an old man in a turban, a priest, a madman, a wise man, and all the millions of Eves, their veils blown by the wind as they walk, or, sometimes, when they emerge from the bath and dry their saris, their hands across their nude breasts. I have known people who have seen India only through the photographs they framed in their cameras. This works well as protection; according to an intelligent study by Dr. Benoît Quirot, a young psychiatrist attached to France's embassy in New Delhi in the 1990s, the camera separates the traveler in India from the overload of the reality it presents.

Camera and photographs act like a pretty bandage against the shock of reality. Sheltered behind this small gadget, the eye riveted to its small viewfinder, the photographer-traveler sees a greatly reduced India, without its blemishes, its piles of dung from sacred cows, its chewed pap, its whitewash, its scents of honey, excrement, and ashes. Here is a *sadhu*, his forehead colored with yellow and red powder, his coal-dark eyes empty: click! I need not respond, I have a good photo. There, a woman at the well, hand on her back, tucking up her hair with an exhausted air: click! I do not think of her fatigue. Over there, women carrying baskets of stones on their heads, constructing a road, quickly, a snapshot! This is not how our seeker of peace works. He gives the impression of someone who became a photographer in order to escape from the world that saw his birth. Far from highways and blinding headlights, Hans seeks his paradises in order to live there, then he brings them to us to prove that they exist; in between, he has used his camera, but almost apologetically. He is neither ethnologist nor observer, but a man gone overboard who returns from the depths. "I've seen peace in action, yes I have! I swear it. Look at these smiles, the beauty of these eyes, their laughter, listen to them." He is barely capable, when he returns, of explaining where he has been. Where was Hans? Someplace where it is a good place to live. But where? In paradise. And can you tell us where to go to join you? No, he responds.

He tells us nothing. It's up to each of us to find these Eves in the village. No, he responds, you don't visit paradise, you live there. Hans did so, for a long time. And like Percival in search of the Holy Grail, he is a forgetful hero who has lost the way and cannot say anything, as it is too secret.

When not offering a "photo opportunity" India can swallow up people like Hans. Randomly wandering into a village, they settle in there. The people of India do not drive away visitors to begin with, and they are also accustomed to swarms of oddball strangers who nourish their own madness in India. The desert has few policemen, and the cities pay no attention to visitors. Life lived slowly enswathes them in its folds; time passes; the visitors, entranced, find a place to live, a bit of work, some hashish, and end up staying. Time no longer exists for them, while, back in their countries, years pass. The visitors have adopted Sanskrit names, calling themselves Ananda. They live in their tunics and grow thin. Some of them do not return from paradise. For the most part, however, India the whale eventually spits out its fallen fish, these Western Jonahs who return home, incurably dreamy. Hans is somewhat like that and somewhat different. He knows well India the whale, which has digested him fully, yet also spit him up again.

It is India the whale that has established the setting that gives rise to these Eves in a biblical desert. The Christian or Jew would feel only heat. Yet here, in the middle of the Hindu desert, is the Bible. Trudging along like the people of God led by the prophet Moses and his brother Aaron, here are the caravans, donkeys, and camels carrying bundles attached by cords; here are the running children, the houses made of earth and thatched with straw; here are the dry balls of brambles tangled together and blown about by the wind; here are the slope and the sacrificial ram, the rock heated to white; here is the spring and the livestock scrambling to drink from it, the shepherd who drives them, and the lamb staggering along. . . . and, at last, the women, all beautiful and all Eve, even the oldest one, whose smile reveals missing teeth.

It is all that one needs.

3 BEYOND THE ILLUSION

Let us awaken from the dream for a moment, return to reality. Take, for example, the smile with missing teeth. In India, the enormous, poorly cared-for smile was popularized by Mahatma Gandhi, who refused to attend to his teeth properly, as was normal for the middle-class Indians of the time, instead imitating the villager who hadn't the means. Thus, the teeth of Mohandas Karamchand Gandhi loosened. When he reached his seventies, with his smile having no more than two or three stumps left, all of India melted before his glorious toothless smile. Such a demonstration in the West would be greeted with horror. Further informed that it had been done on purpose, people's reactions would be that he was crazy. Any evidence to the contrary would be lost on the audience. Our youthful criteria demand a full set of teeth. That an Indian national hero, in his campaign of resistance, would deliberately lose his teeth in order to demonstrate the condition of poor people cannot be credited. In the Indian paradise envisioned by the West, people do not lose their teeth.

Let us leave paradise and go to Rajasthan. Not the Rajasthan of palaces or of tourists. A Rajasthan far from maharajas and colored stucco homes, far from pilgrimages and camel markets. We are in the Rajasthan of the Thar Desert. There's nothing to see, move on, please! But they are there, the Eves of the seeker of peace. They live a hard life. To start with, their men, these tough Adams, are not at all tender and sometimes beat their women. Not always, but this region of India has the highest rate of infanticides, and in India only female babies are killed. Life in Rajasthan is harsh. Like all villagers in poor areas, the Eves find their calcium where they can—pregnant women in Africa obtain it by chewing crumbling stones—yet sometimes their children have the faded rusty hair that signals a deficiency. On the other hand, they no longer suffer the terrible famines that decimated Indians during the colonial period. Since independence, people do not die of hunger, although many have vitamin deficiencies and many infants die from the measles. In India, cows produce little more than a gallon of milk a day—as opposed to nine gallons in Europe—and much of the livestock perishes from lack of water. Yet there is water—all of it polluted. During the monsoon season, typhus and cholera epidemics rage. Among its laws concerning purity, the Hindu religion decrees that the right hand be used for eating, as it is pure, whereas the impure left hand is reserved for less noble purposes, notably, those involving excrement. India's paradise is not a bed of roses. How can people wash their hands when there

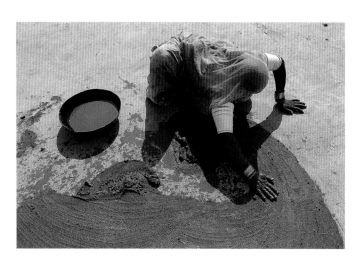
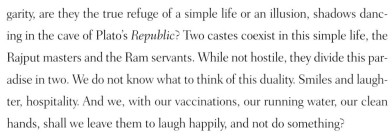

is no water? And how can they avoid con-tamination?

So the women are beautiful, displaying an unparalleled dignity. They are strong, bursting with health, quasi-vegetarian, living primarily on millet. These harmonious villages, utterly lacking in ugliness or vulgarity, are they the true refuge of a simple life or an illusion, shadows dancing in the cave of Plato's *Republic*? Two castes coexist in this simple life, the Rajput masters and the Ram servants. While not hostile, they divide this paradise in two. We do not know what to think of this duality. Smiles and laughter, hospitality. And we, with our vaccinations, our running water, our clean hands, shall we leave them to laugh happily, and not do something?

This is an old dilemma. Mahatma Gandhi preferred village life to city life, a moderate vegetarian diet to banquets, the human voice to the music of instruments, and rustic life to the factory. Like Jean-Jacques Rousseau and the great reformists, Mahatma Gandhi wanted to change the world by turning it back to the simplicity of its origins. He was not completely opposed to modern changes, but he disliked aimless modernity: industrial complexes, machines that had no liberating effect. And he eschewed all medications.

Living in these paradises, such dilemmas occasion awful clashes of conscience. Deciding to remain true to his ideals, Gandhi refused to use medication for his desperately ill son, treating him instead with wet clay. His son survived. During the winter of 1943, however, his aging wife caught pneumonia and, in deference to her husband, declined penicillin. Wet clay could not help her, and she died.

Is there such a thing as a balance between the harmony of the village and modernity? As a life shared with Eve? As the biblical paradise of simplicity?

4 THE TRACES OF HISTORY

These desert regions served as passages for caravans and warriors. Bereft of mountains, except for the modest Aravalli Range, the plains of Rajasthan were swept by invading Aryans. Not far away, the Khyber Pass, beginning in the dry peaks of Afghanistan and ending in Pakistan, emerges from the Indus Valley. Alexander the Great led the Macedonians there after Candragupta drove them from Punjab in 316. About 80 B.C. the Scythians established an empire at Gujarat. The true conquerors burst on the scene later—the Ephthalite Huns, who forged a path of pillage, destruction, and fire before settling in the desert; another parallel to the Bible. The Rajput, the aristocracy of Rajasthan, appear to be descendants of these terrible Huns. But there are Huns and Huns. Those who invaded under Attila were "black," while the Ephthalite Huns were called "white." "Above all, they had a light complexion, and they were frequently called 'White Huns,' an appellation found in Sanskrit under the form Cvetahûna or Sitahûna, a Sanskrit name that is probably the transcription of the Mongolian form Qara Qun, 'Black Huns.'"[1] The Huns of Attila thundered into Europe at the end of the fourth century A.D., while the invaders of the future Rajasthan, who were called the Hunas, at that time were subjects of the Avars. Later, their king, Ephthalanos (or Etailit, transcribed as Ye-tai in the Annals of T'ang), battled the Sassanids and invaded Persia, Sogdiana, Bactria, and finally western India. About the year 500, the empire of the Ephthalite Huns stretched from the Caspian Sea to the coasts of Gujarat. The capital of the kingdom was established in the wonderful Bamian Valley, where giant Buddhas sculpted in the cliffs overlooked fields of poppies—before the Taliban of the twenty-first century began their campaign to destroy them. My evocation of the Kabul regime is not inapt, since its leaders, Sunni fanatics, all too horribly illustrate the abrupt turns of history that seem to follow an unchangeable sequence: victories, pillages, massacres of humans, destruction of gods. The often-conquered Thar Desert frequently experienced the yoke of the "strong" driving off the "weak" natives.

These White Huns lived under tents. "According to certain sources, they were sedentary or at least semisedentary, as a Syriac source noted that they lived in tents and the Chinese ambassador Sung Yun had also described them as nomads."[2] They used Persian transcribed into Greek.

The Rajput of today retain aspects of the Mongols, of Persia, of Greek and Alexander, even if they seem fully native, authentically of the land.

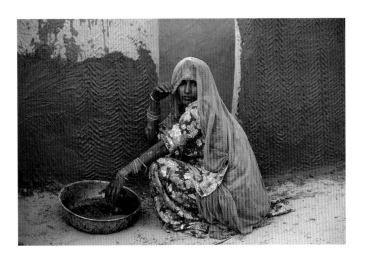

Much later, the Ephthalites were attacked by Muslims, the first time at the beginning of 1000, by Sultan Mahmud of Ghazna, the last time in the sixteenth century, by Emperor Akbar, great-grandson of Tamerlane. The Rajput resisted so fiercely that even today they are feared. These are no choirboys. The custom of forcing widows to burn on the pyre with their deceased husbands is still followed by the Rajput today. Look at them closely. Their celebrated pride, the swaggering air of the turbanned men are the remnants of the Rajput culture in Rajasthan. Western India breeds fierce and proud men, not gentle humanists. They remain White Huns.

As for all the others, all the rest labeled autochthons, since they ended up there—having migrated thousands of years earlier—they found themselves shoved in the shadows of the weak. Nomads, Gypsies who roamed as far as Spain, artisans or untamed types, Bhil aborigines, peasants, tinkers, the Banni tribe of Kutch, all the "small people" of India waited a long time for recognition. Up until independence, the British rulers called on the Brahmans to justify by sacred texts a highly formal and very strict division into castes, in order to have a clearer view of the crazy disorder that separated people according to their diets, an indicator of their degree of purity. Autochthons were impure by definition, the visible sign being their brownish skin in a land where suddenly the powerful were white. Independence brought with it the frightful catastrophe of the partition of British India: the Punjab was cut in two, the border zone around Jaisalmer, on the edges of Pakistan, was torn apart, Muslims rejected on one side, Hindus on the other, leading to a bloodbath that lasted three months.

After fifty years of freedom, the new India agreed to recognize its aborigines. This took the form of devoting three new states to them in 2000. The autochthons of the desert had no part in this movement, but their existence had come to light some twenty years earlier. This slow evolution came about by way of art history. The classical art of India, given sanctuary in Europe since the nineteenth century, has its museums where the major gods of the pantheon sit in majesty: Brahma, Vishnu, Shiva, and their companions. This was the classical order, immutable and clear. Unfortunately, toward the end of the twentieth century, the Indians became aware that their pantheon has some three hundred and thirty million gods, including those of the "small people," the obscure, the unranked of the desert in western India.

O Pithora, divinity of warriors and sacred horses of the Bhil of Gujarat; O Savaja, tiger with the face of a man for the Kathi of Gujarat, O all you innumerable gods and goddesses with earthenware noses and clay feet, you who people the isolated villages, what will become of you? You sit nestled in niches on private altars, on the corner of a window, near the spot where the glow of dawn alights, you wait, you watch. Only one among you has revived: Aditi, the earth mother, she for whom the earthen drums resound, Aditi, mother goddess, who fertilizes the fields when the monsoon abates. Large with black clouds, she blocks the desert's horizon and runs, driven by the wind, to cross India.

The name of Aditi is rarely heard in India, as she has been transformed into the female principle. In simplest form, under the name Sri, she is Woman; in reflexive form, under the name Devi, the divinity; in figurative form Durga, an armed goddess riding a lion; intellectualized, as Shakti, the dynamic energy of the woman, she gave rise to the sect known as Shaktism. But her name matters little. What counts are the images of large hips and a fecund pelvis, her head with round, enormous eyes; the seed of "Mother India," this goddess of a new type whose temples flourish in modern India.

This is not the noble India of wise men, nor the India of poets or of philosophers. In the land of its roots, in the shelter of Aditi, no one meditates by chanting the mantra "om." The inhabitants make things, work the land, trade, smuggle. Past these dunes have trod camels, carts, donkeys, onagers, forming the soil by caravan. As these animals carry their bundles in mysterious directions, the air resounds with brusque cries, bells, the beating of wings, the unknown; spirituality hangs about, sneaks around,

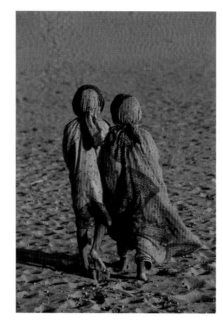

hovers. This is not the India of the Brahmans, and even if they have retained their citadels, it is no longer the India of warriors. As for the third and last caste of the "twice born," that of the merchants, they carry on relations with the "small people," because they need them.

5 THE DAUGHTERS OF MIRA BAI

Before he became a hero, Mahatma Gandhi was born into the caste of merchants near the ocean, not far from our desert paradise. Humbled by his experiences in London and South Africa, Mohandas Karamchand Gandhi stoutly sided with the small people. Having successfully defended his countrymen in South Africa, Gandhi toured India to reacquaint himself with the country after an absence of twenty years. Few Indians have benefited from similar experience. Although today's wealthier middle class has the means to travel by airplane, most trips are made only to visit family. Gandhi, before throwing himself into the struggle for independence, methodically traveled throughout India, becoming one of only a handful of Indians who truly knew their country well. While high-born Indians—that is, the Brahmans—listened to Carnatic music or dhrupad songs, Gandhi delighted in the popular *bhajan.* These monotonous chants, songs, and simple compositions were performed accompanied by a portable harmonium, a musician working its bellows, cymbals, and sometimes a rustic drum. These songs honored the divinity. Which one? Whichever the singer desired. A *bhajan* needed only to exalt the "bhakti" (devotion to a deity constituting a way to salvation in Hinduism); the root of both words, *bhaj,* means reverence.

In these lands, the women sing. It is a common rule of the countryside that women sing while working in the fields or while picking over grain. However, they do not sing with the same intensity in every corner of India, and in the desert regions we are looking at here, they sing. For example: "Jee Jee Ho Re Ho Re, I say Ho, I sing Ho, I sing my little one to sleep in his cradle, I say Ho, I sing Ho, I am all yours! I would die for you, my beautiful child." In this old song from Gujarat, the strange names of

angelic beings in the Zoroastrian tradition, the Meher Ijad or Sharori Ijad, come up here and there. Another example: "My courtyard has been cleaned and plastered, give me a child who will print it with his footsteps, O Rannade!"[3] in which a sad, childless woman beseeches the queen of the sun.

These wonderful songs accompany the washing of saris, the spinning of cotton thread; they entertain the sister-in-law, irritate the brother-in-law—all in the courtyard of a farm the size of a pocket handkerchief, that interrupts the endless space of the desert. Their origins go back to the Middle Ages, between the twelfth and fourteenth centuries, about the same time the myth of Tristan and Isolde was taking form in Europe. It would be wrong to suppose that these modest songs did not carry the grandeur of a love poem; love canticles arose in Rajasthan during the same period. As in the European medieval legend, the women of these love songs were unfaithful, but not with mere men—they took as their lover the charming god Krishna. And far from being punishable, everything was possible, all was permitted. Oddly enough, the poets of Rajasthan who celebrated these adulterous and divine love stories were women, named Ratan Bai, Gangasati, Radha Bai, Gauri Bai, and, above all, Mirabai.[4]

Mira Bai was born a princess in a small village, a principality with few resources, yet her father, from the caste of warriors, managed to arrange a brilliant marriage for her with a powerful raja. But the young Mira had other ideas. She had been given a statue of the god Krishna, wearing a crown of peacock feathers and playing a transverse flute, his hips flung out at a jaunty angle, like those of a girl. The child fell in love with the god and swore she would remain his lifelong spouse. She did not refuse to marry the raja, as long as the marriage remained unconsummated. It must have been hard for the raja, with his wife falling into ecstasy at the foot of a statue, to be jealous of a god, but he soon died, which ended his quandary. At the time, it was the custom in Rajasthan for widows of princes to throw themselves on their husbands' funeral pyres. As the wife not of a deceased prince but of the god Krishna, Princess Mira declined to follow it.

Her husband's family unleashed its fury on her. Her brother-in-law sent her a basket of fruit with a viper hidden inside. Mira draped it around

her neck and was not bitten. Nor did she die from a poisoned drink, or by means of an arranged "accident." Driven from the palace, she struck out on her own in her widow's garb—a white sari—taking with her an *ektara,* a drone lute with one string that sounds like a sea trumpet. On the road, she begged while singing of her love for Krishna.

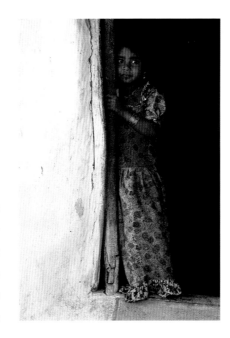

> *O cuckoo, utter not the name of my love,*
> *for if one of his lovers hears you, she will tear off your wings!*
> *O cuckoo, I will cut off your beak, I will put black salt*
> *on you. . . .*
> *My beloved belongs to me, I am his, what sort of man is he, this*
> *lover of whom you speak, cuckoo?*
> *I would love your song if it heralded the arrival of my beloved*
> *Then I would put gold on your beak and make a crown out*
> *of you. . . .*

Princess Mira died in 1546 while singing at the feet of her god.

The aged Mahatma so dearly loved the songs of Mira Bai that he listened to them to his last breath. This is not entirely innocent. For Princess Mira also sang about the lovers of her god Krishna, including the lowliest among them. These were the women of Bhil, women considered worthless, dirty. Yet the god Krishna did not turn them away, the women we see in these photographs. "The Bhil woman tasted them, plum after plum, and finally found one she could offer him. What kind of genteel breeding was this? And hers was no ravishing beauty, her family was poor, her caste quite low, her clothes a matter of rags, yet Ram took that fruit—that touched, spoiled fruit—for he knew that it stood for her love. This was a woman who loved the taste of love, and Ram knows no high, no low [caste]. . . ."[5]

Here, finally, is the much sought-after alliance! This melodramatic version of mysticism, of poverty and its half-eaten fruit, could be found laughable, but in India, in the desert, whoever does not scorn the plums of a Bhil woman is a saint. According to the Brahmans, the criteria of piety are purity of relations and the exclusion of any contact with impure beings.

Among all forms of contact, food is the most defiling, which makes offering a fruit into which one has bitten the most defiling of all offenses.

The god does not care that the woman is low-born. Dirty and common, the impure woman found the best of the plums, and she entrusted them only to the papillae of her tongue. There is no greater misdeed, no finer love. In the sixteenth century, even for a princess using it in a poem, it is a revolutionary thought.

All the unwed women of Rajasthan have something of Mira Bai in them. A rebellious air. A mocking eye. Their fierce shyness followed an instant later by their shamelessness, alive and nude, in front of you. Their royal bearing, the outlines of their veils, their manner of carrying the world on their heads. Their disarming smile and their strength, their courage. They are not noble, but something more.

6 CANTICLES OF RAJASTHAN

They are the cardamom, that hard-skinned seed that on being cracked releases an odor of mint and pepper. They are the melon, which grows in the sand and on being split offers its sweet water. They are fenugreek, allspice, saffron, betel leaves, gold and silver that is imbibed, they are spices mixed with honey. And they are the sky that falls abruptly to earth after sunset.

Like all Indian women, they have dexterous hands. Dexterous and clean. In order to purify a house, the woman has gathered balls of cow dung in the roads and dried them, in well-shaped briquettes or plastered on the walls, with the mark of five fingers, to resemble flowers. The technique consists of adding water to the dried dung to make an antiseptic liquid, which is used to coat the walls, the floors, the courtyard. It is, of course, applied by hand. The women also create alapana, wonderful designs on the floor by hand, with limestone diluted in water. The proud housekeeper will make this floor ornament at dawn. If the children don't mess it up, it could last a month.

These hands, capable of hard work, know how to decorate clothes with broken bits of mirror, surrounding them with stitched-on embroidery,

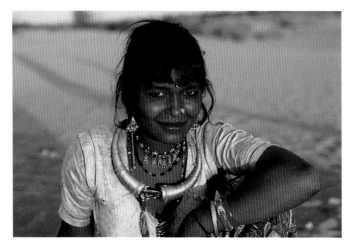

cotton swatches of every color sewed on artfully, orange and pink, apple green and black, red and shocking pink; crackling colors, creating brilliant streamers in strong contrast to elegant saris. And these magical clothes set off the tinkling of their wonderful jewelry. In the past, their bangle bracelets were made of ivory, colored red for married women. Today, they are made of plastic. Ankle bracelets, rings on each finger, necklaces—nothing precious, yet the crude combination is so powerful that no priceless jewel could equal their charm. But what is the point of describing them? Clothes, jewelry, all have been copied by high fashion, so thoroughly that the women of the West have assumed the costumes of young women of the desert, ludicrously carrying telephones in their handbags.

Golden calves exist only in the desert. Looking at Hans Silvester's portraits, I can put my finger on the origin of the Bible's golden calf. I understand why it needs to exist. For Moses, the idol with the face of a calf, copied from the Egyptian goddess Hathor, violated the love and respect of God. The founder of the Judaic laws had just returned from listening to God on Mount Sinai; his anger was so great that he had three thousand of his Levites killed. But in India there is no single god, no interdictions. Idols are recommended, especially in the desert, for without them the desert would be parched with a spiritual aridity. What did these people of God undergo while plodding in the desert for forty years? Walk; follow God's commandments from one day to the next and every day, and add to these all the new rules He makes up; eat manna, the sole nourishment; keep walking. No end to the rebellions, complaints of thirst, of hunger, of exhaustion. And, faced with the requirements of the God who brought Israel out of Egypt, of spiritual aridity.

Had I been a Jewish woman walking toward Canaan, I would undoubtedly have fomented revolt here and there. And in order to enrich the life of my family, I would secretly have twisted my gold necklace into a snake, a bird, a lioness with a woman's face, any minor divinity, to hold it in the palm of my hand, something to beseech in the suffocating heat. Golden calves exist only in the desert, for they refresh the soul in a water shortage.

If the rigid commentators of the Bible had stopped concealing the charm of amulets, the beauty of jewels, and their magic powers! If they had reread the *Song of Songs*, the only love poem in the great sacred book! There lies the beautiful link between boy and girl, the only link between nature and humankind, the lover followed by goats and sheep, the beloved with full, ripe breasts and vines in her hair.

Separated from him she laments, she suffers, sick with love: "Without my beloved, I cannot live, I have sacrificed to him my body, my life, my soul, night and day, I wait for him, crazed with love for my beloved, o lord, the desire to see you again has pierced my heart." And the young women around her prepare her—there he is, crowned with glory. . . . These words are not those of King Solomon but of Princess Mira. It matters little; all transports of love take place in the desert. In public, man and woman behave with reserve. He does not stare at her; she hides her face under an angle of her veil. When they are alone, though, they unite. Two cooing turtledoves do not display more liveliness.

Comparing the songs of Mira Bai, the *Song of Songs*, and, in another direction, the poems of Majnun "the demented" for Layla, you will see the same terms. Three deserts: the Thar, the Judean, the Arabian. Three males: the god Krishna, King Solomon, and Qays, who became Majnun, the demented. Three females: Princess Mira, Balkis, the queen of Sheba, and Layla, married to another. Three separated couples: Mira loves a god, Solomon a foreign queen who will depart, and Qays will die because he cannot marry his beloved. The same love, the same words of the desert.

You, morning bird, go, fly and bring him
My greeting, let me hope when I invoke him!
Bring him these words, God lead you to her!
If you come back to earth, if this land
be there, to Layla, desert where all lose their way. . . .[6]

It becomes clear that in deserts, the need to worship, to adore, is inextinguishable. Whether it is the voice of a lone god, the face of a woman, or ecstasy that calls, it is all one.

7 ANNAPURNA, THE ANTIPURDAH

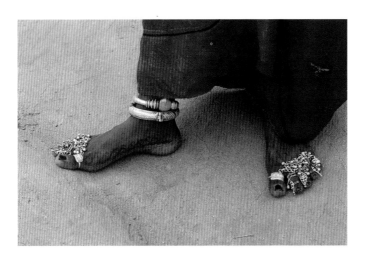

Annapurna is a goddess who gives boiled rice. Anna, which was also the monetary unit of British India, means the minimum needed for a full stomach. For this goddess, love in the desert is the least of her concerns. Annapurna measures the Absolute in quantities of rice—or wheat, or onions, or pink lentils, the ones used to make dahl, half soup, half purée, every day for those who are wealthy. Or potatoes, cooked in a stew of spices. And millet, especially millet. Goat, eight times a year.

Annapurna is she who nourishes, the "Great Provider," as Liliane Jenkins called her in *Mâ, l'Inde au féminin*.[7] Look at these photographs, look at the faces of these women, then at the men at their sides: Annapurna, nourishing women, but free.

This is not something that follows naturally. Logically, the nourisher is not free, as she lives under the guardianship of a male whom she serves. We would not go so far as to deny the guardianship of men in the very conservative state of Rajasthan, but the photographs speak for themselves. These women do not always have the veil covering their faces. When the men go to draw water from the well, the women cannot help laughing from the heart. They do not run from men who are near. Thus, they are free.

Freer, in any case, than the bourgeois women in towns or the ladies of the newly rich. Their situation, of course, is changing; the evolution of India's social life has reached a point where some wives have begun to break from tradition, and young women in jeans may manage to lift the heavy weight of the arranged (not to say forced) marriage. But many aspects of tradition are still in full force, notably, purdah.

The word *purdah* comes from Persian and means screen. Veil, closed palanquin, tapestry hangings, chador in Iran, chadri in Kabul, purdah consists of protecting women from the eyes of men. Before the Muslim invasions, women in India went uncovered, except for the wives of Brahmans, who did not leave their houses. Adding Brahmanism to Islam resulted in an unparalleled level of subjugation: the well-bred woman did not go out unless she had an urgent reason, in which case she covered herself with a veil and traveled in a palanquin. A Muslim woman could sometimes go out walking, as in Kashmir, under the *burqah*, a pleated chador, in the Afghan style, but larger, almost like a portable tent. These laws seem to have become more numerous. Hindu women have never stopped wishing for emancipation. But they cannot budge the bolt that keeps them locked in, since almost all marriages in India are arranged, decided by their parents following criteria of caste, fortune, education, and beauty, then confirmed by a reliable astrological consultation. The future bride and groom are not consulted and have no choice. Although this practice is in total contradiction of Article 21 of the Universal Declaration of the Rights of Man, which in 1948 looked forward to the free consent of the spouses, the arranged marriage is the law. As a result of this fact, purdah continues to exist clandestinely. Not, of course, through the use of the veil. It has left behind an ingrained habit, revealed in letting the *paloo* (the embroidered panel of veil worn on the head) fall around the cheeks. It is remembered in a hand, which plays with blinds, with fans: it hides.

At the time of her marriage, the woman is called on to worship her husband every morning as if he were a god. She no longer has any other gods, only him. This conjugal cult has a name: *pativrata*, the worship of the spouse. The woman must address her husband not with his given name but with a respectful metaphor in the third person. She owes him her obedience in everything, including food, children, well-being. The civil code authorizes divorce and provides for lodging complaints for physical abuse, but it does nothing to change the dynamics of the couple. These dynamics require that the woman be prudish. Like every major religion, Hinduism in its sacred text charges that woman is lesser than man for one reason, the same everywhere: the blood that flows from her vagina every month. On this point, the codes of Manu, fundamental to Indian life—well beyond Hinduism itself—are no more generous than the orthodox rabbis of Jerusalem. A woman who has her period is on the first day as impure as a pariah, a member of a low caste; the second day, as impure as one who has killed a Brahman. In consequence, she must not look at the

sun, at her children, or anyone else, for that matter; she must not brush her teeth, rinse out her mouth, oil her hair, perfume her body, stretch out on her bed, sleep during the day, or cry. All of these activities are banned, at least for those of the high castes and the well-bred.

Living in India, the small effects of purdah become noticeable for those that deeply mark women's spirits: the modest reserve so admired among Indian women, their delicate steps when walking, the way they hold their heads. But how is it that they are so different from their stone ancestors? What happened to the bold gestures, thighs lifted high, buttocks offered to the taut phallus, the pliancy of lovers, their pleasure?

The answer can be found in the desert, with the "autochthons," when Annapurna was named Adivasi. *Adi*, the first, *asi*, arrived. Even if this term is not the best, the "first arrived," who were not Aryans, did not violate their women, as we see here. In India, it is known that the female Adivasi were livelier in bed, more joyful, more courageous than their sisters who belonged to the caste of the twice born. They knew not the purdah and besides, they had too much to do to seclude themselves, they had to go out to the fields. Maybe a bit, if it is necessary to hide our faces from strangers, but not too much. Purdah—that's another world, and we don't live in it; it has been denied us, and we don't want it anymore.

Not that these uncovered ladies enjoy the privilege of choosing their partners. But escaping the caste system leads to a freer sexuality. Bodies at the bottom of the ladder are more capable of joy. Through a trick of reason, those with nothing anticipate the liberation of others. In addition, when cooking, one can be reckless of rules.

In this desert of penetrating light, contradictions cohabit. Love of the absolute, mystical to the point of death, up and down, here and there, joy of the body. Submission to the divine, to the Law, to order, but also revolt, rebellions of the people of God. The dry wind imparts a whiff of the oasis. Weddings here are the joining of the awful reality of a harsh life to an ideal of paradise. A princess who escapes to live the life of a beggar singing her poems: Could she have existed anywhere but in the desert? No. A very shy gaunt young man who became the father of the nation in 1947: Could he have been born anywhere else but on the edges of the Indian desert? No.

And our Hans, could he have found the hidden connection between the earth and himself anywhere else? No. He says, "I have seen happiness." He says, "Joy exists." He says, "The spouses I have seen are simply caresses, turtledoves, and pecks." He says, and presents us with his dream for contemplation.

NOTES

1. Louis Renou and Jean Filiozat, *L'Inde classique: Manuel des études indiennes*, vol. 1 (Paris: Payot, 1947).
2. Ibid.
3. Susie Tharu and K. Lalita, eds., *Women Writing in India: 600 B.C. to the Present*, vol. 1 (New York: Feminist Press at the City University of New York, 1991).
4. "Bai" is a suffix of respect that means "Lady" or "madame."
5. Tharu and Lalita, *Women Writing in India*, p. 93, translated by J. S. Hawley and M. Jeurgensmeyer.
6. Layla Majnun, *L'amour poème: Choix de poèmes* (Paris: Sindbad, 1984).
7. Liliane Jenkins, *Mâ, l'Inde au féminin* (Paris: Mercure de France, 1986).

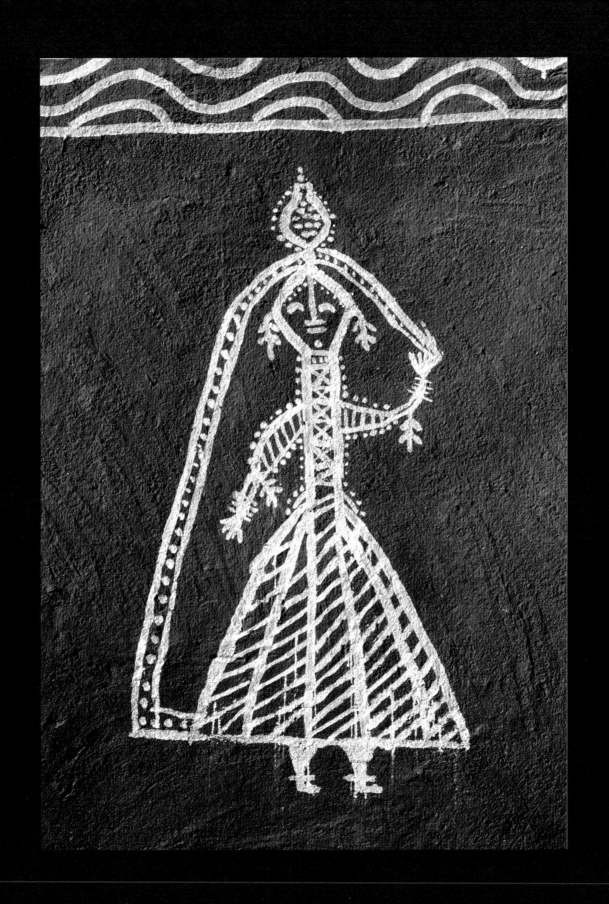

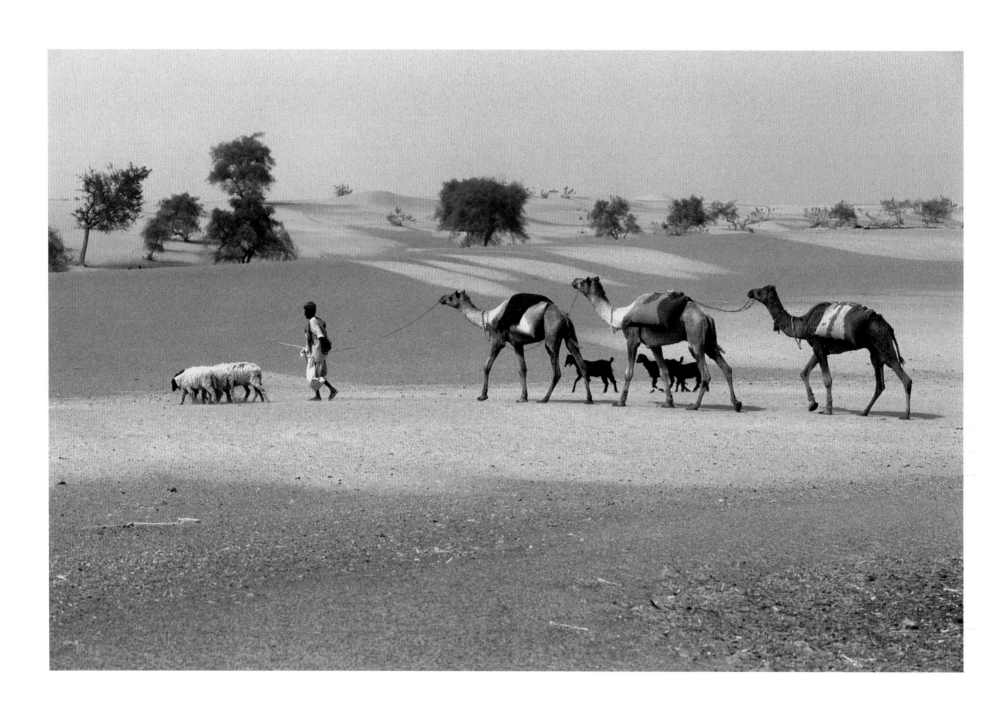

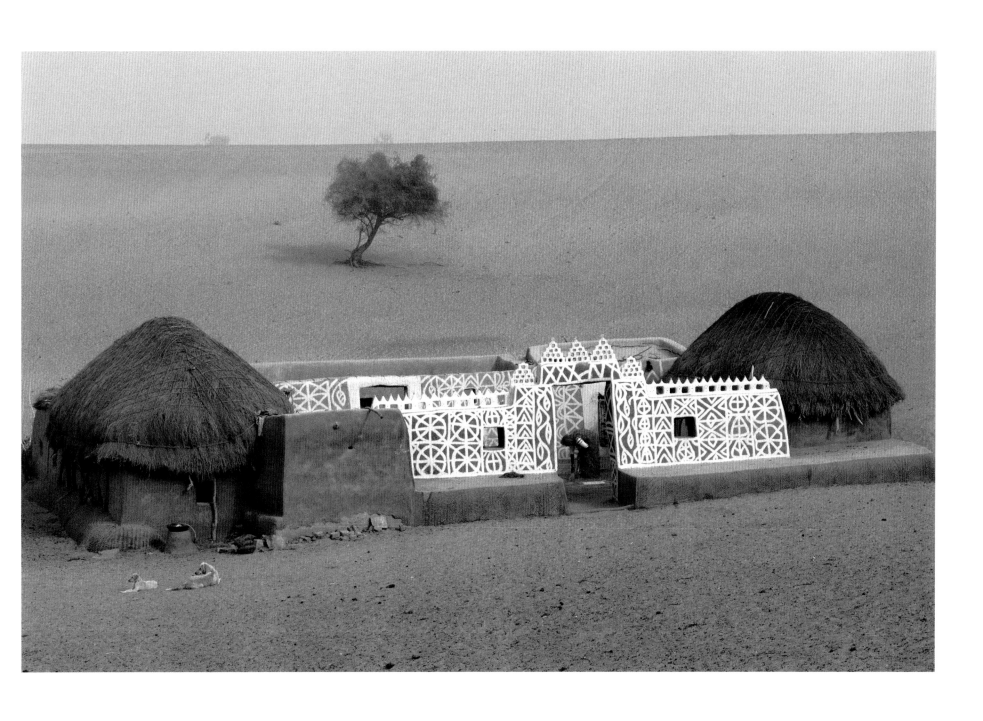

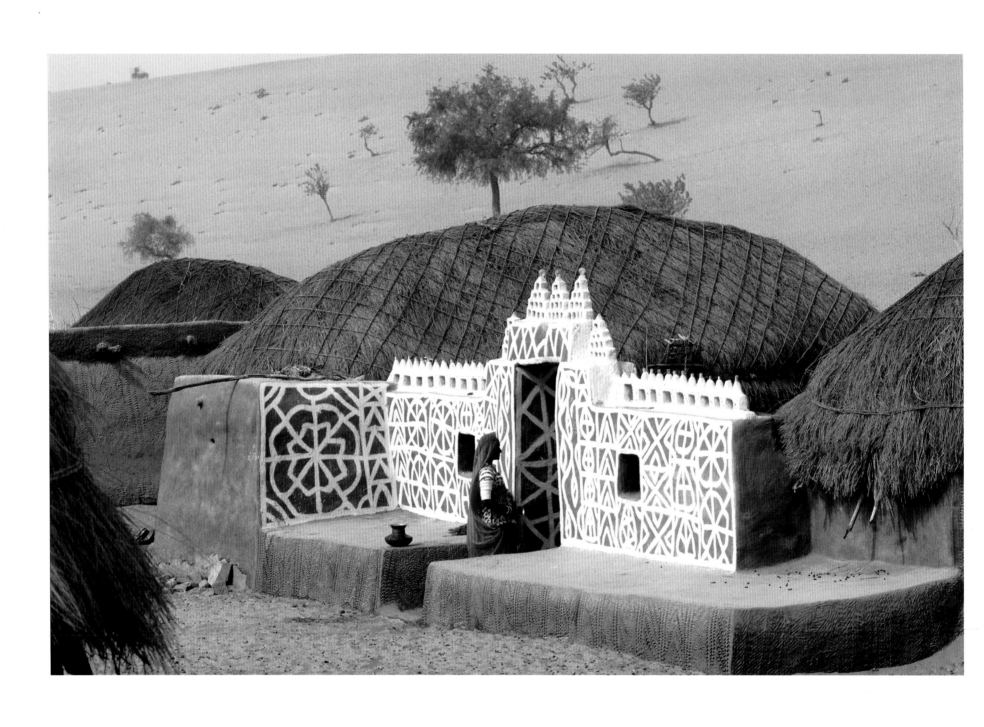

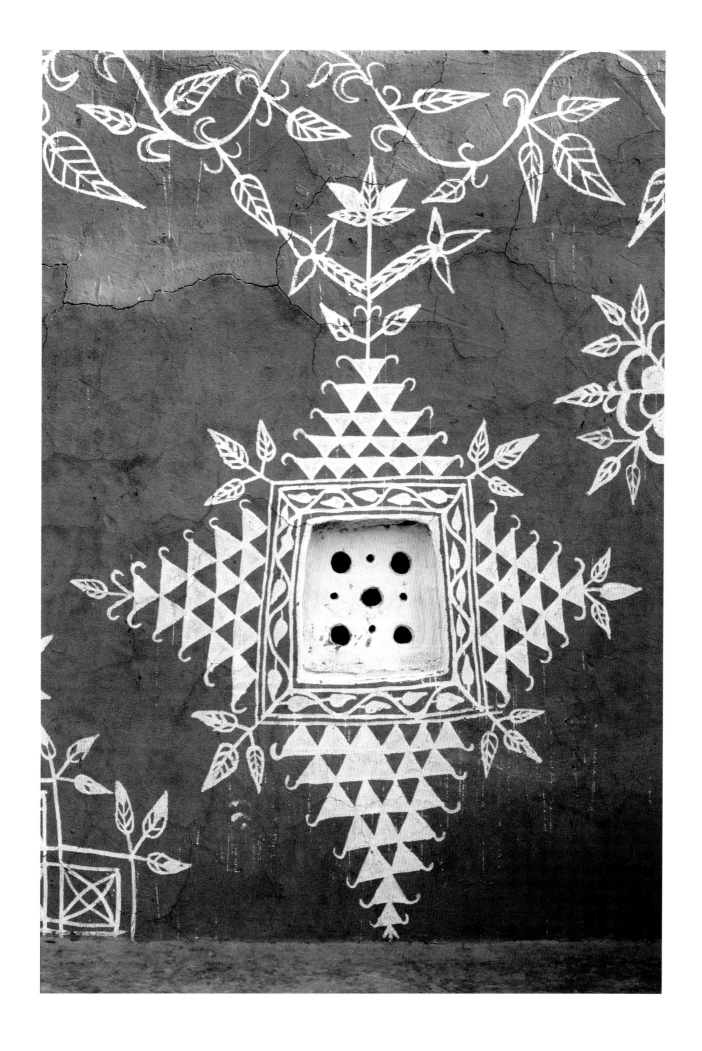

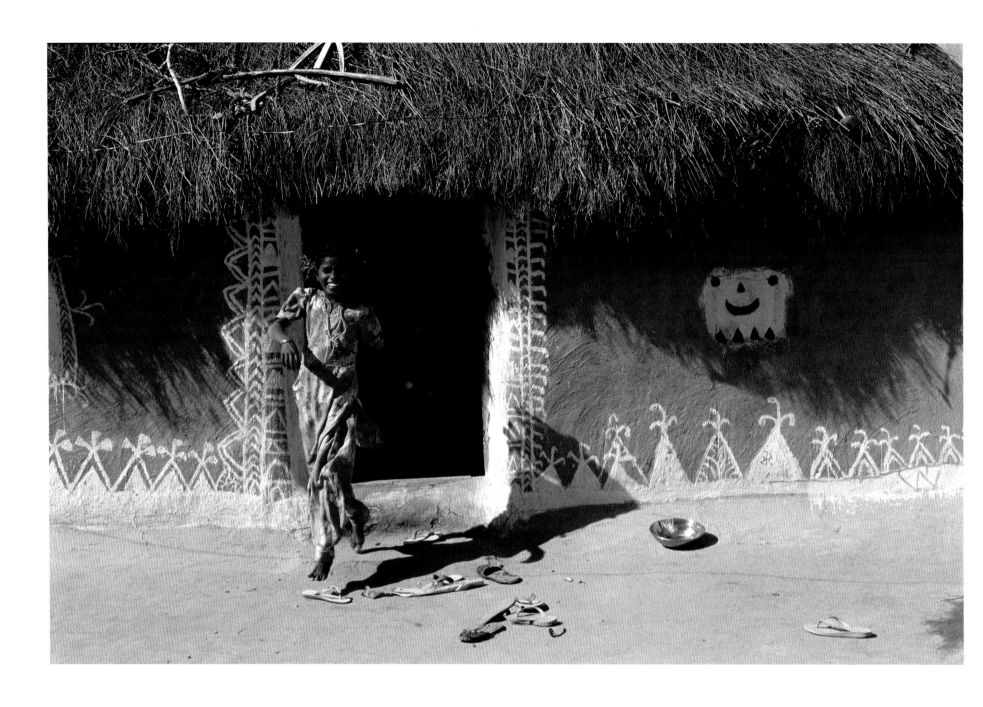

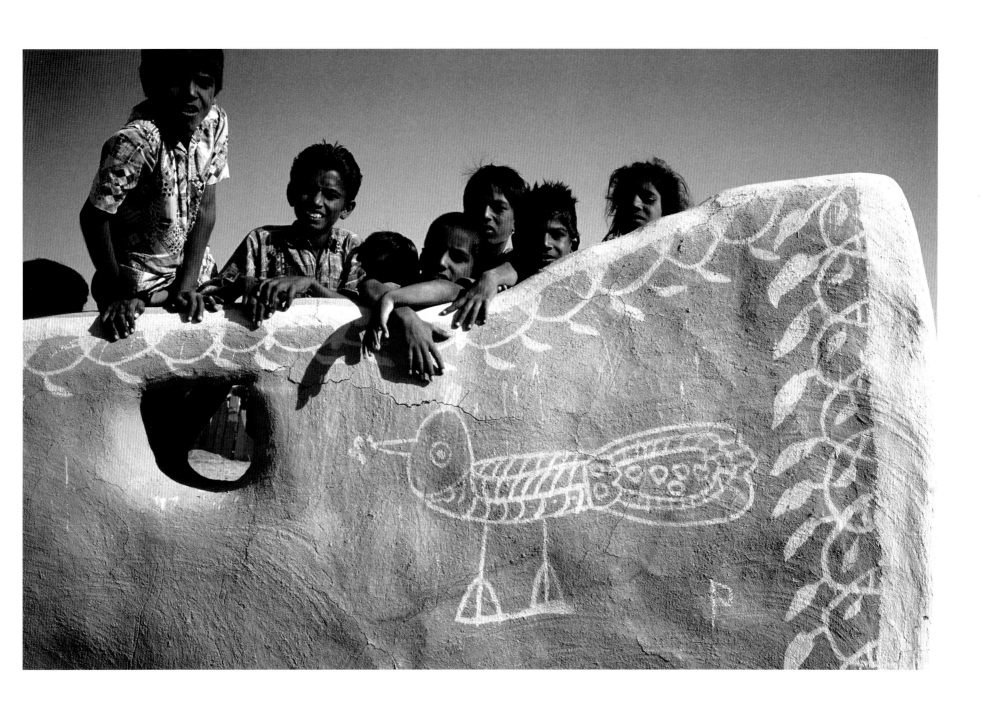

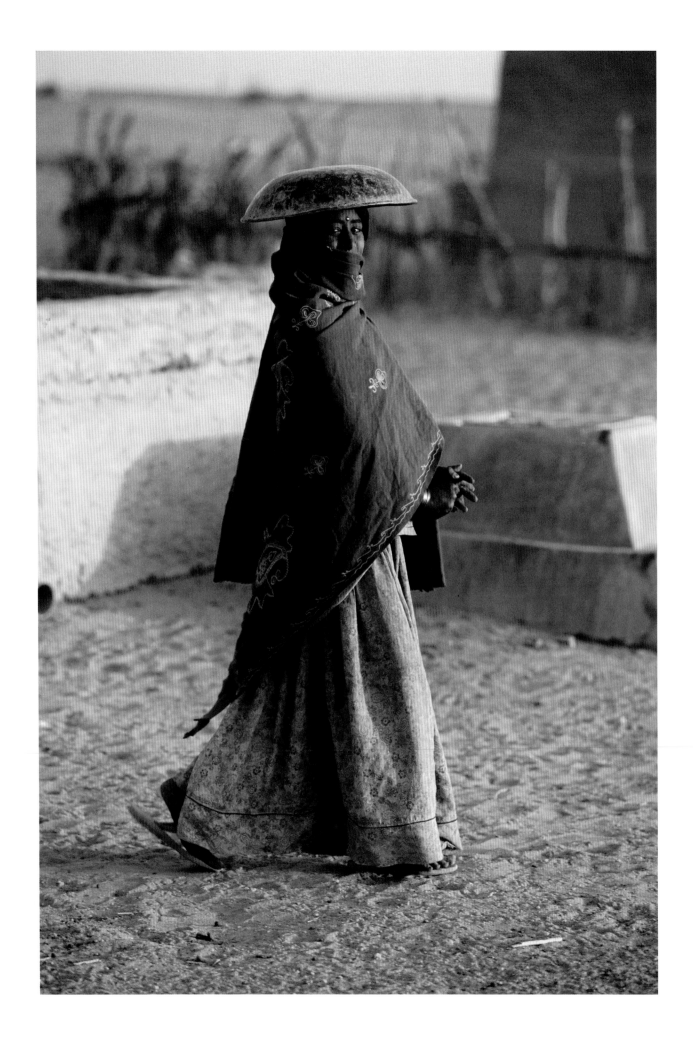

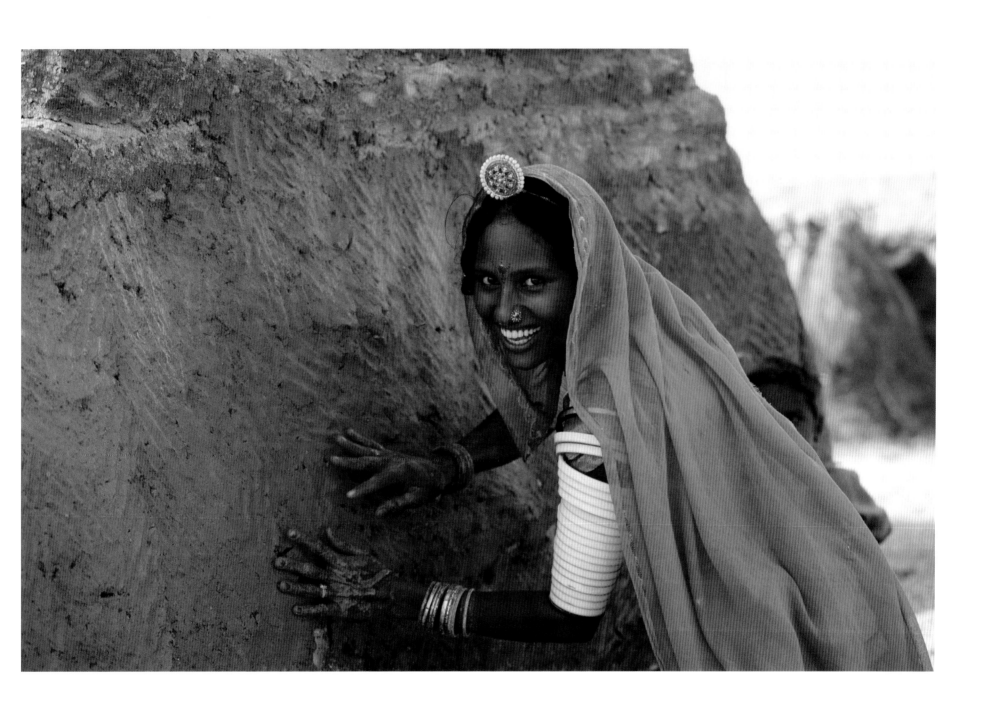

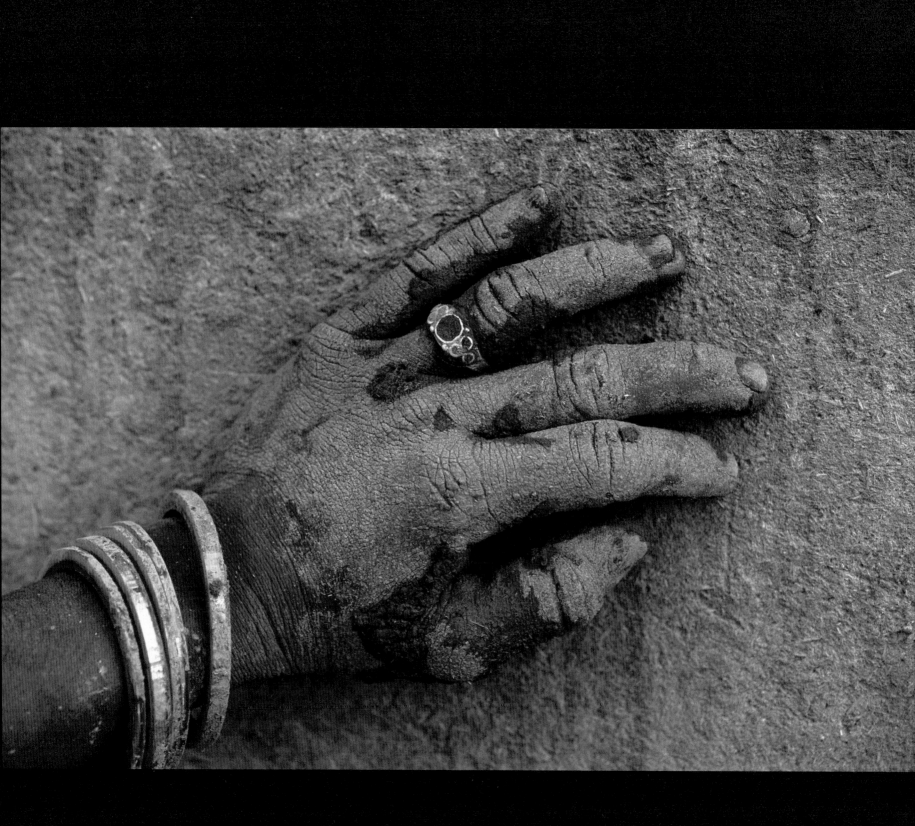

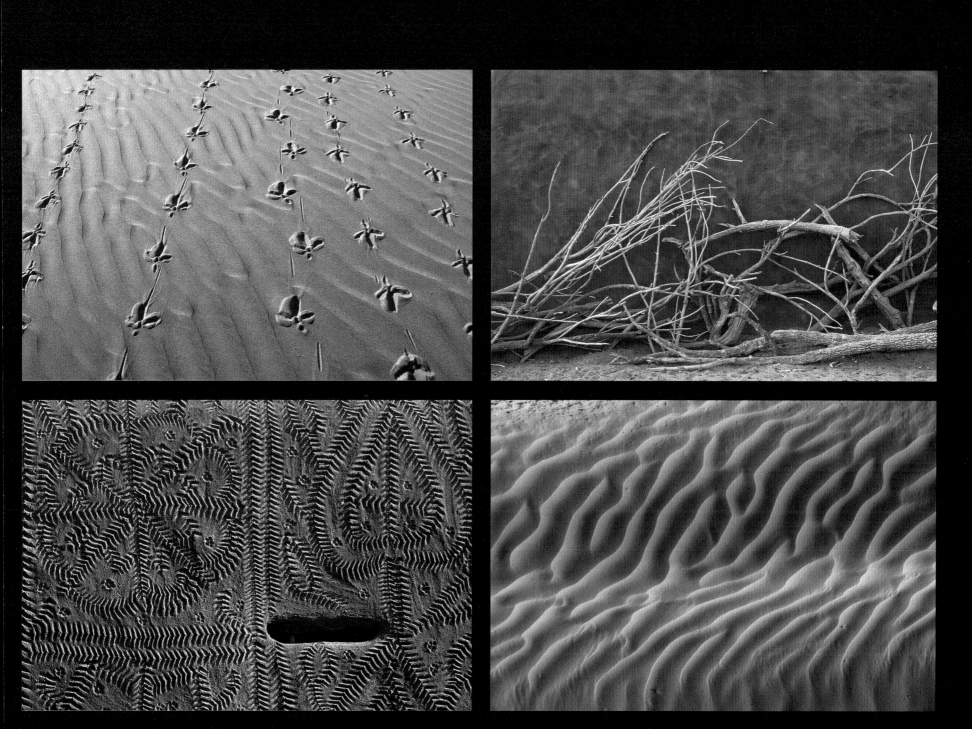

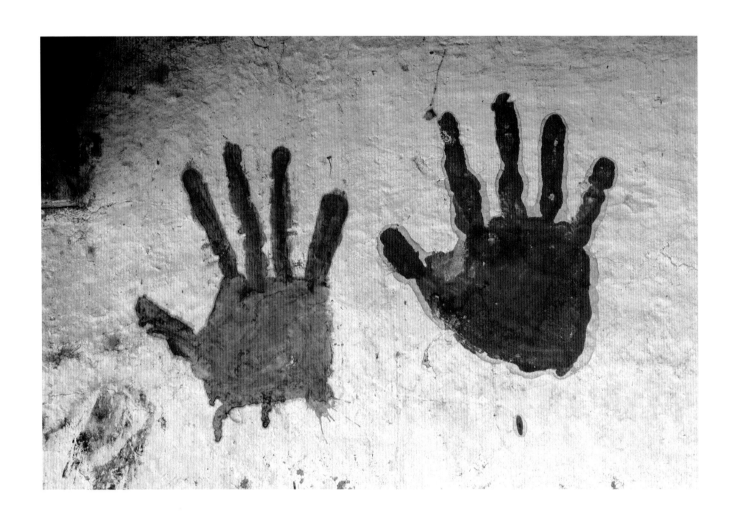

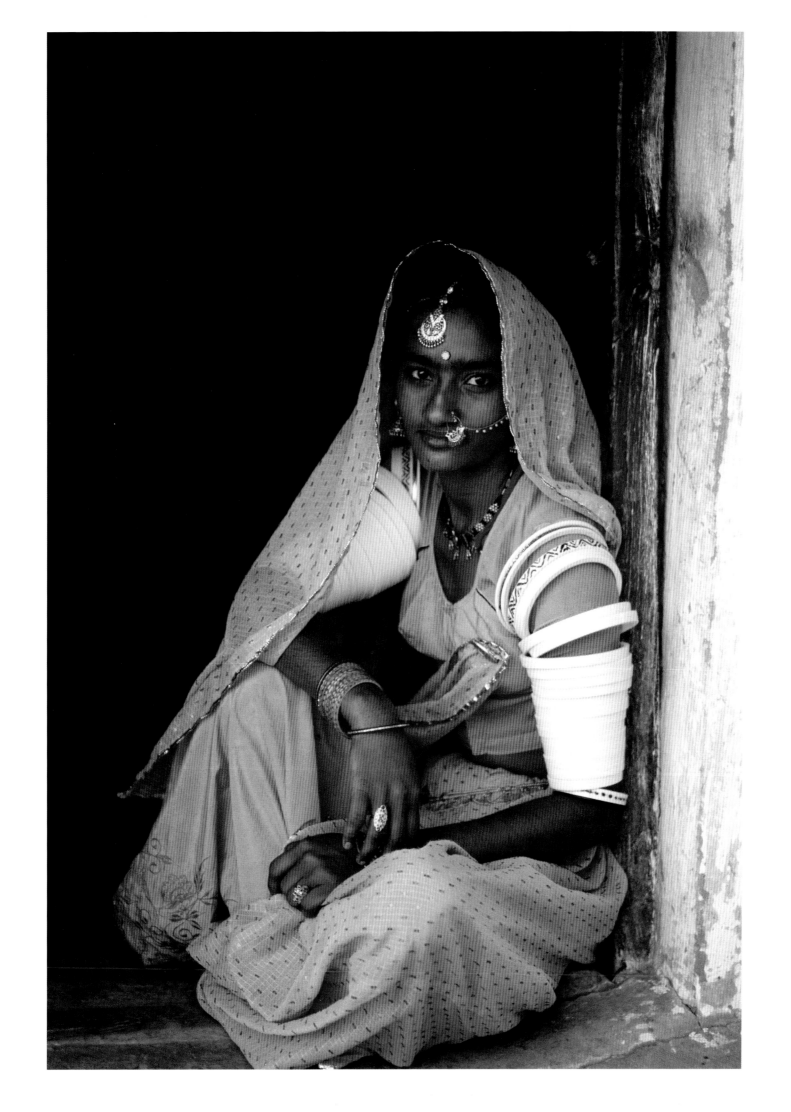

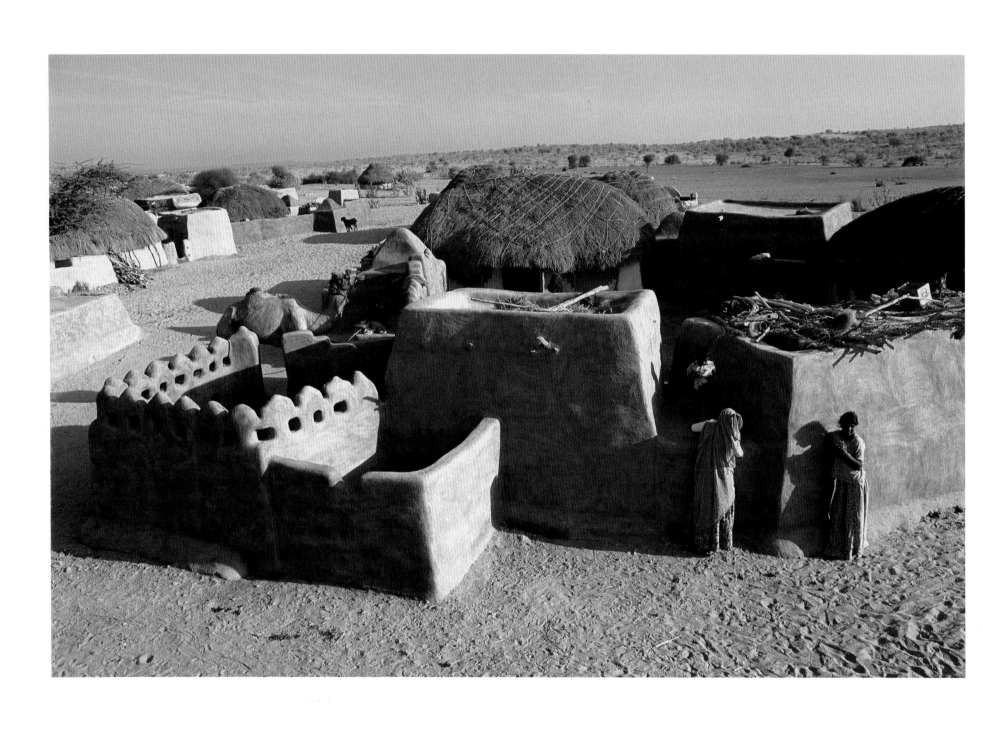

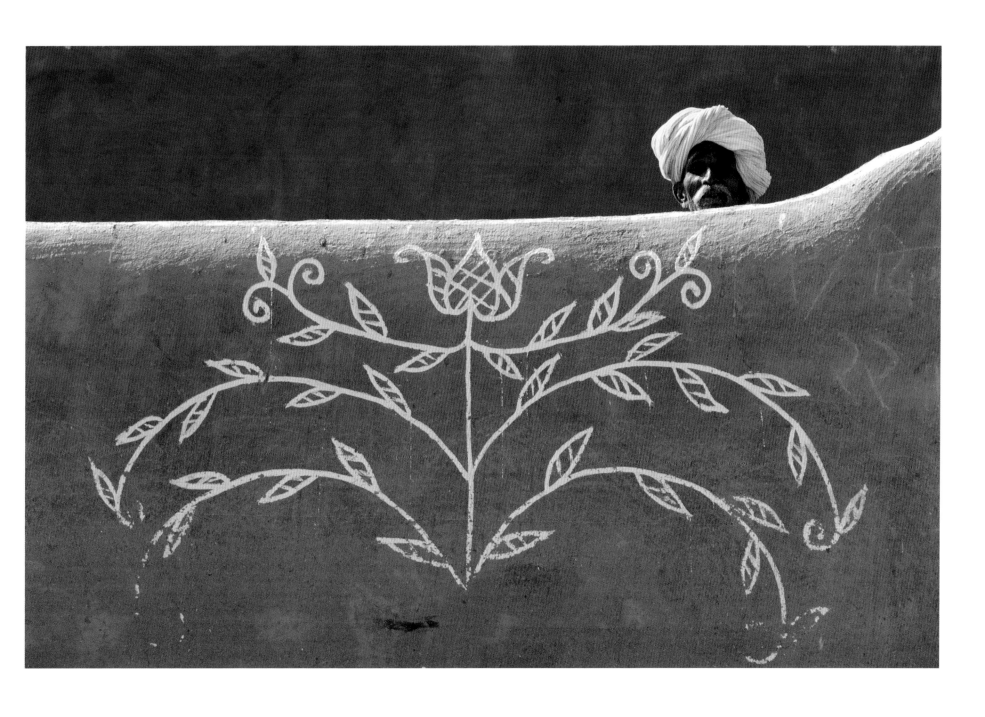

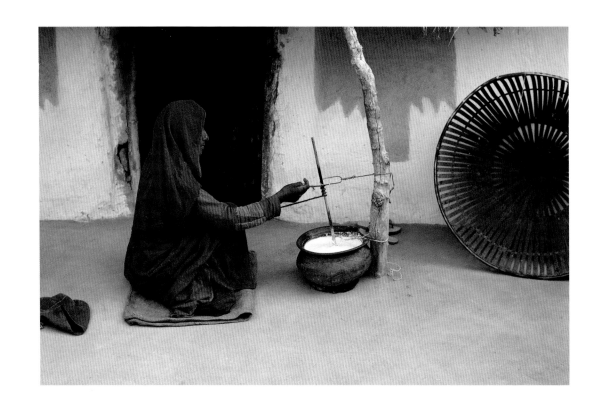

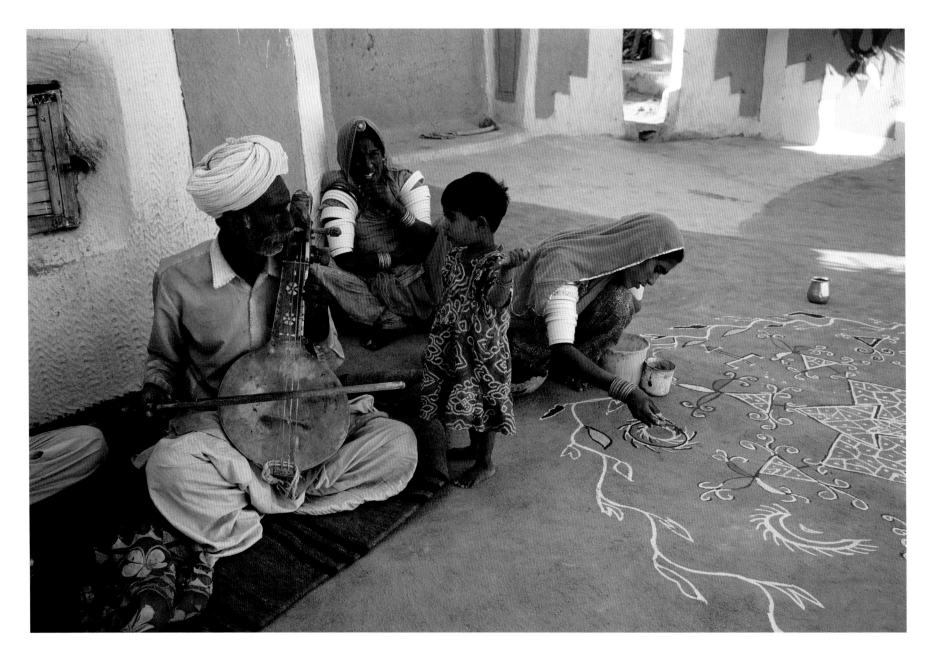

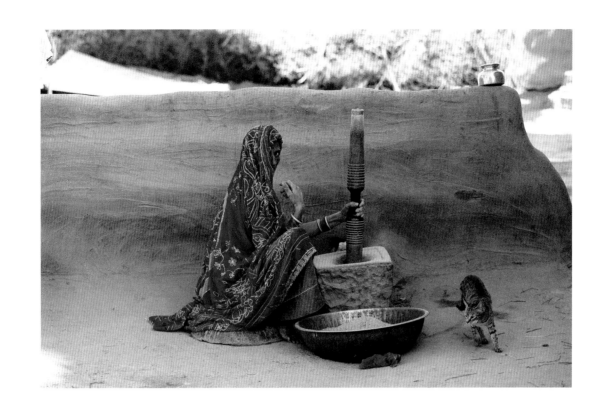

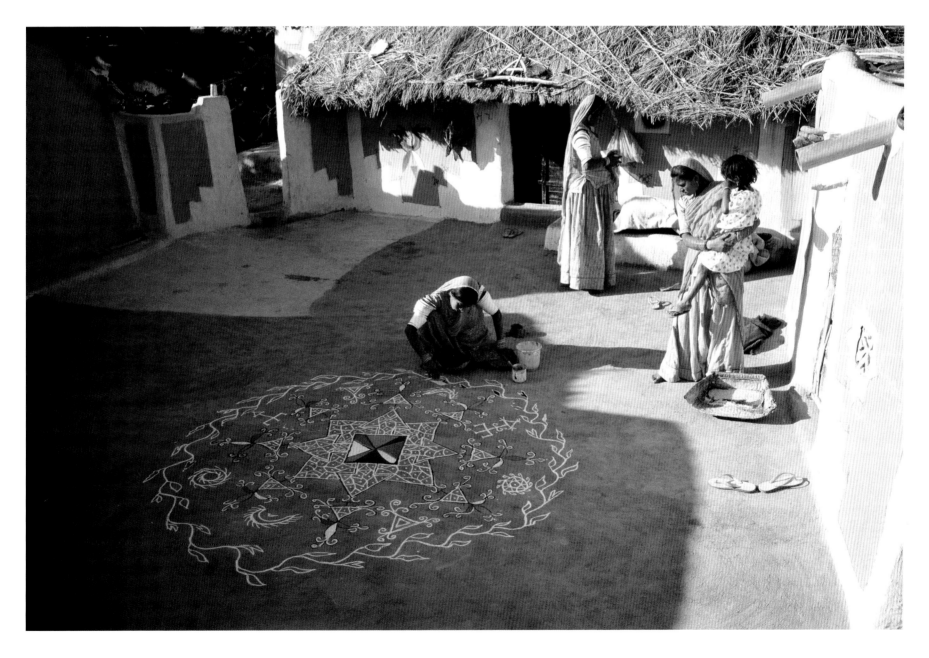

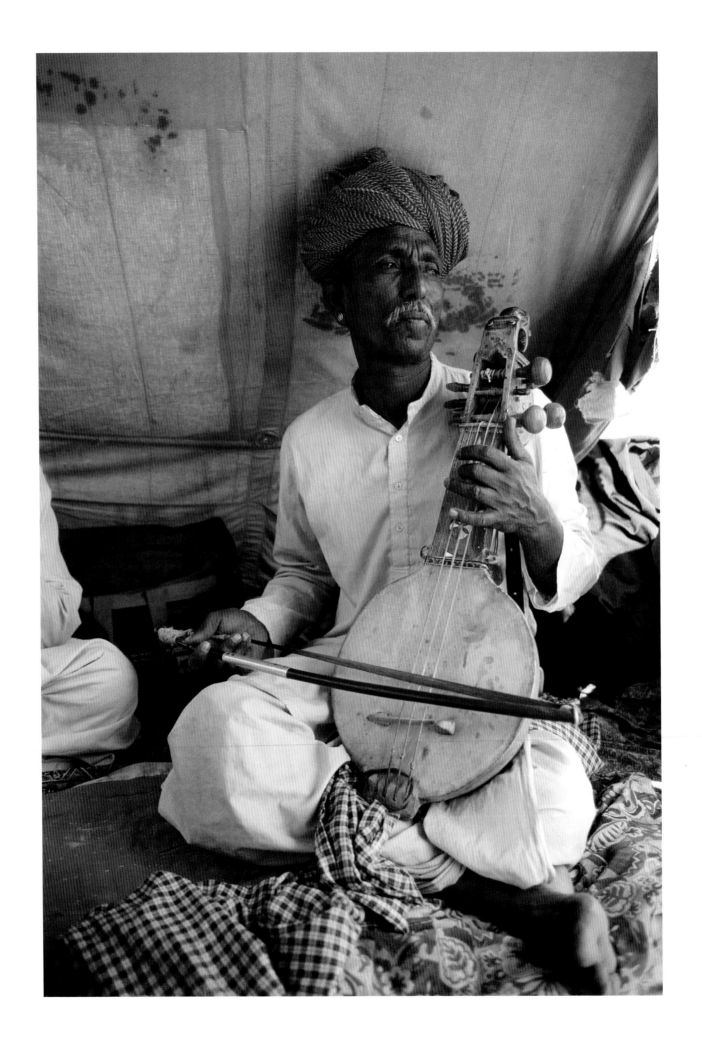

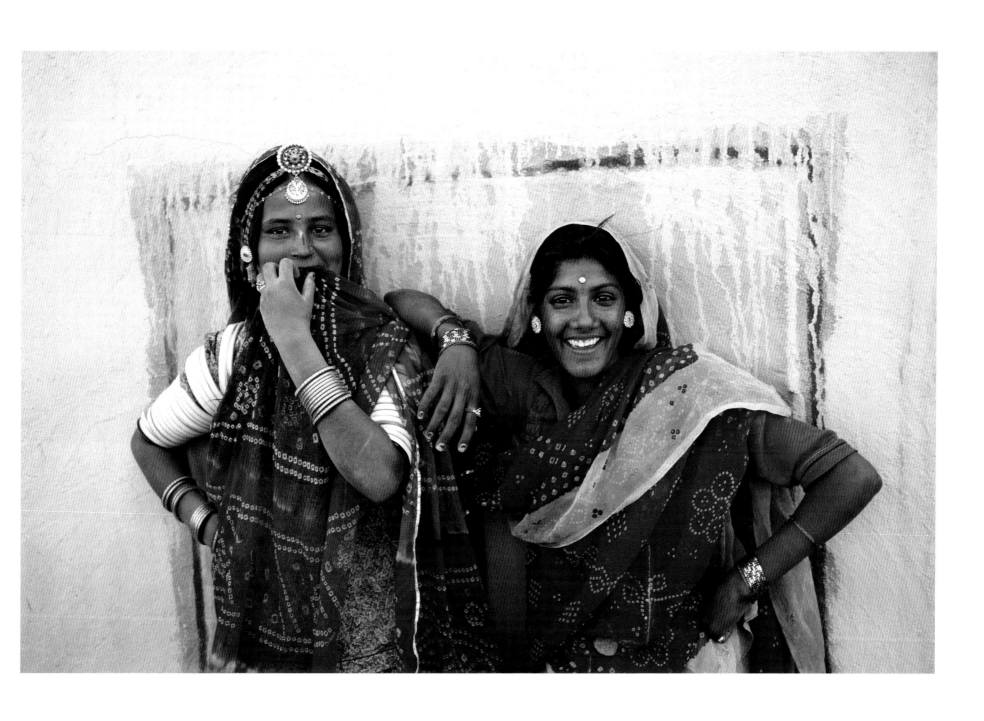

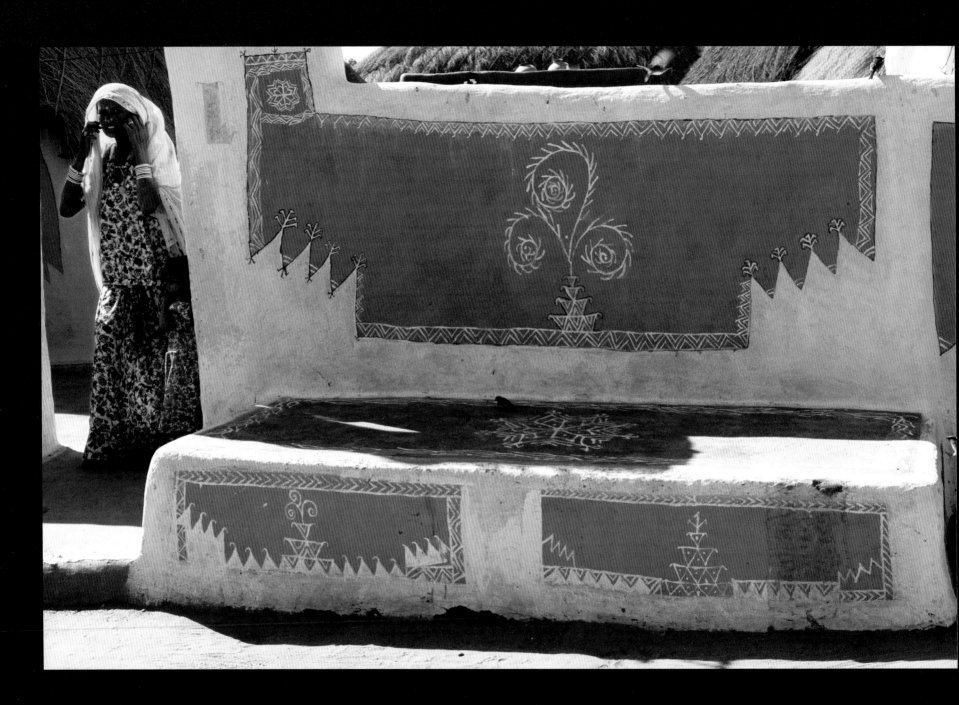

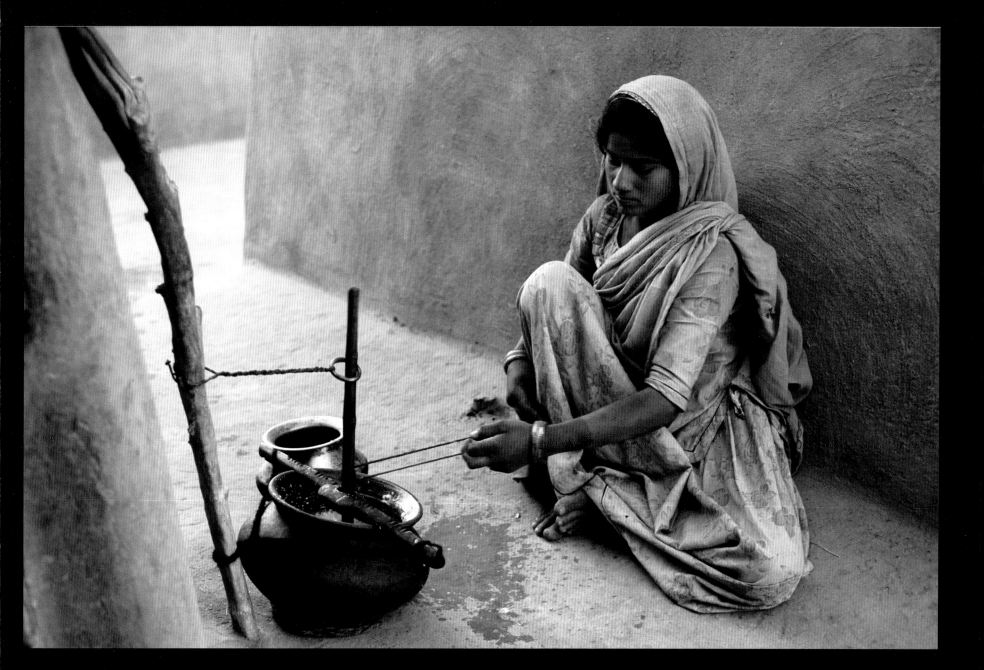

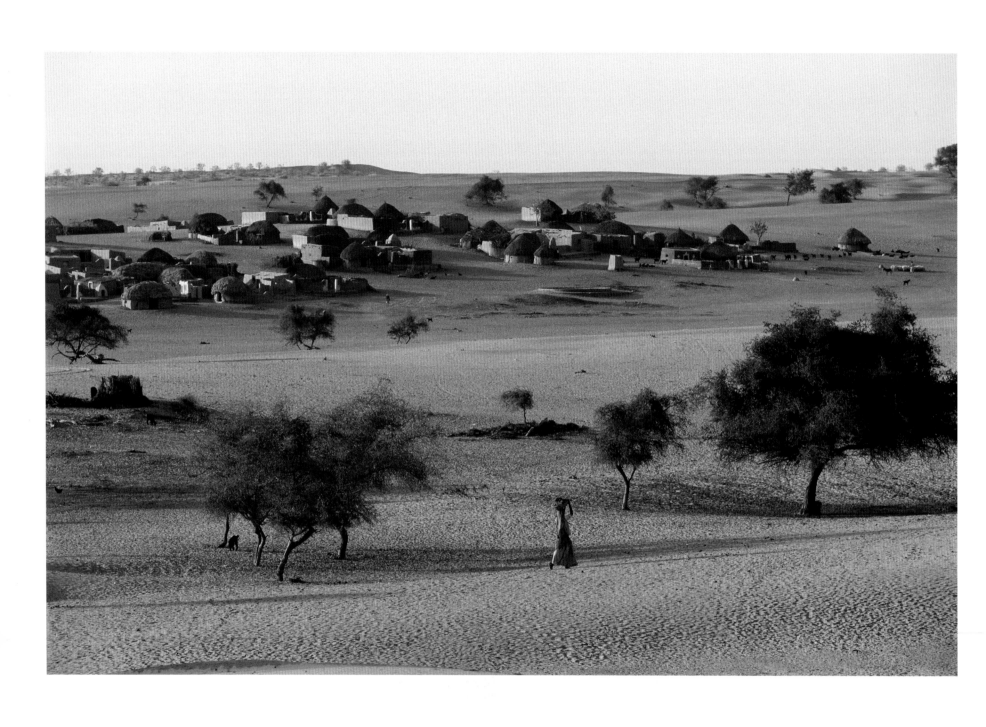

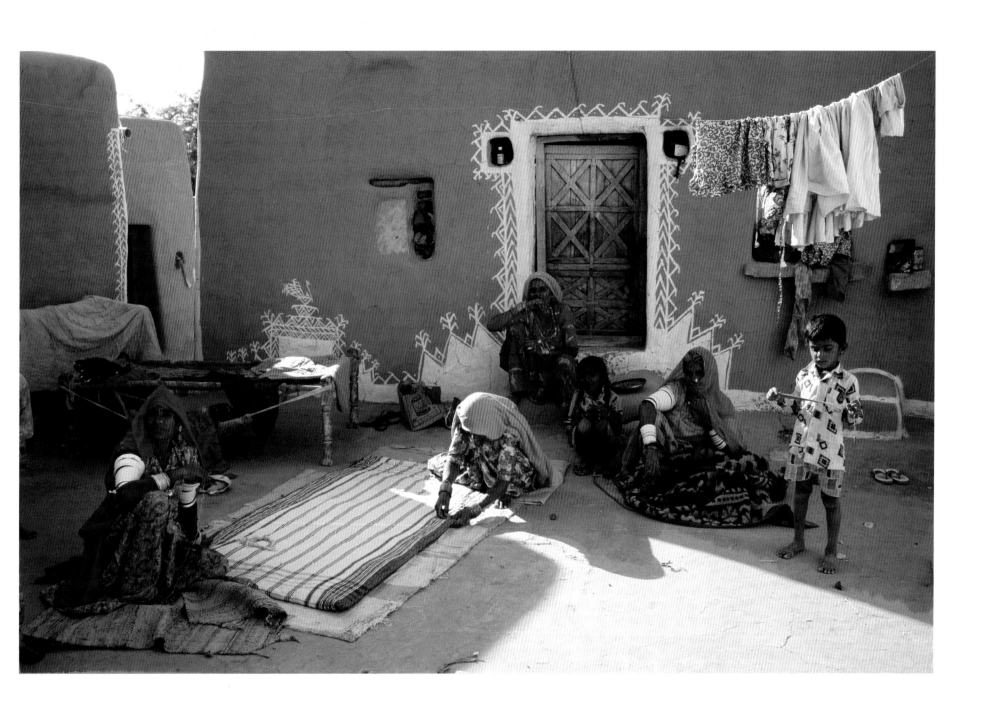

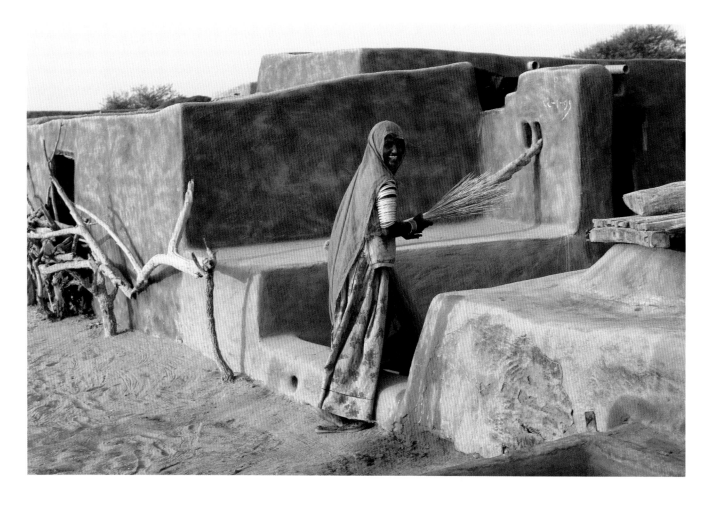

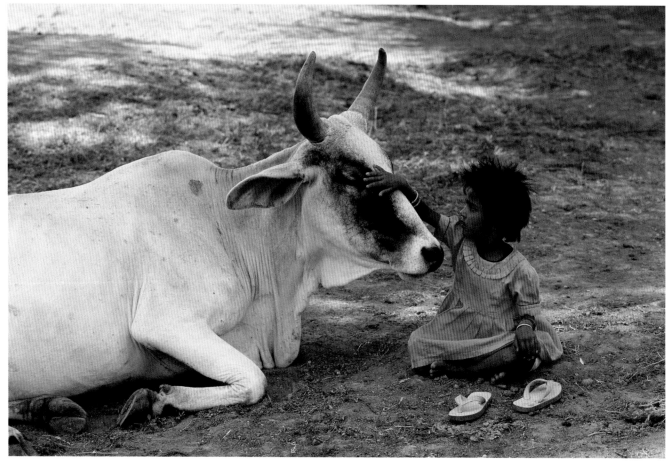

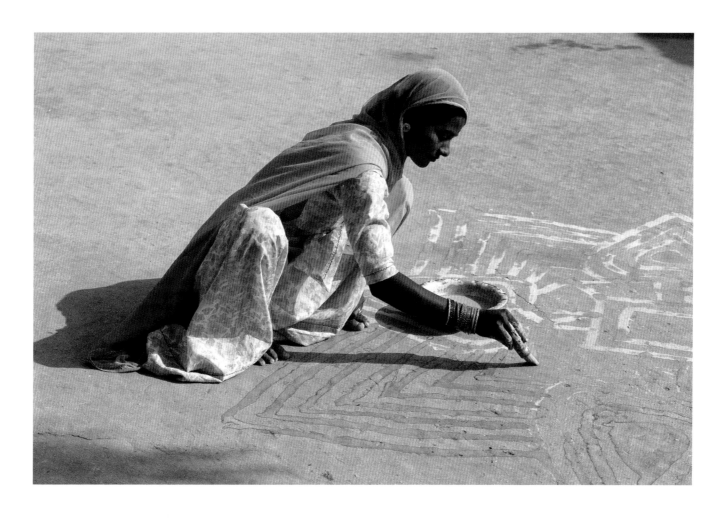

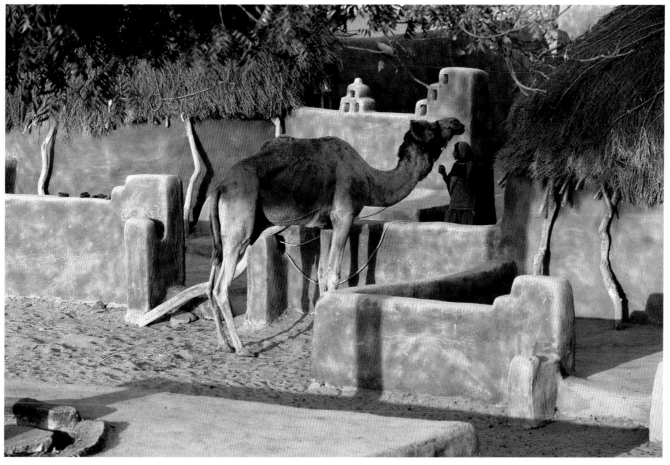

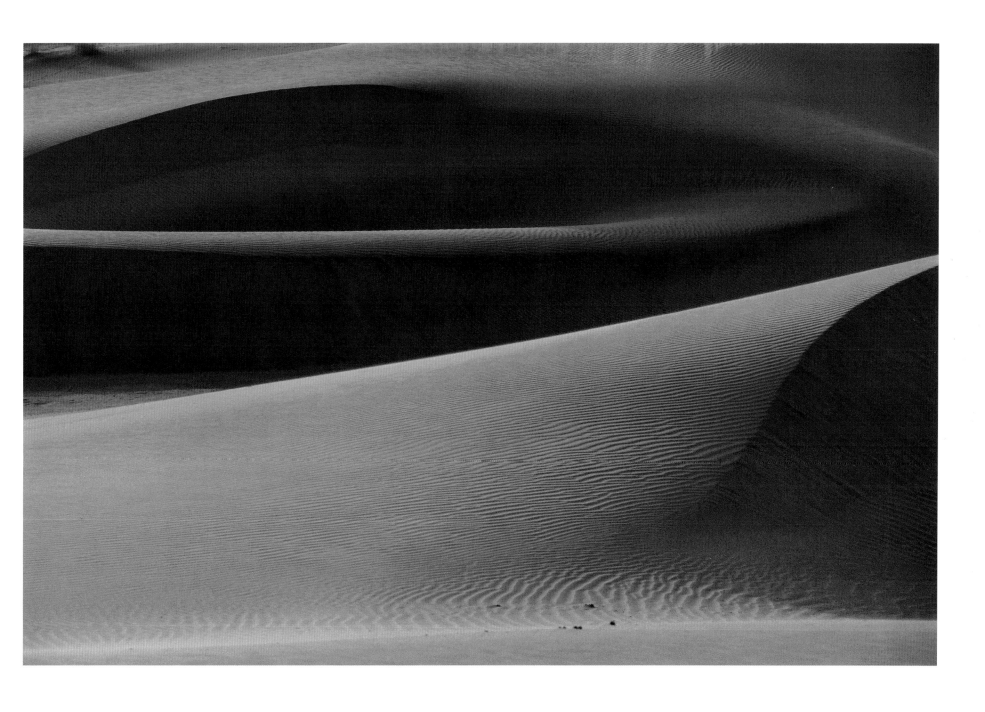

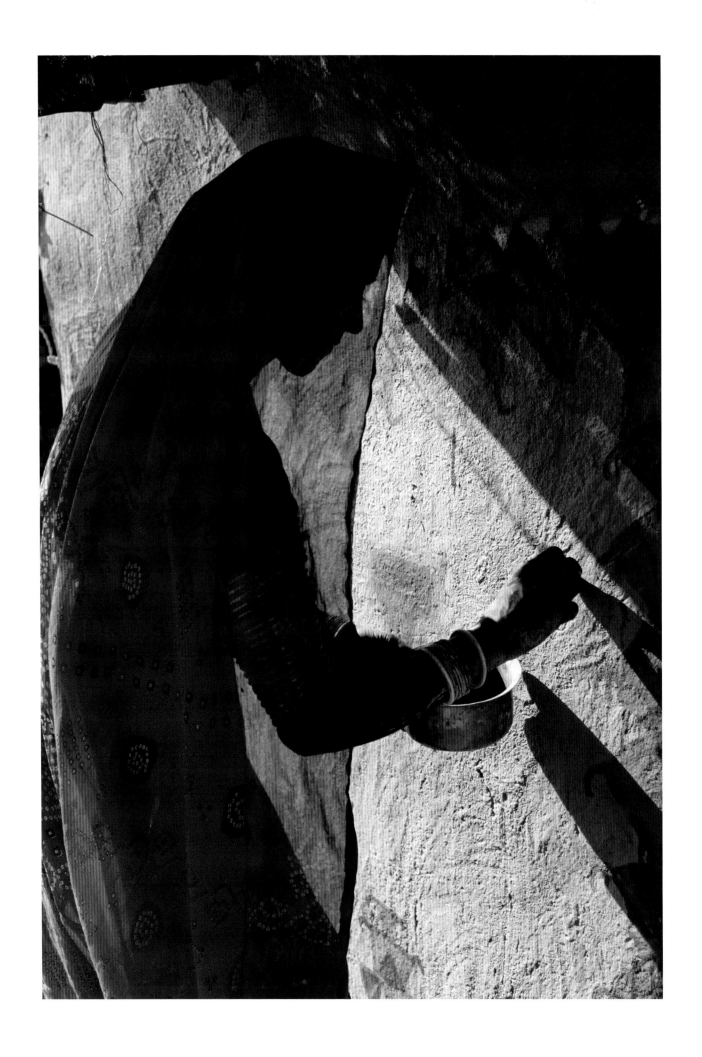

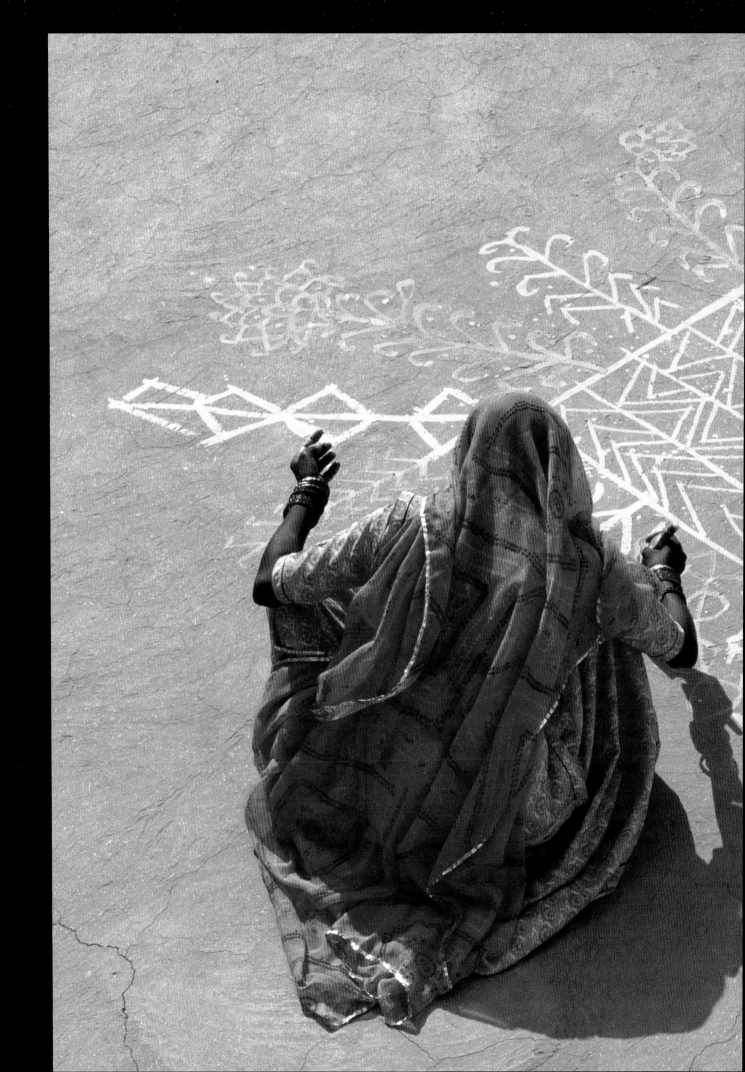

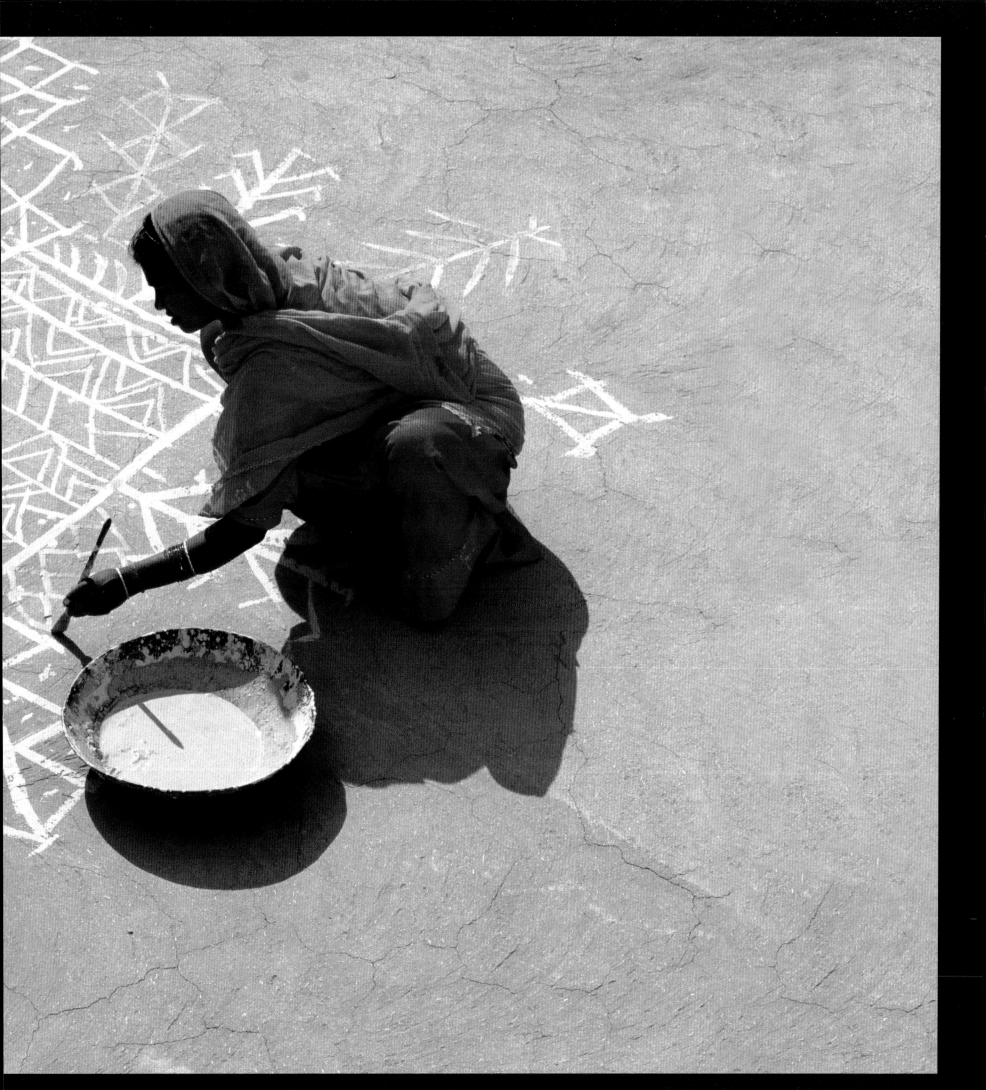

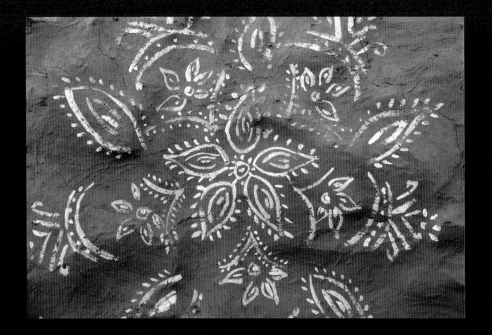

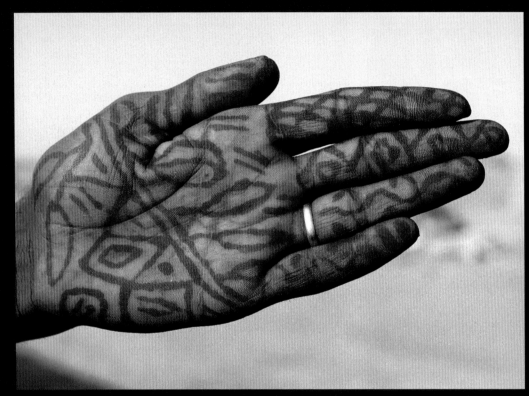

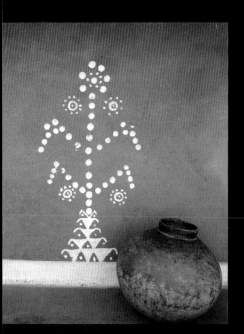
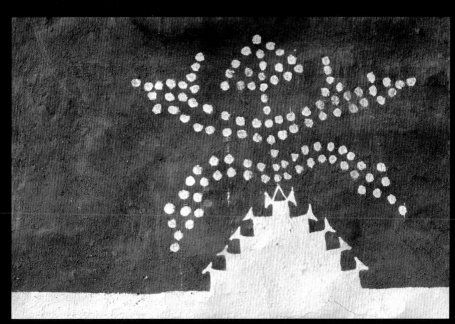

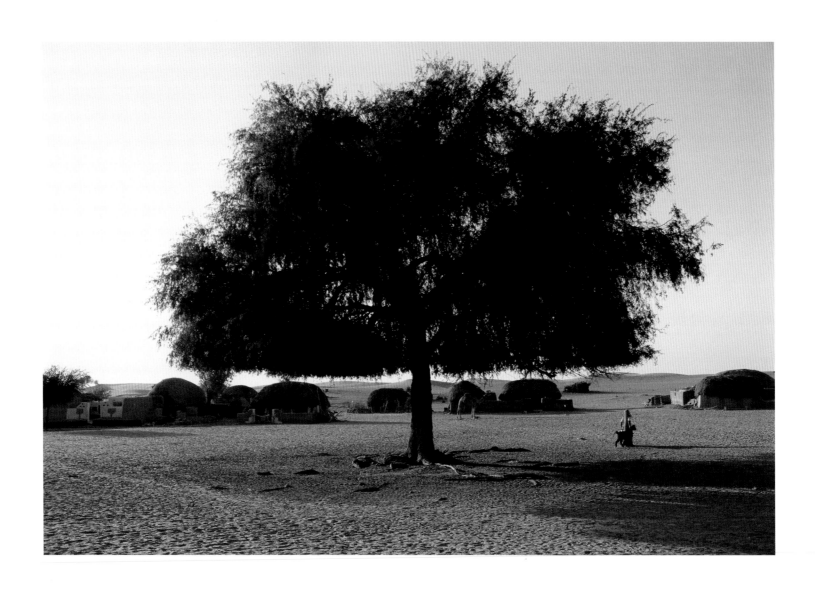

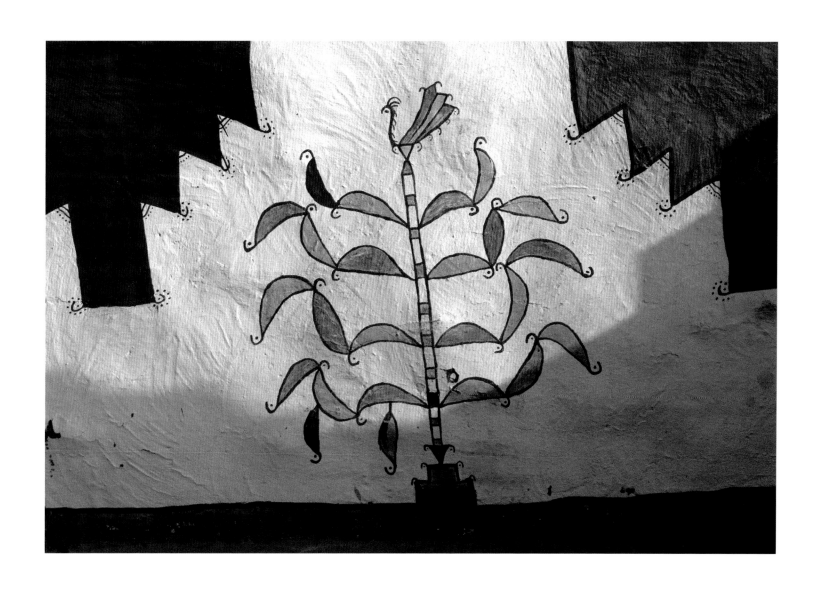

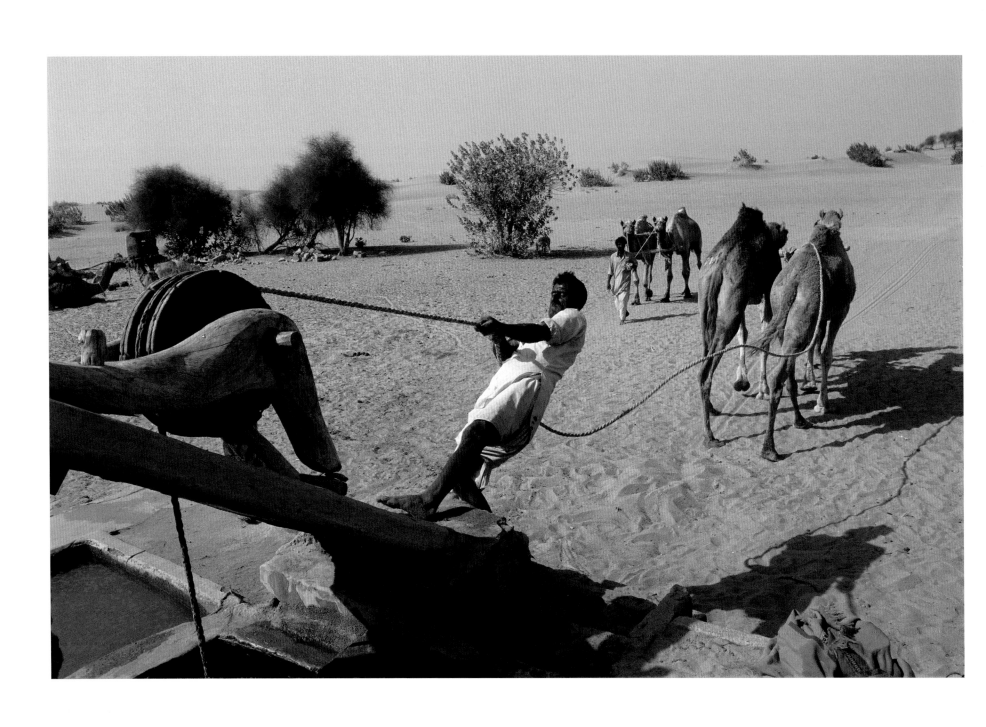

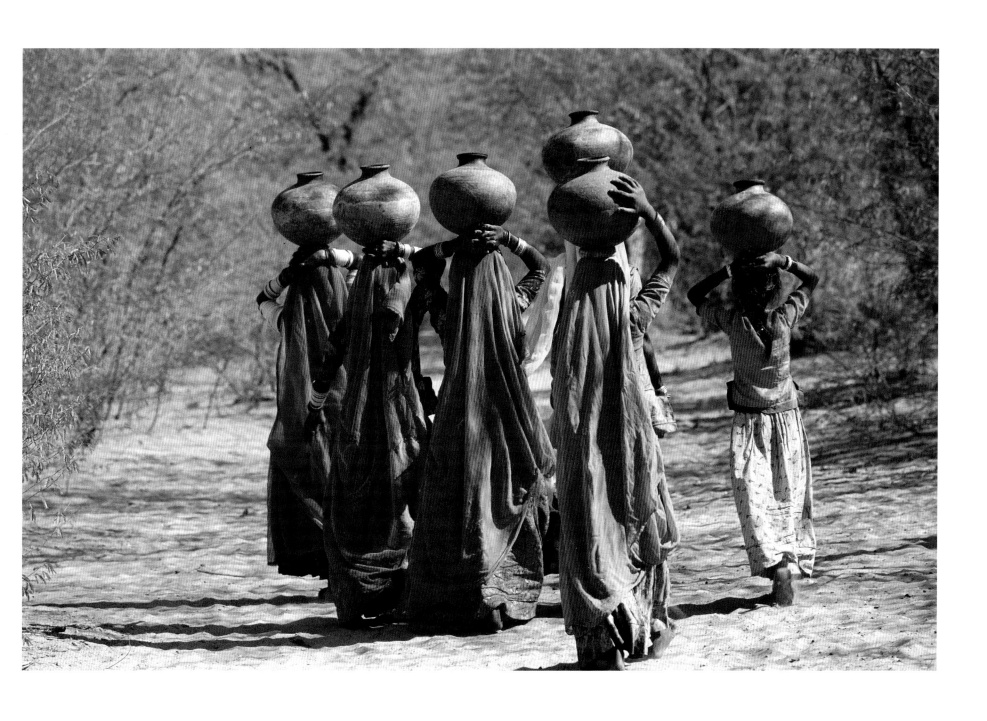

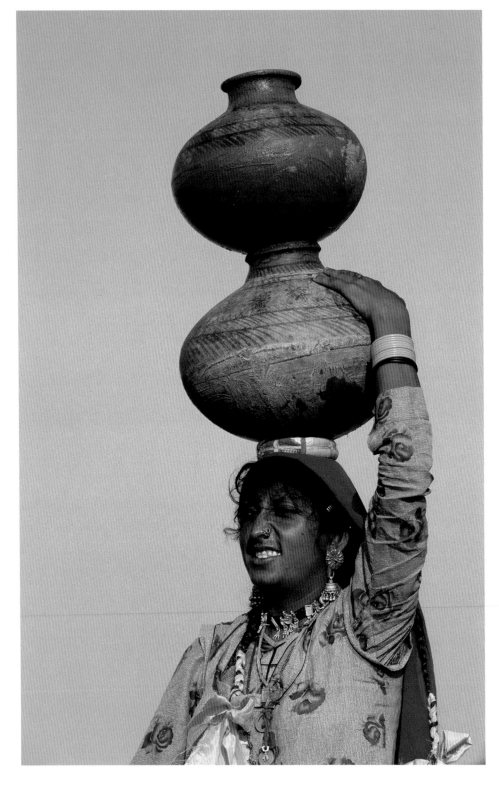
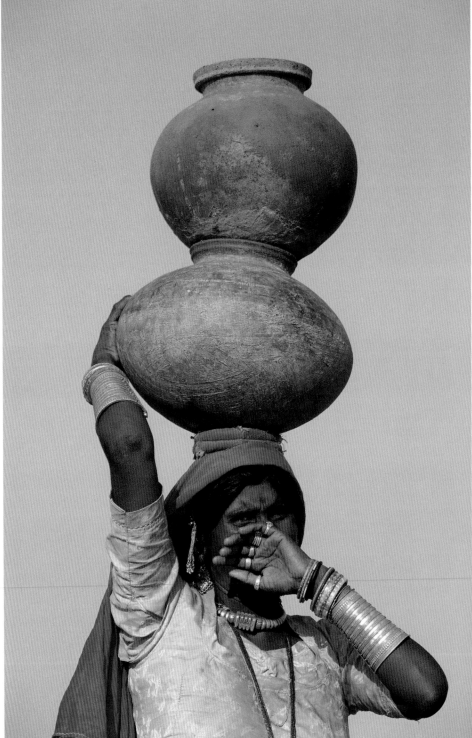

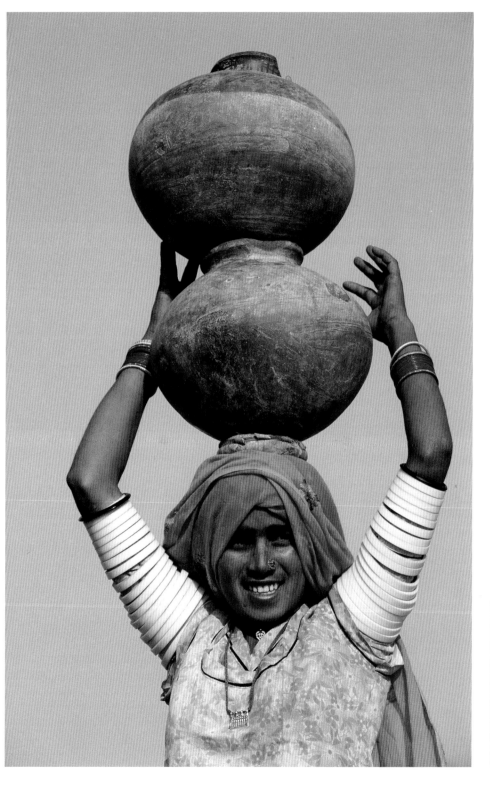
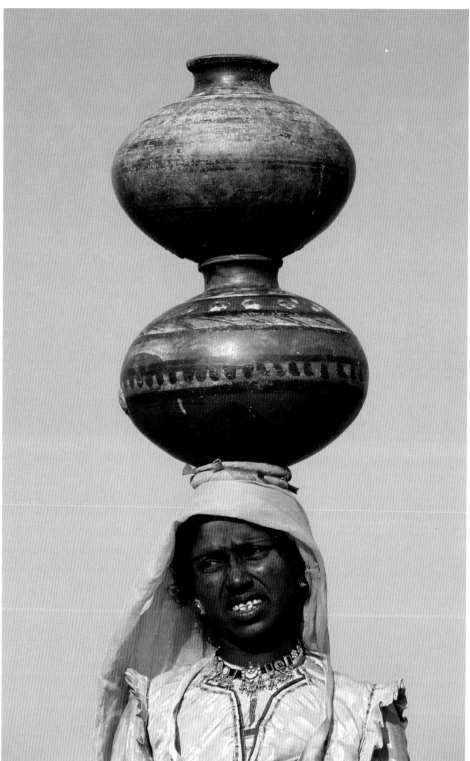

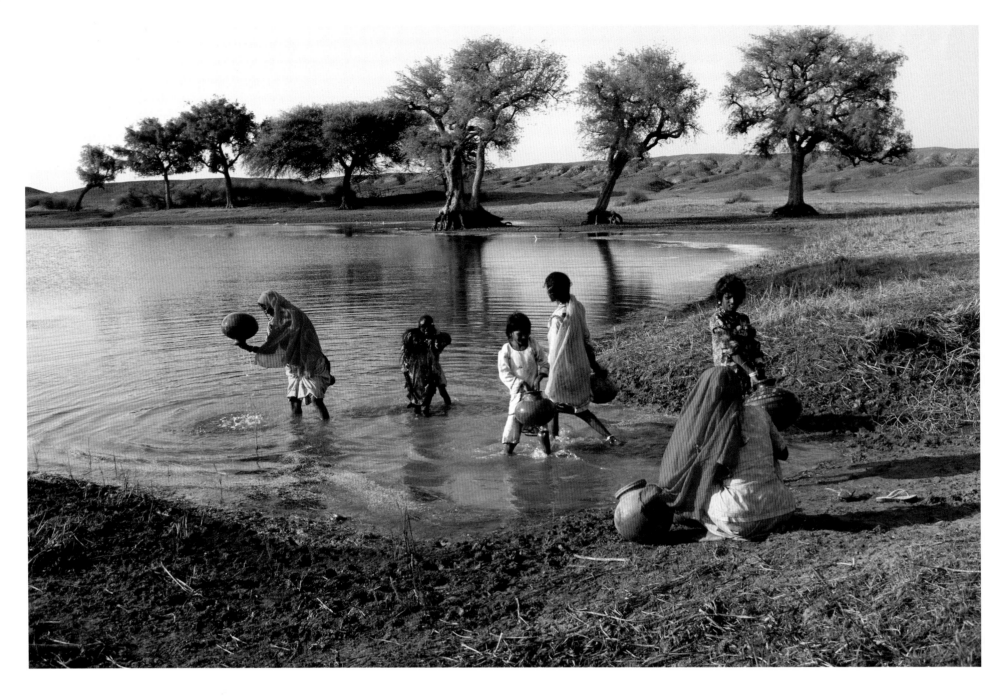

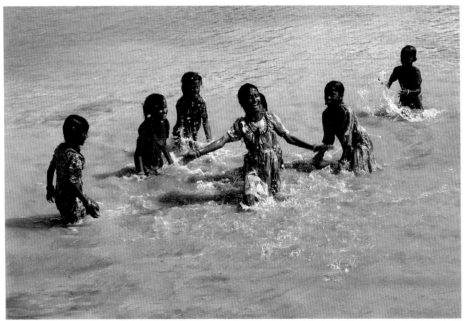

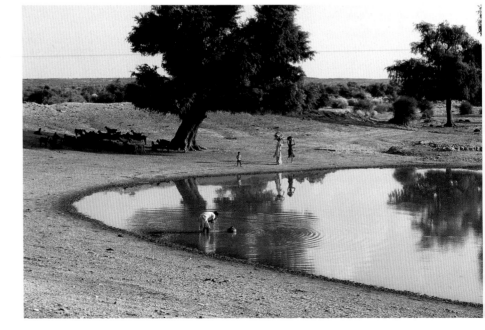

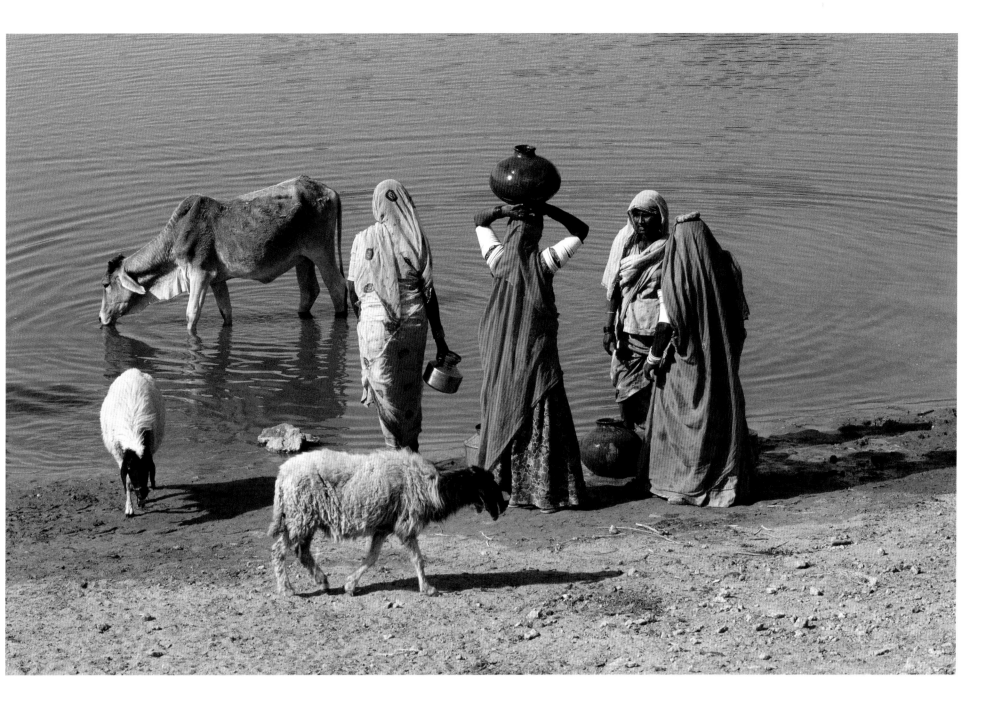

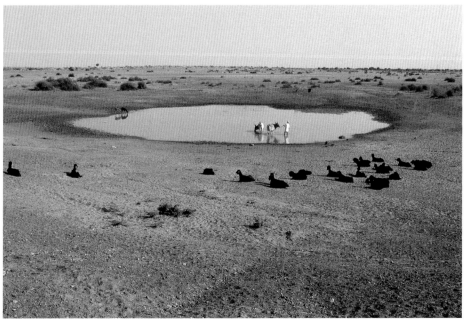

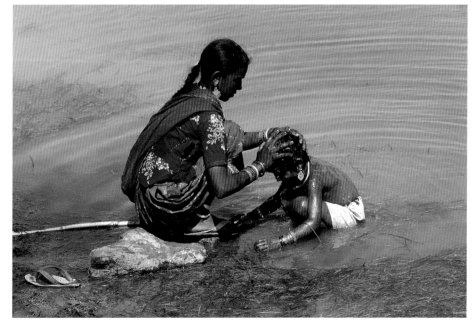

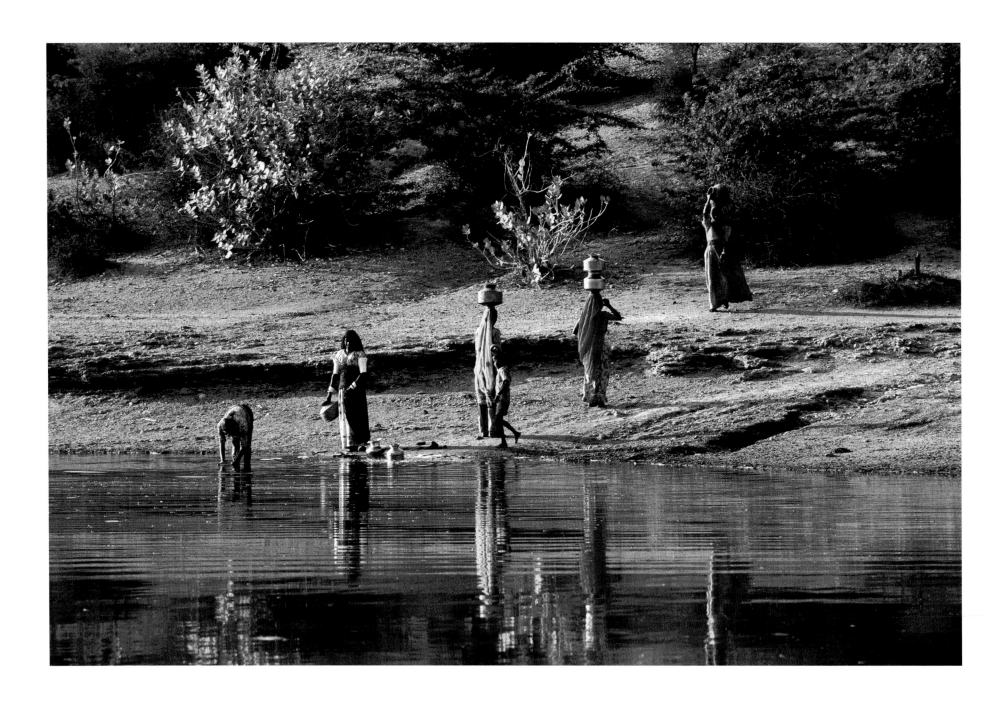

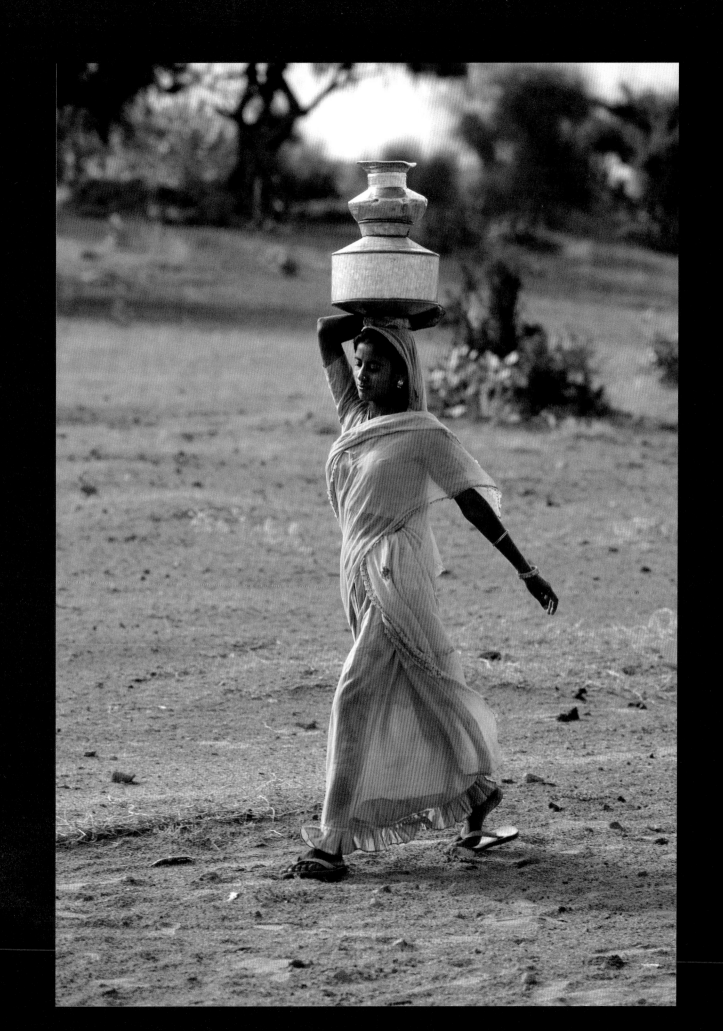

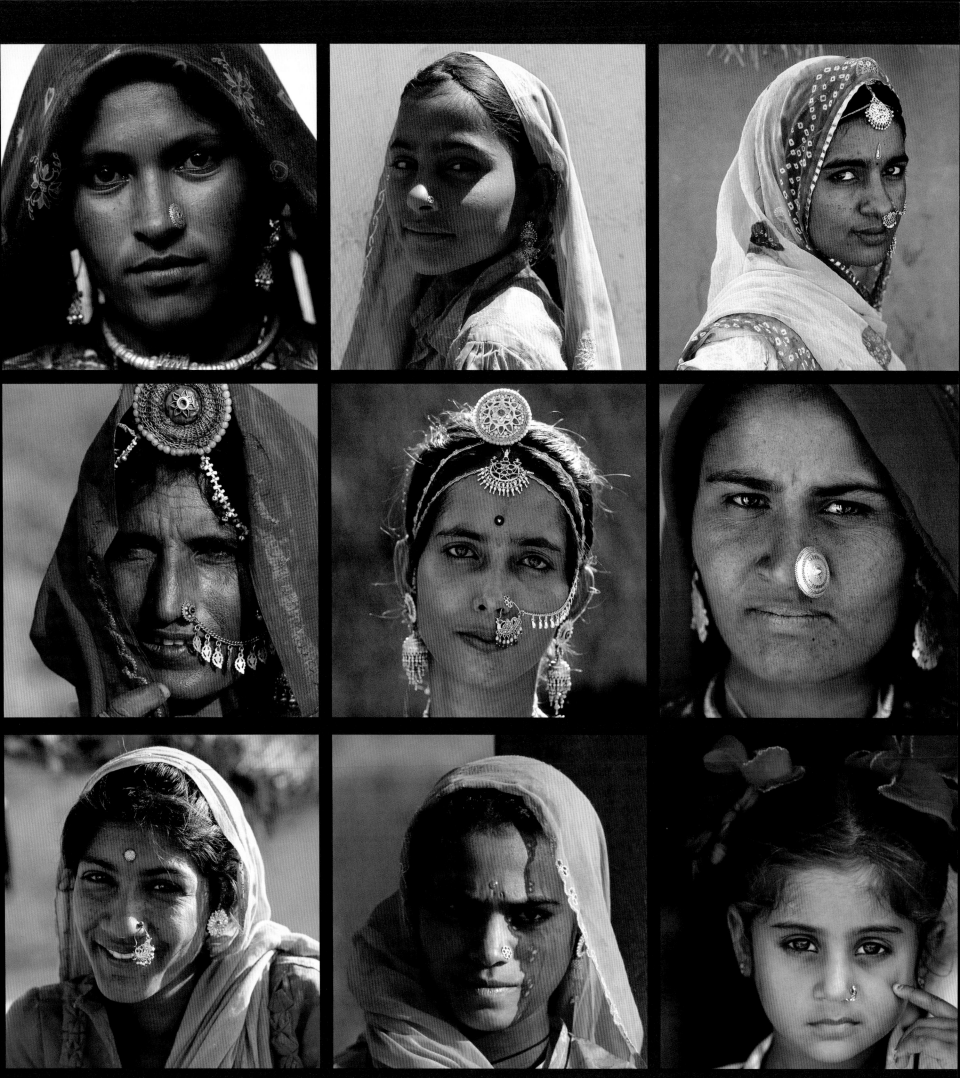

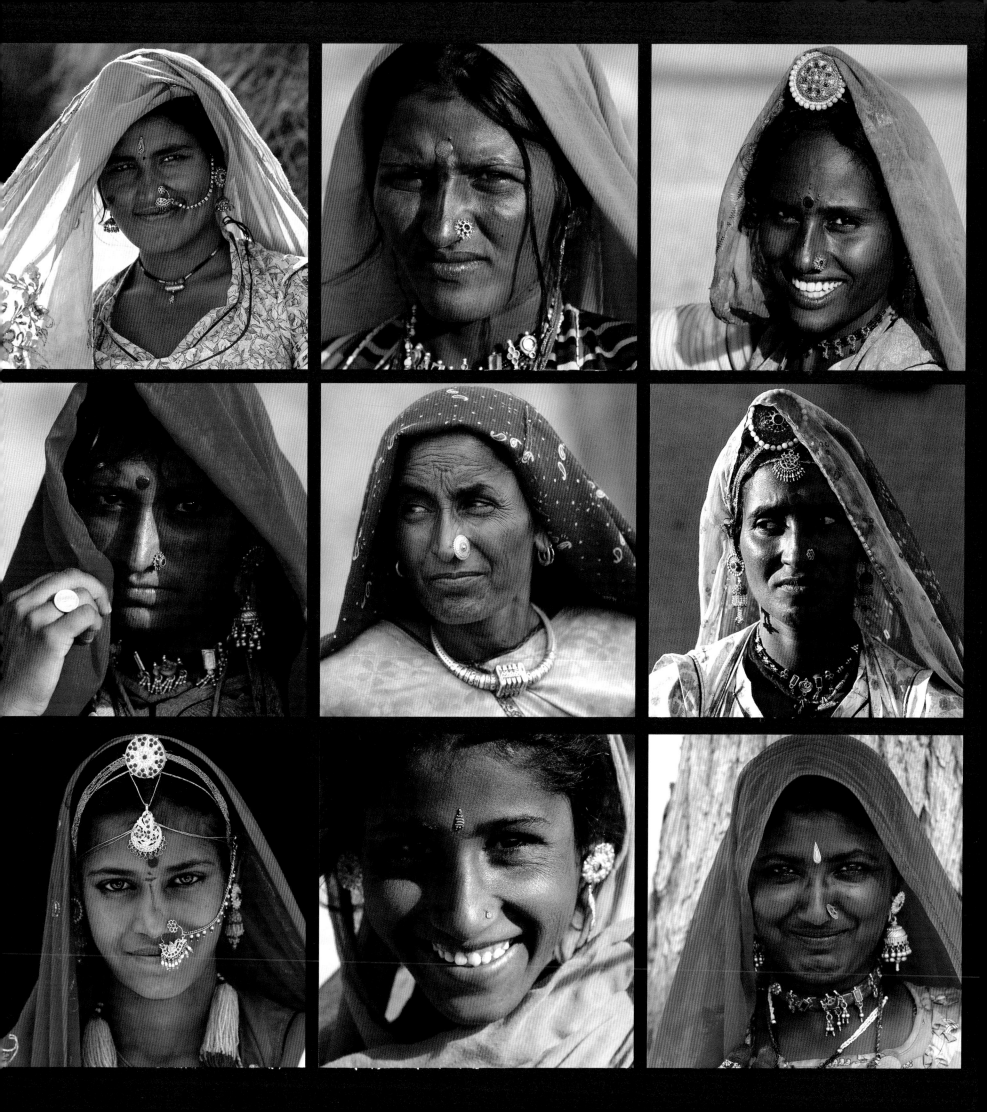

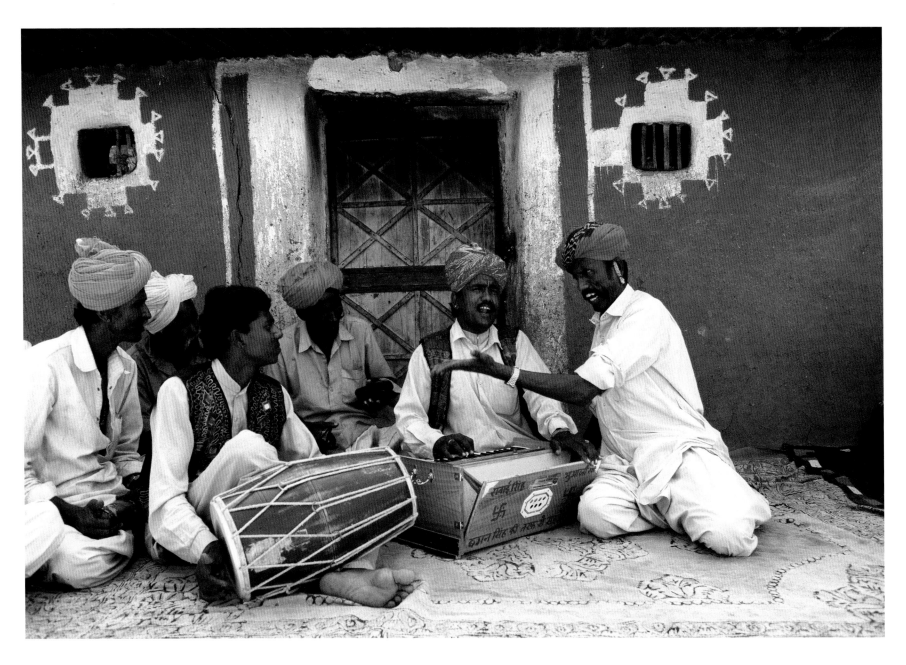

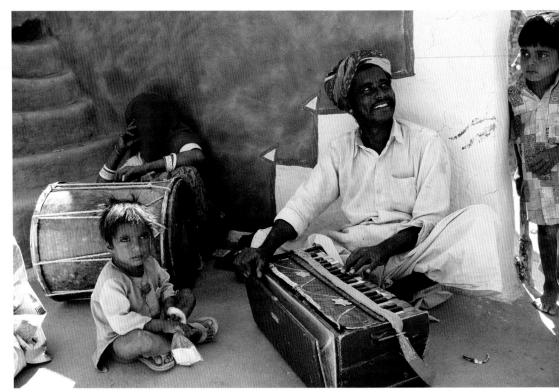

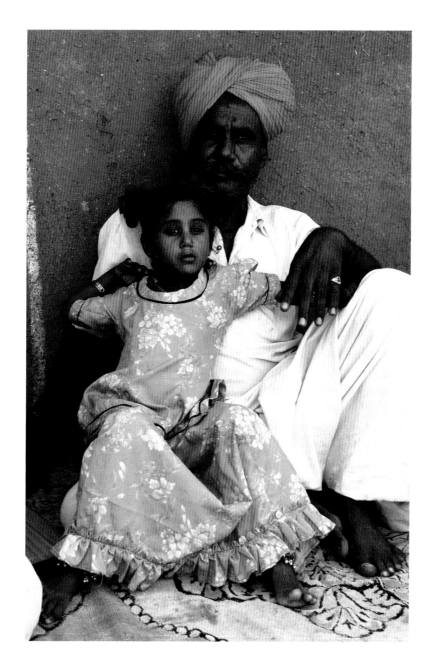

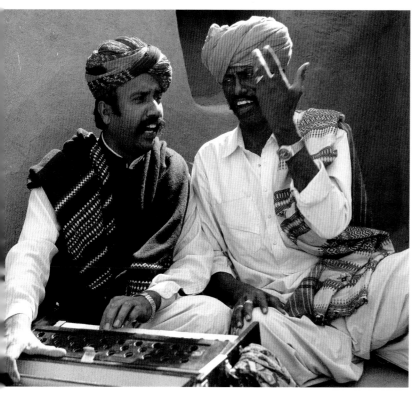

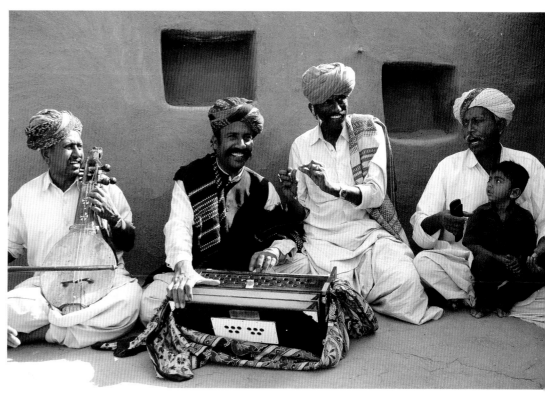

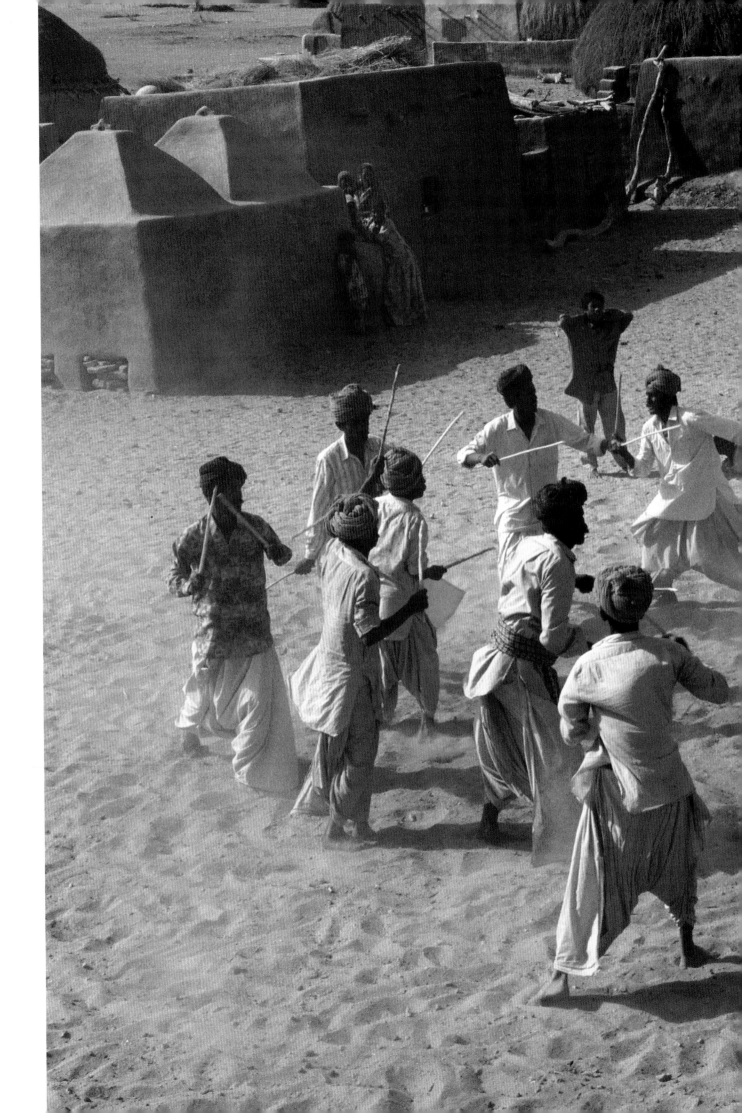

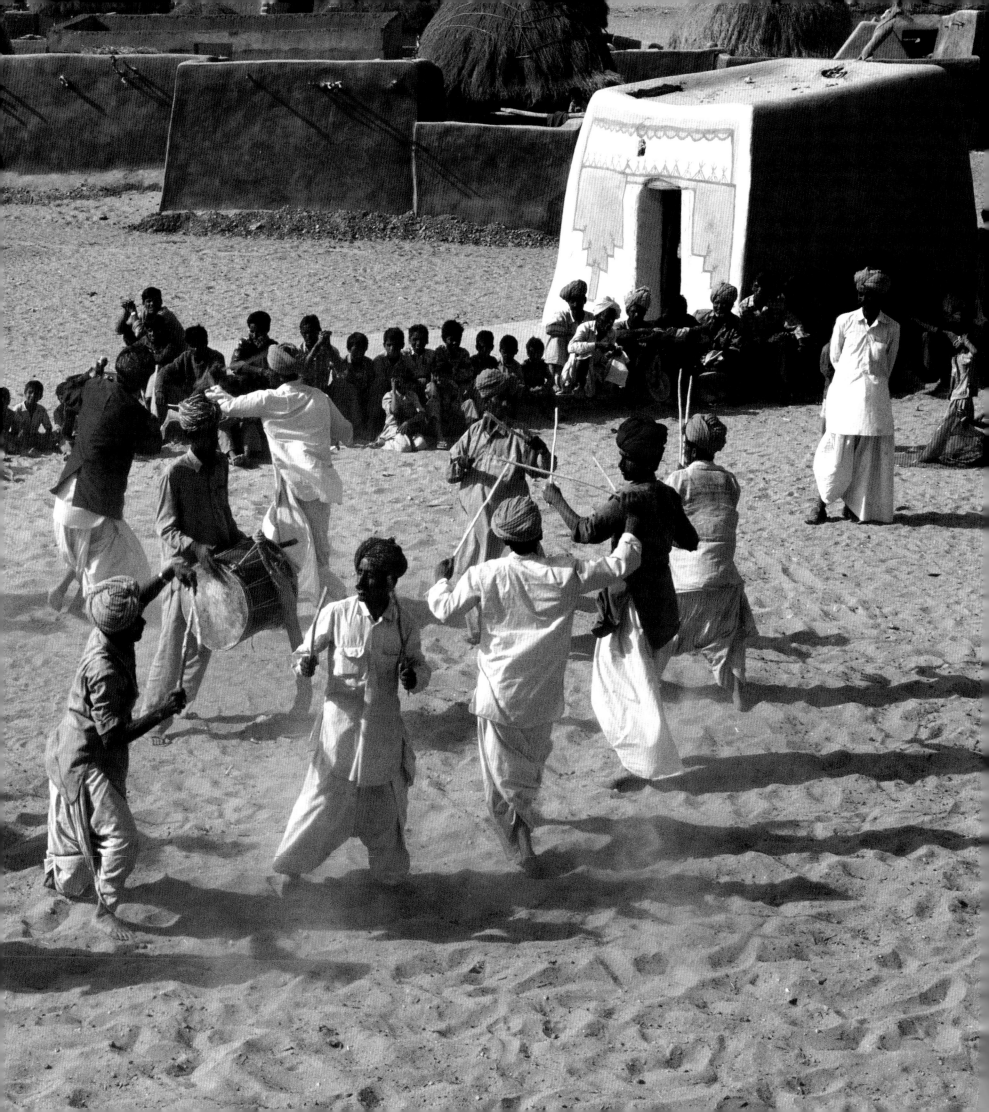

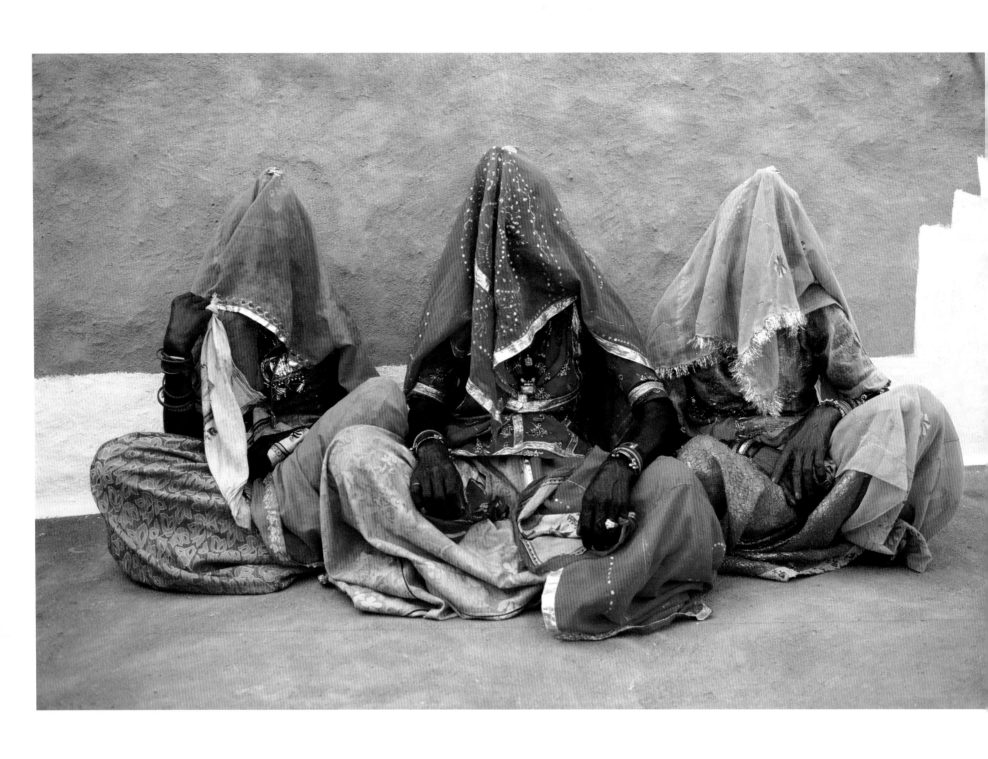

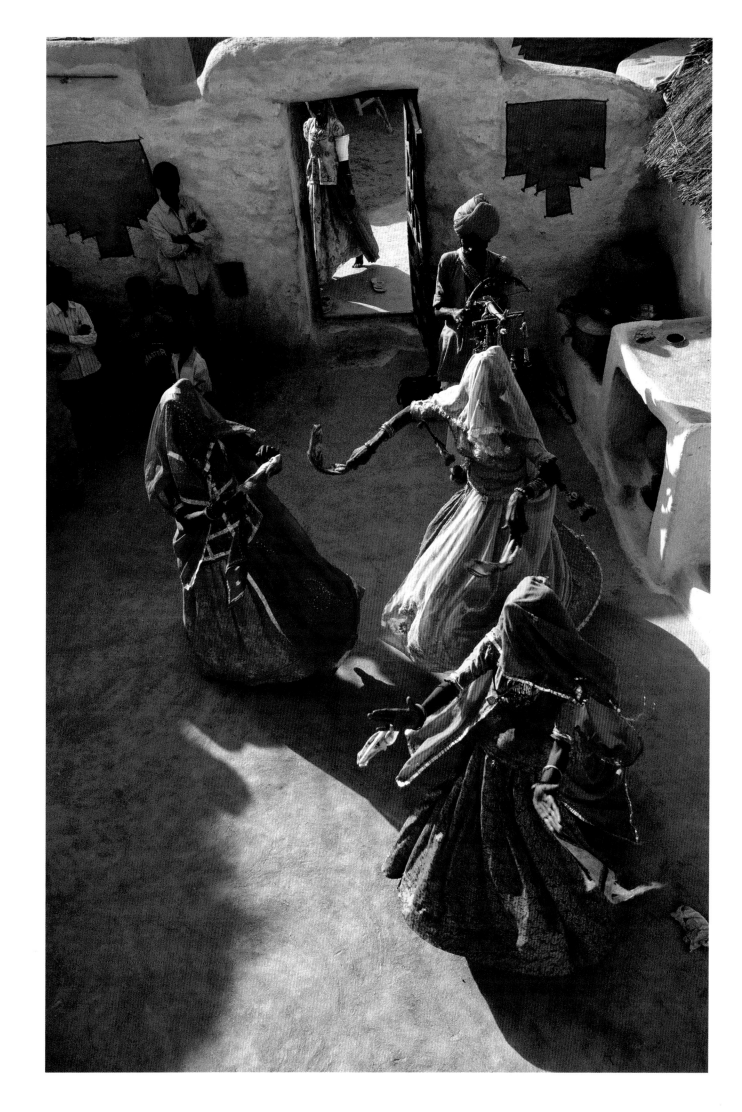

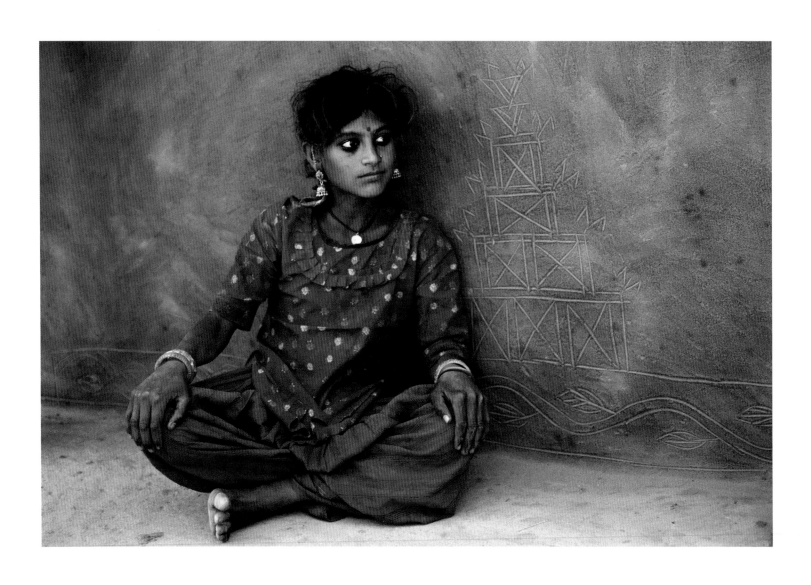

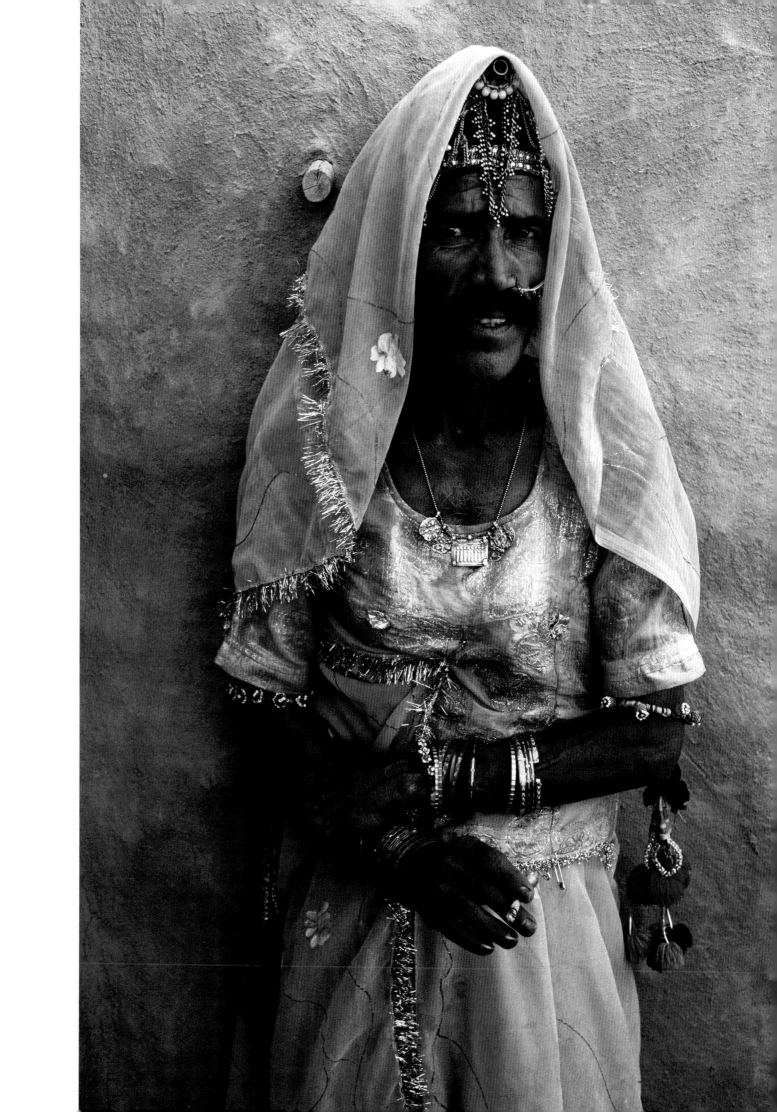

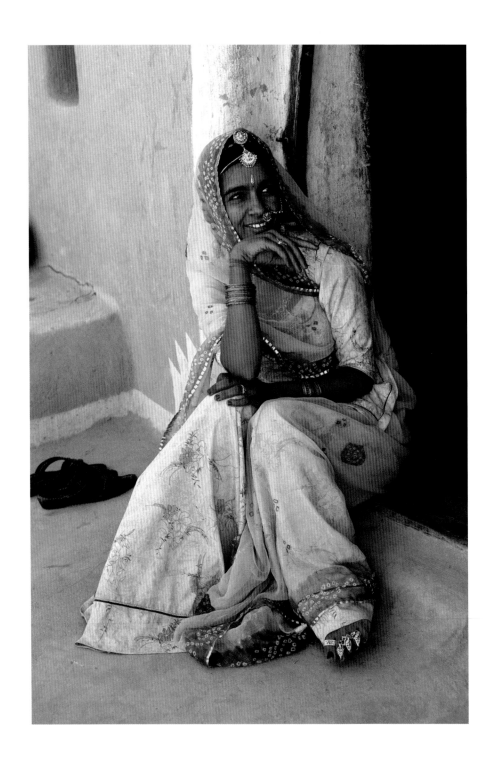
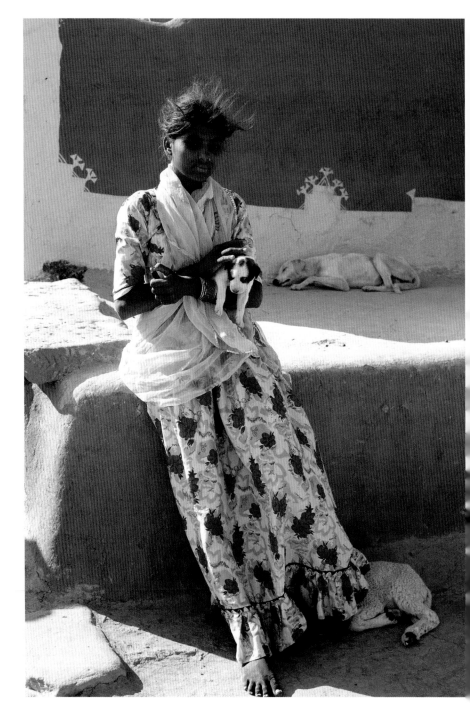

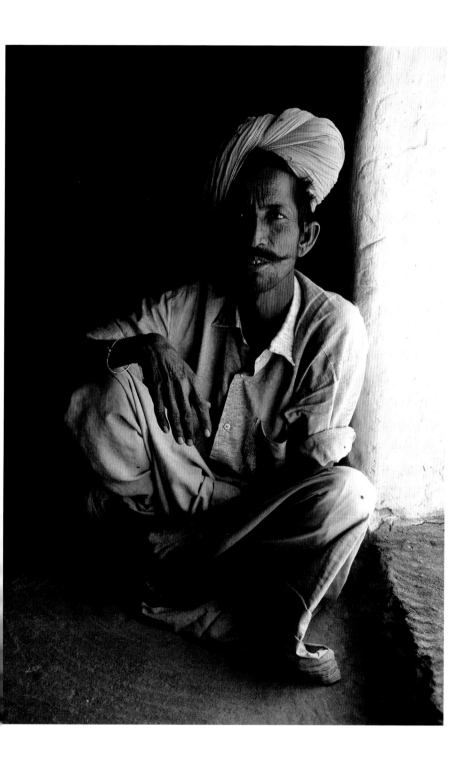
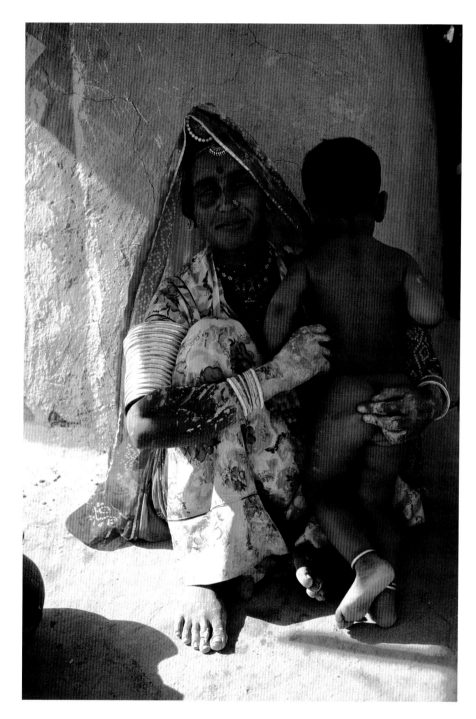

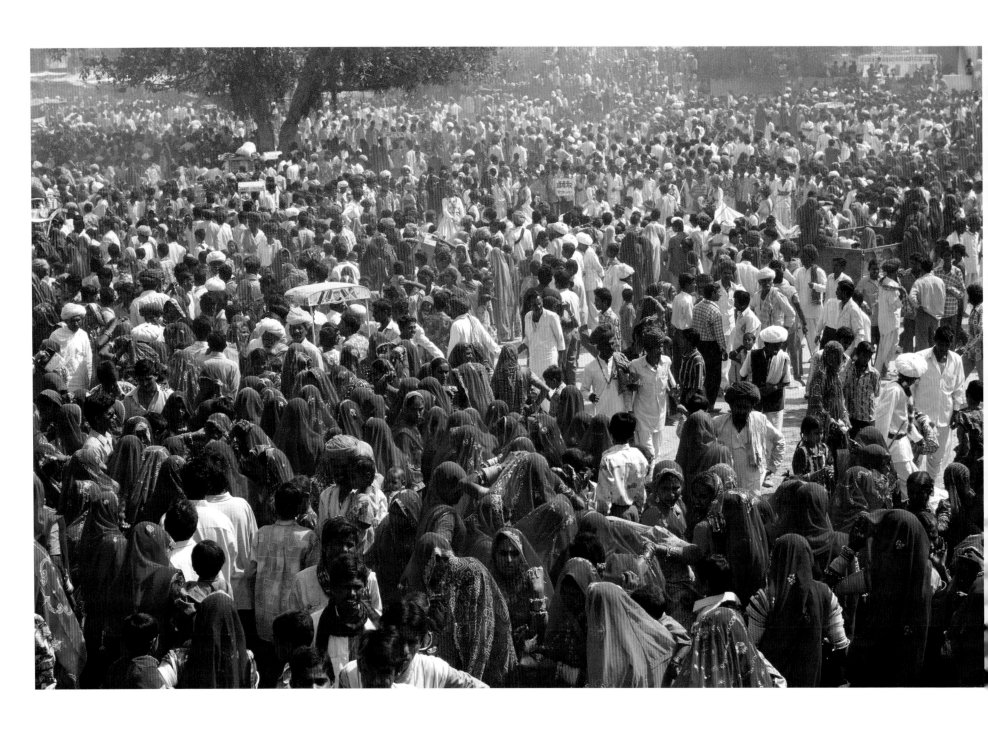

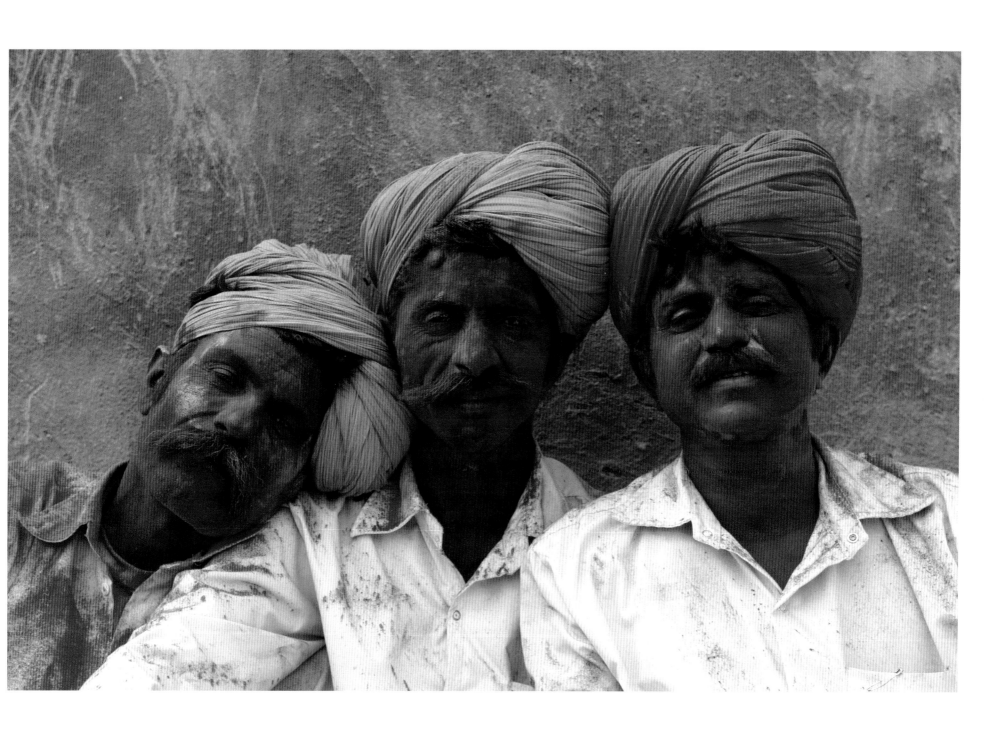

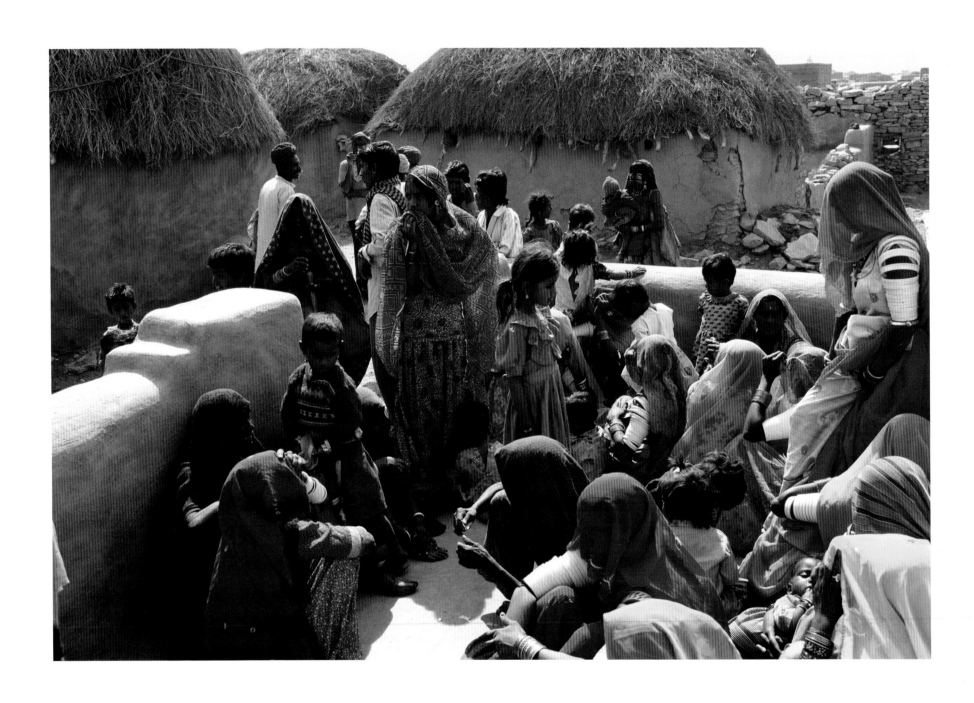

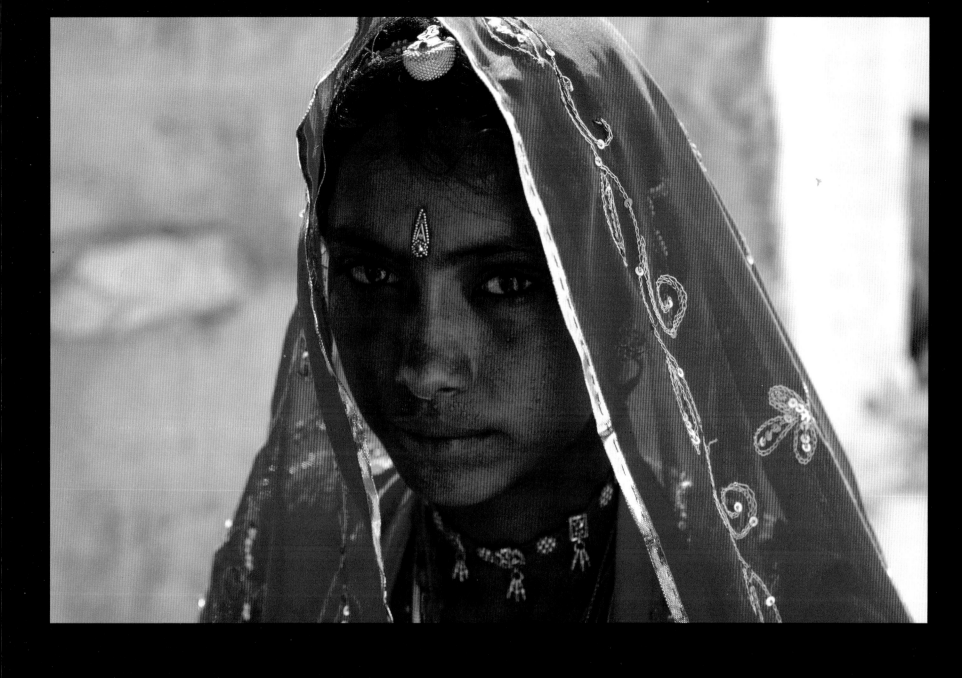

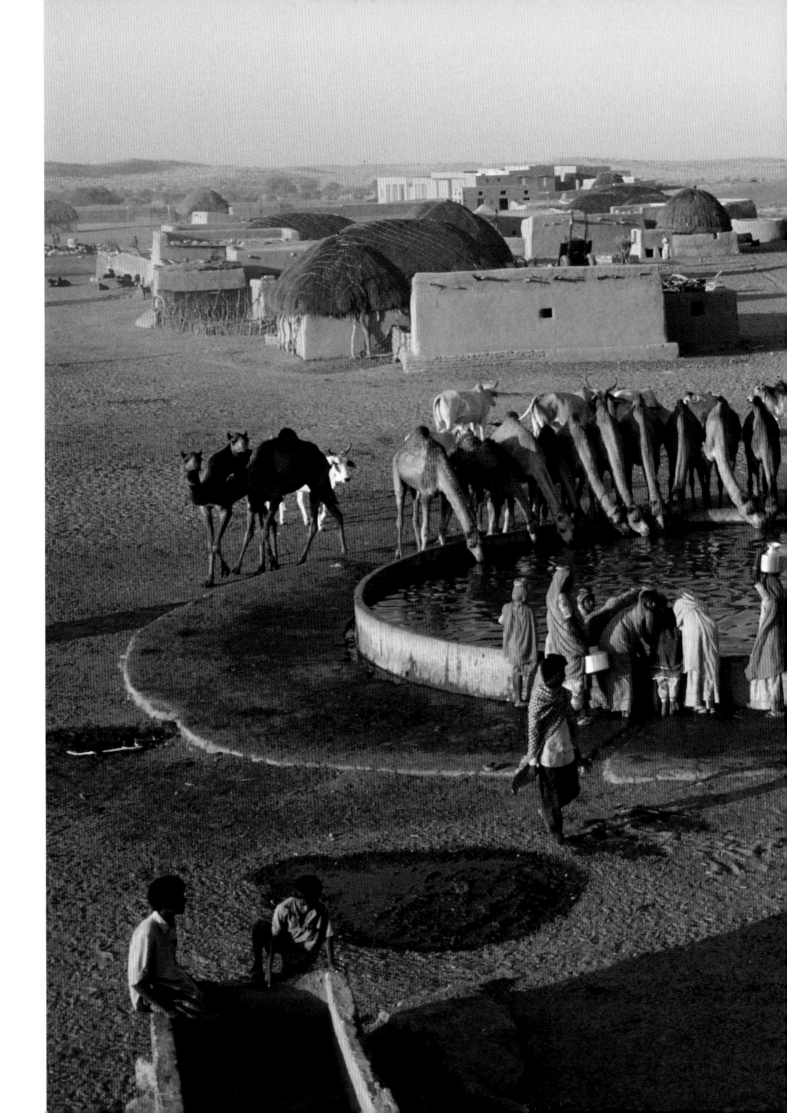

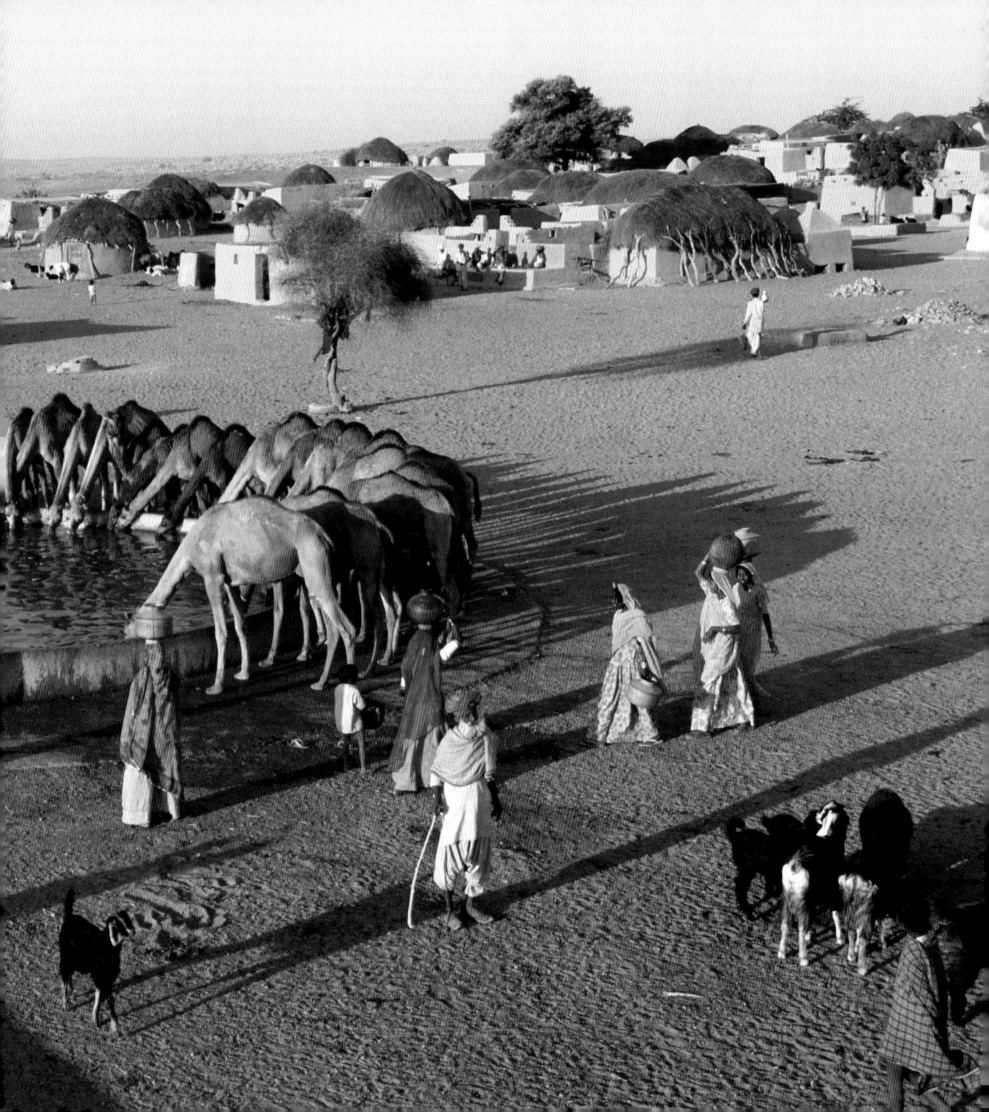

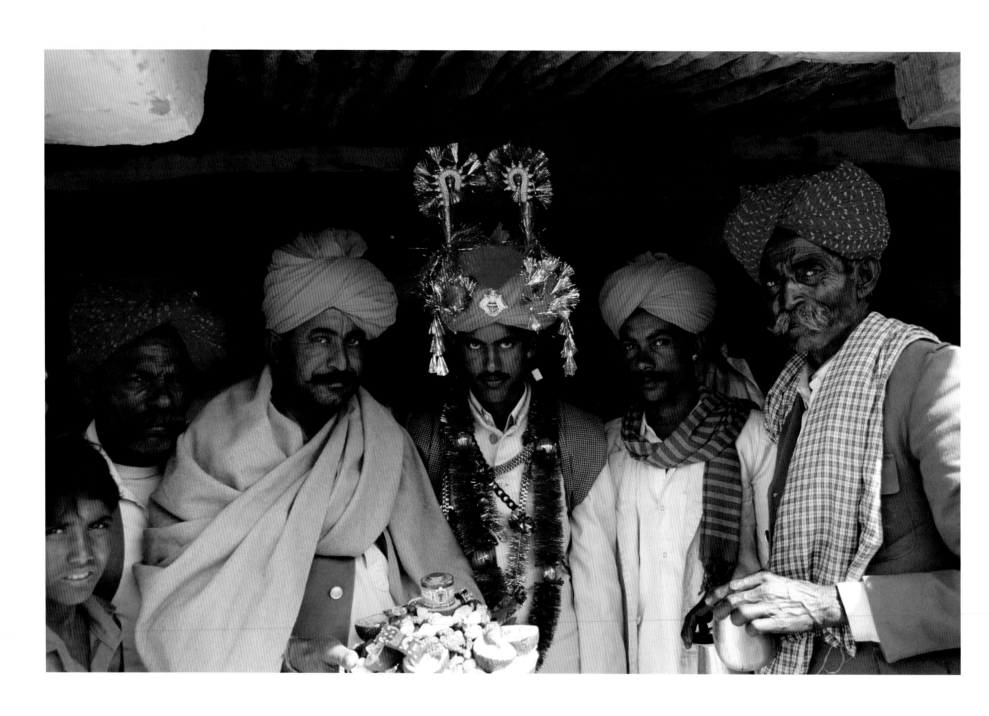

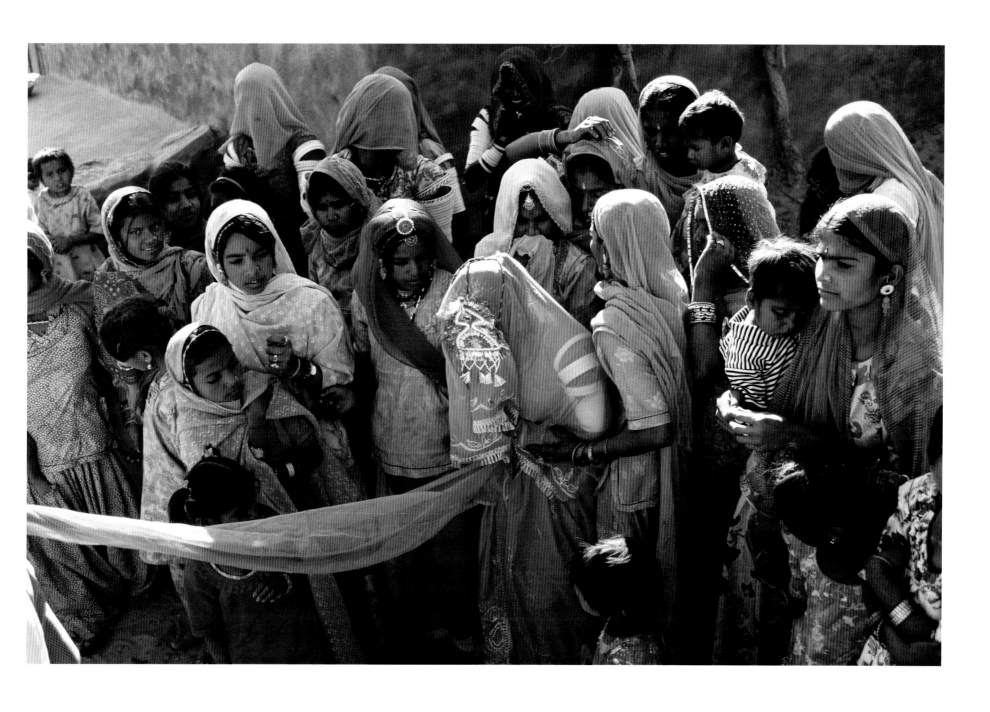

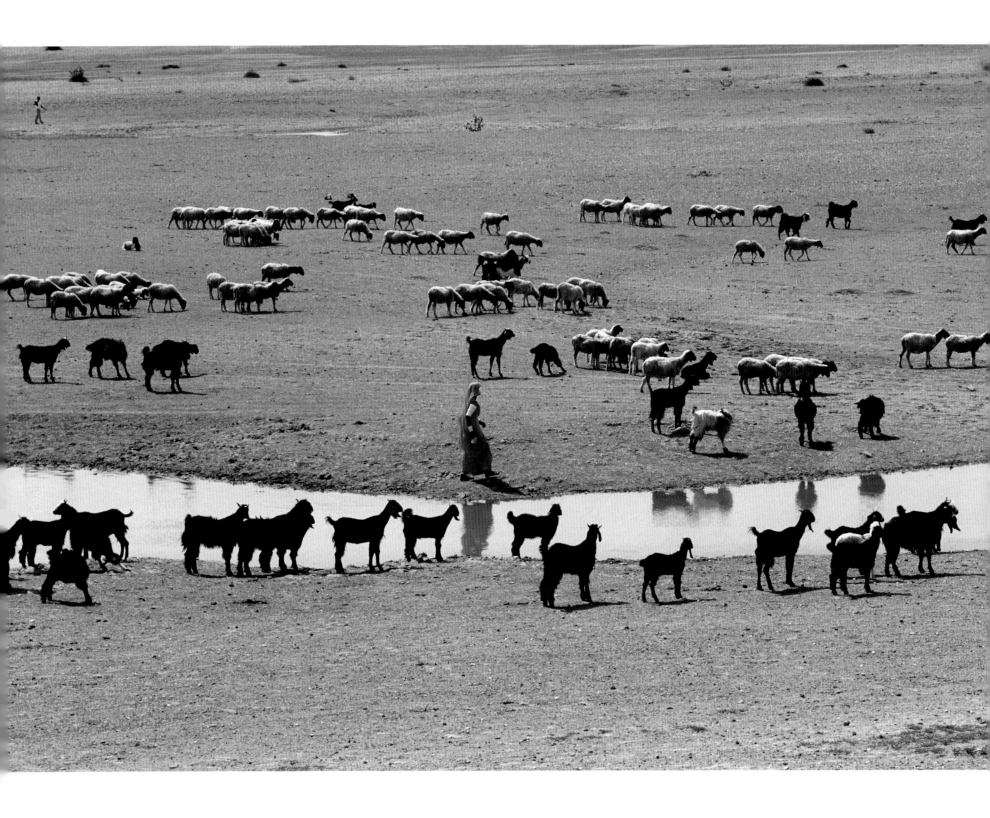

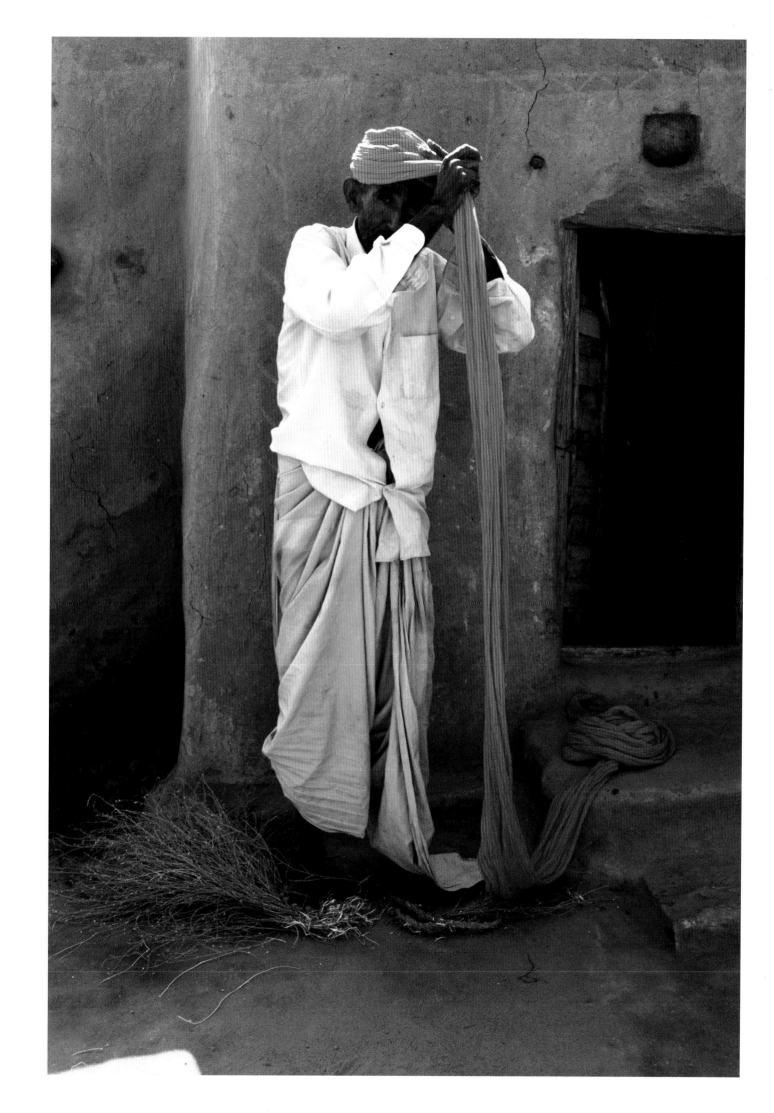

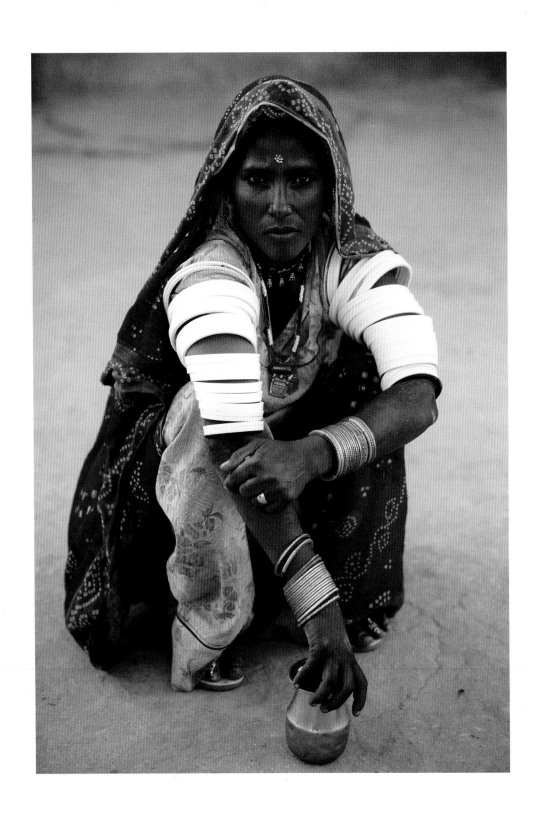

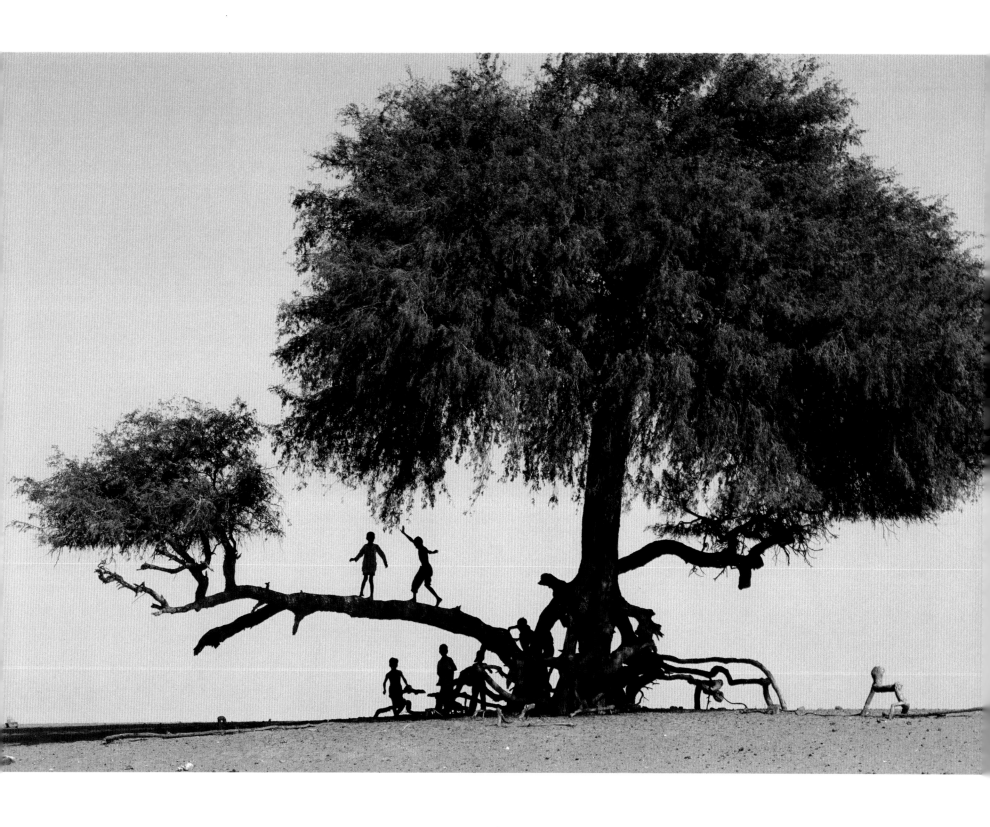

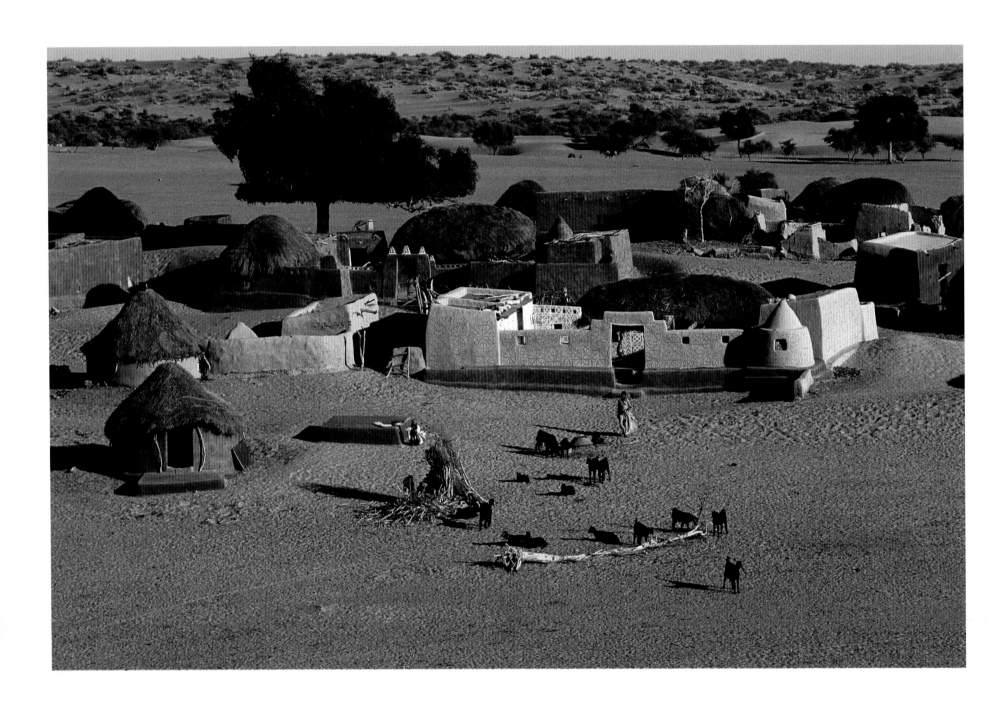

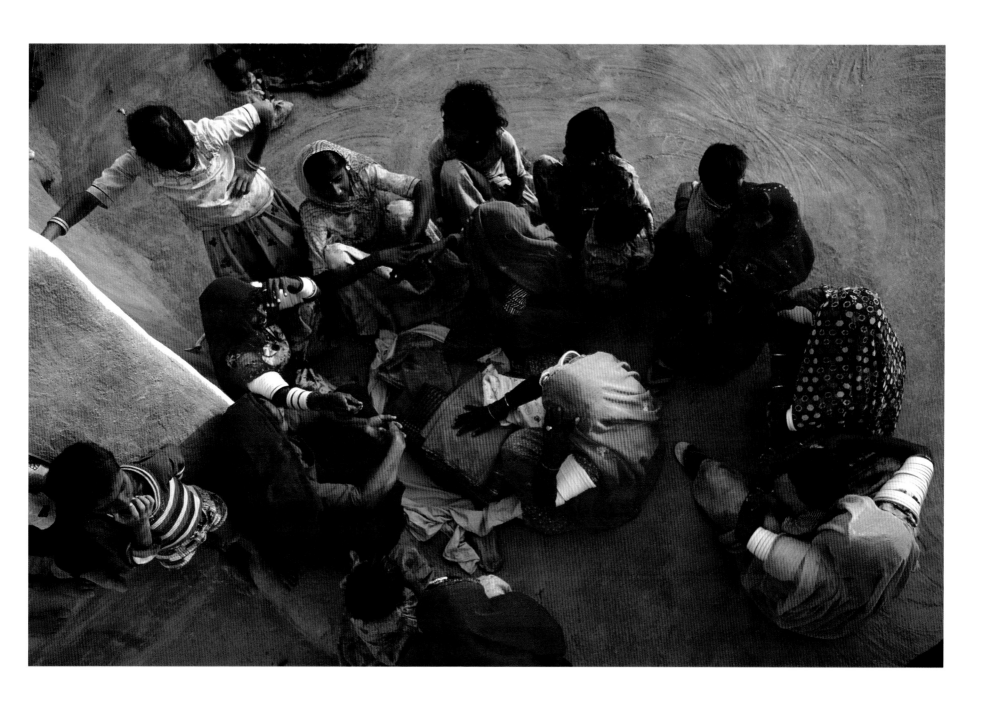

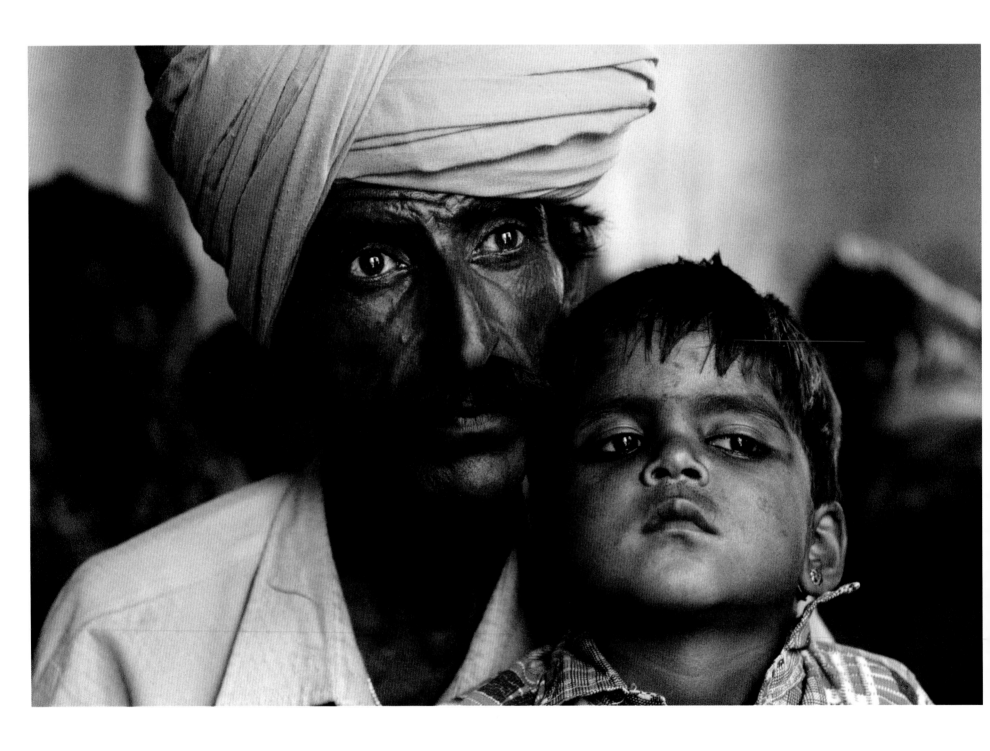

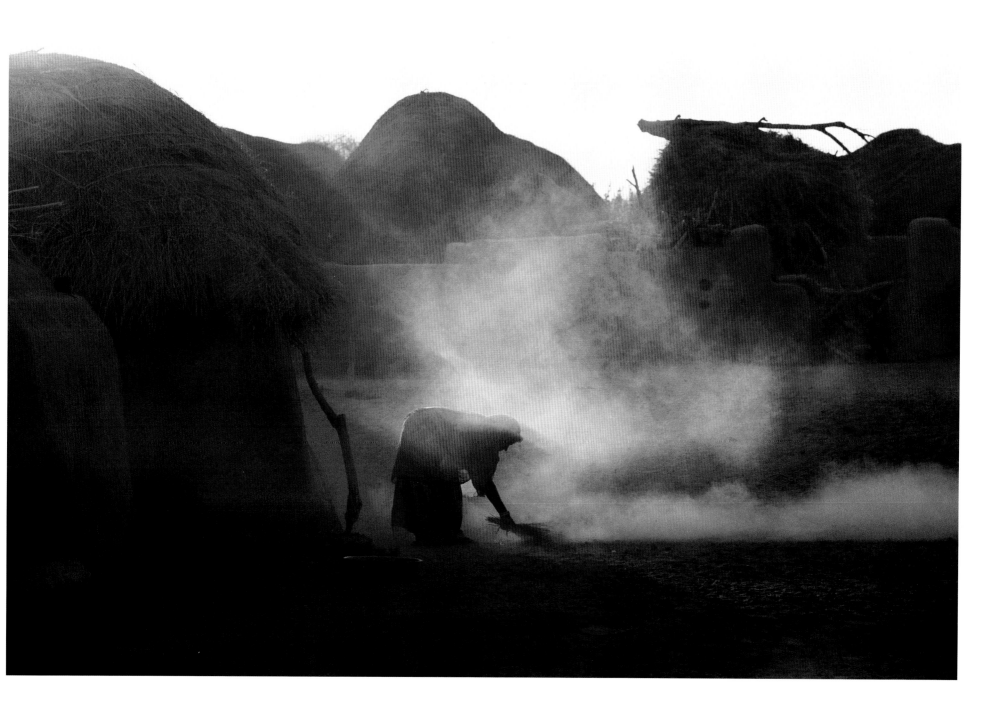

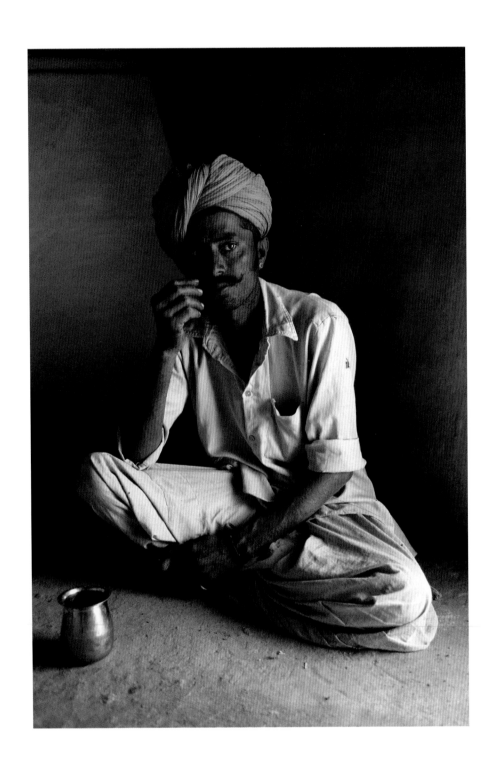
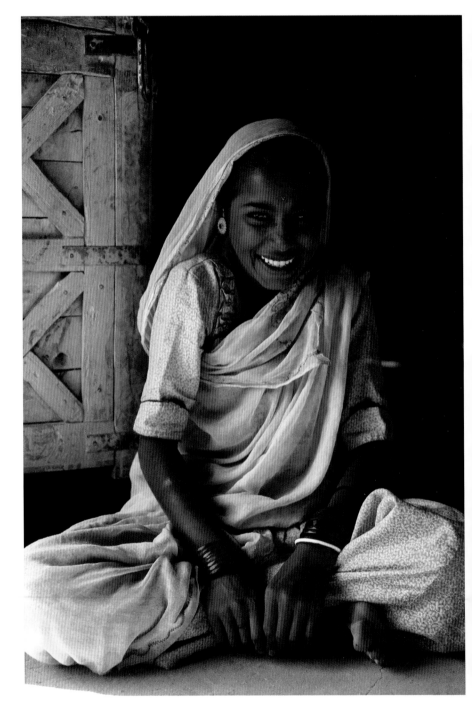

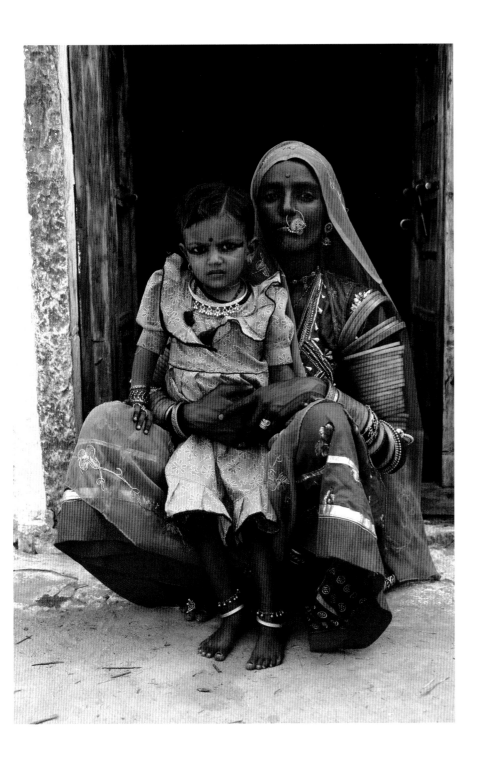
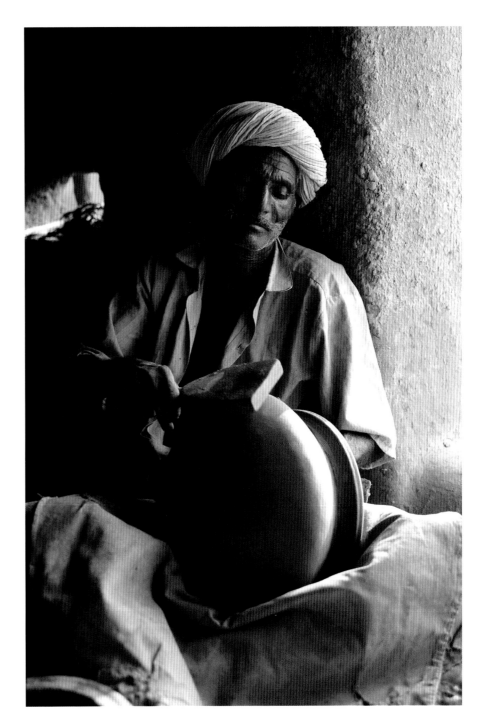

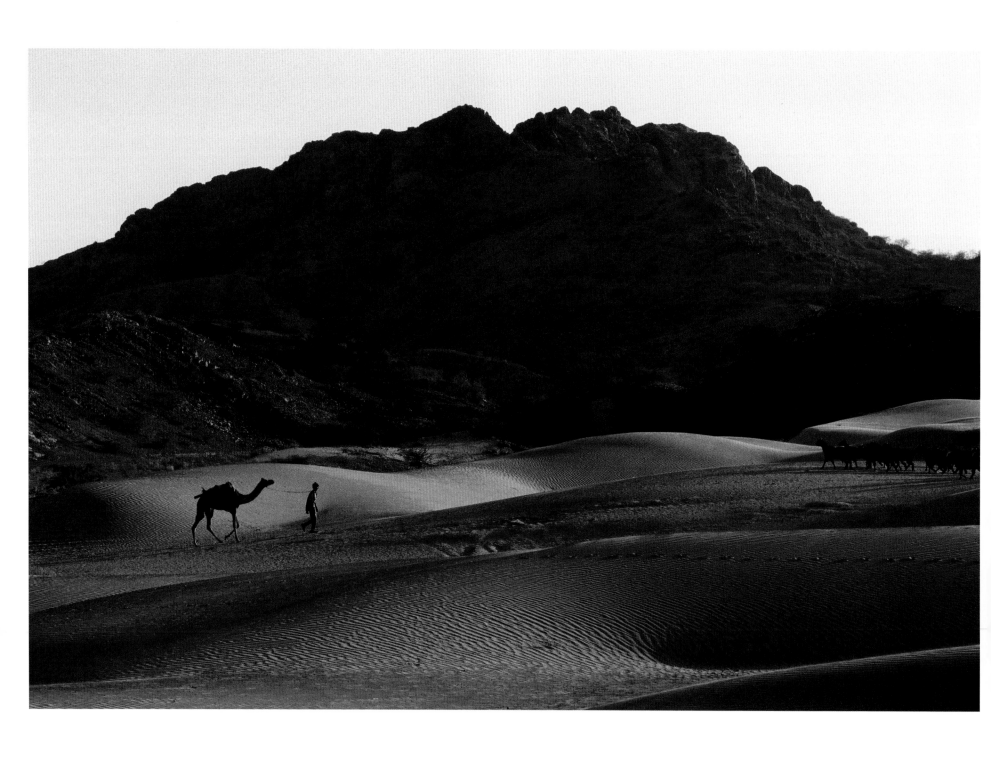

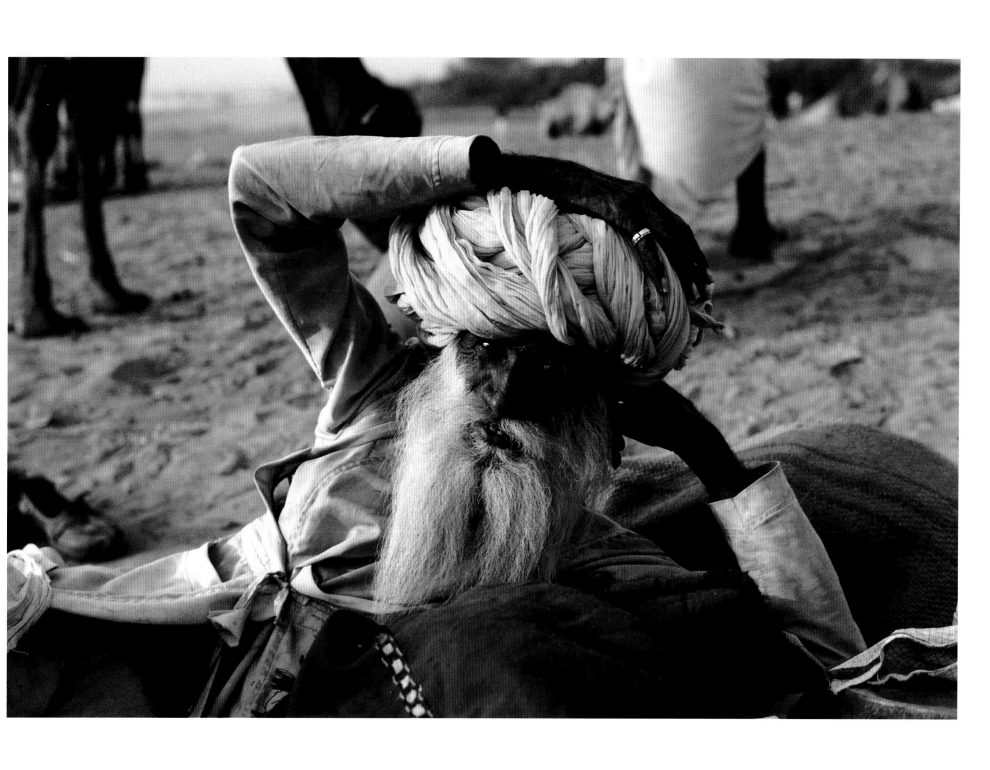

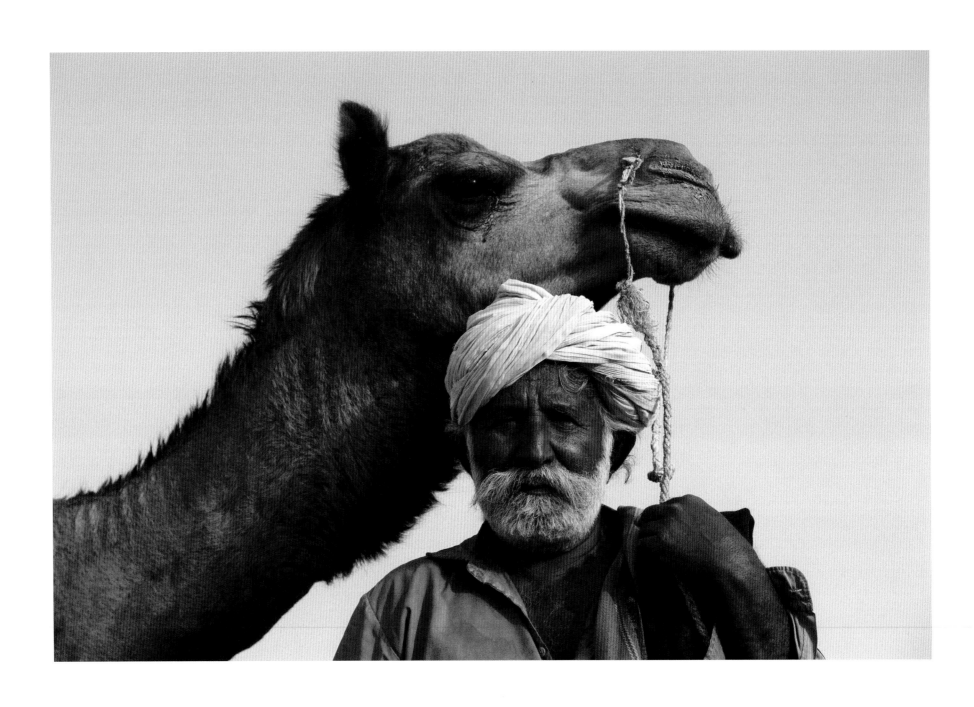

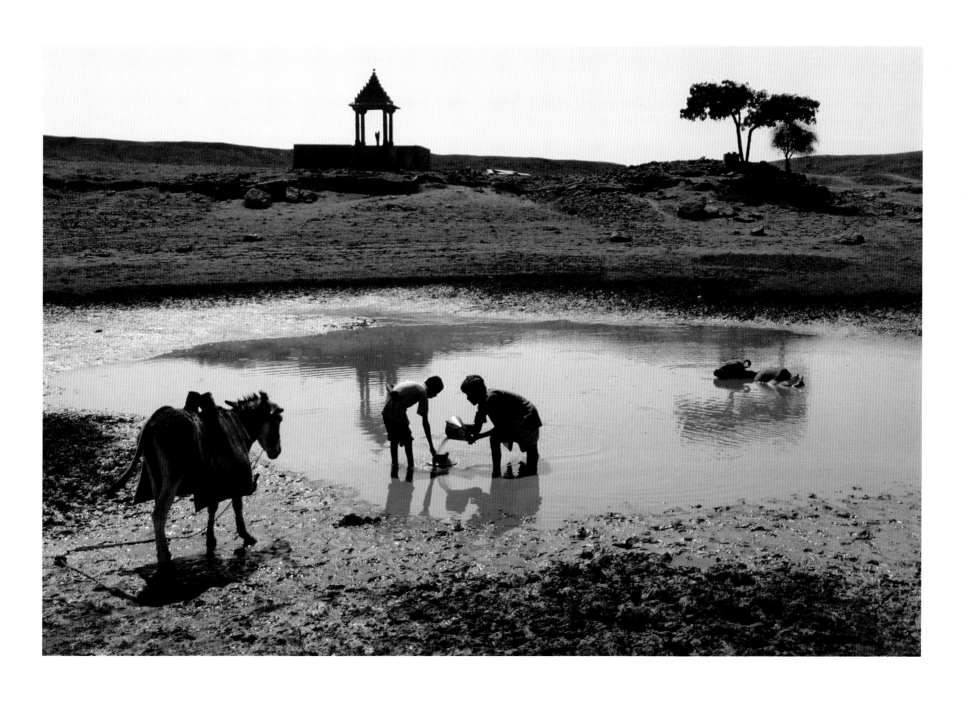

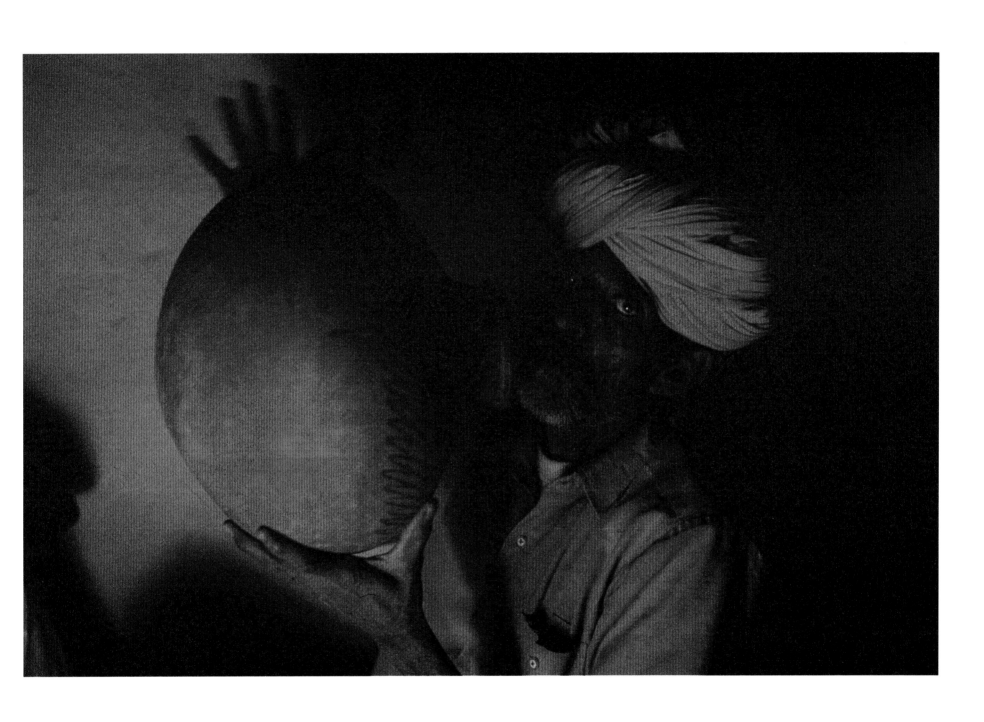

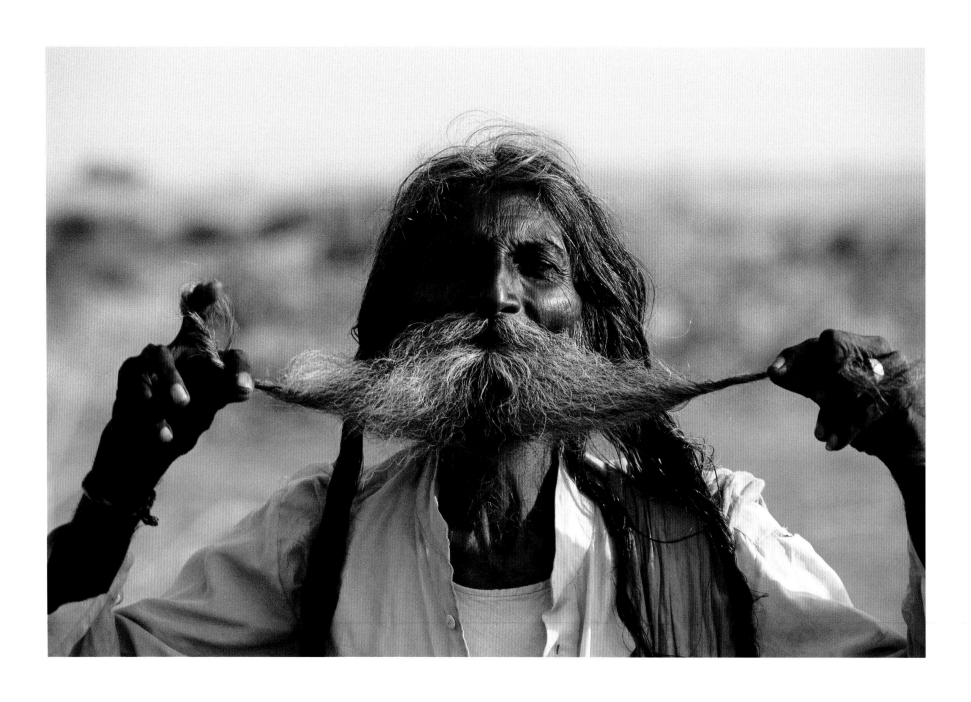

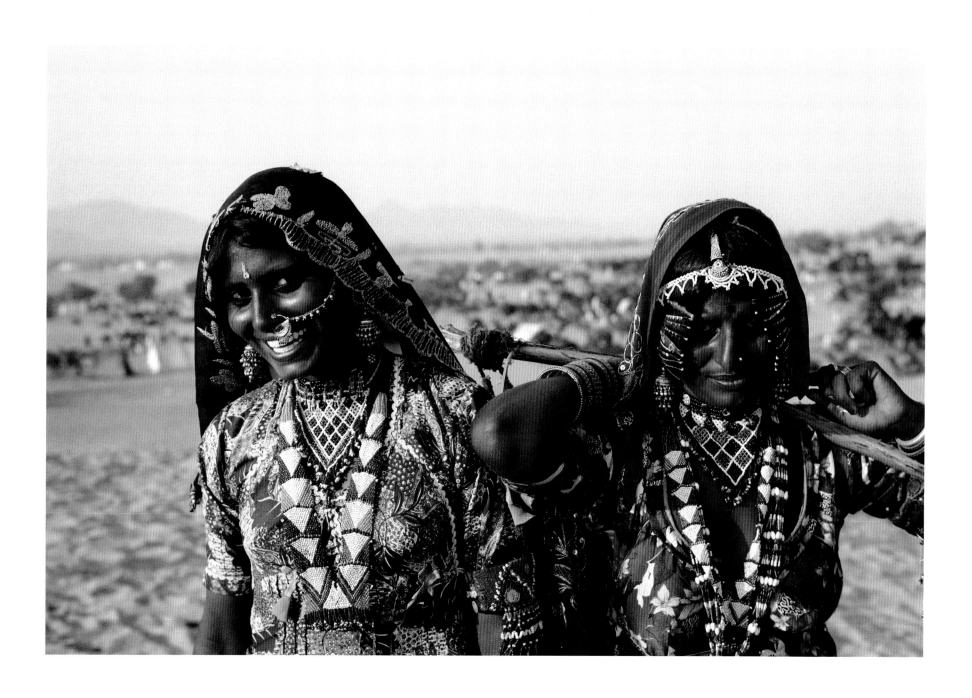

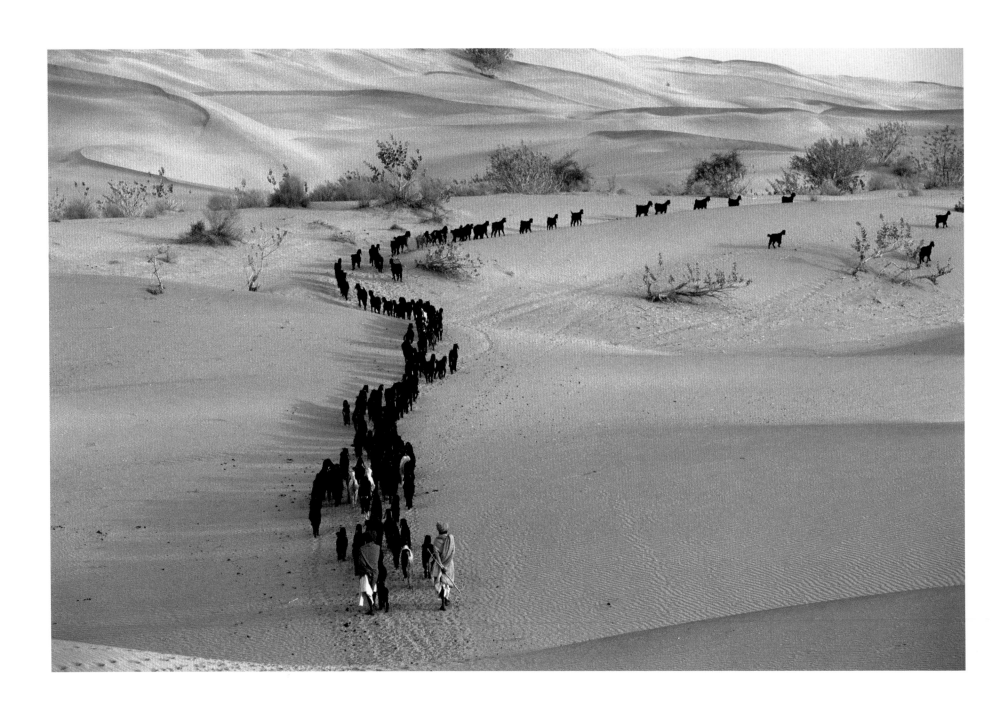

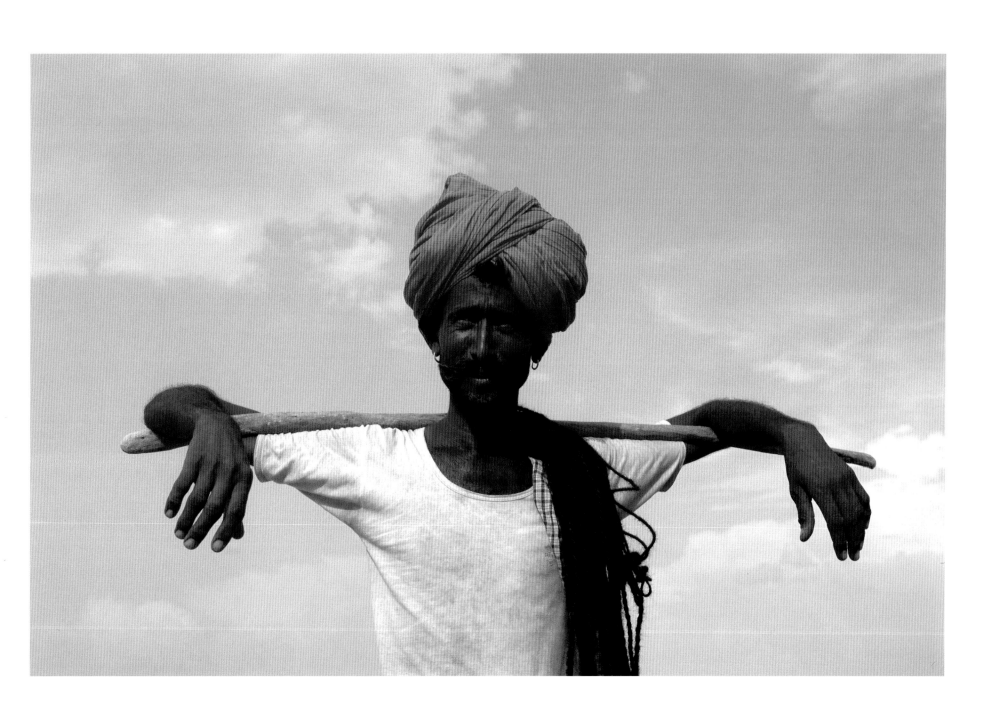

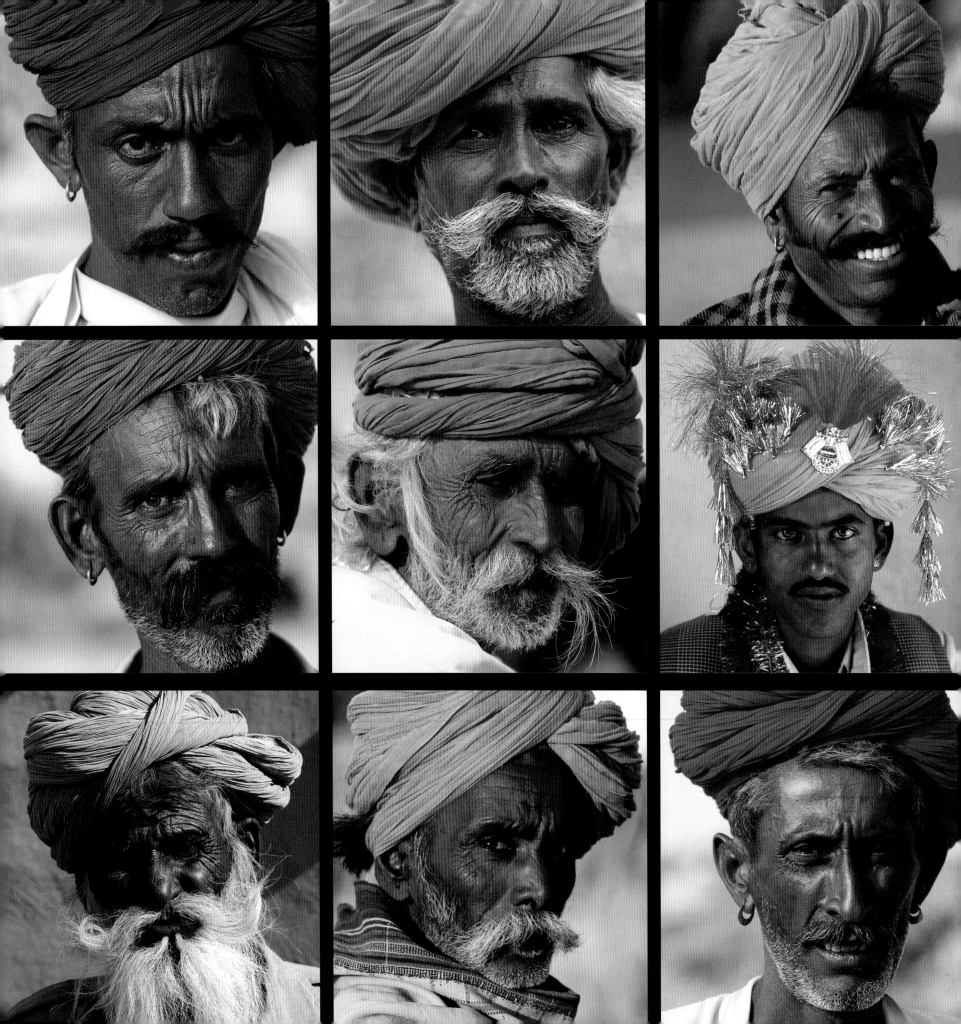

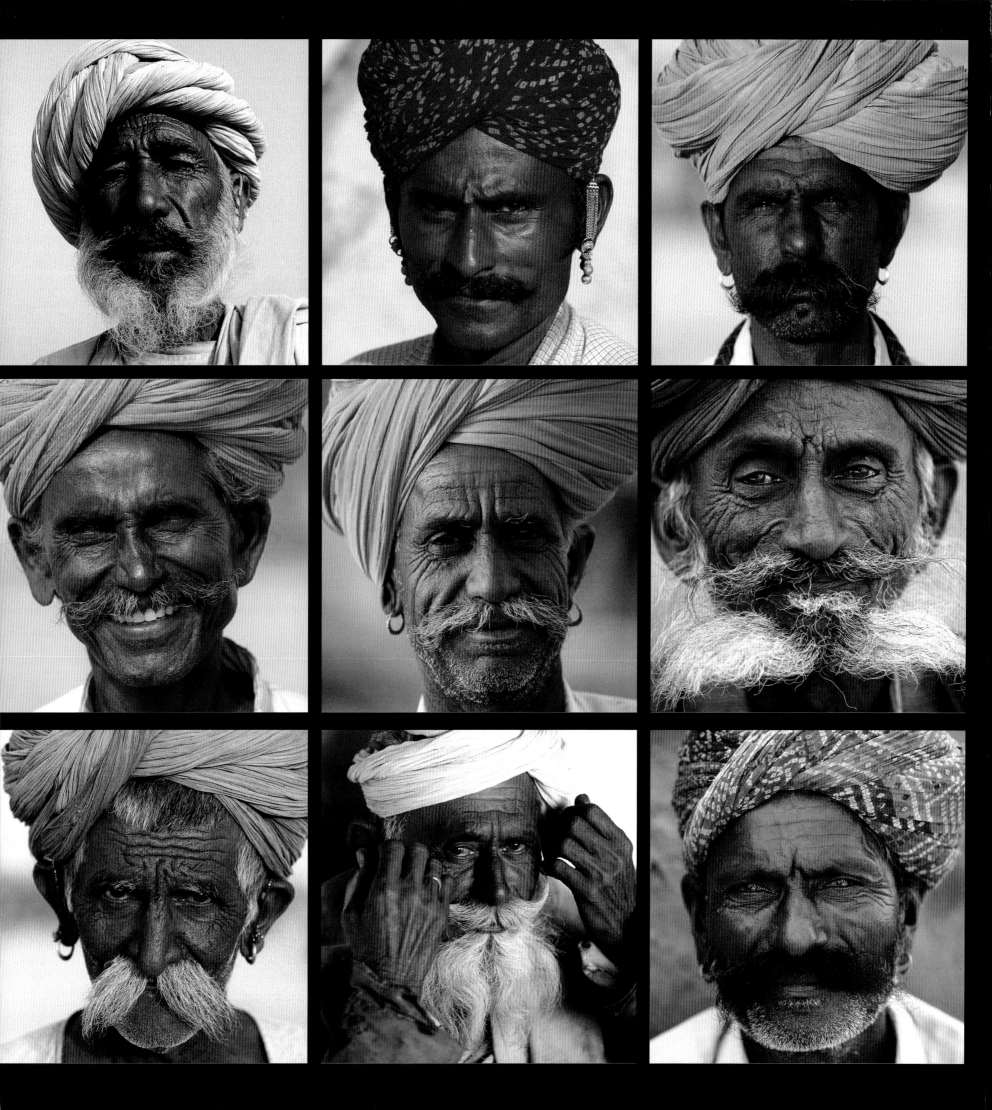

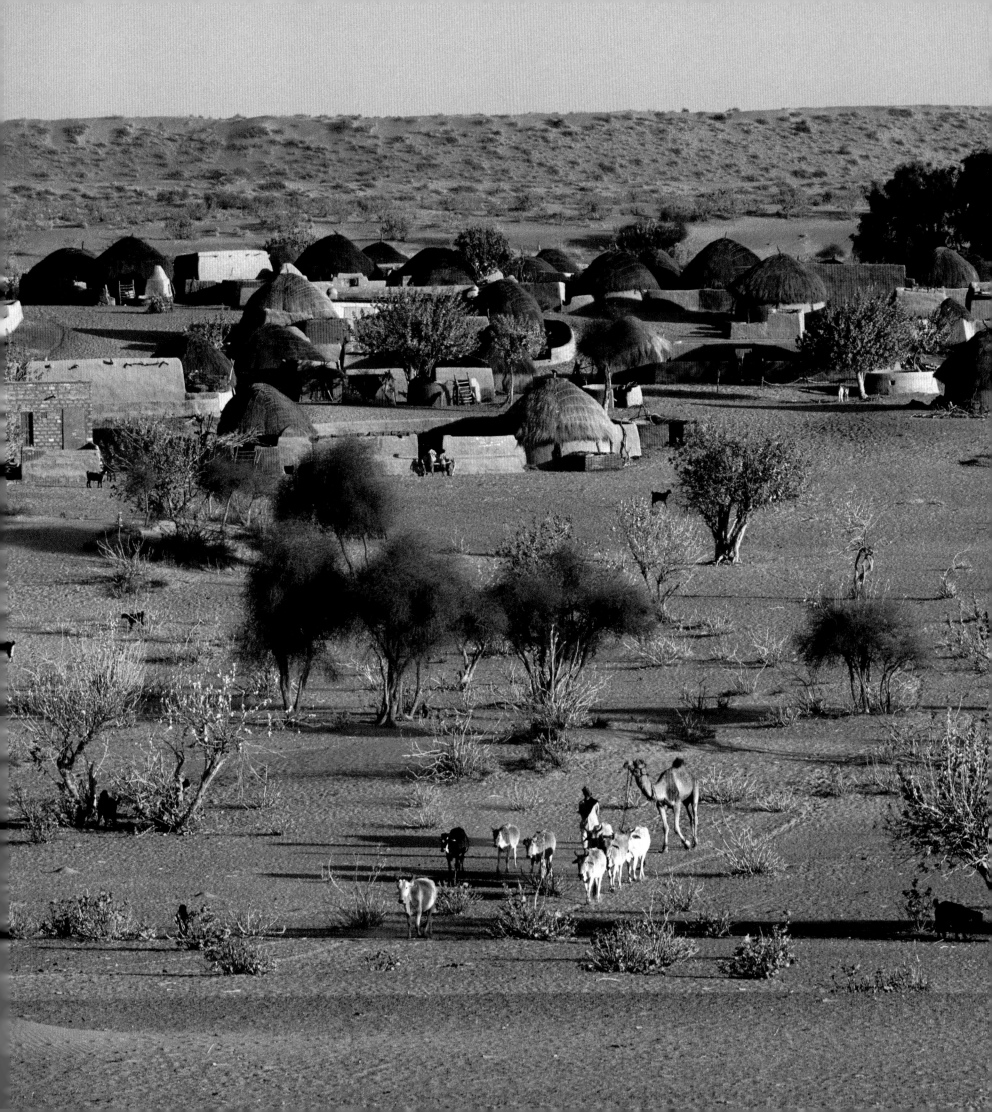

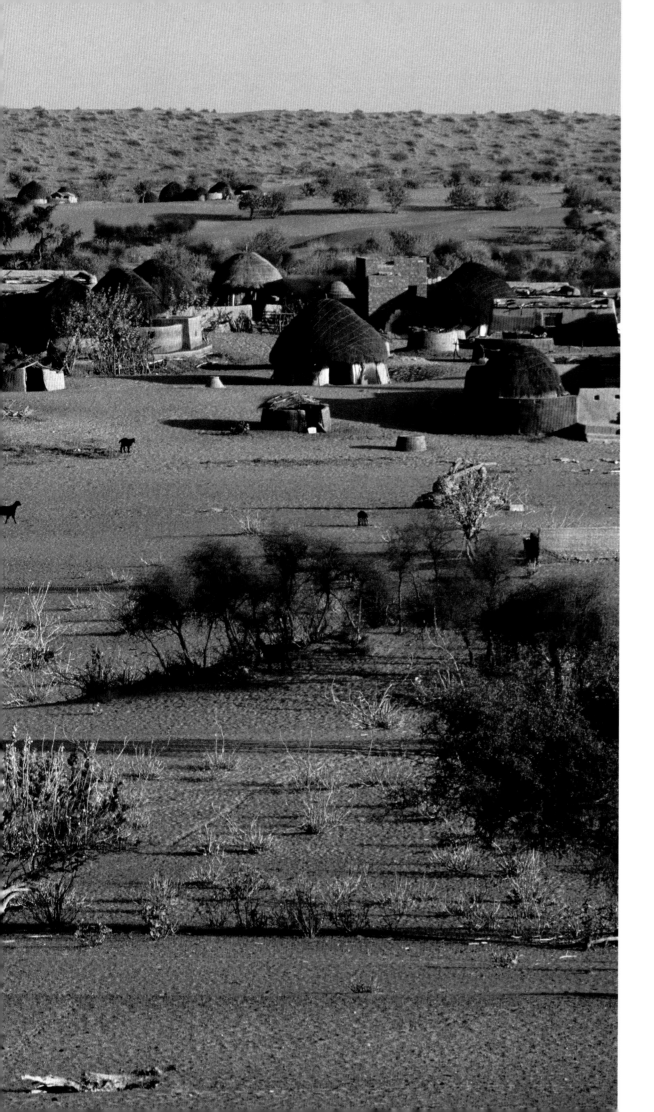

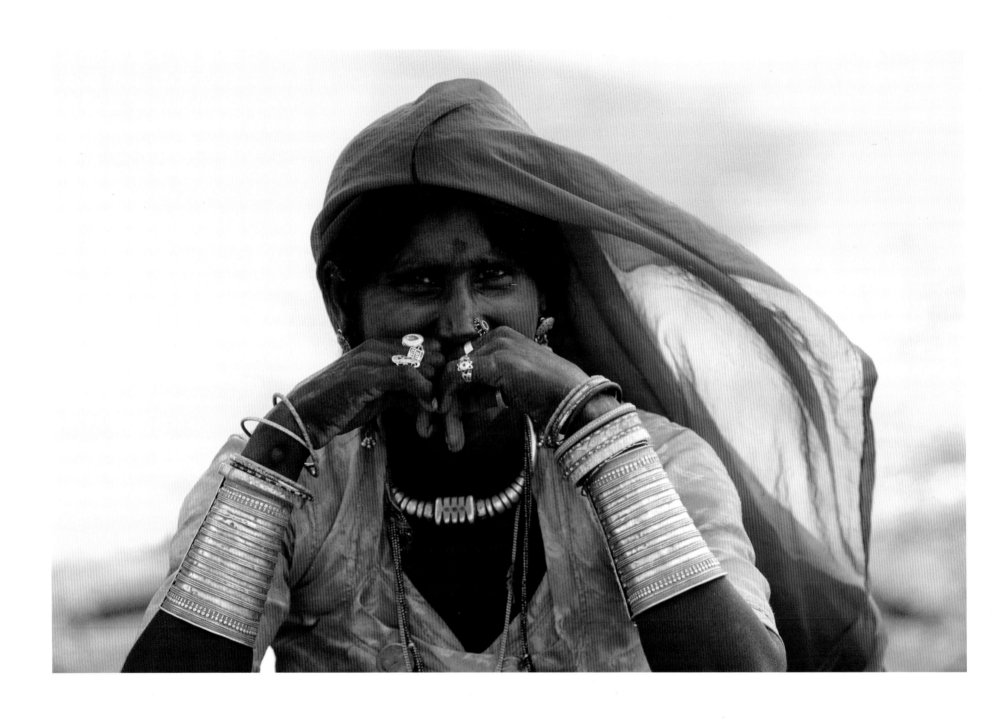

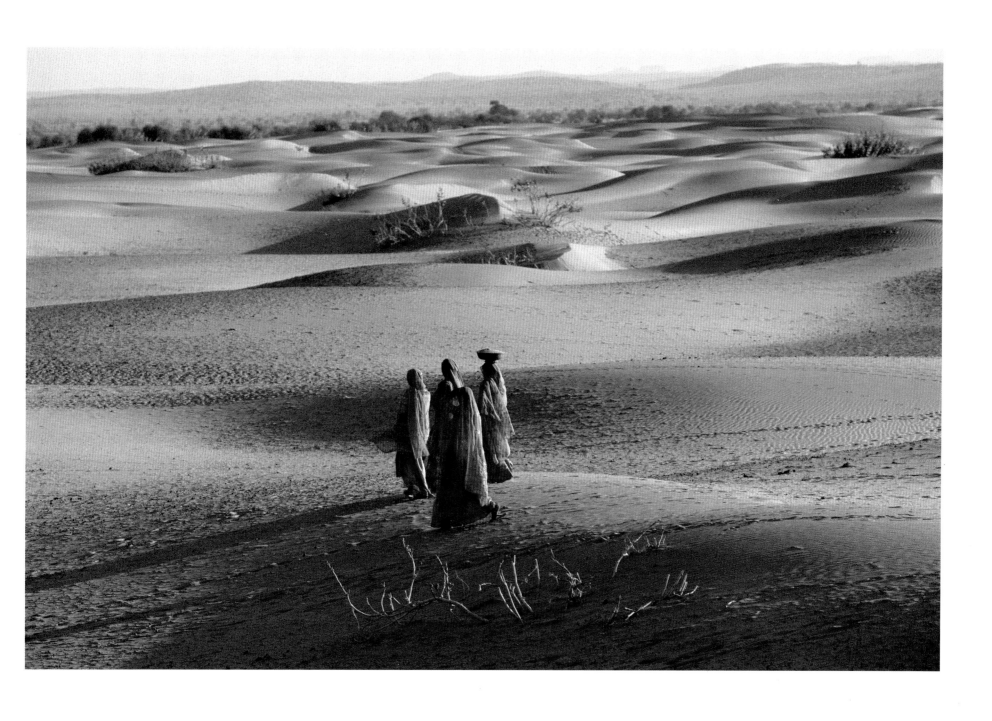

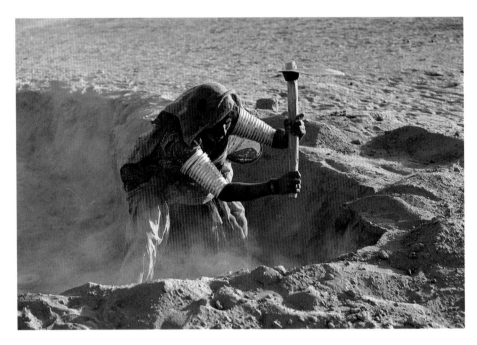
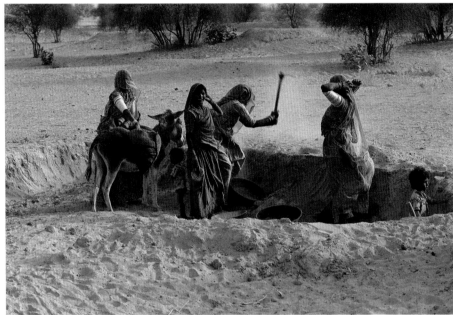
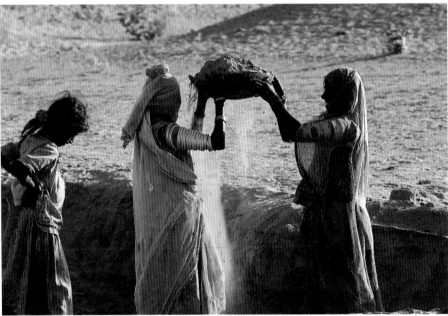
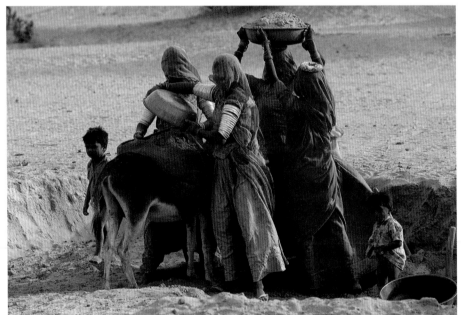

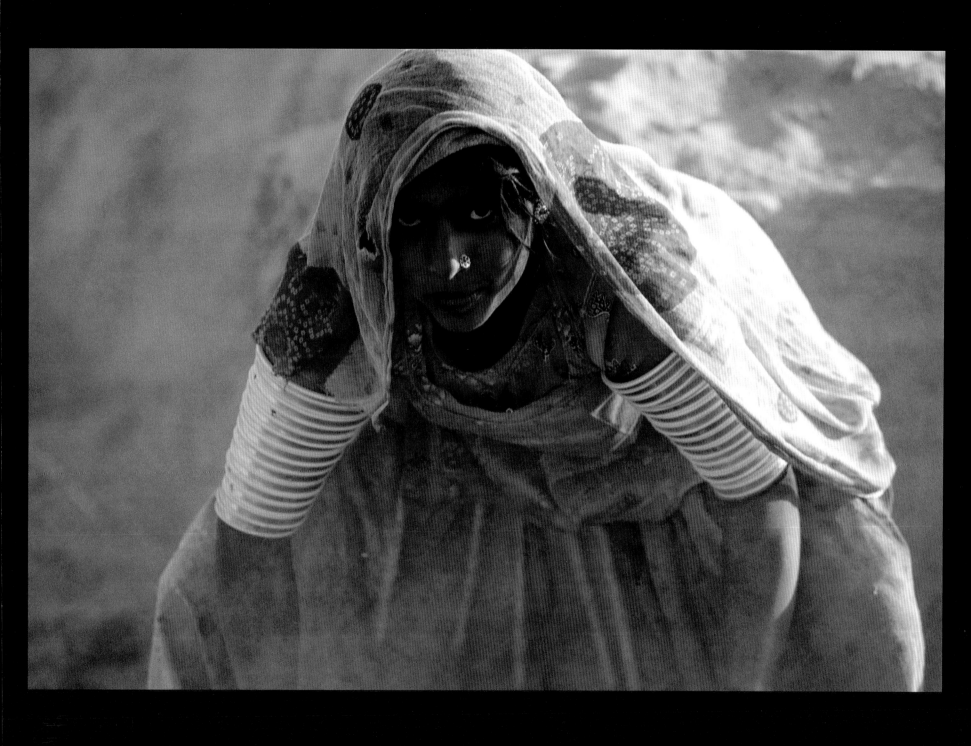

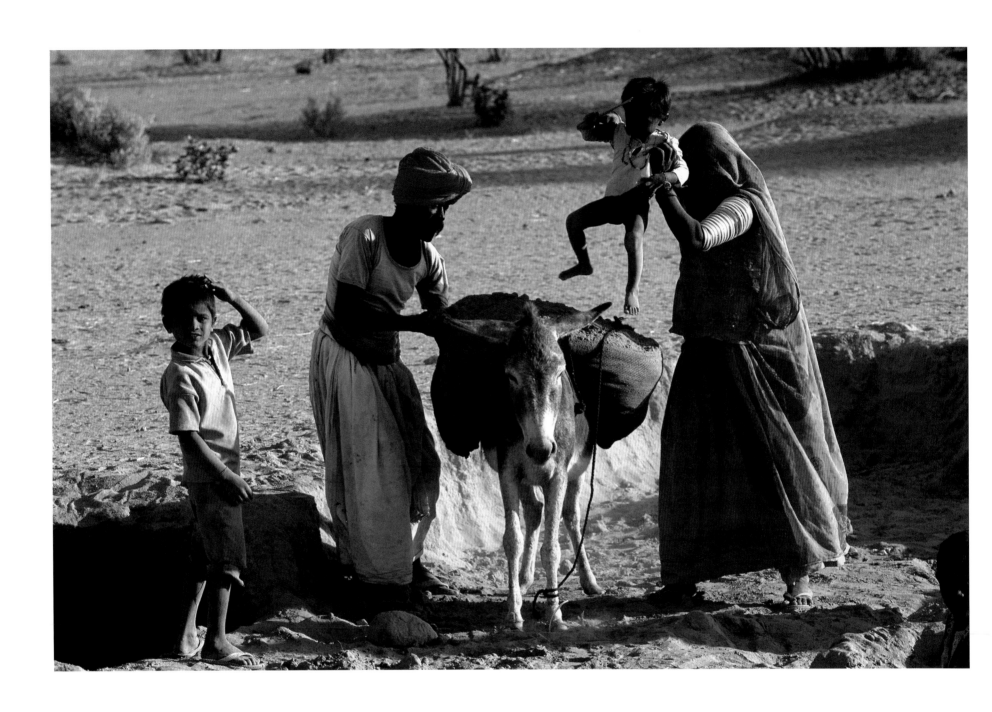

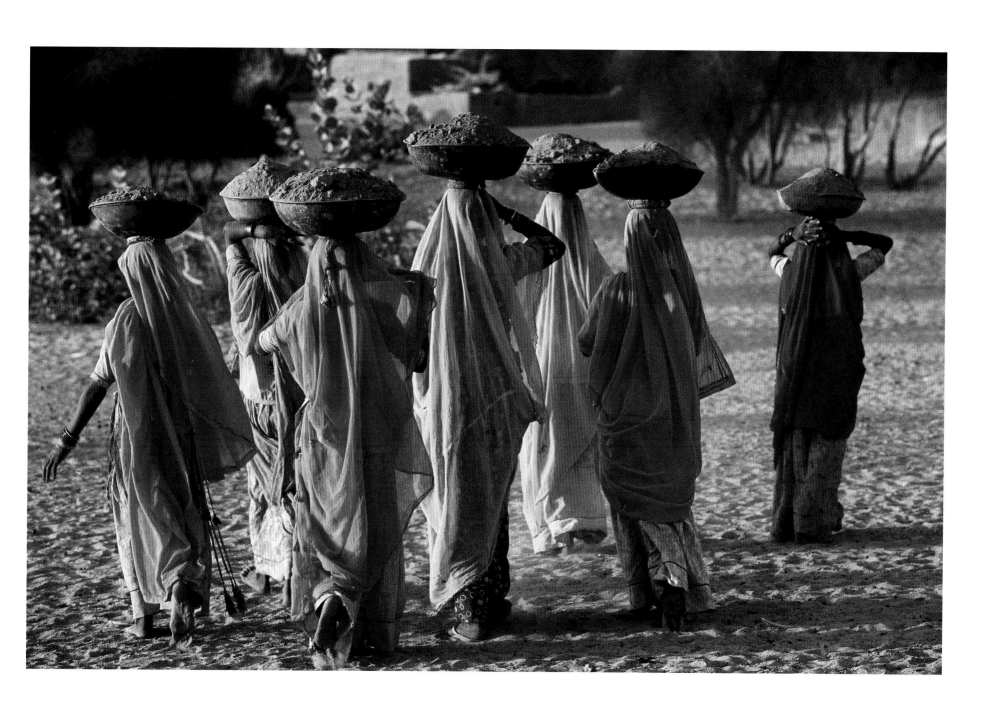

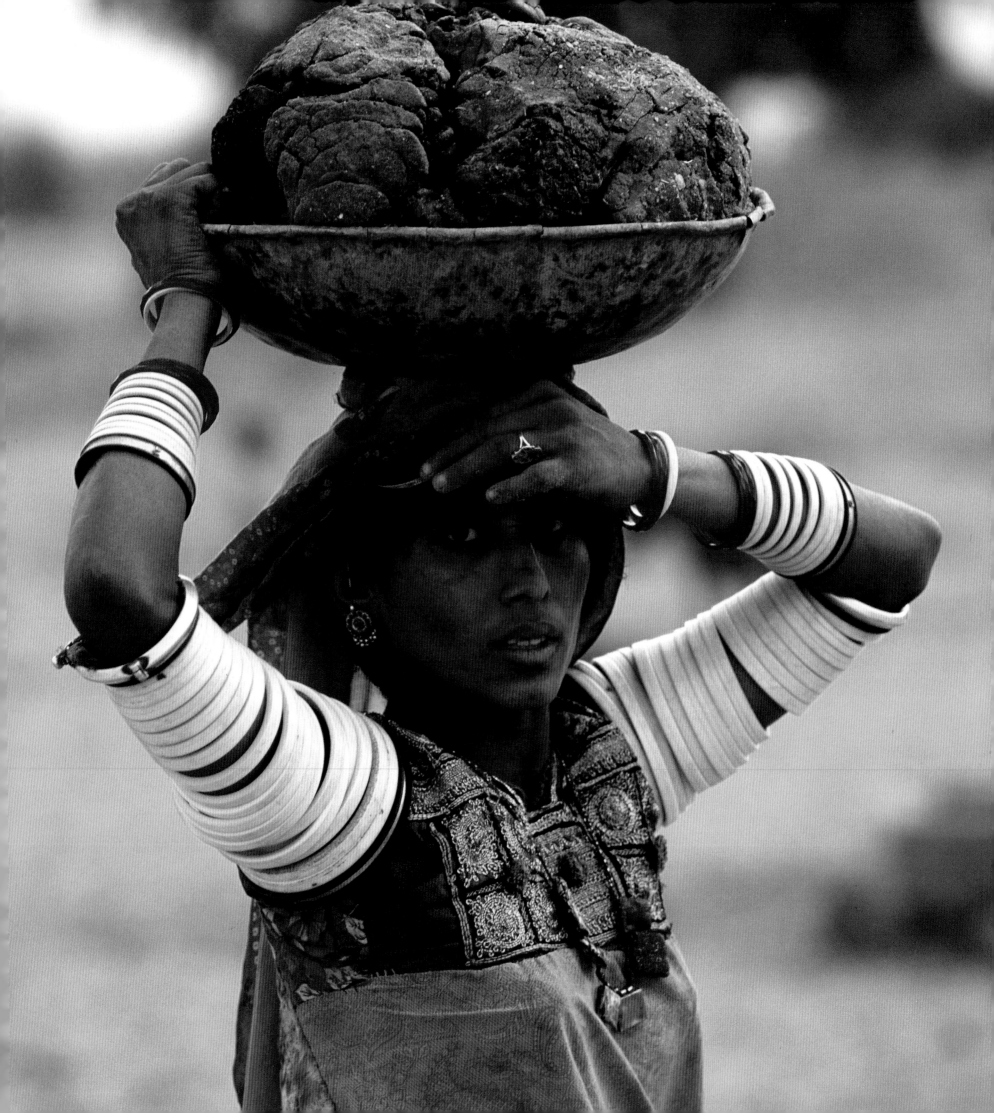

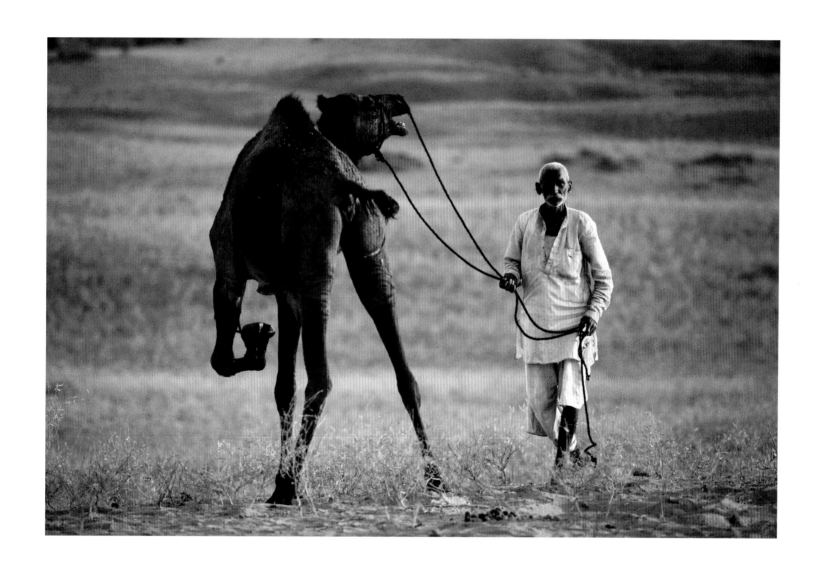

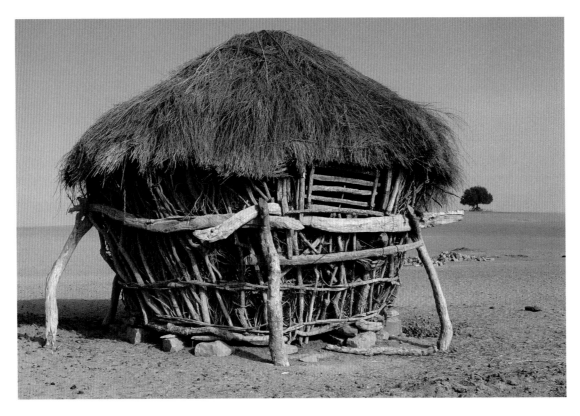

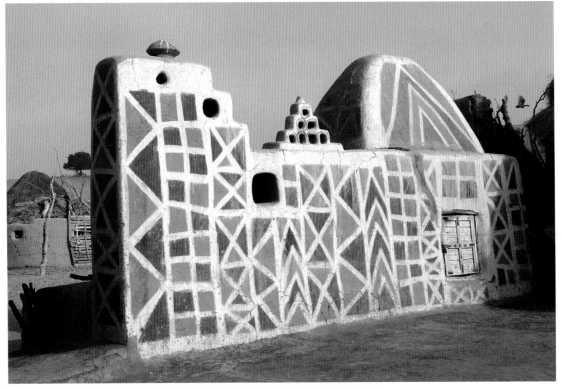

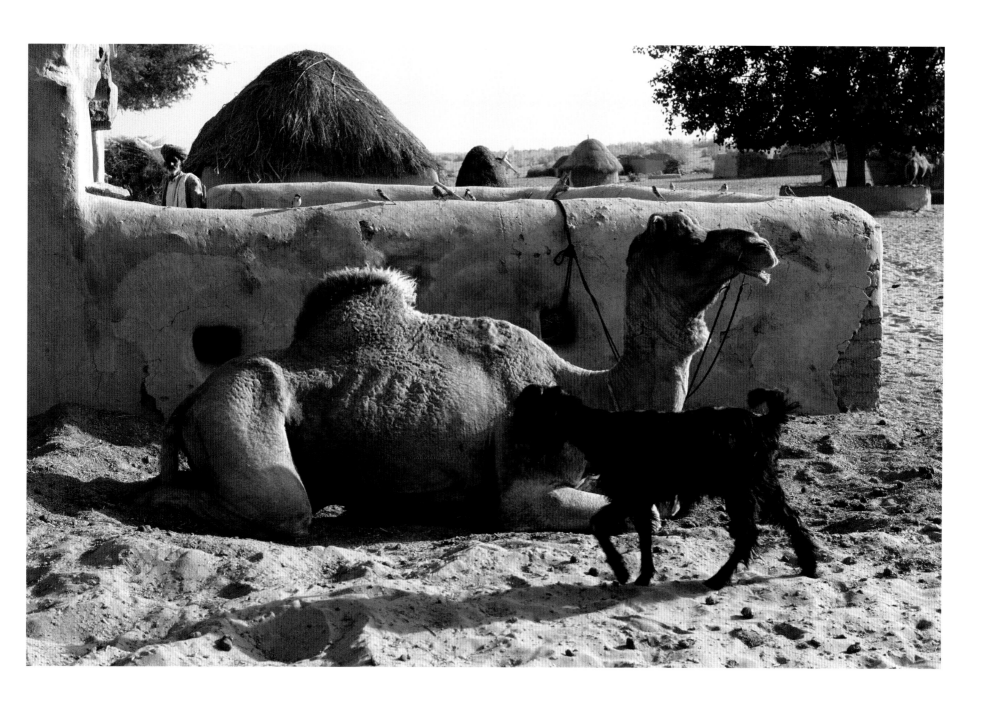

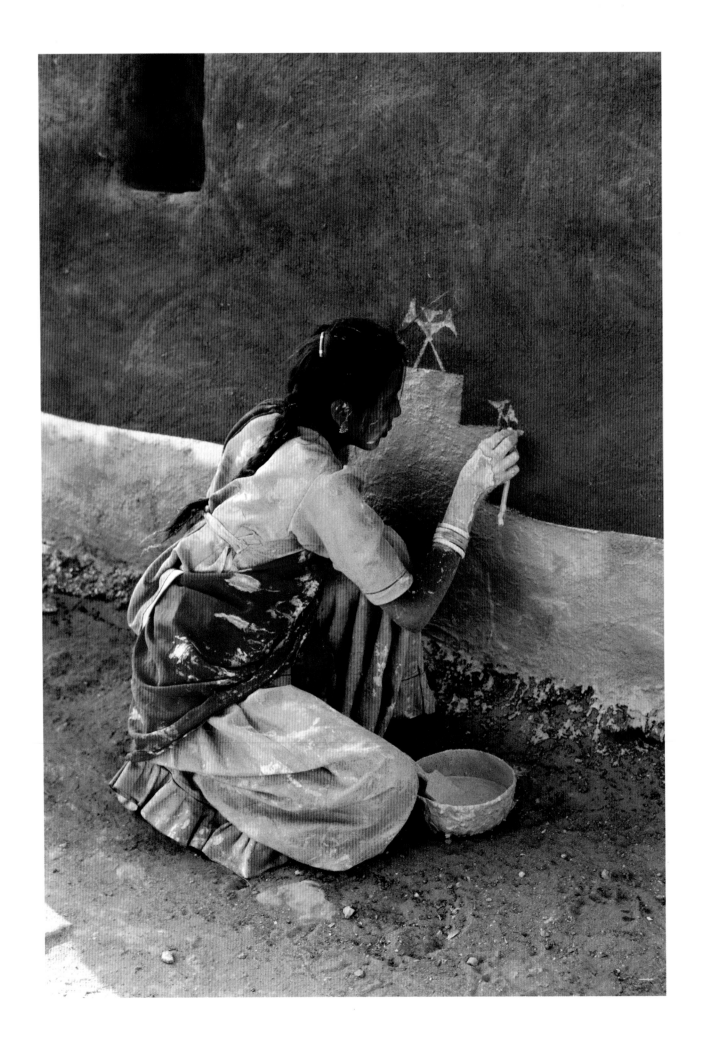

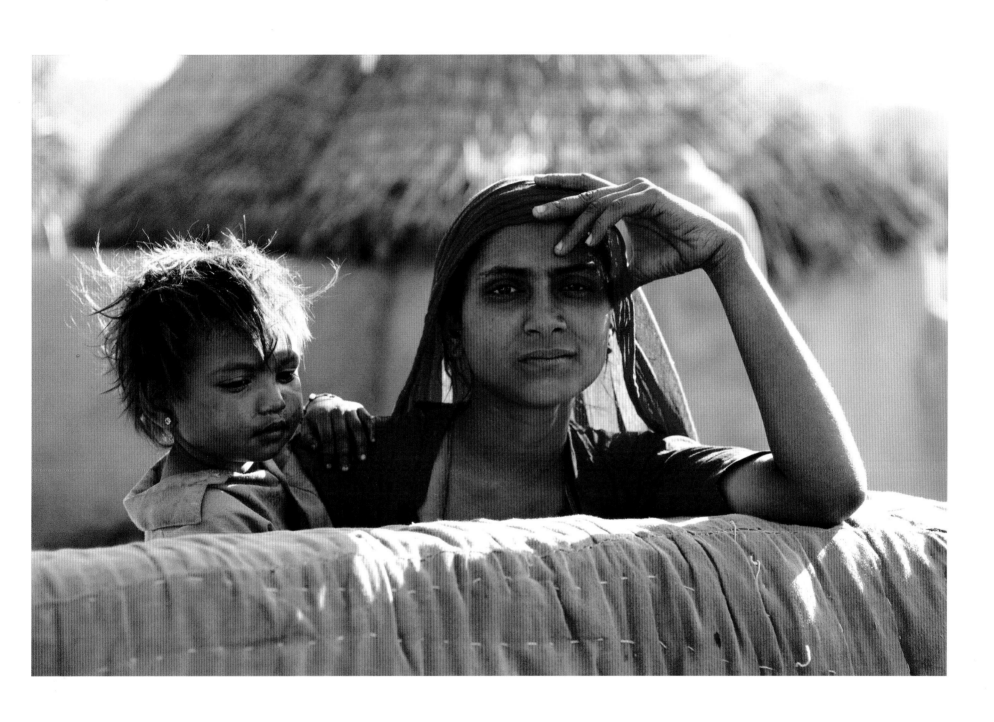

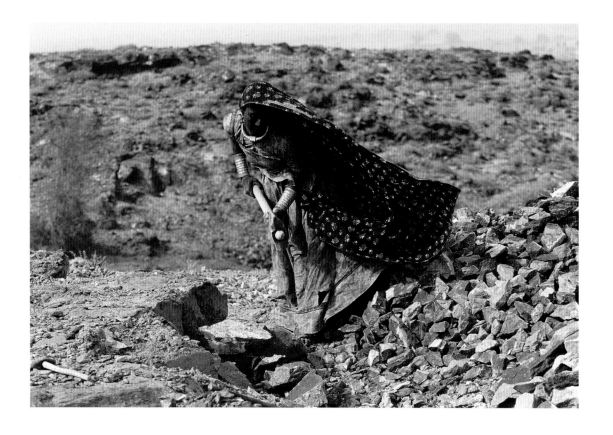

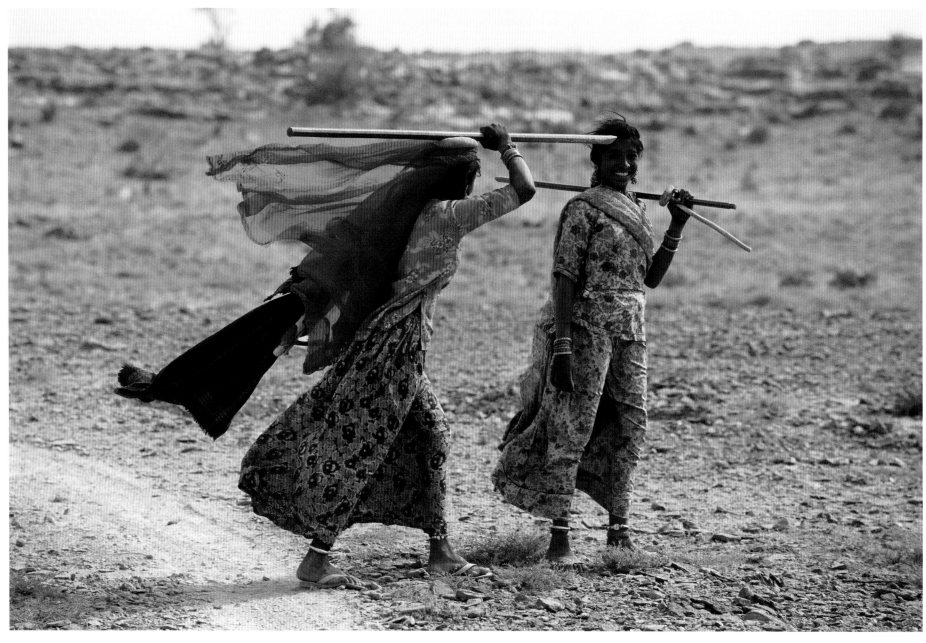

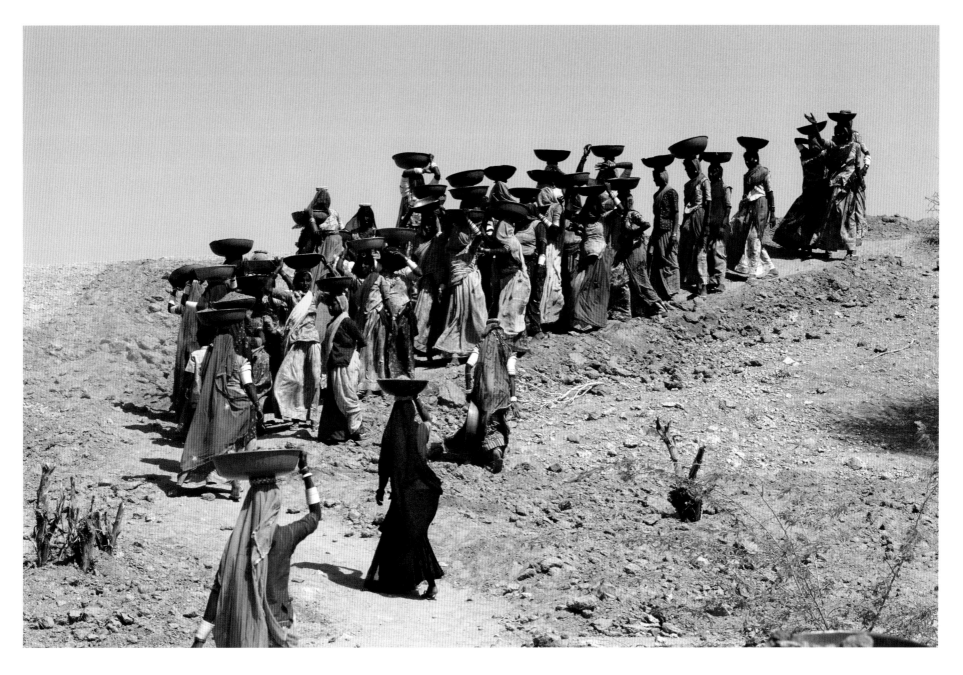

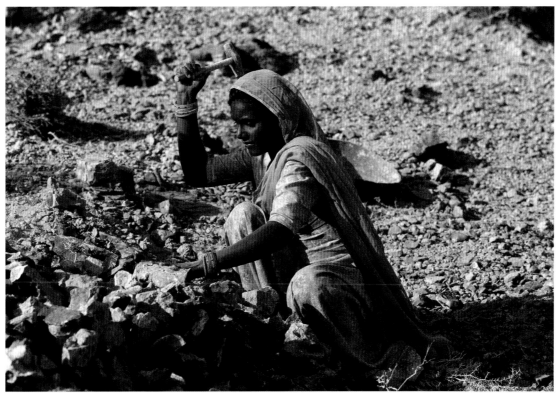

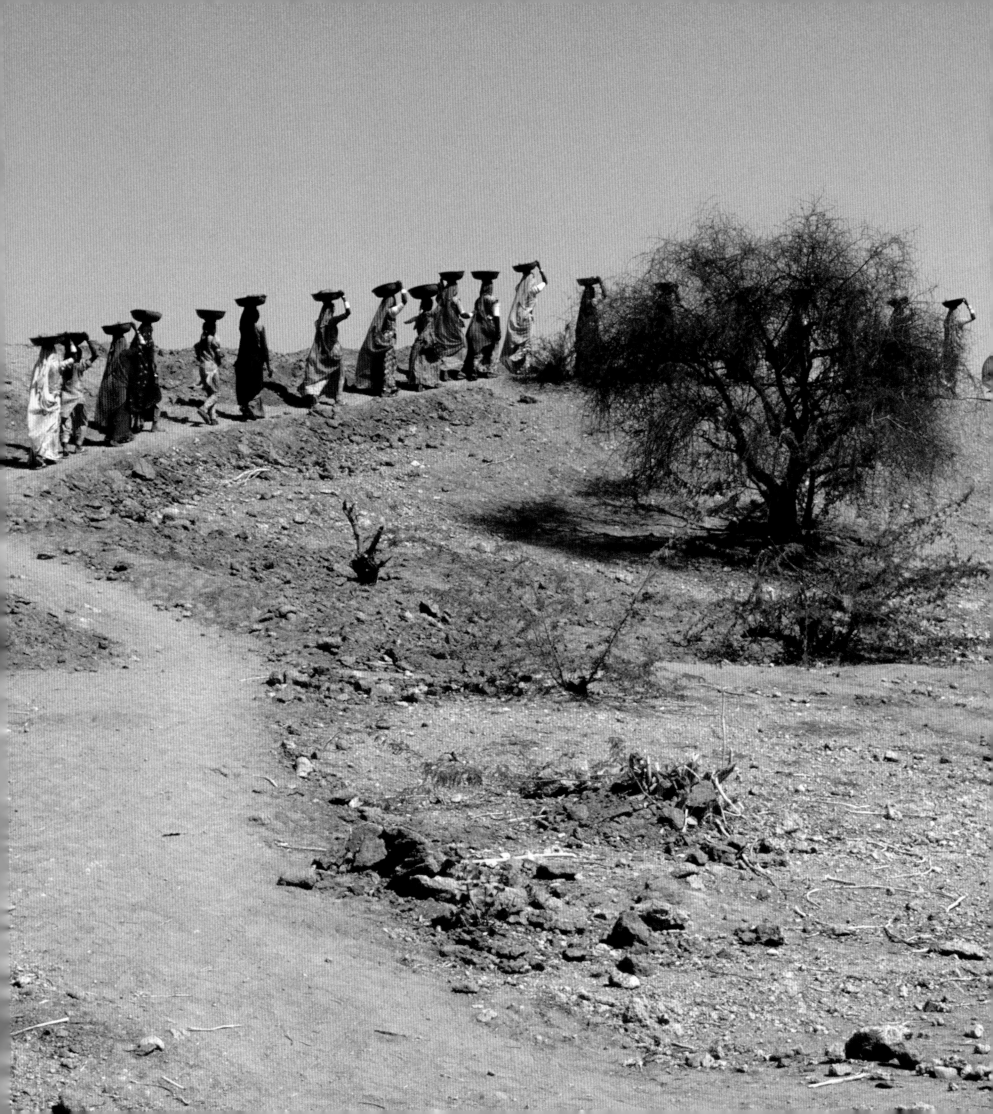

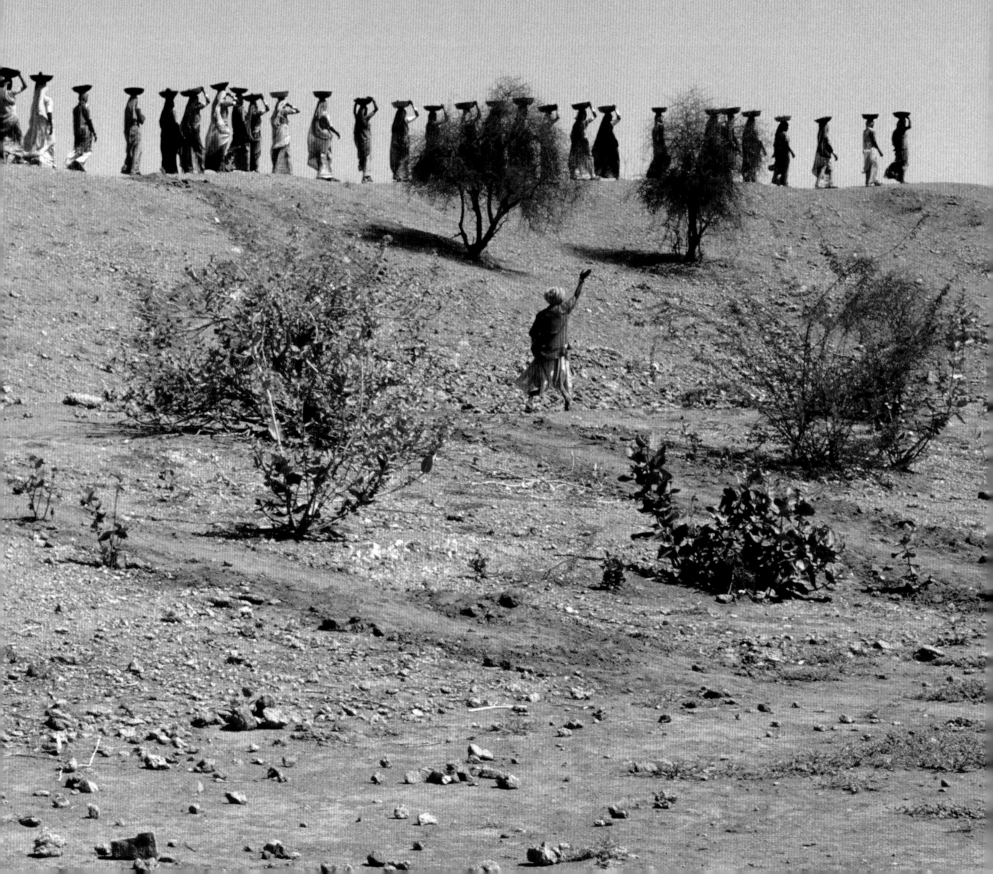

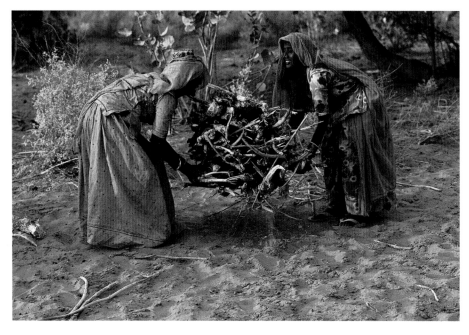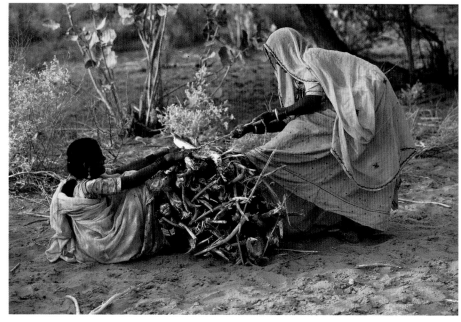
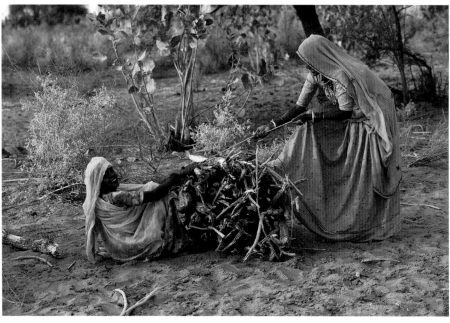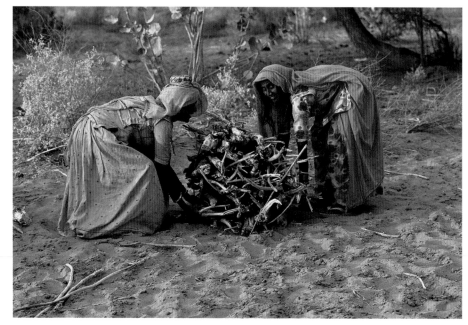

122

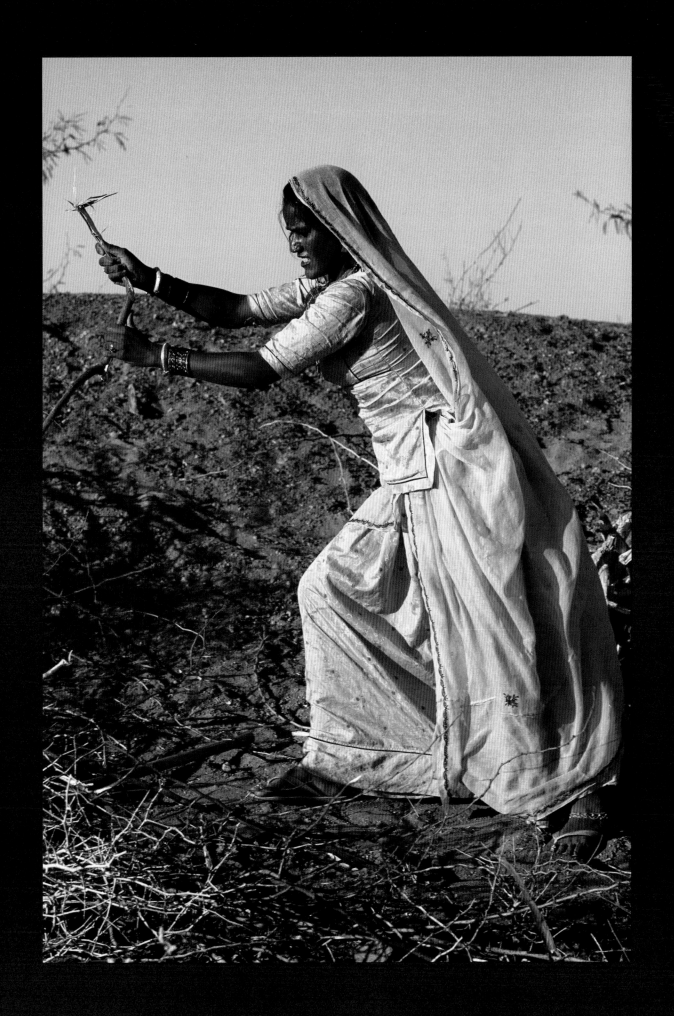

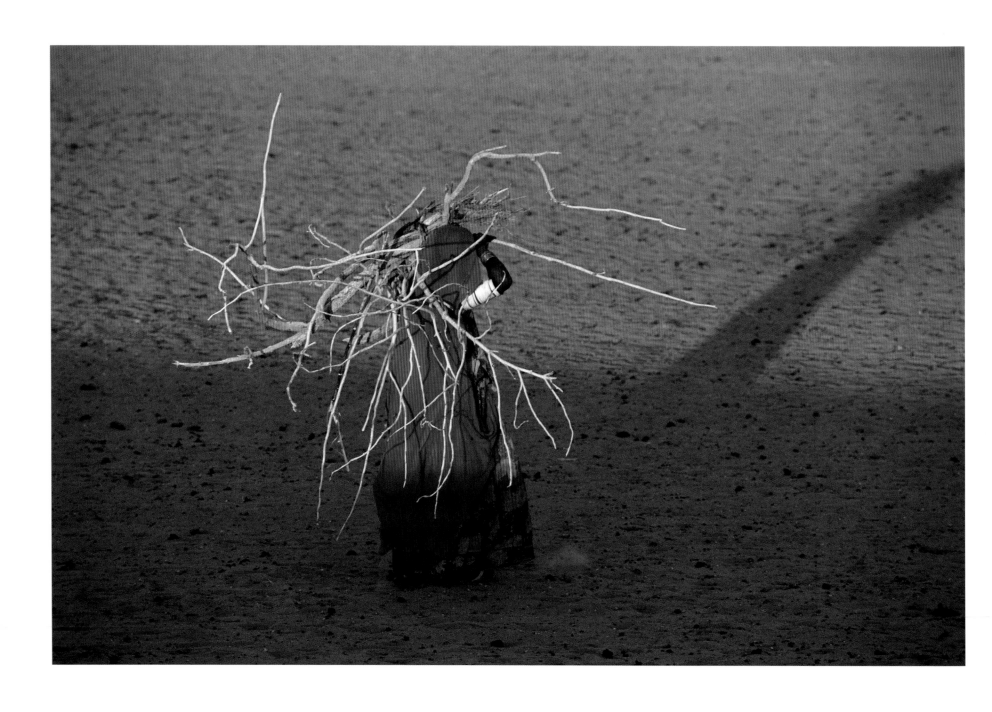

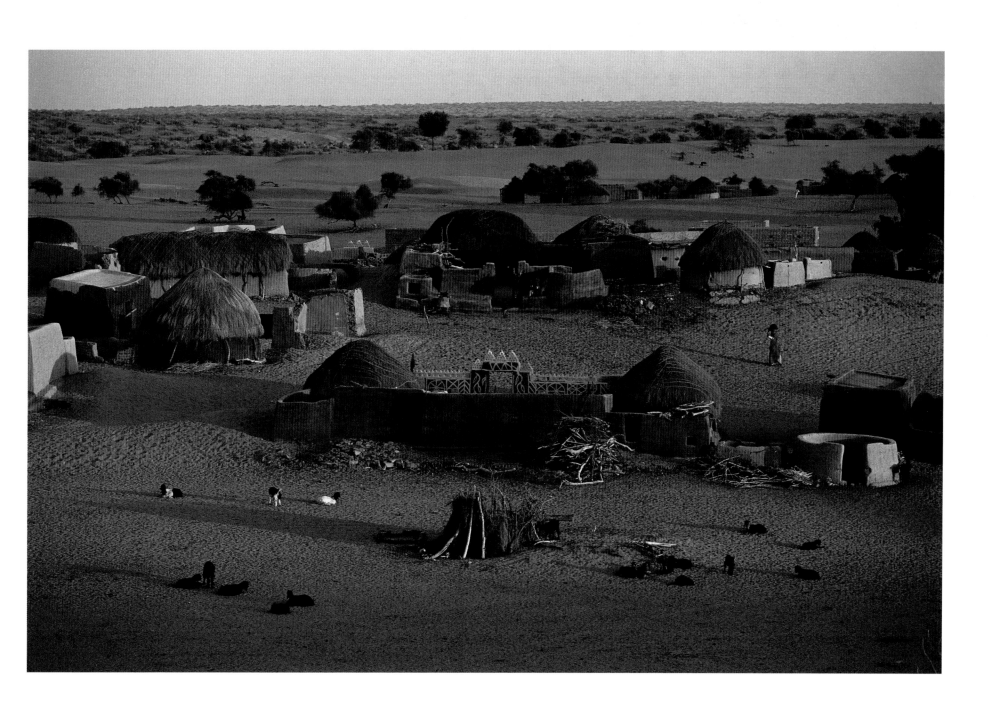

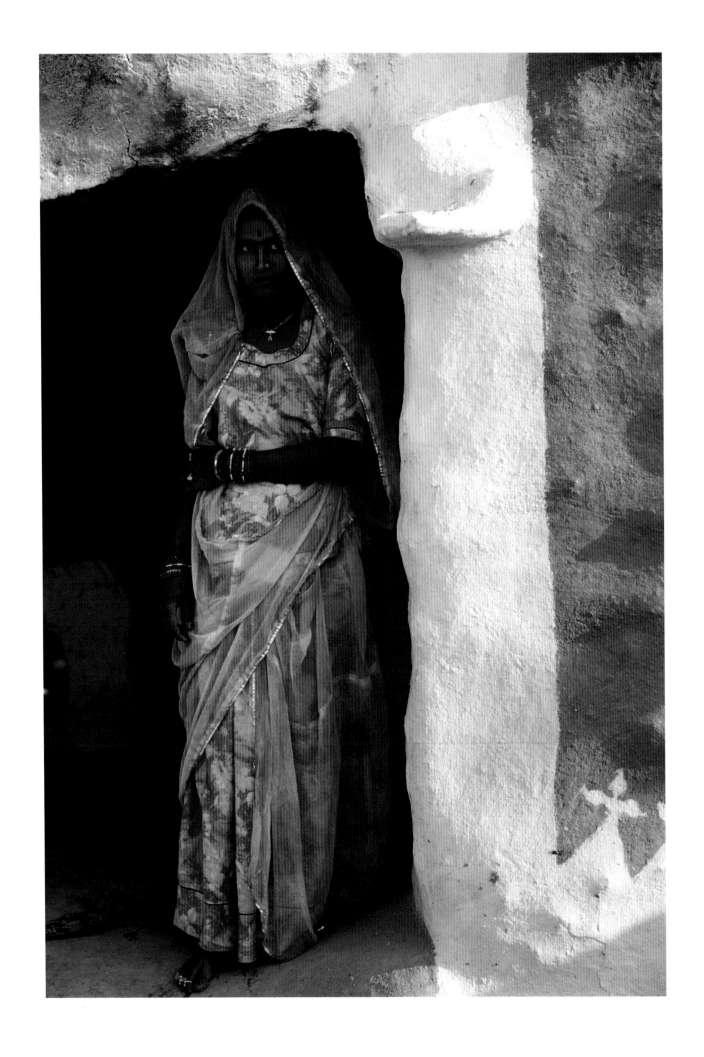

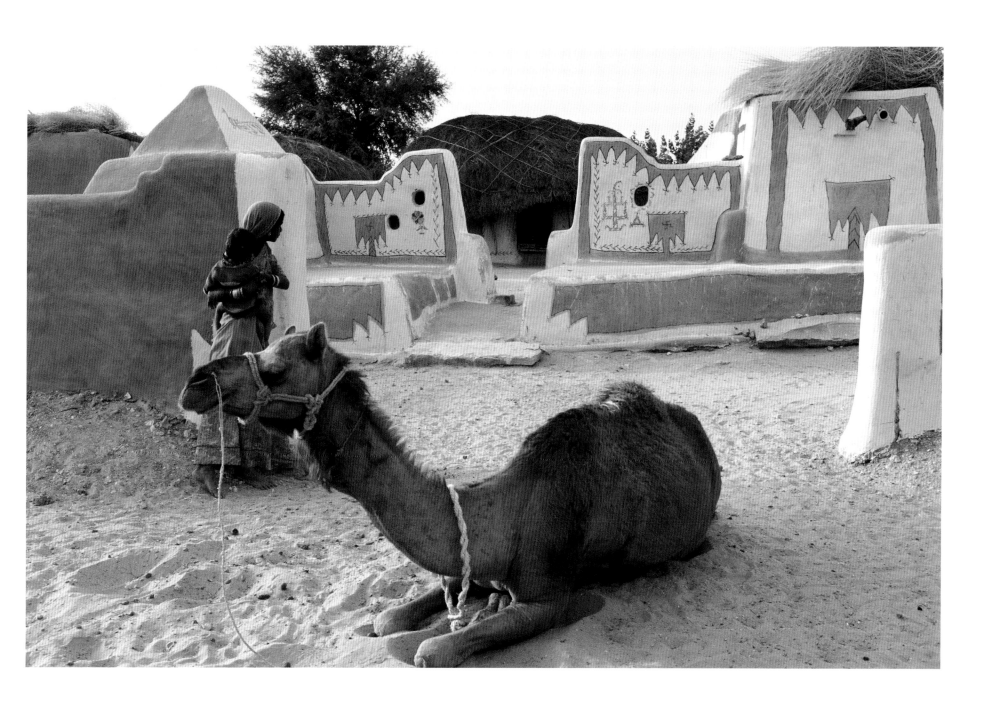

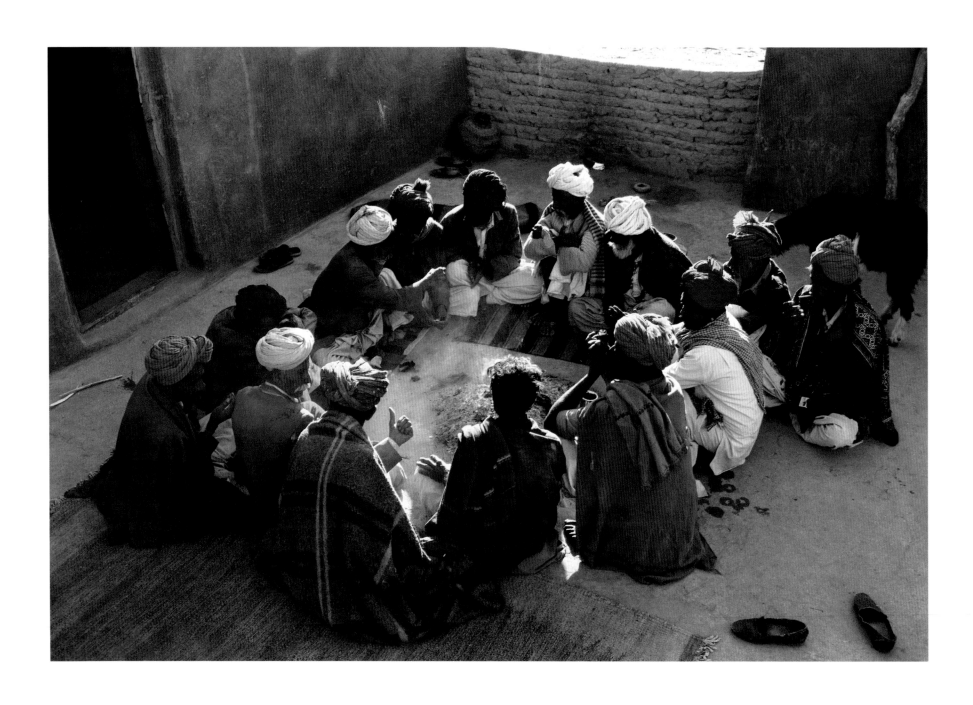

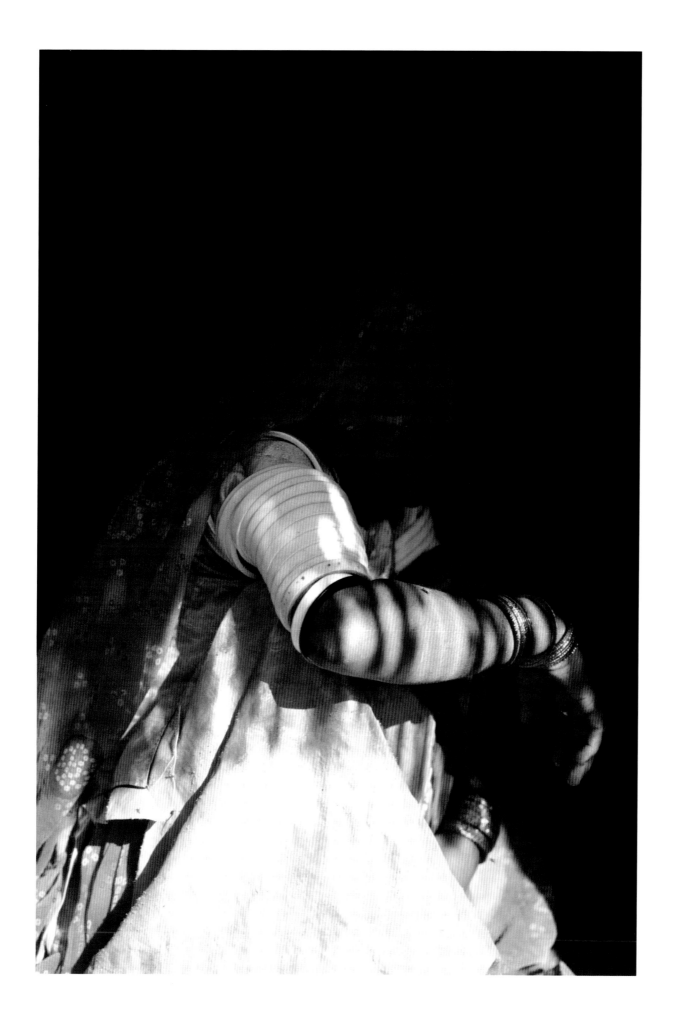

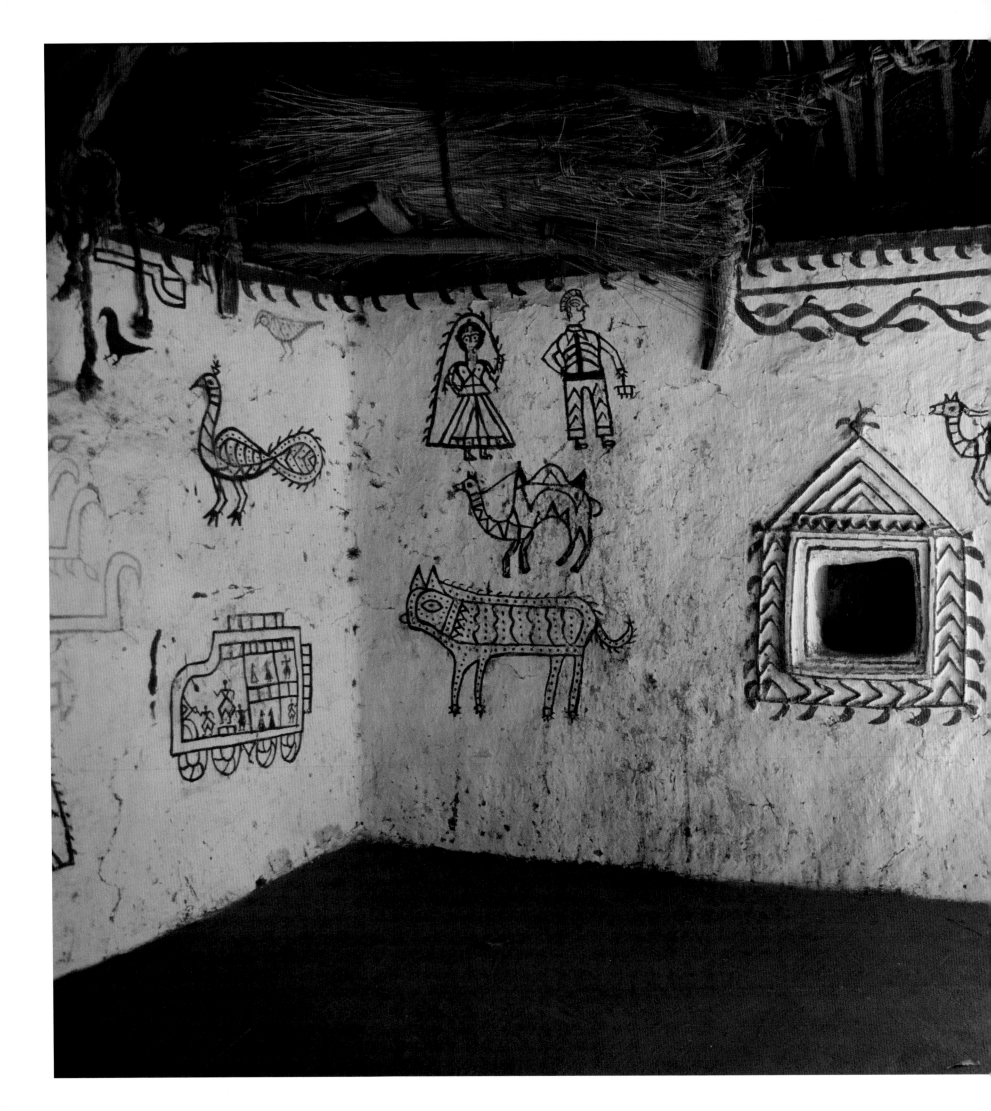

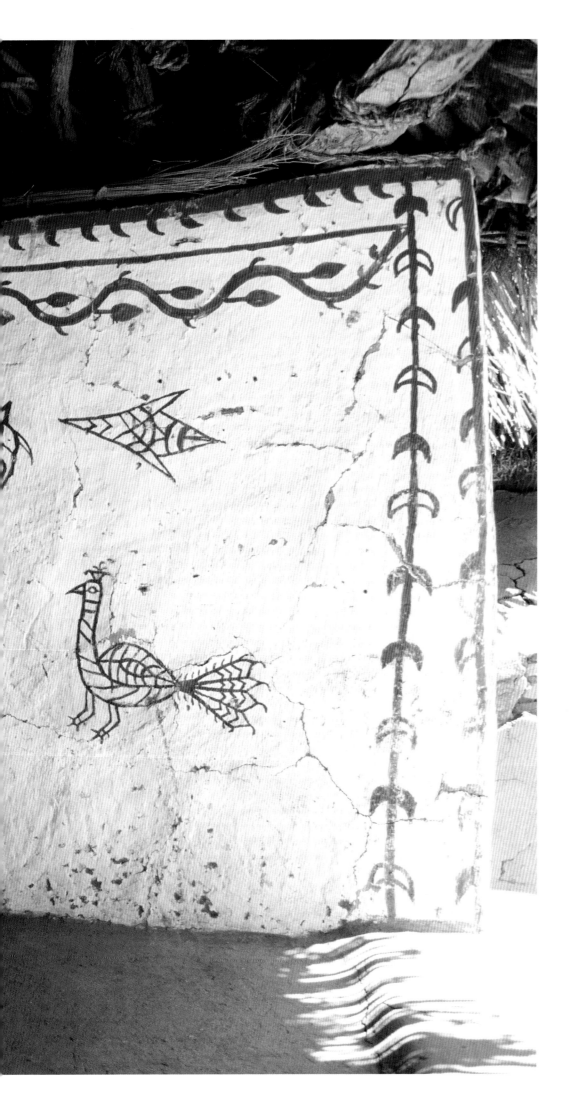

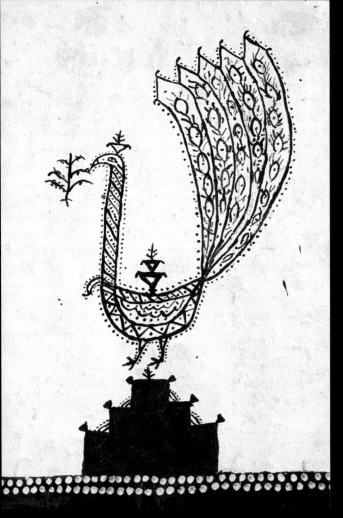

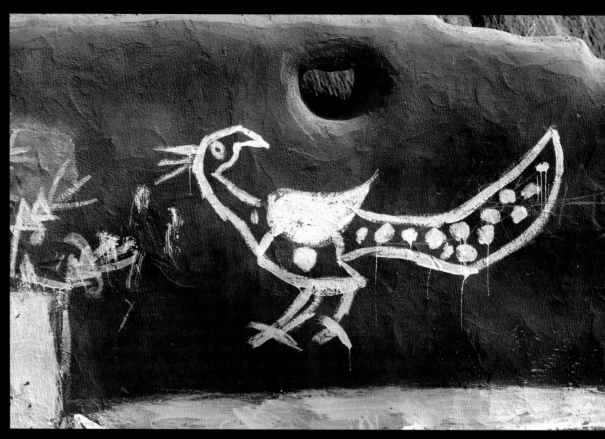

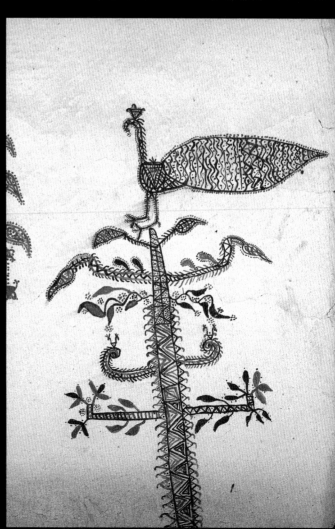

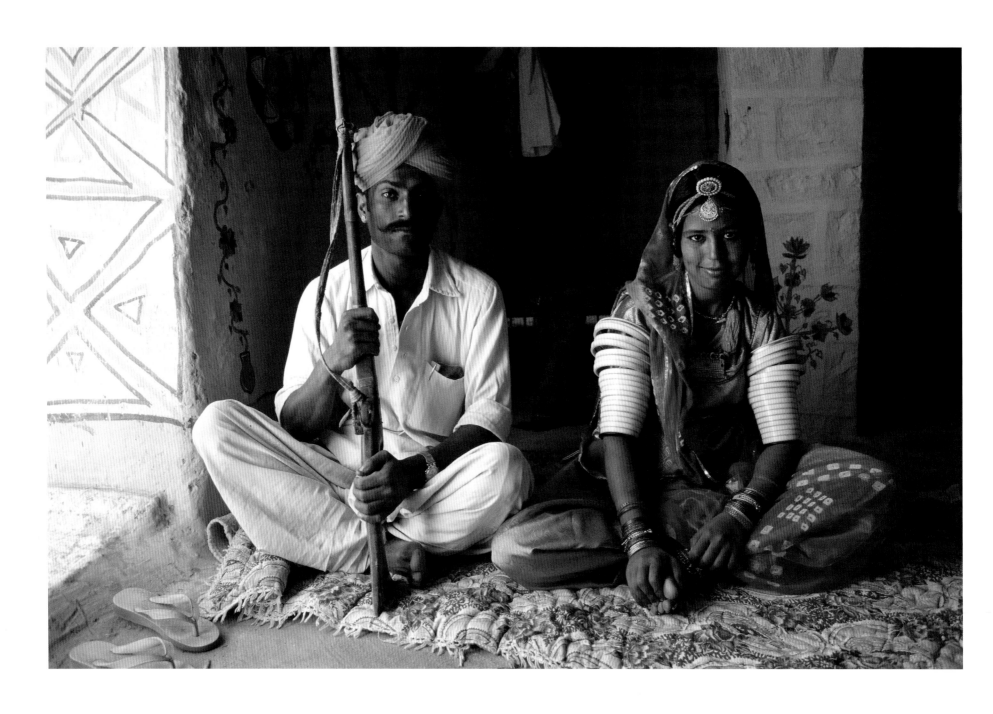

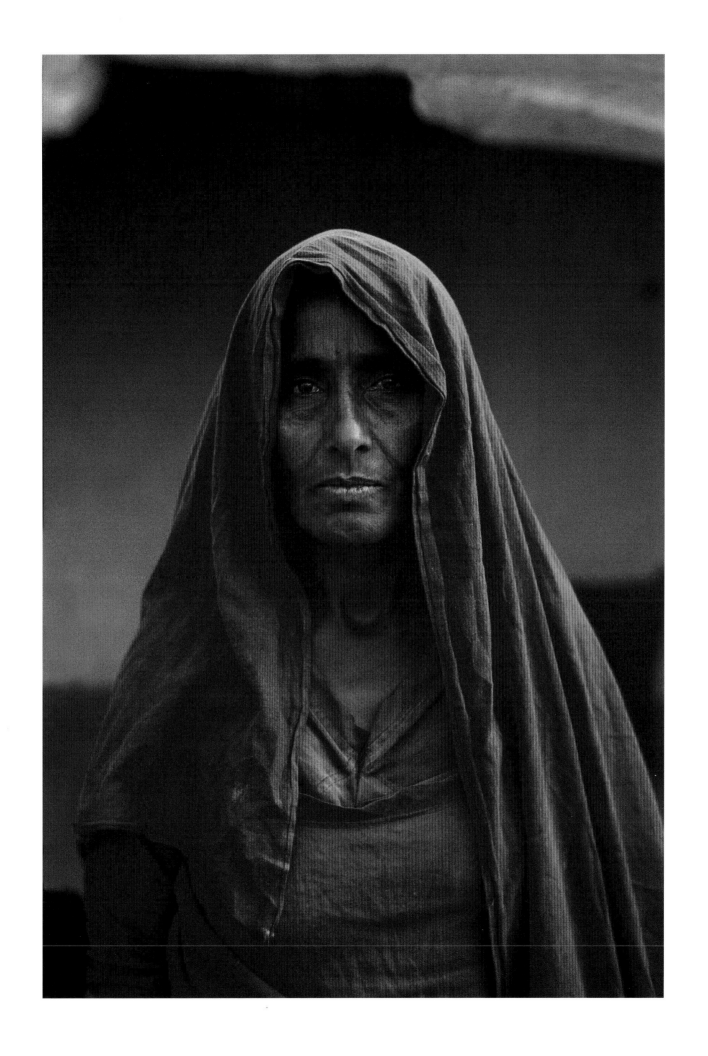

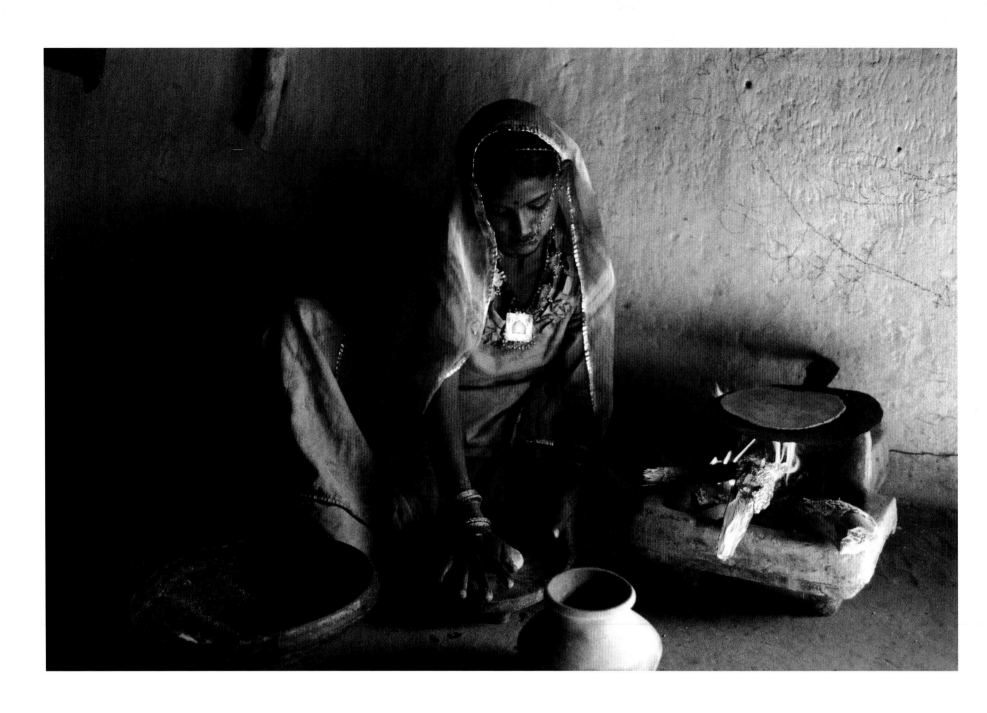

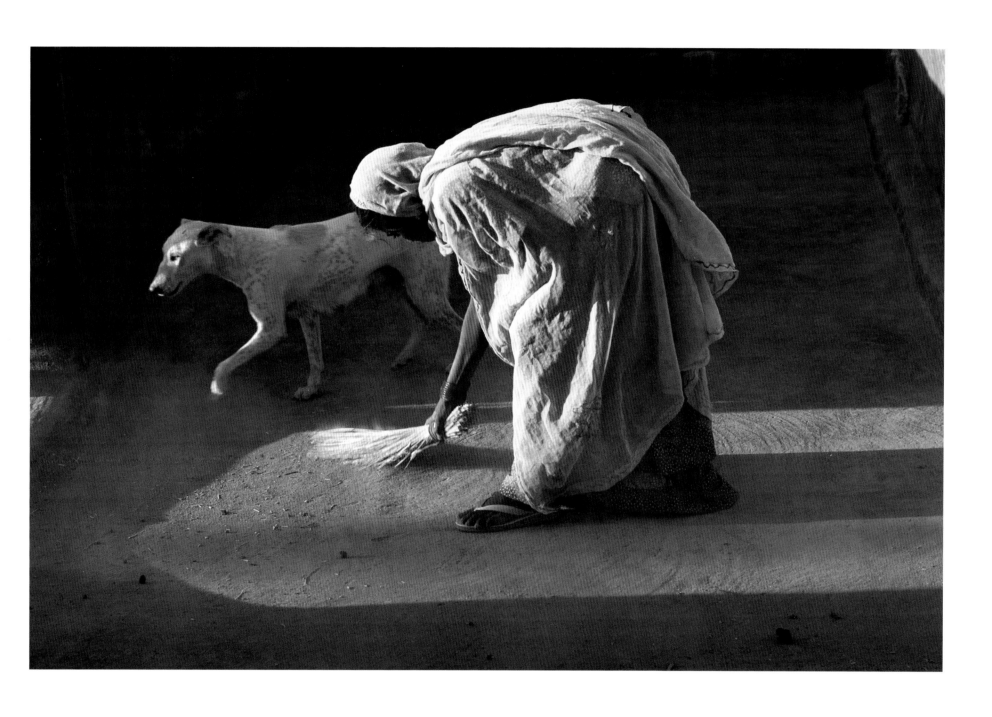

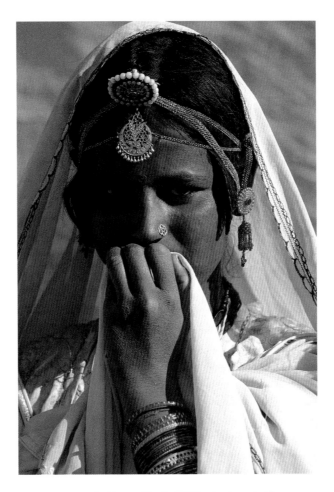

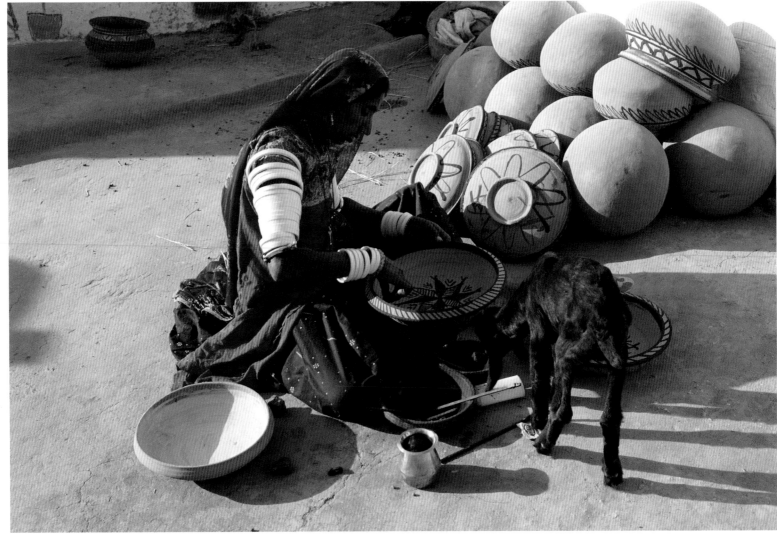

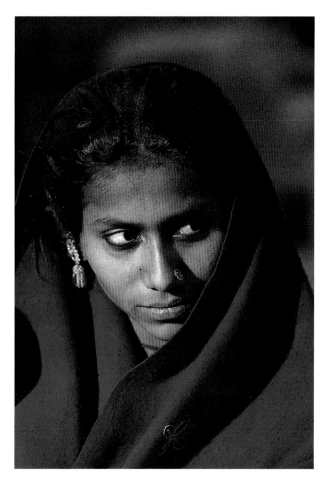

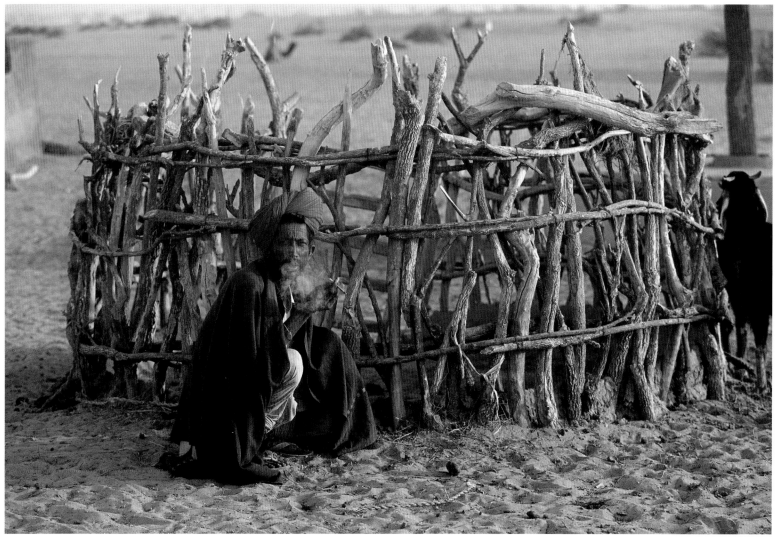

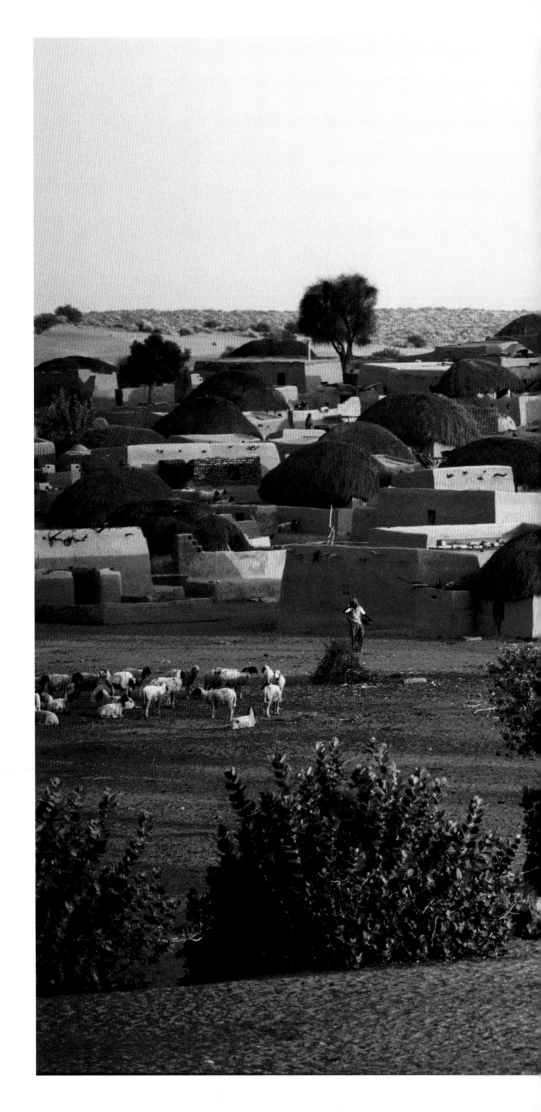

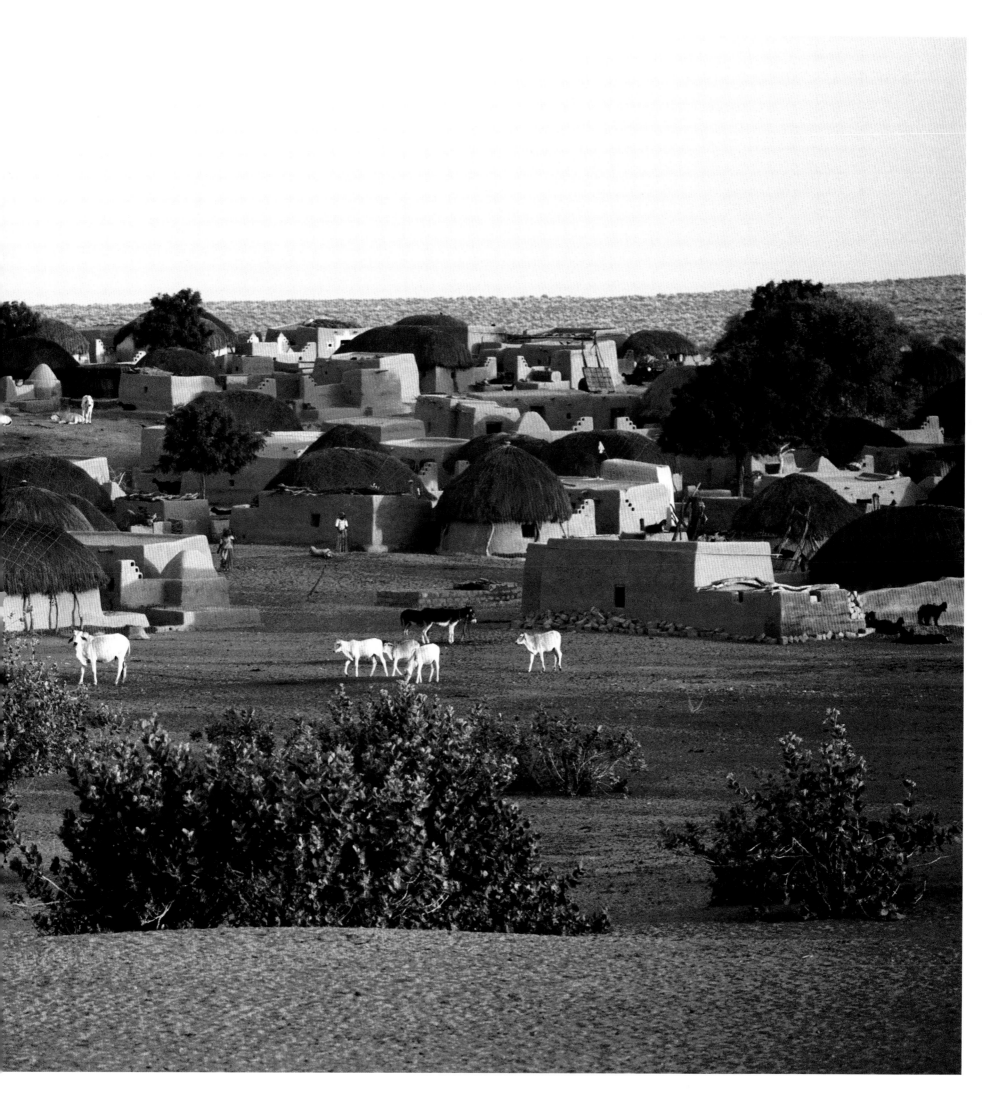

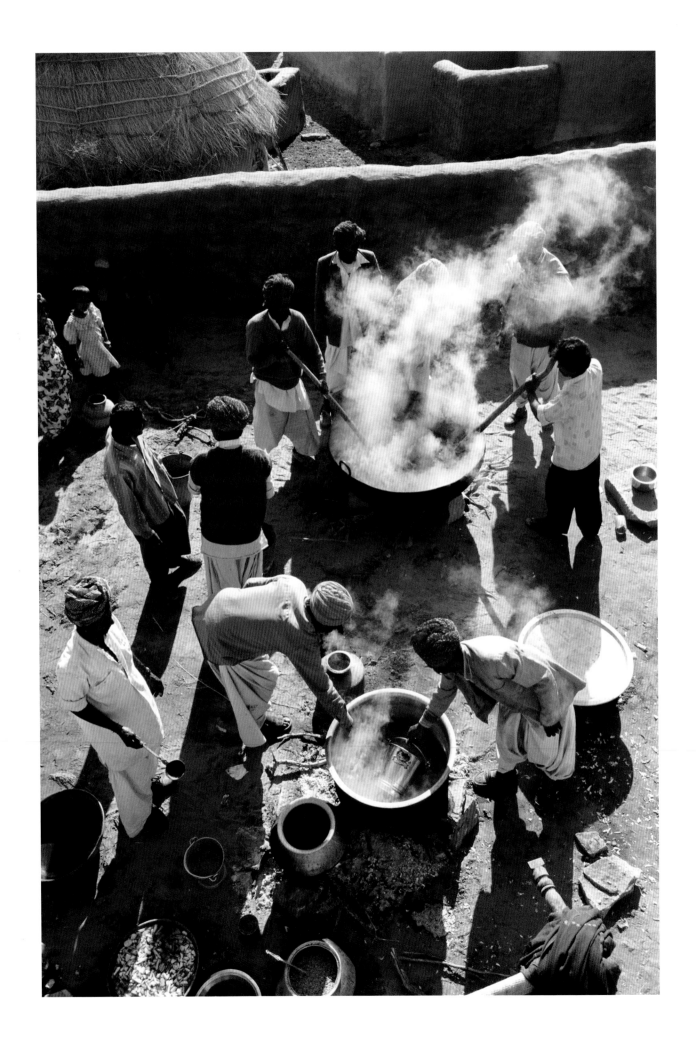

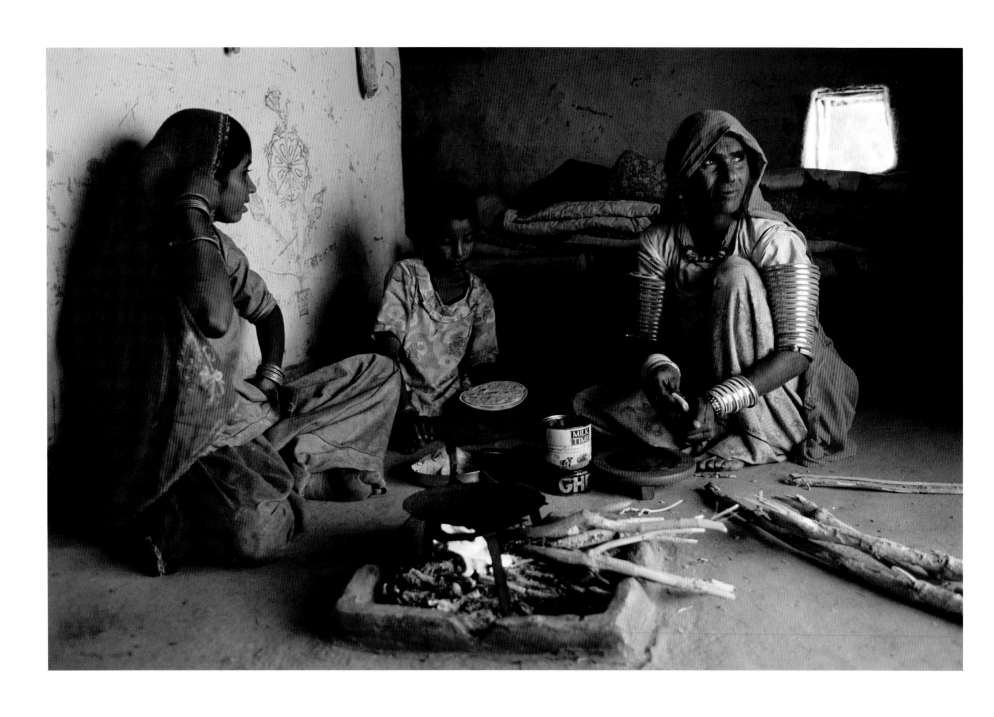

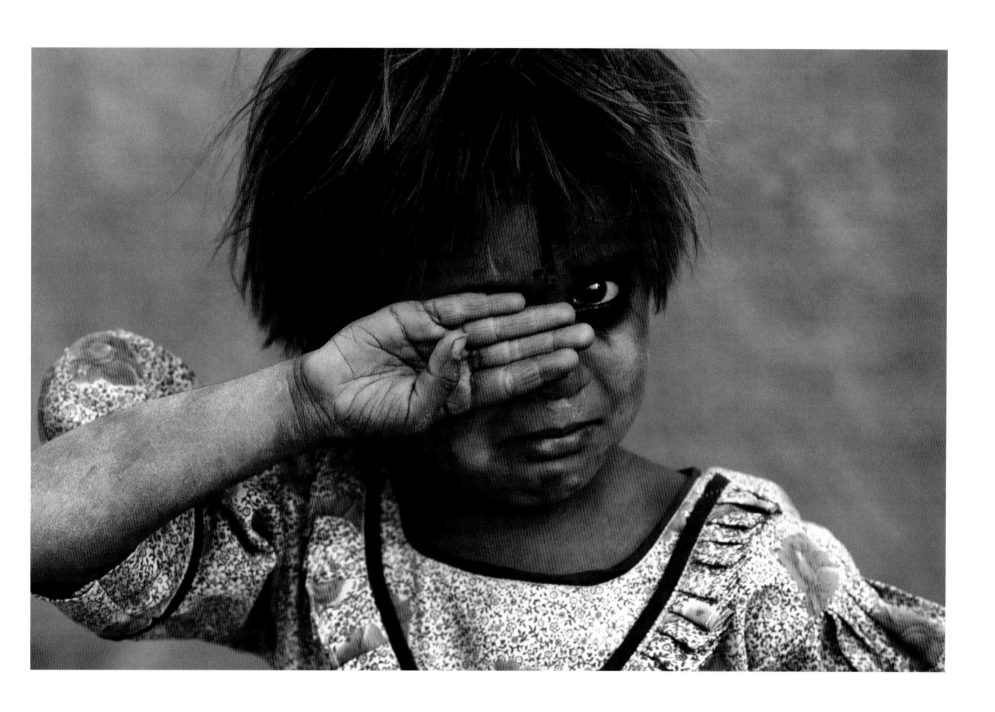

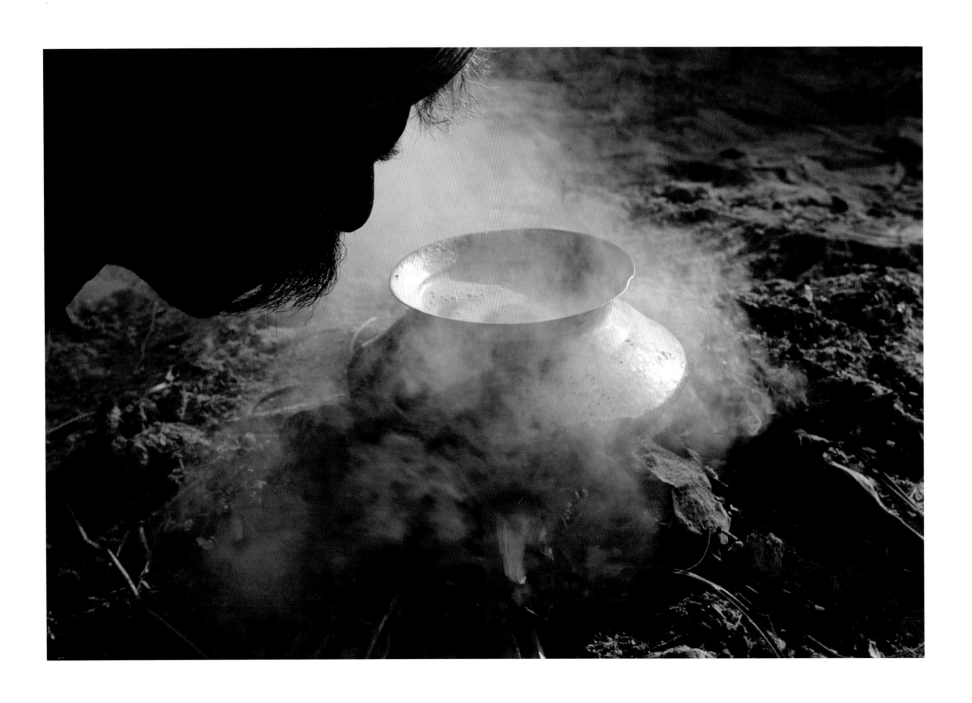

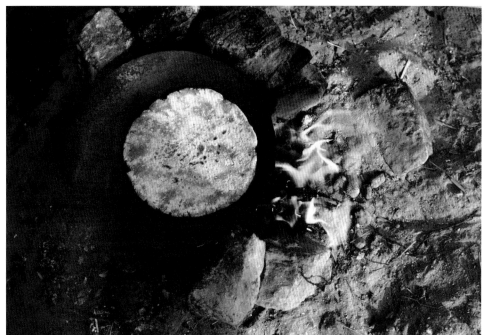

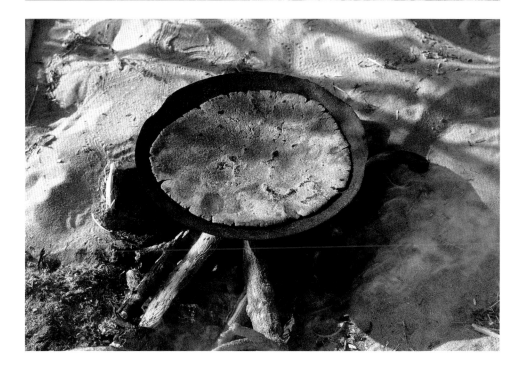

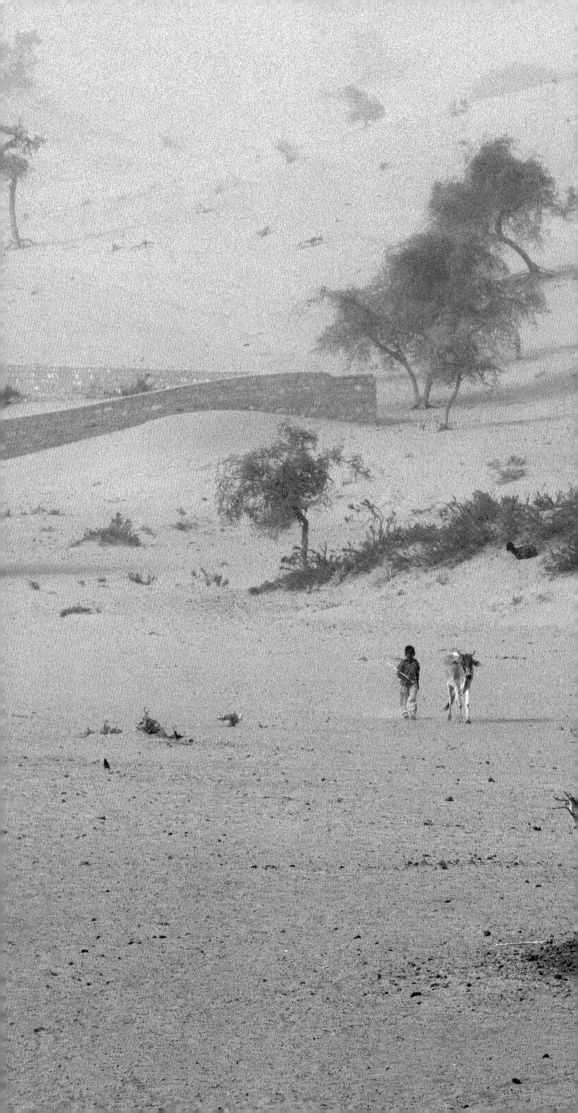

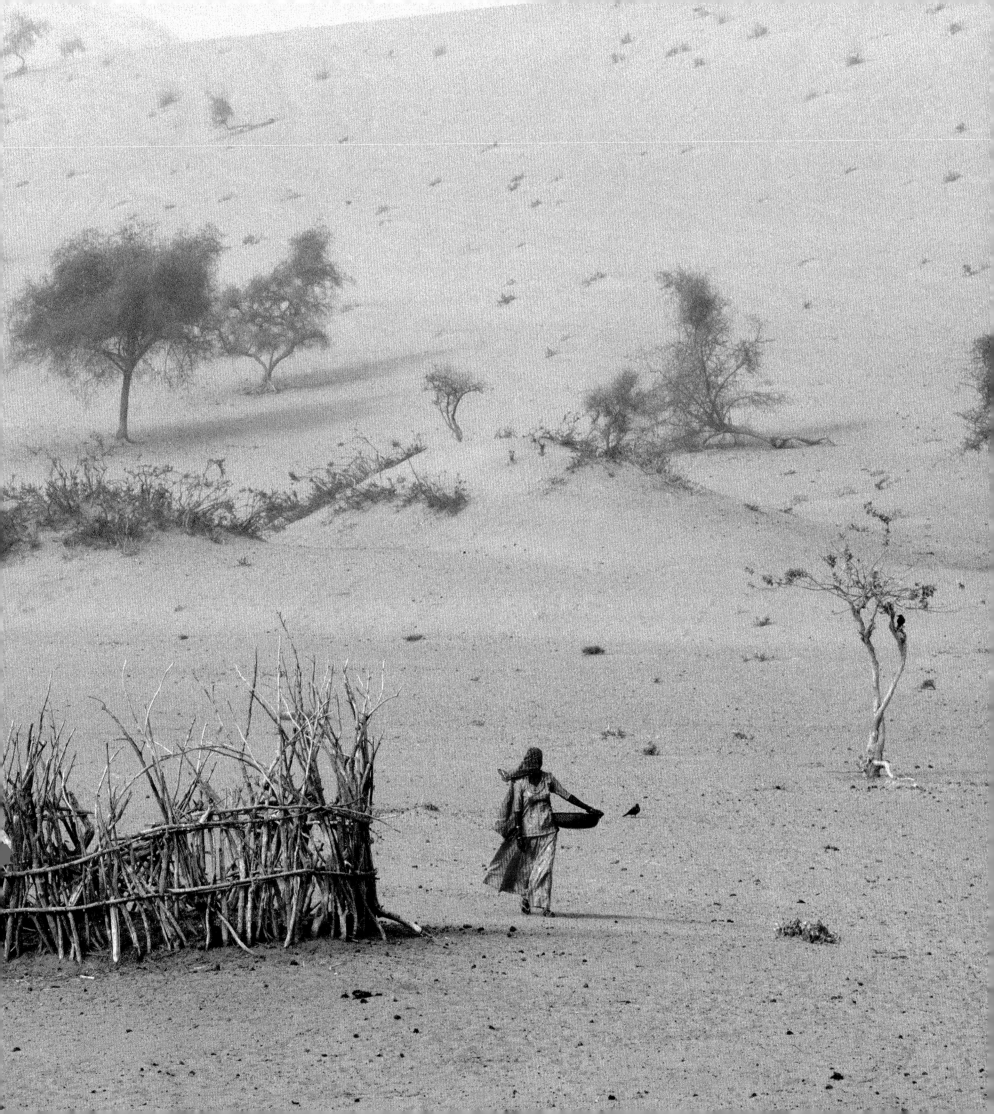

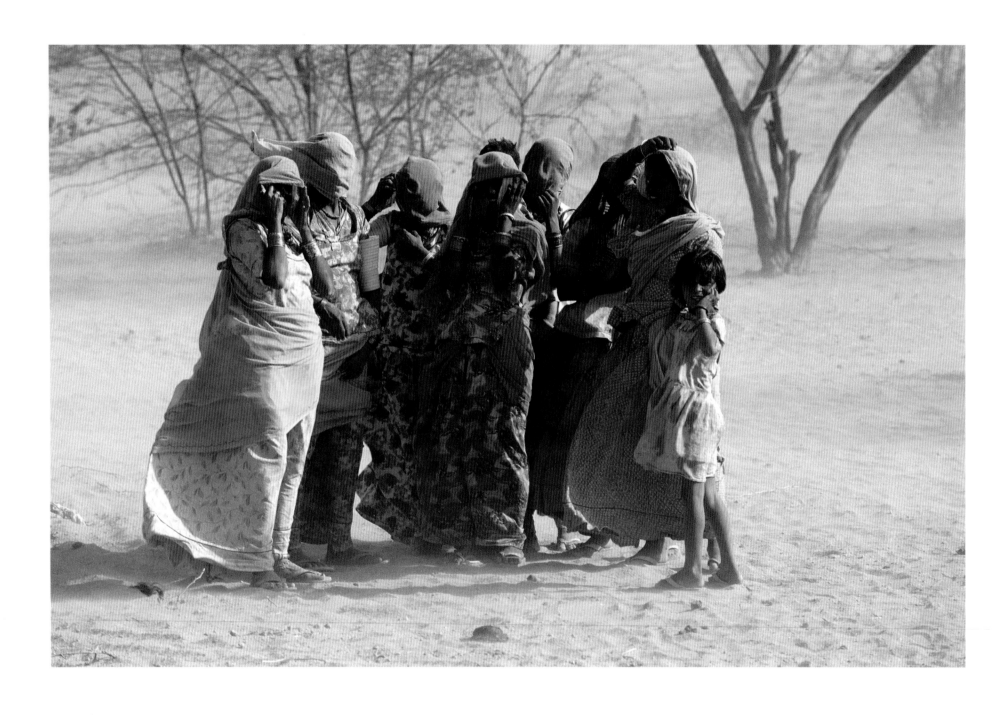

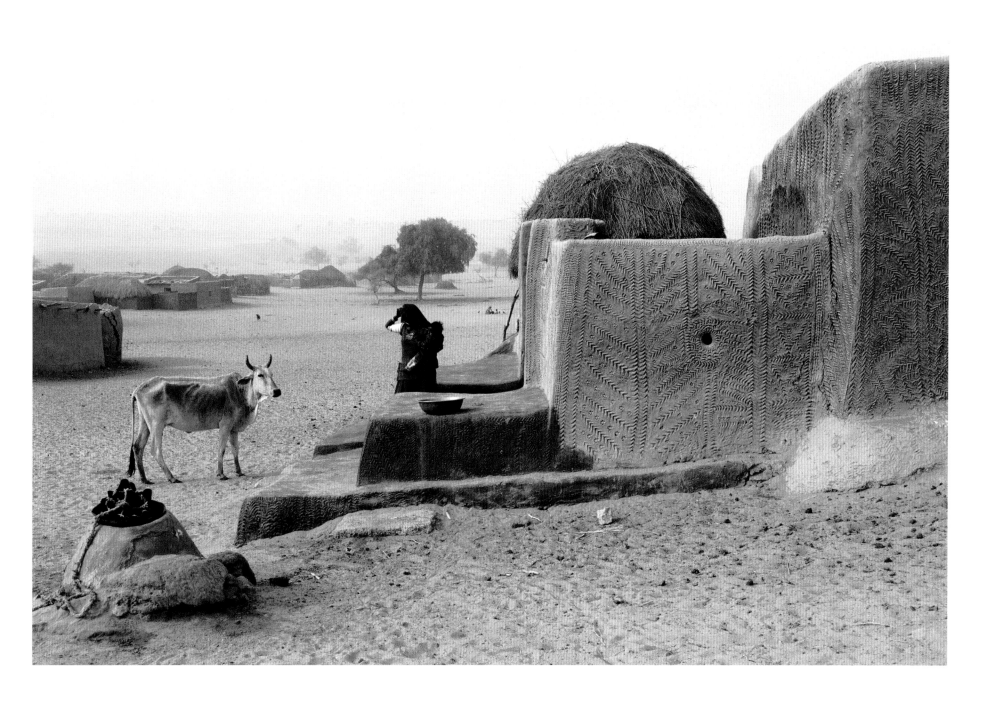

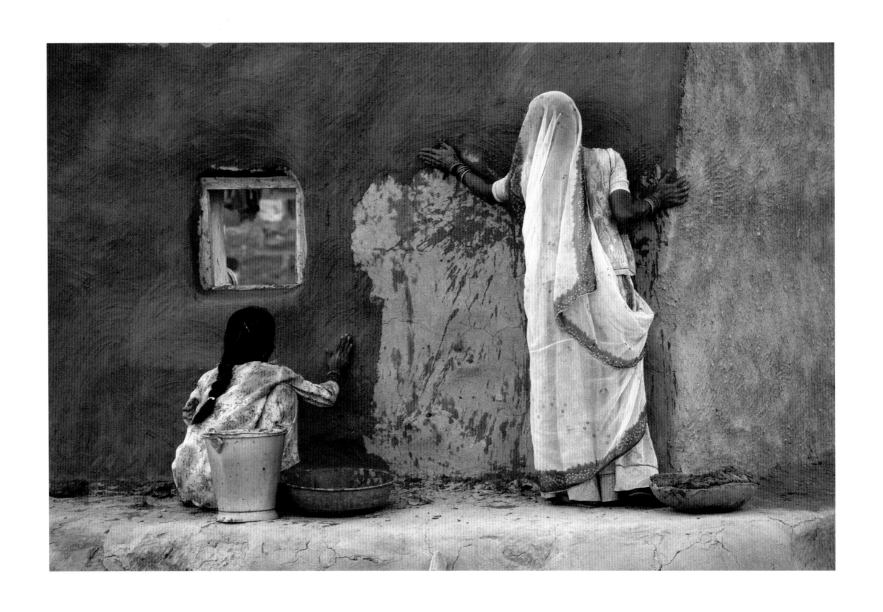

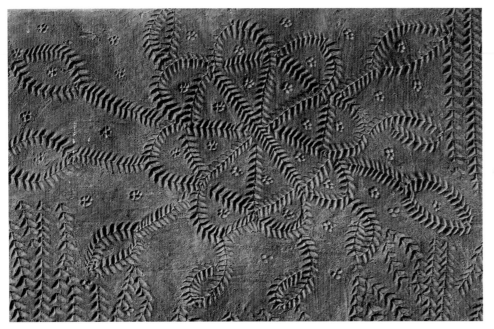

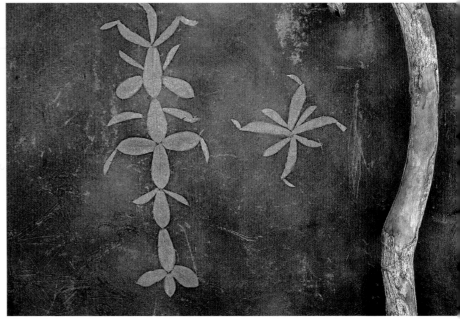

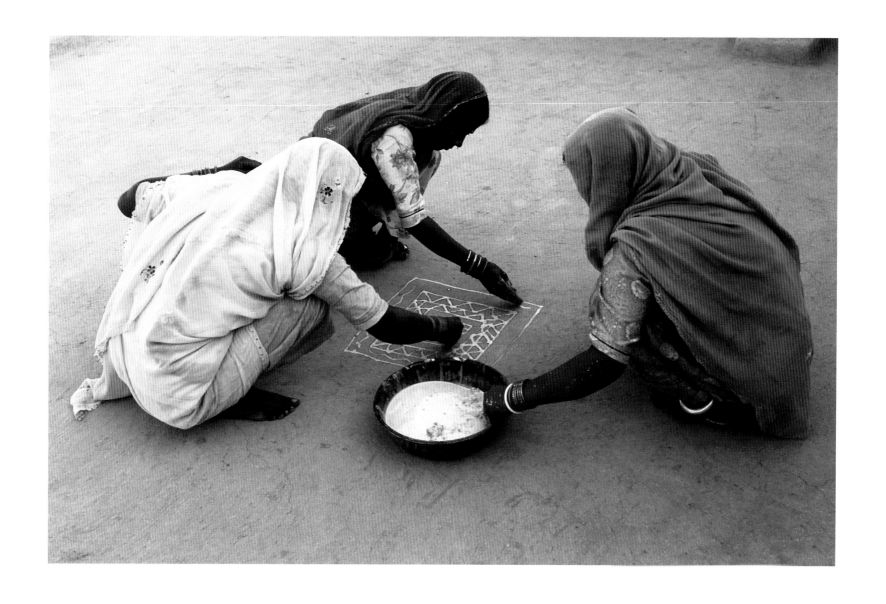

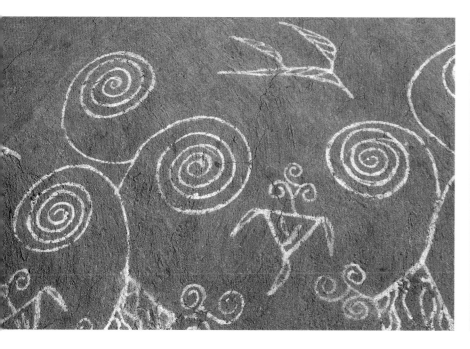

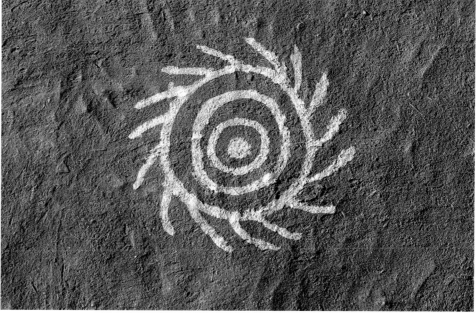

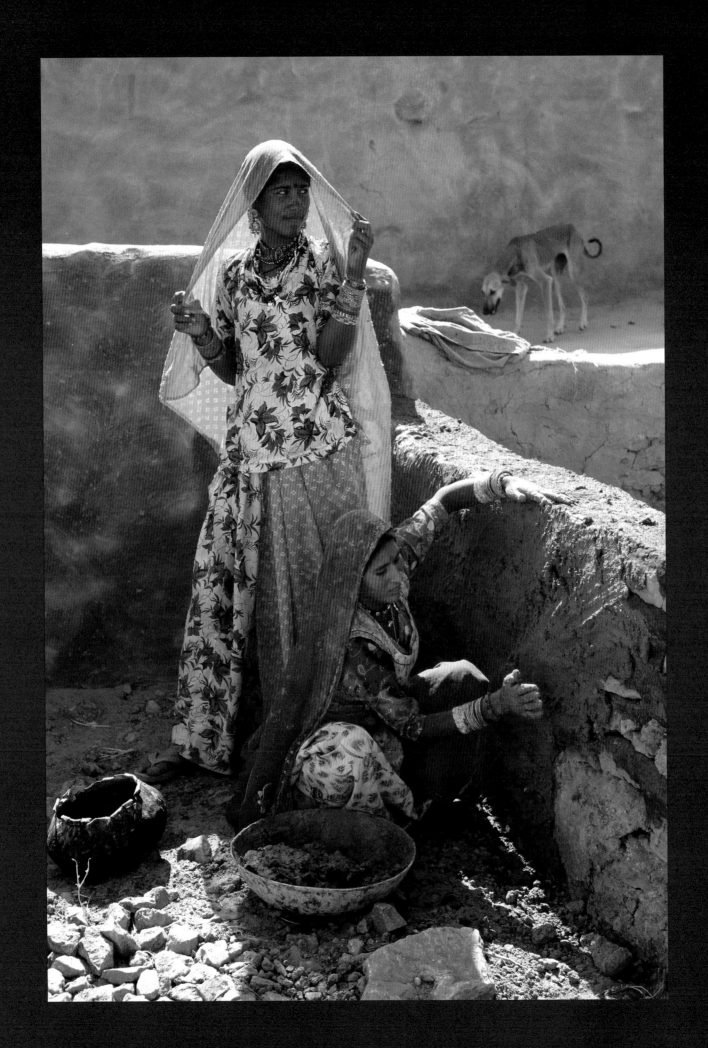

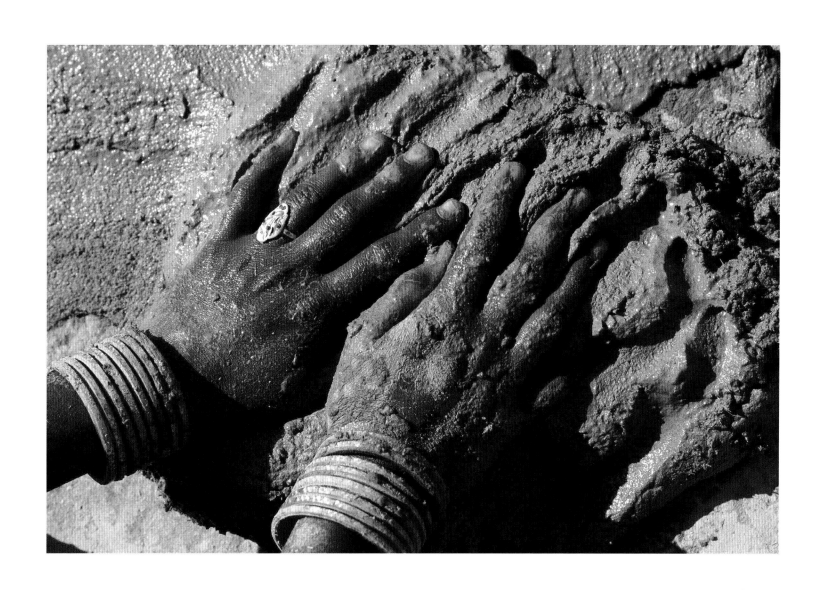

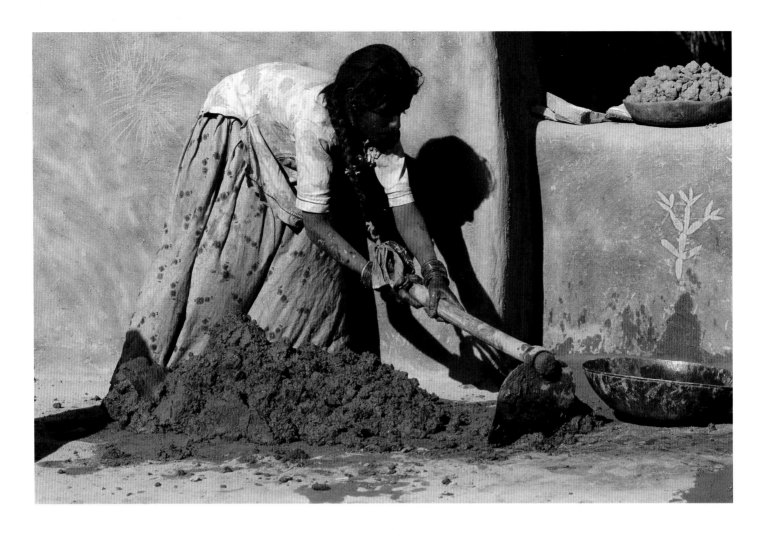

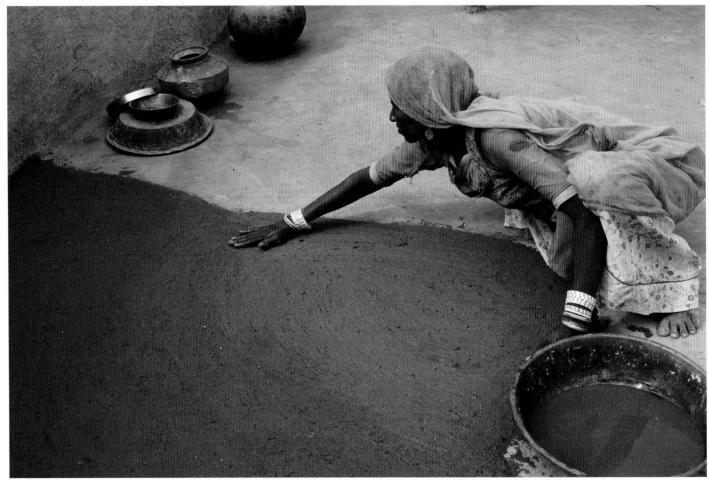

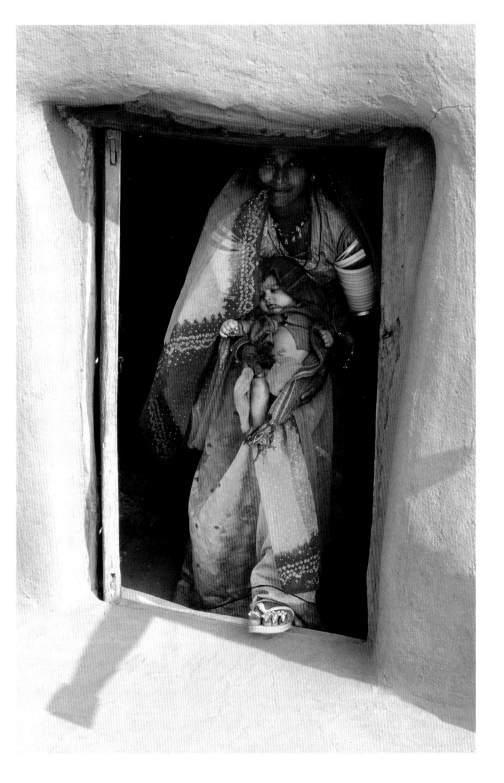

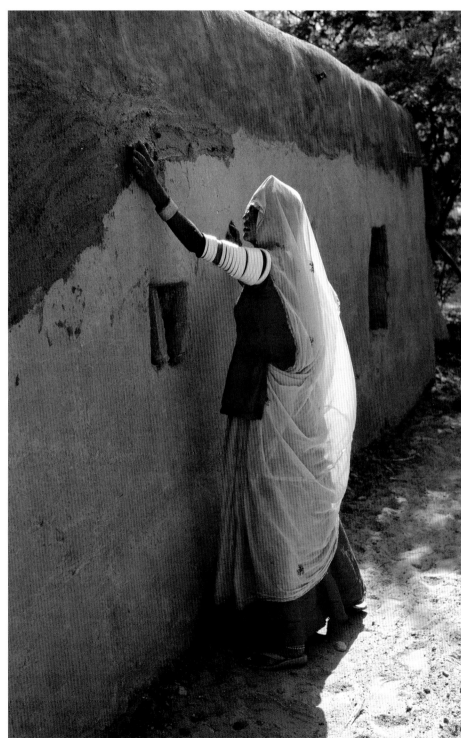

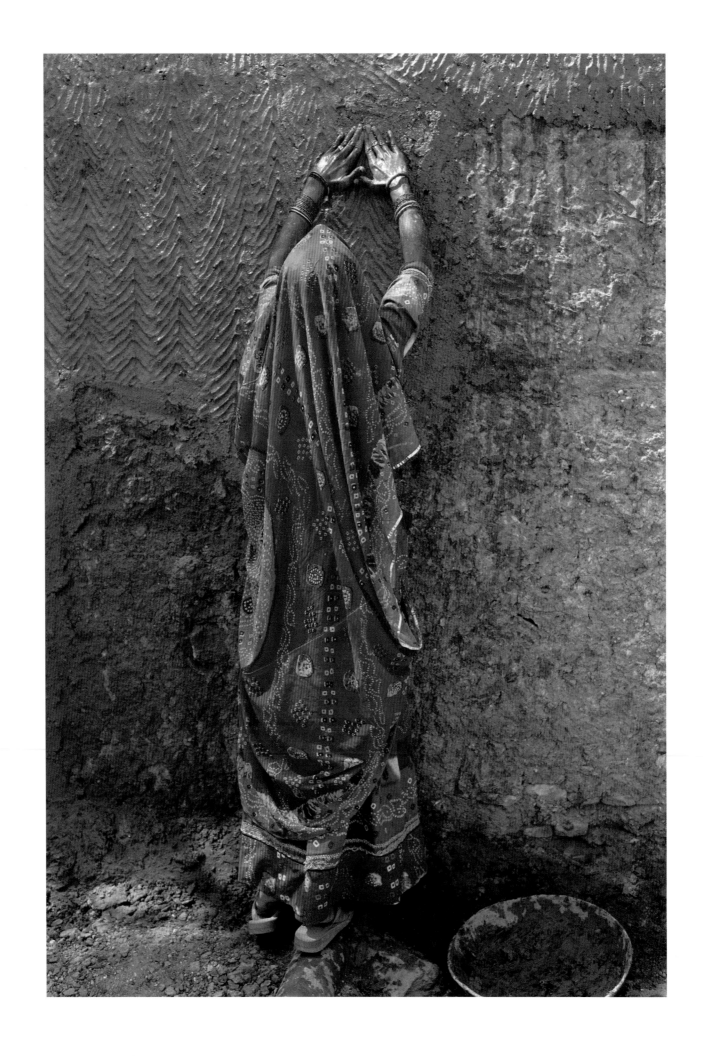

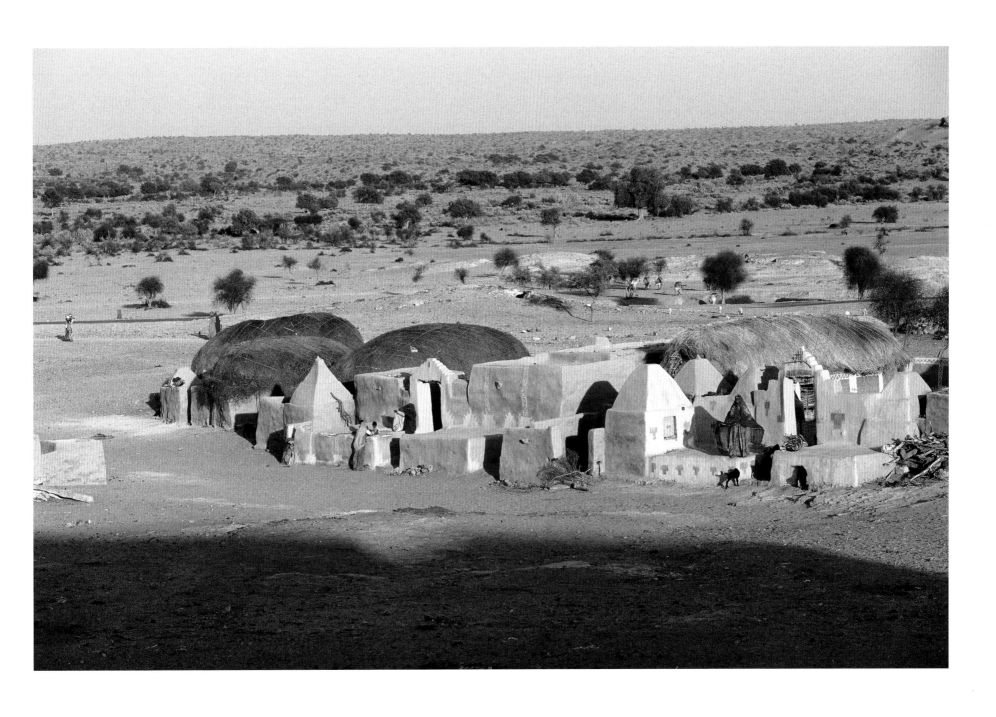

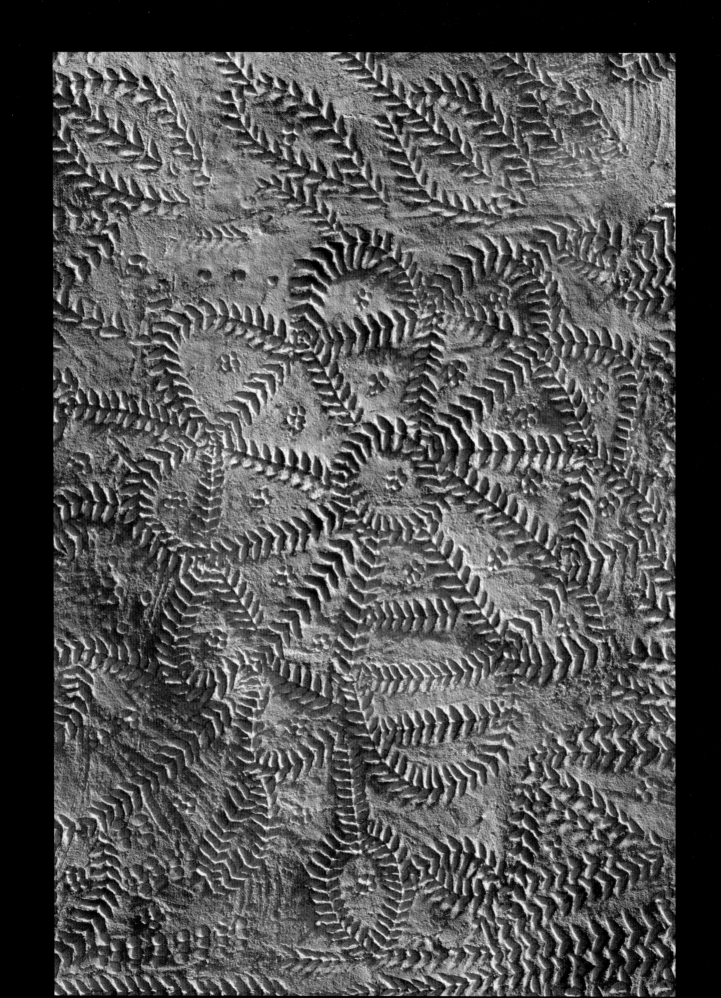

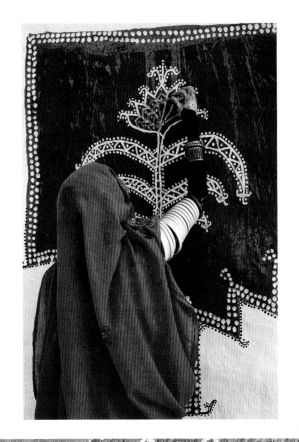

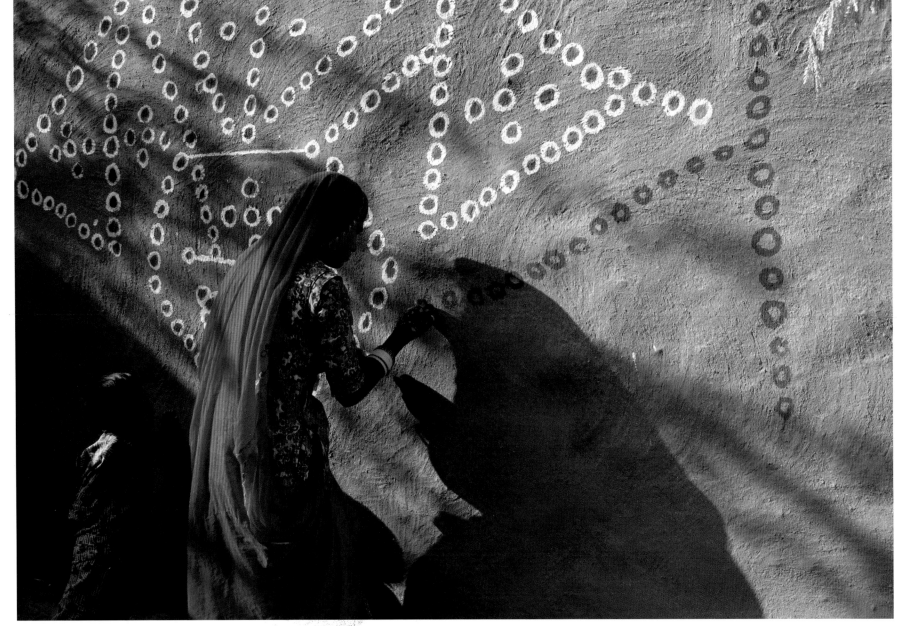

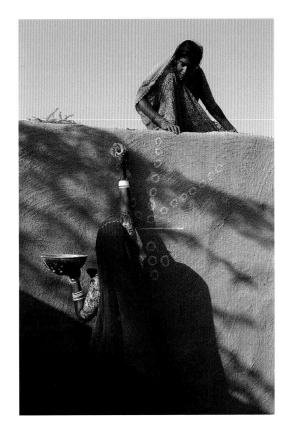

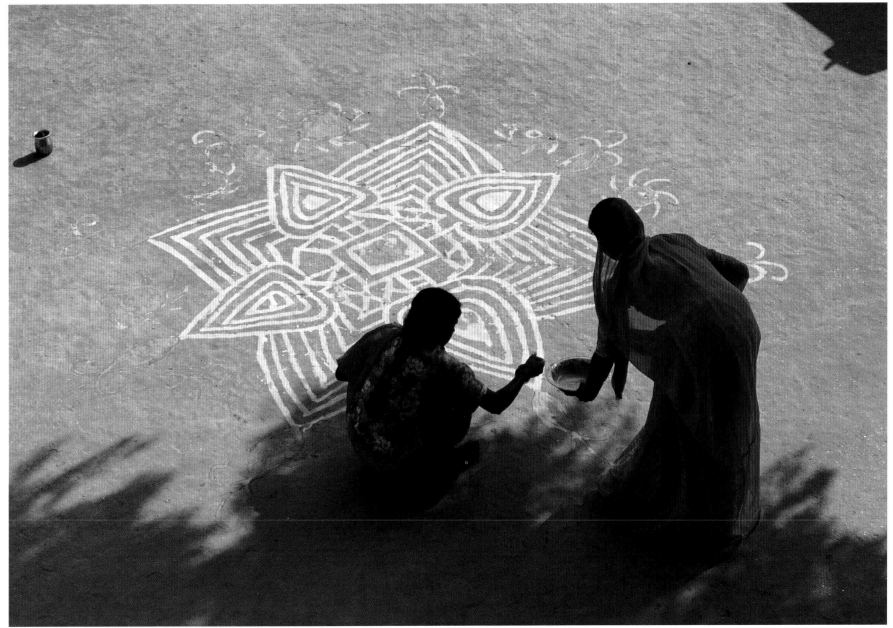

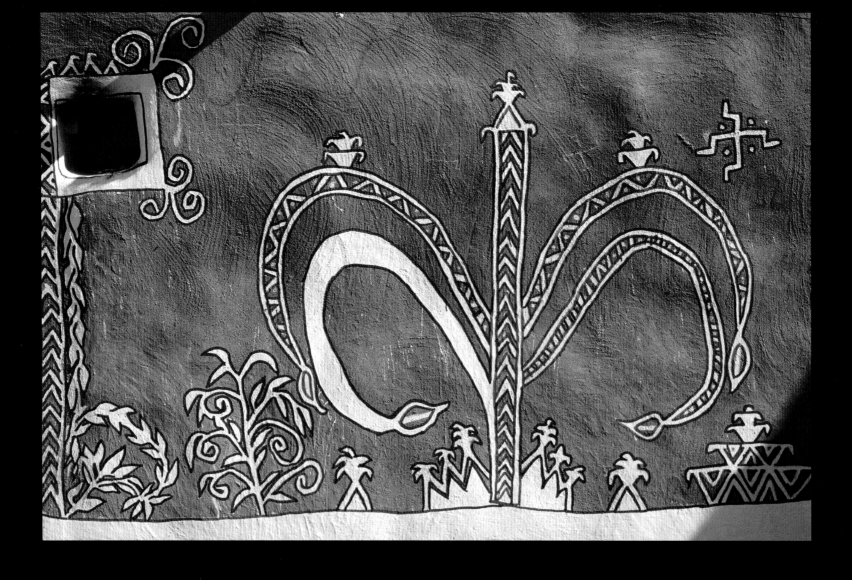

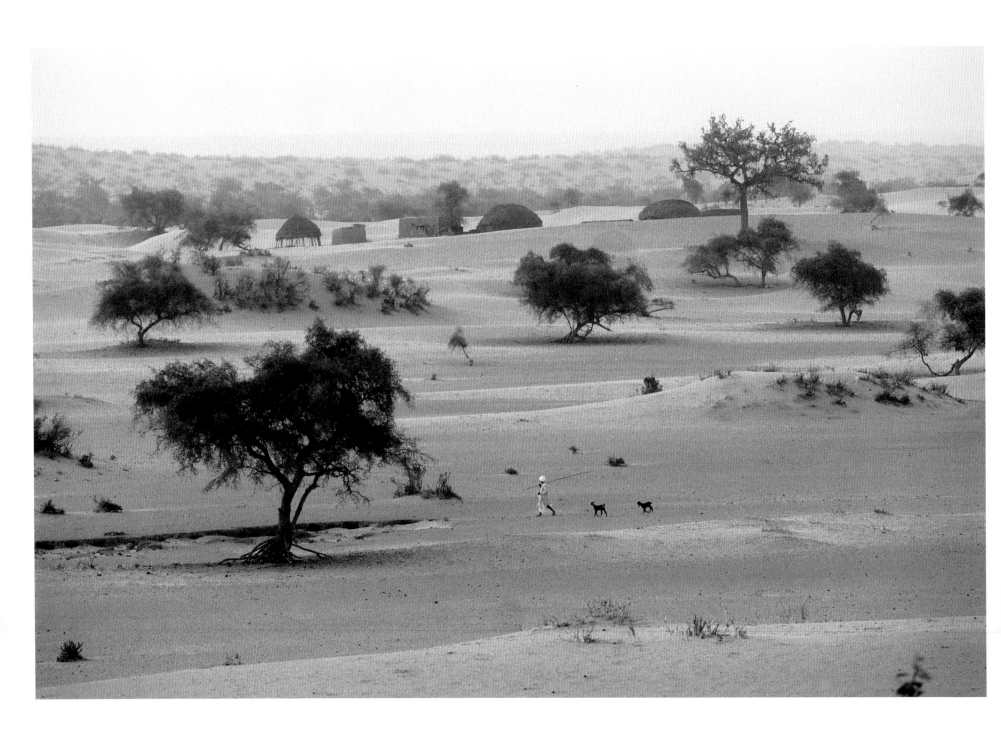

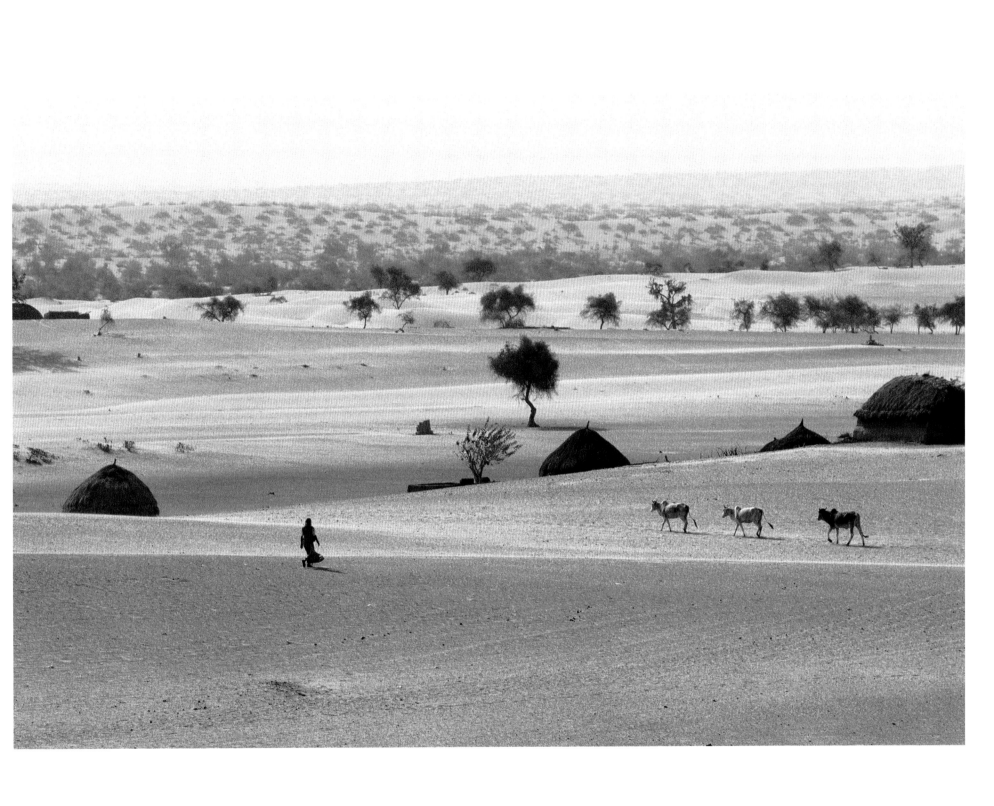

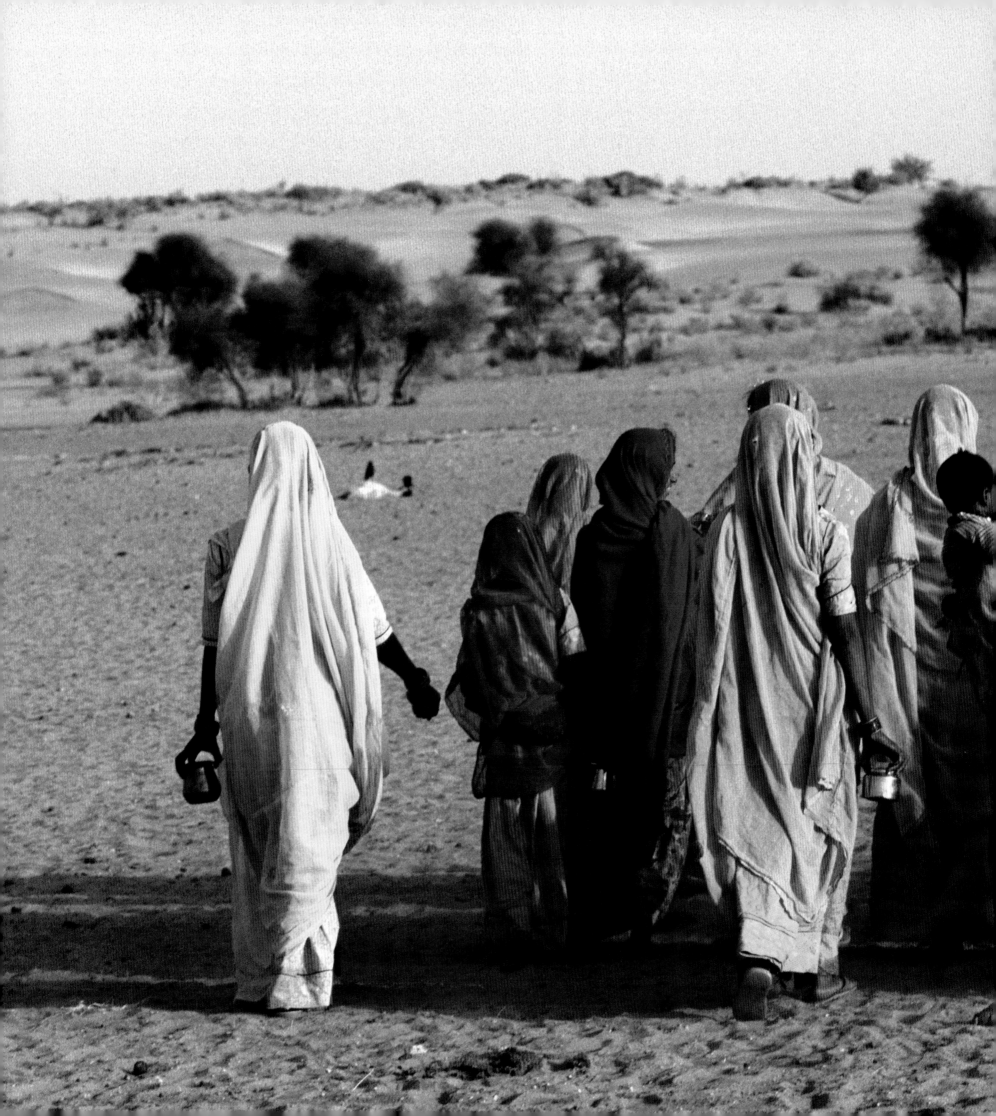

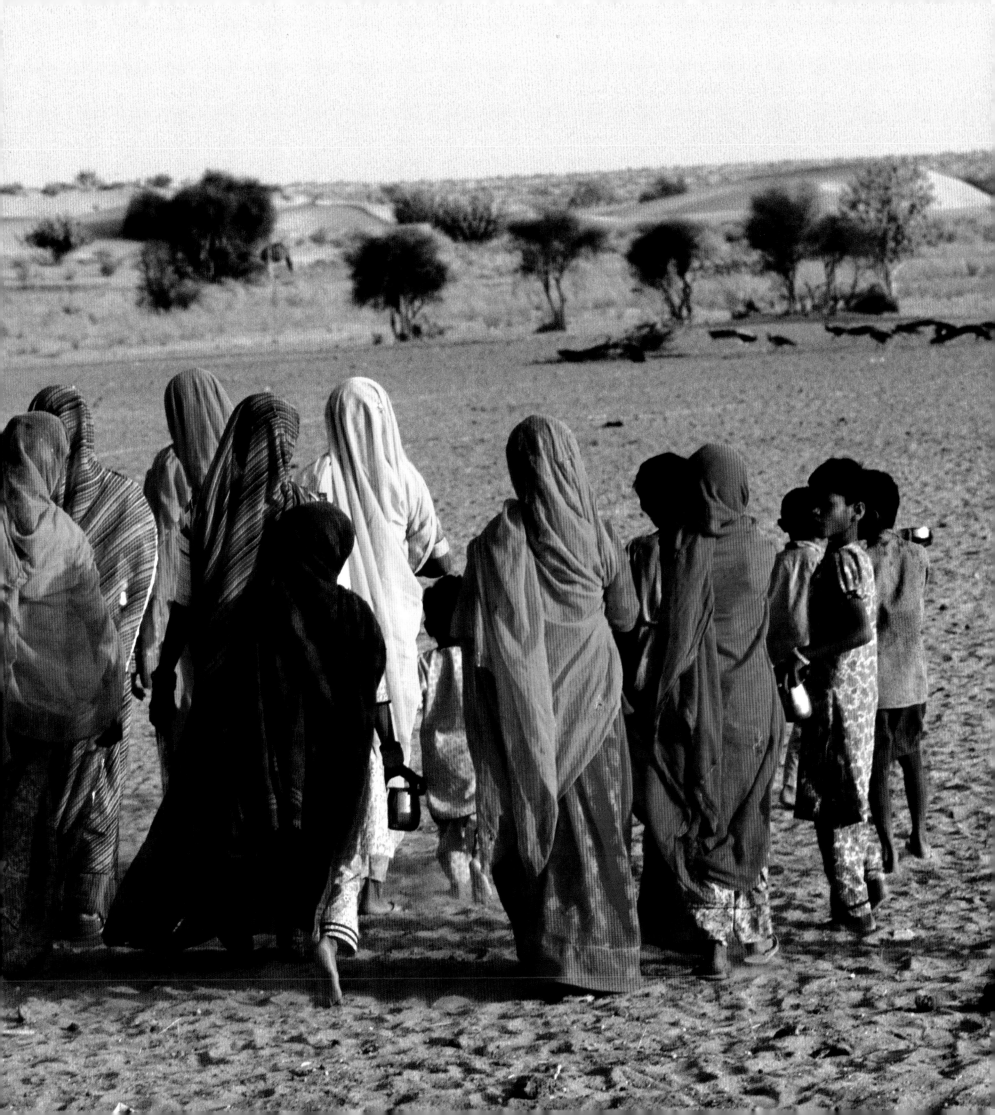

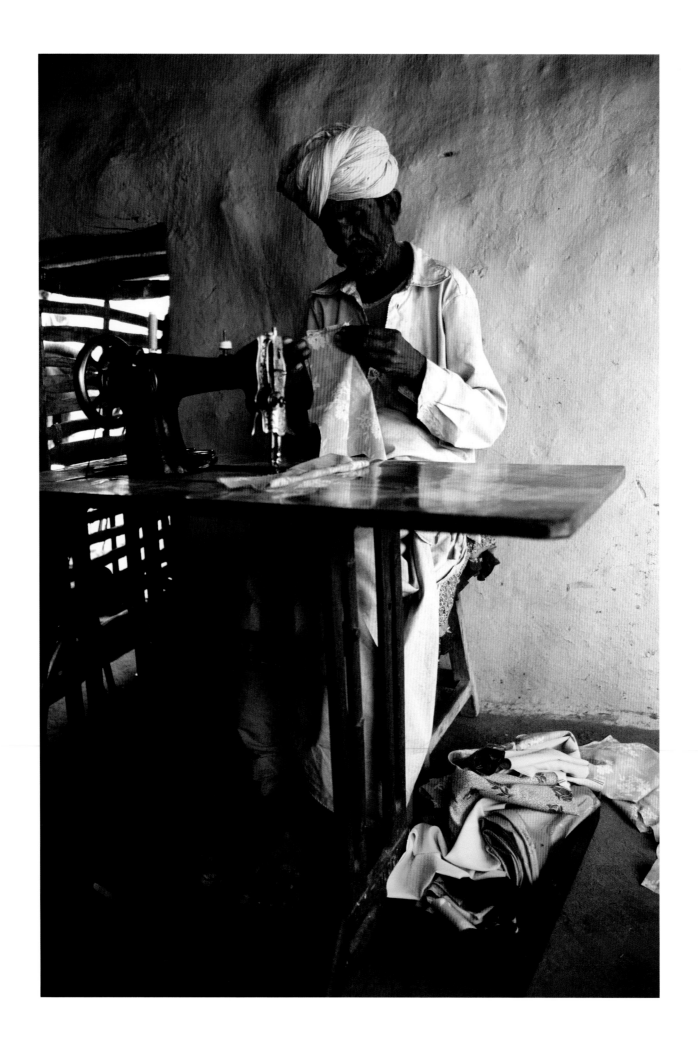

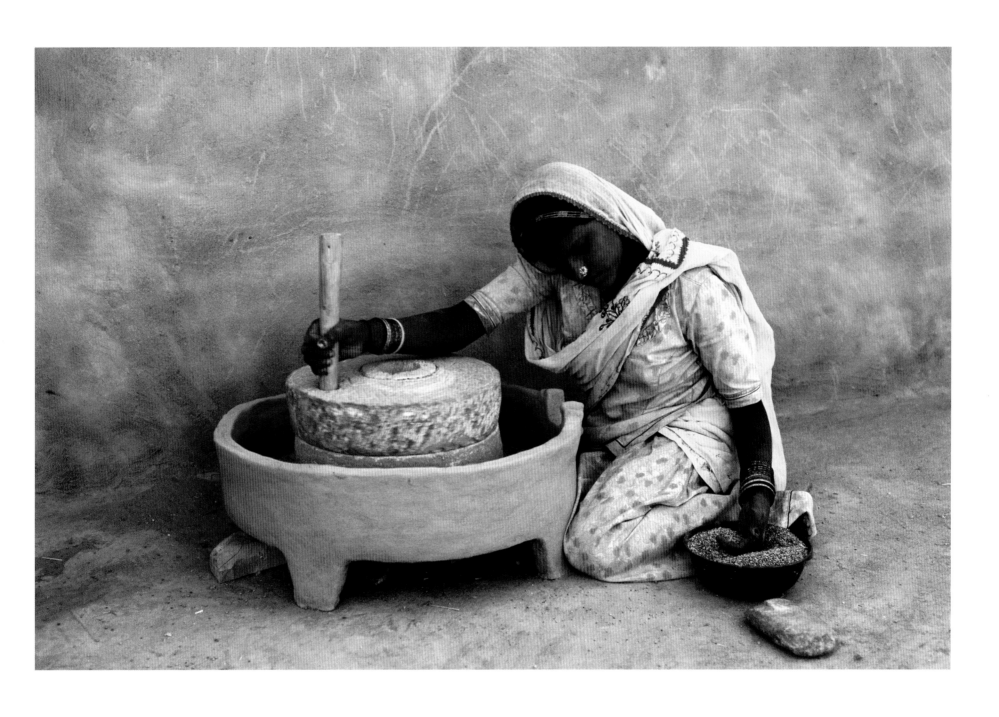

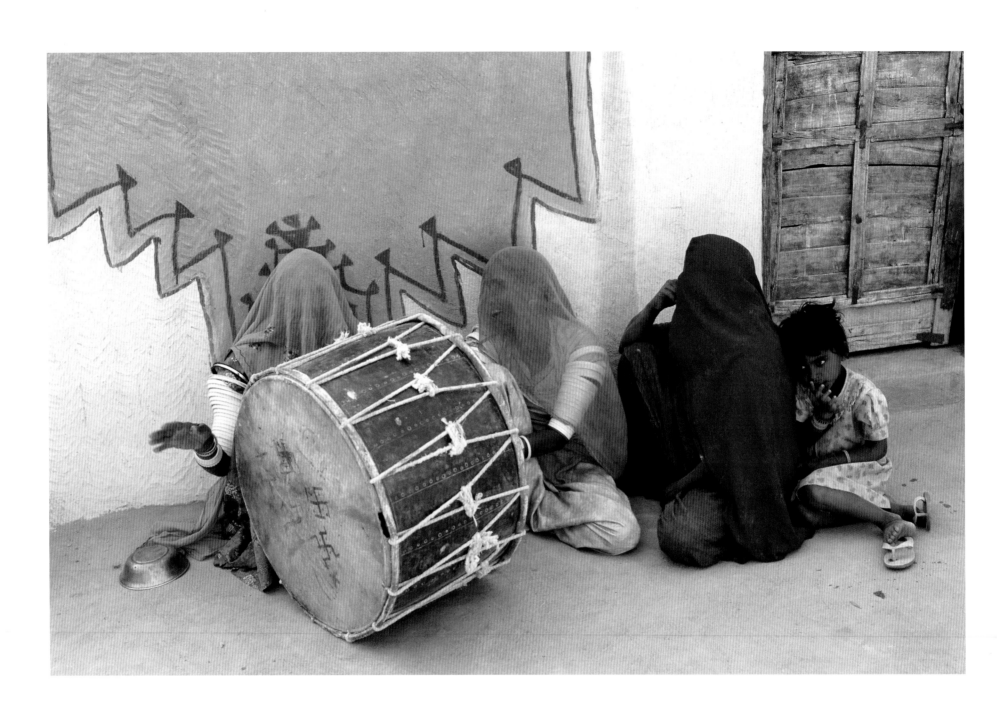

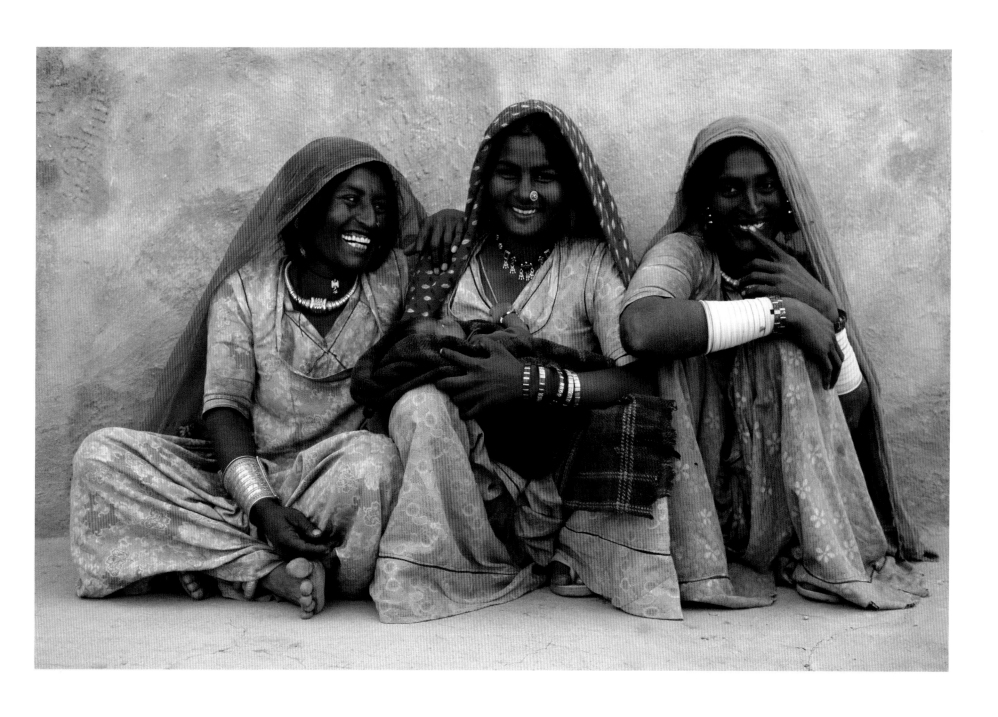

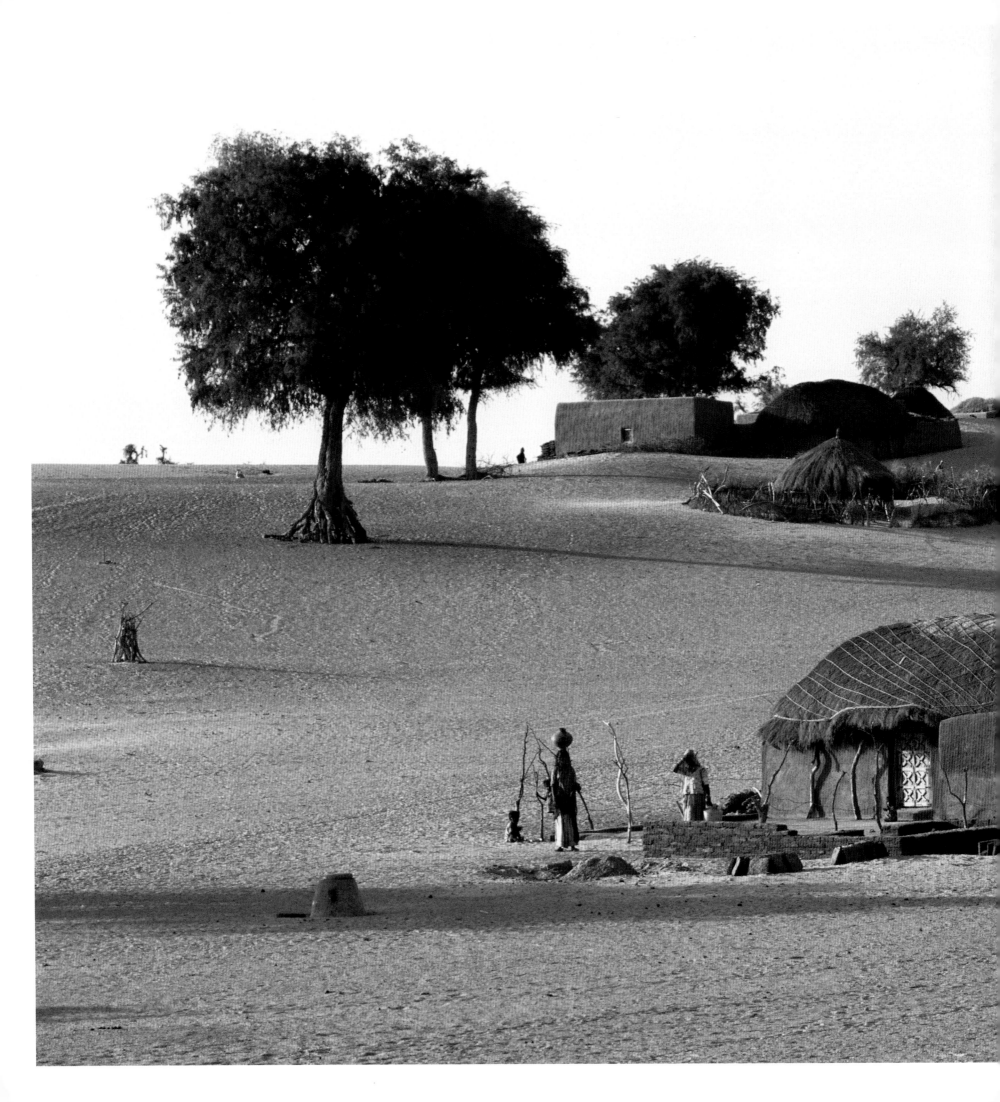

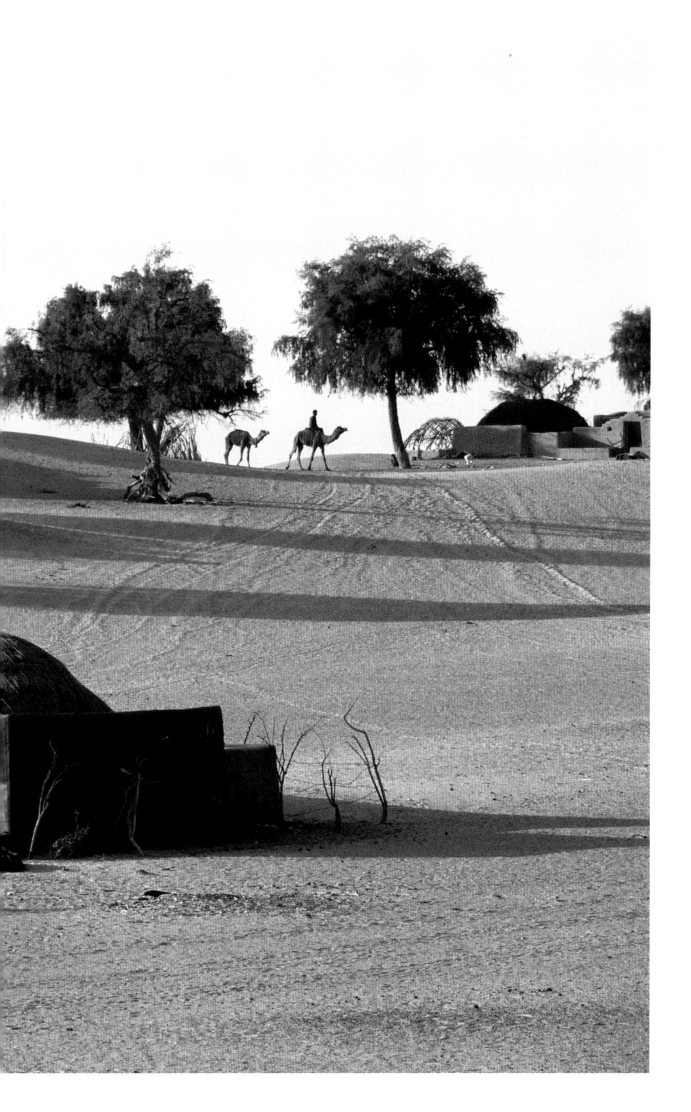

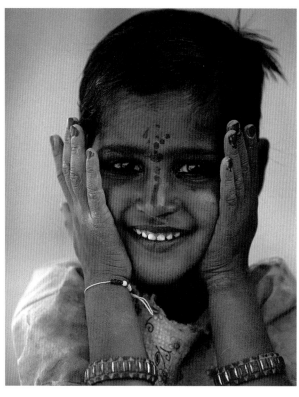
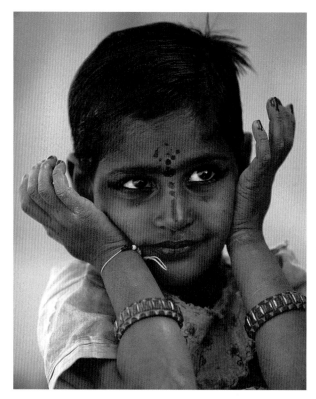
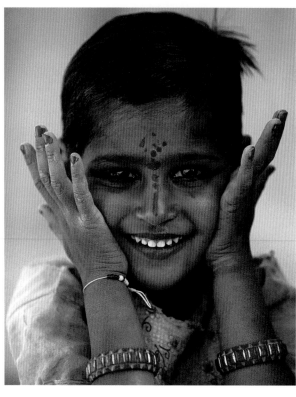
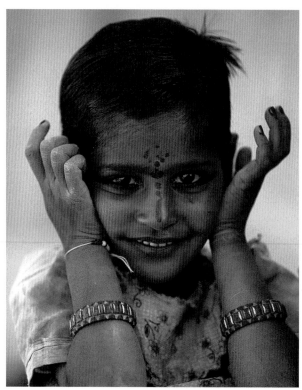

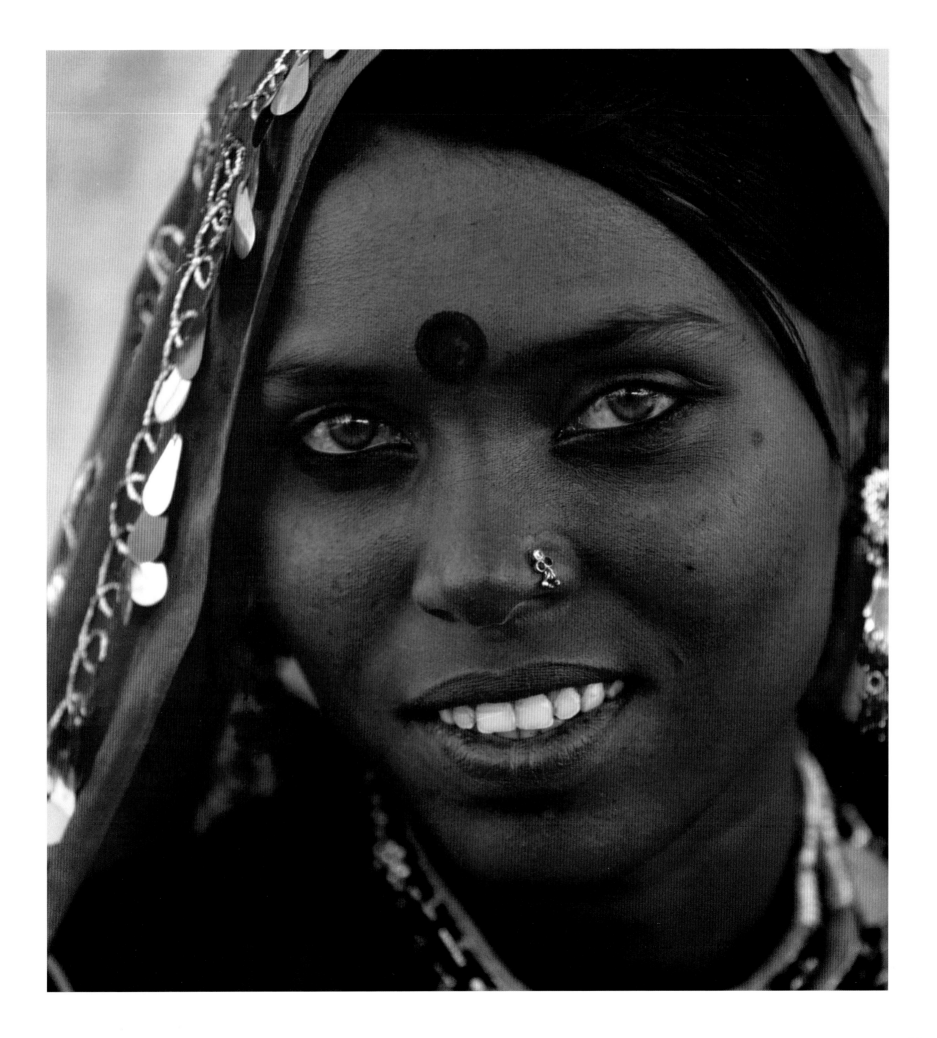

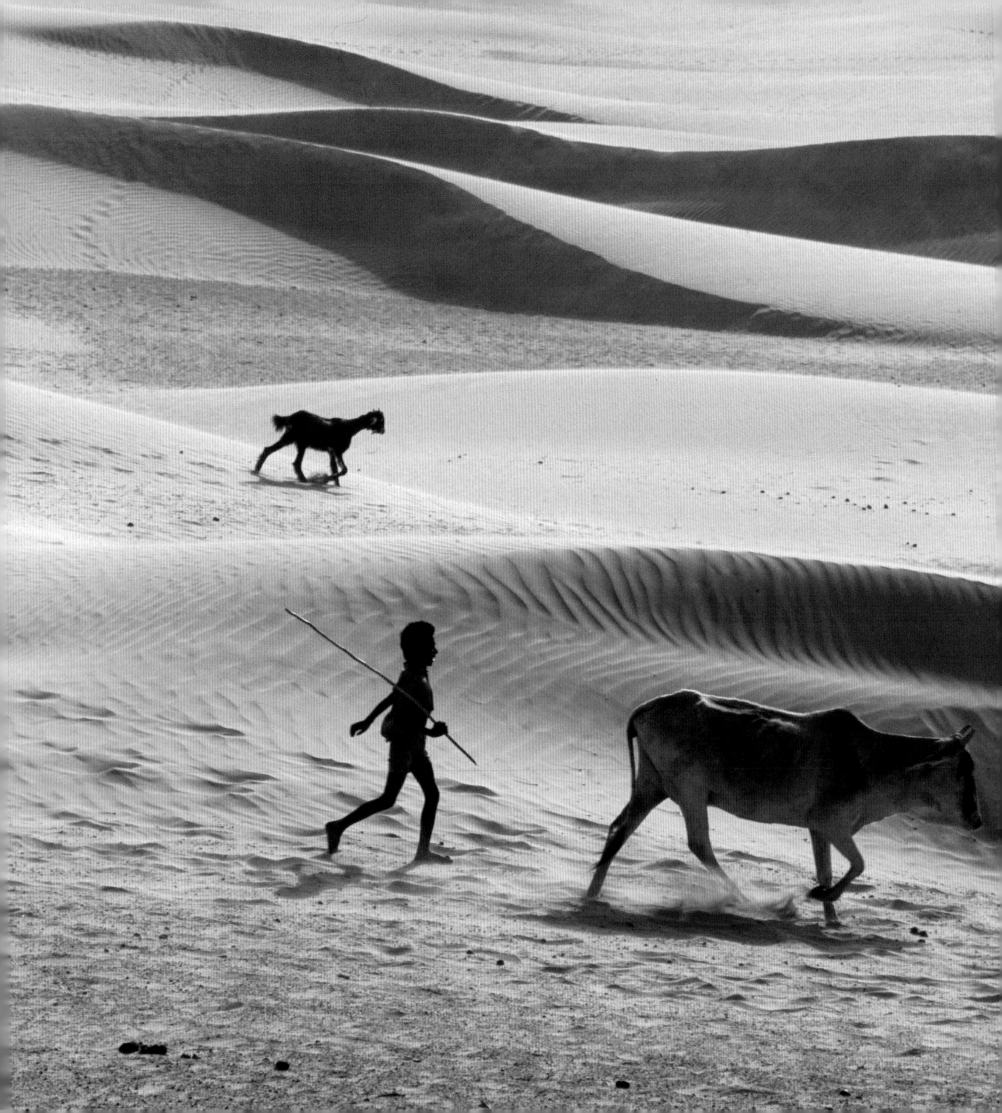

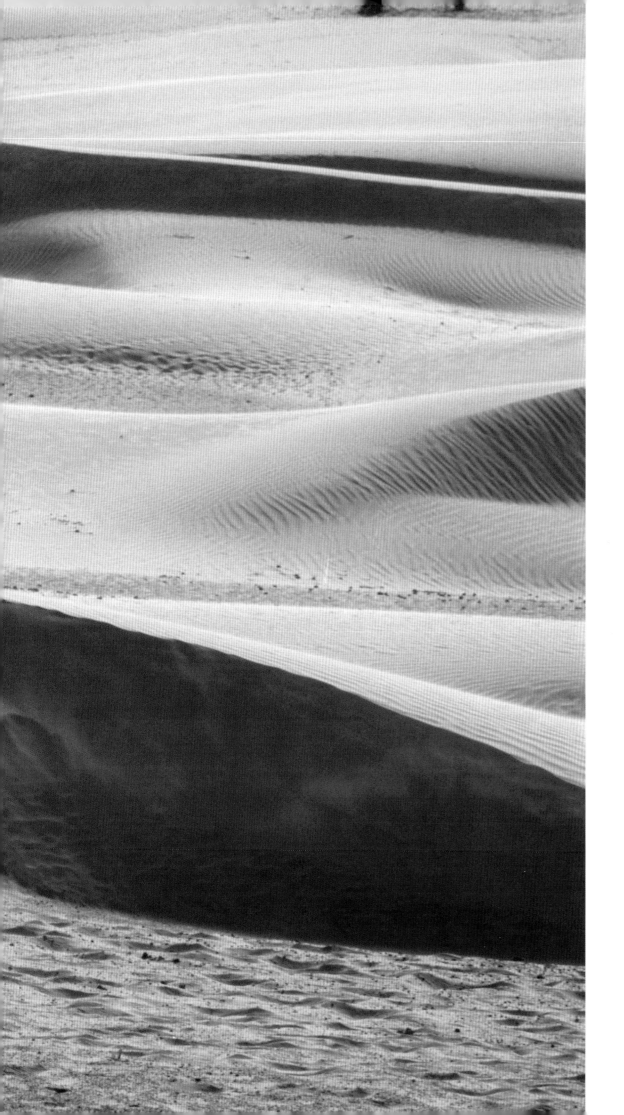

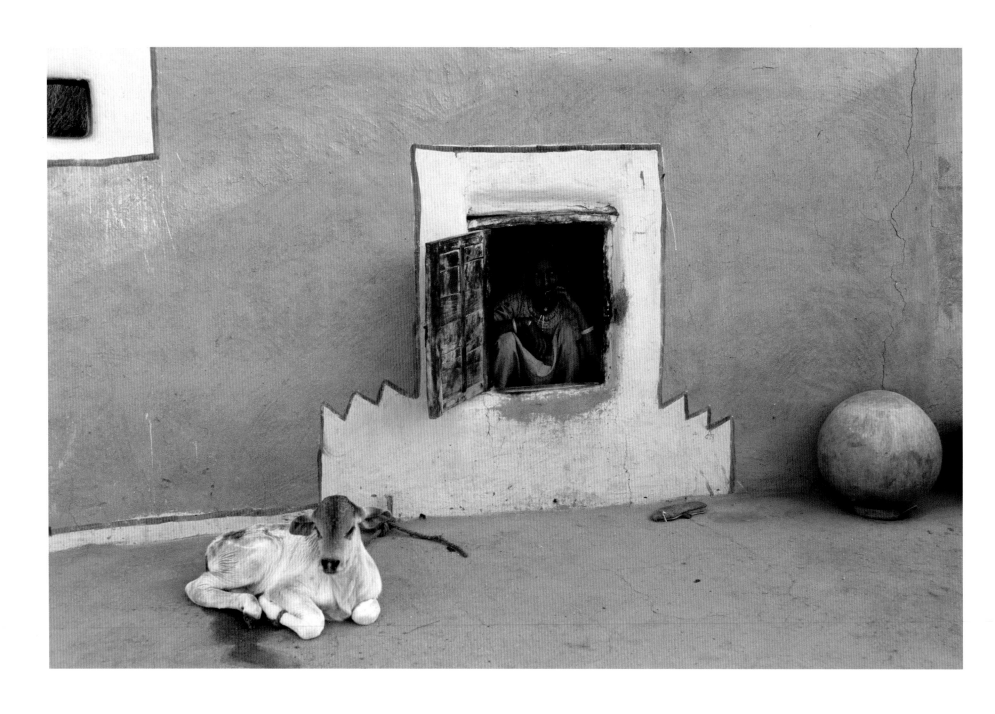

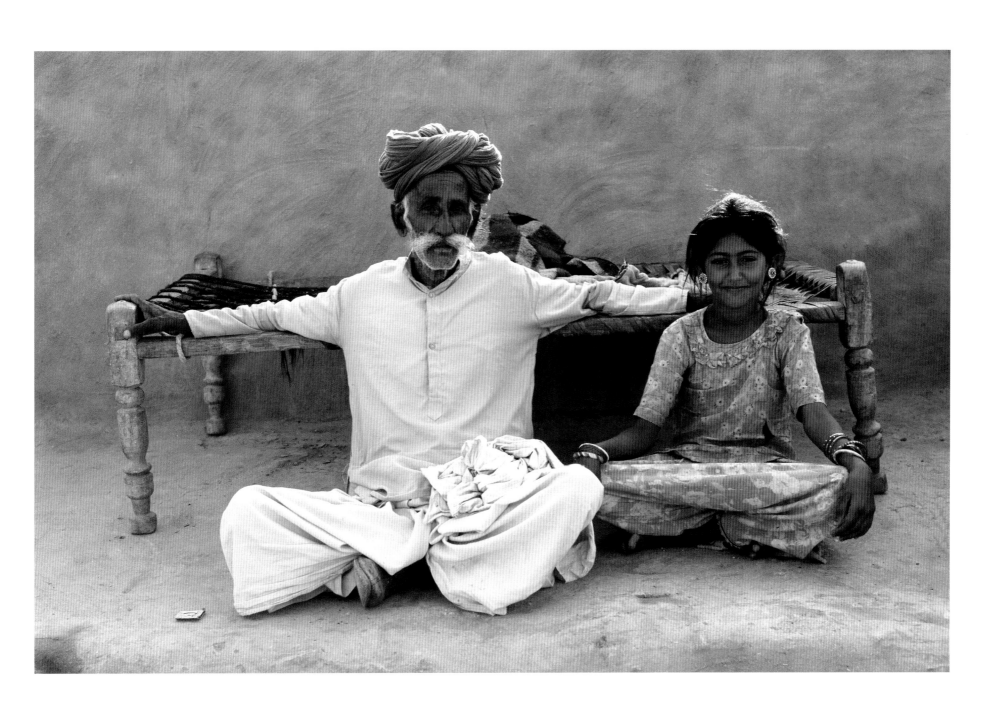

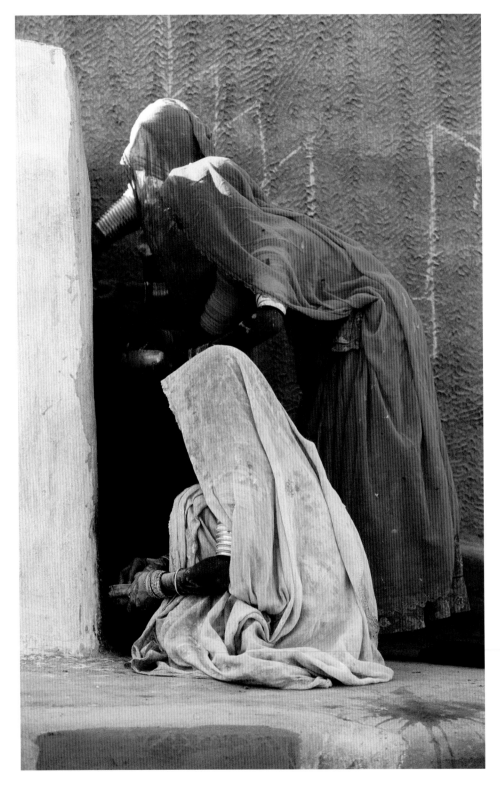
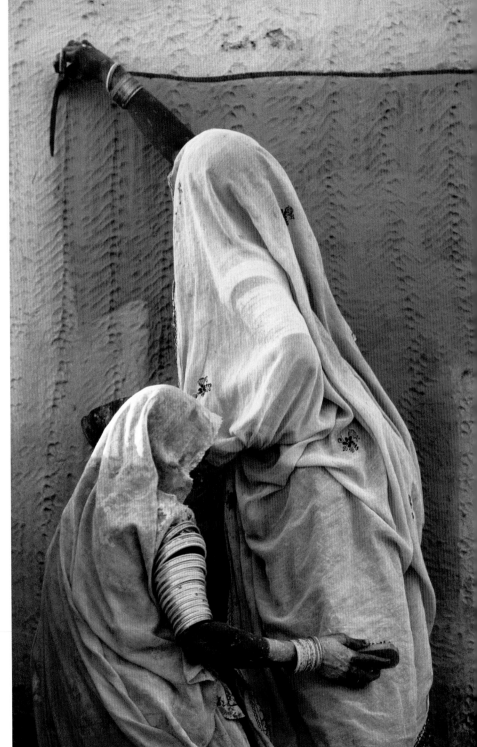

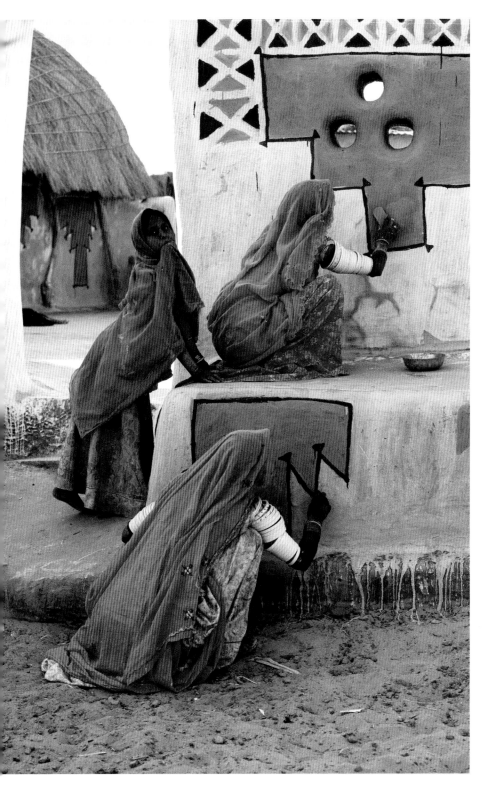
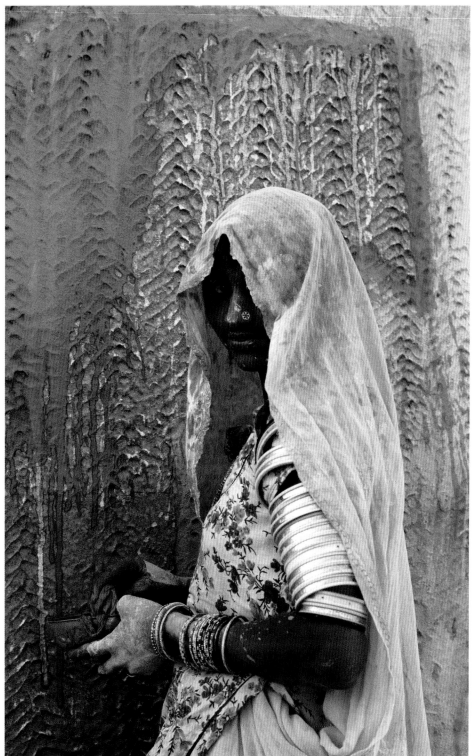

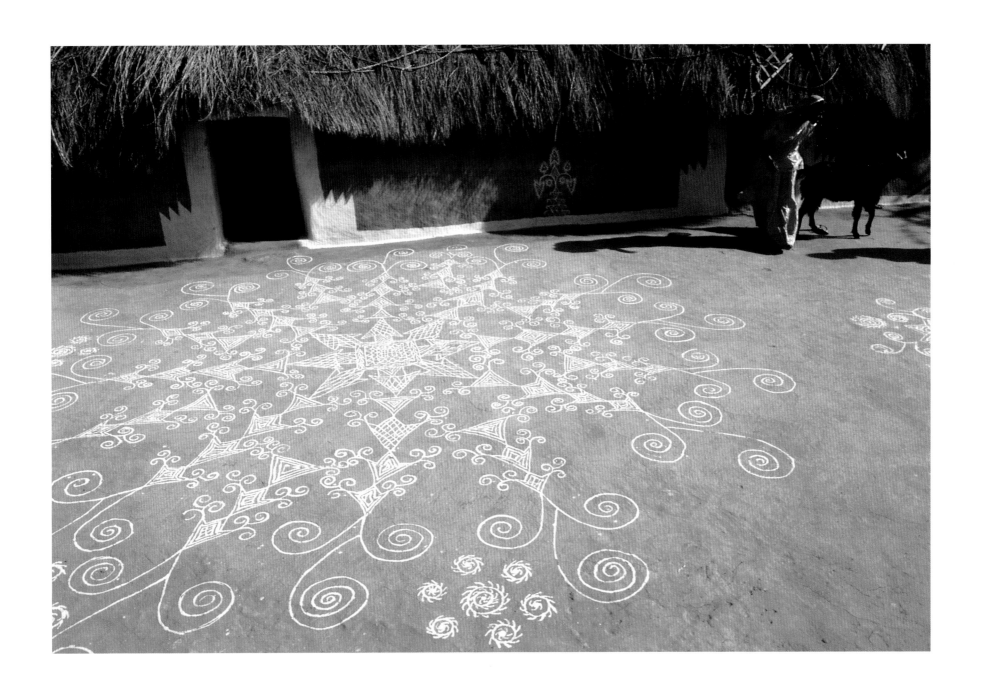

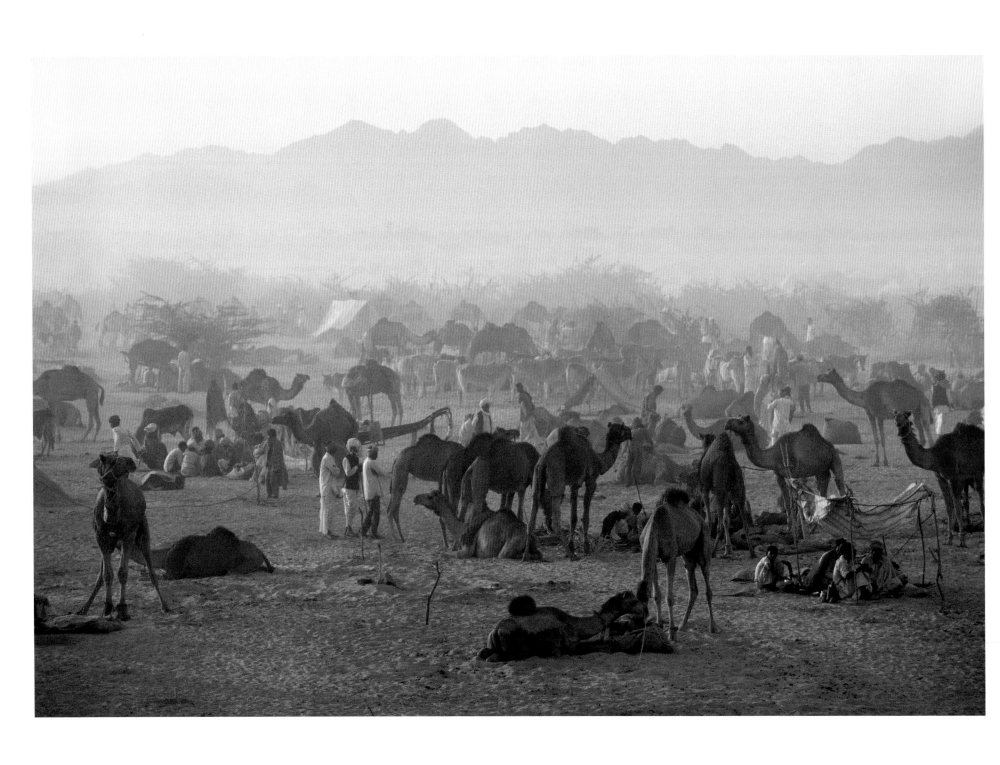

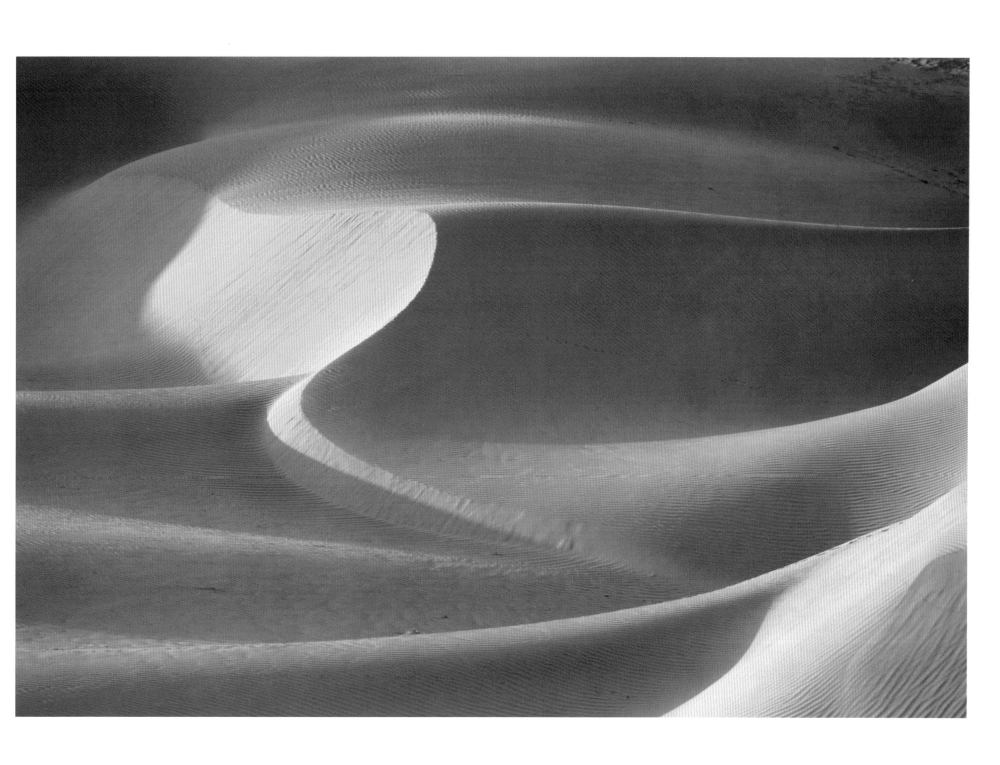

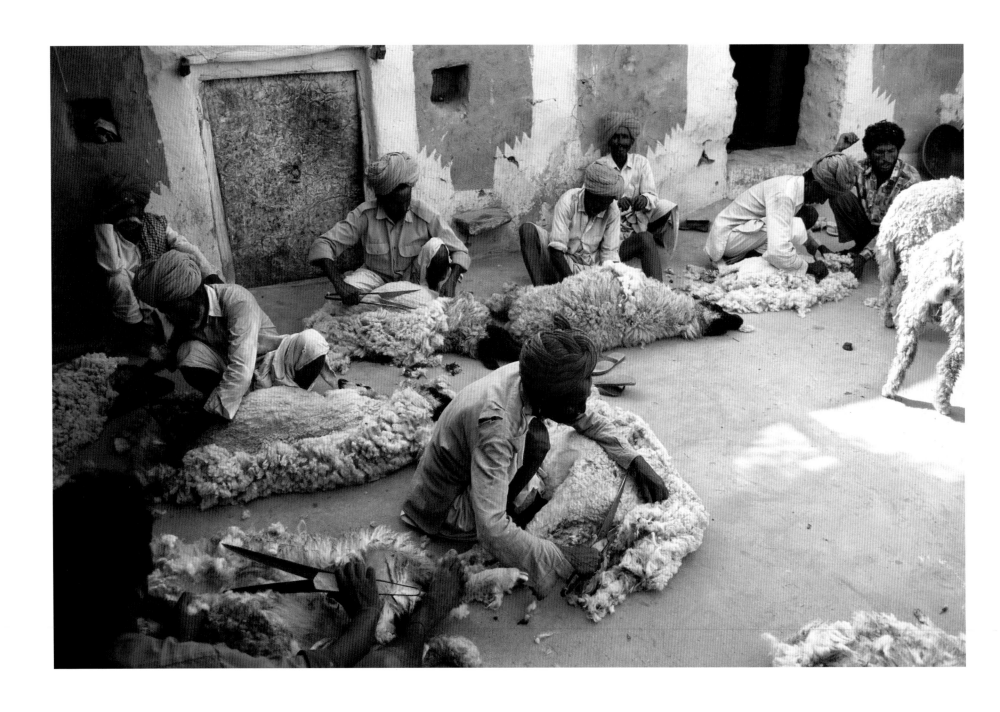

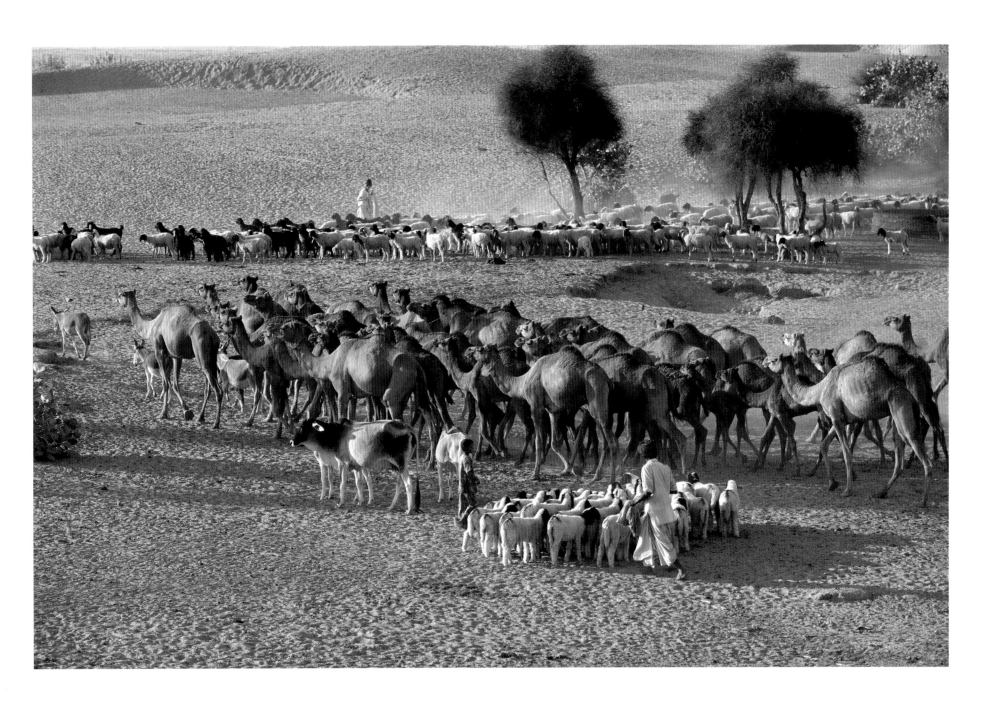

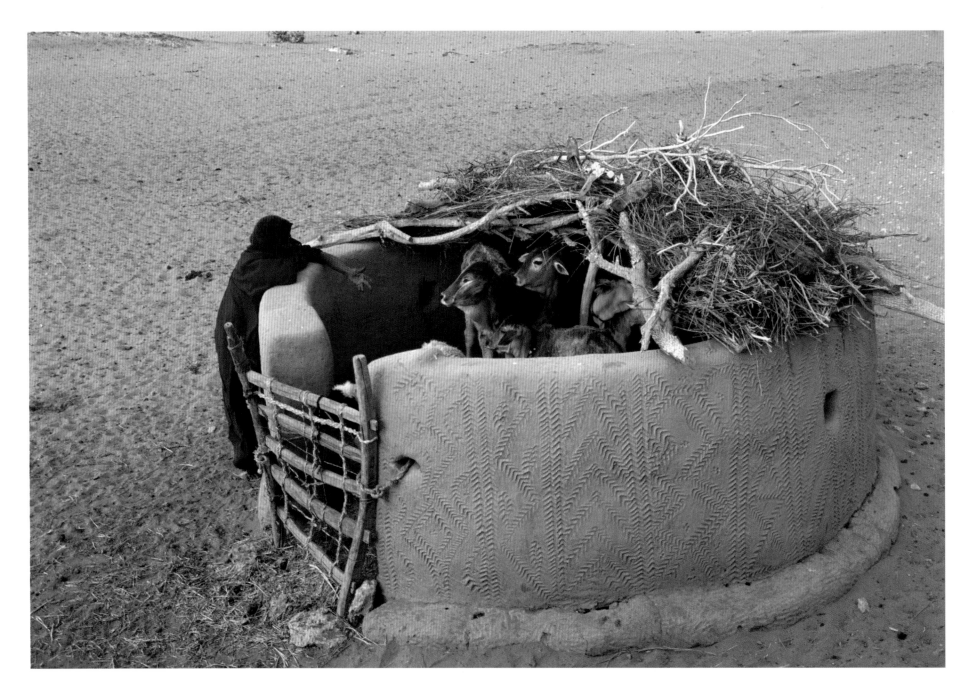

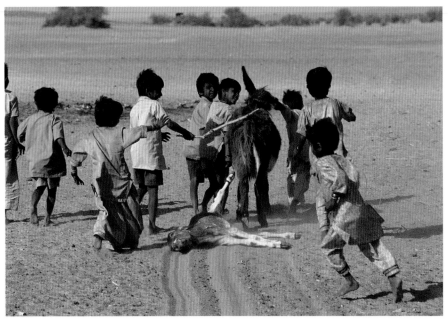

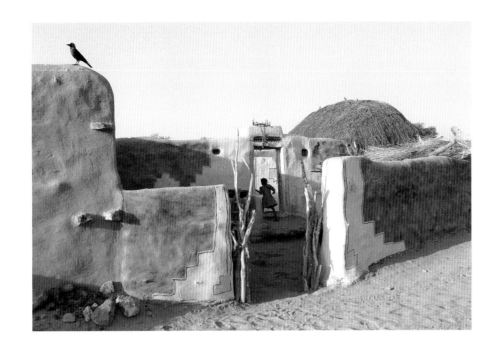

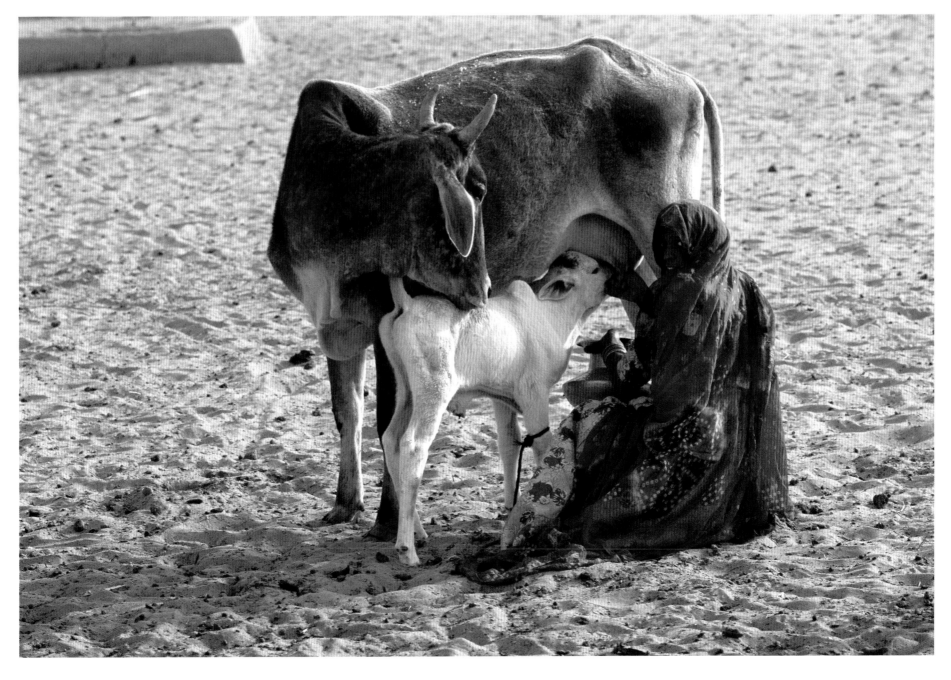

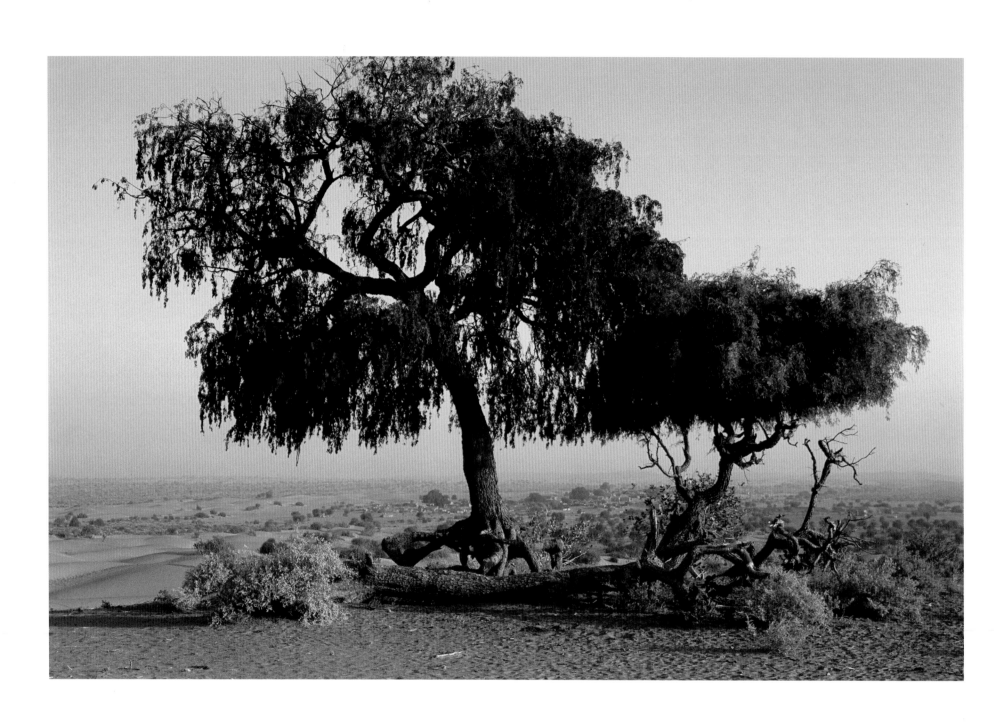

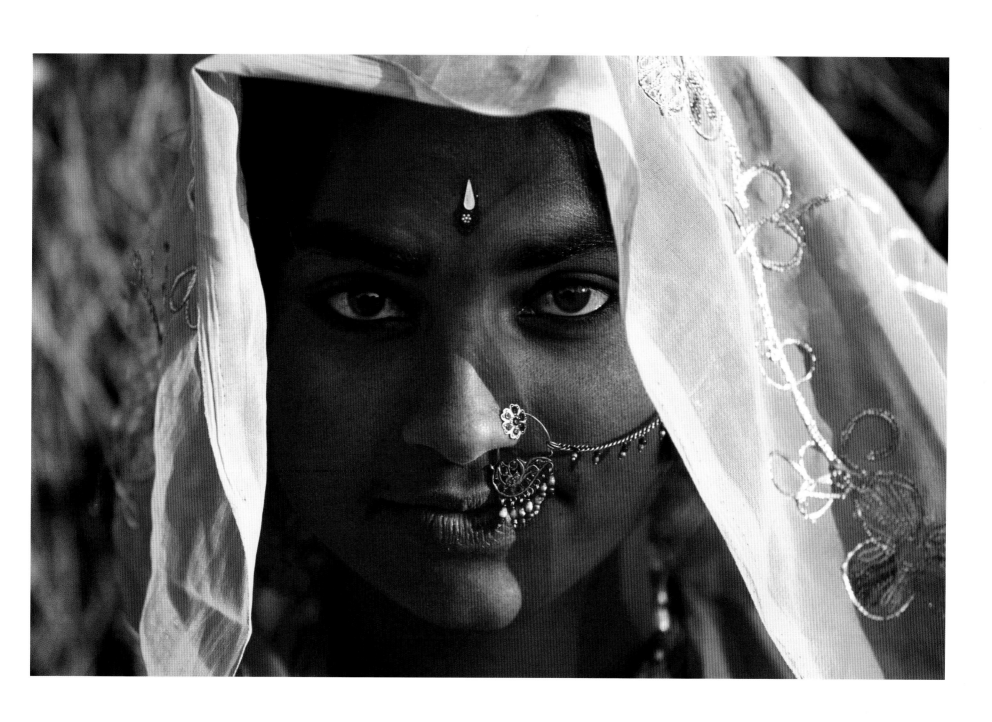

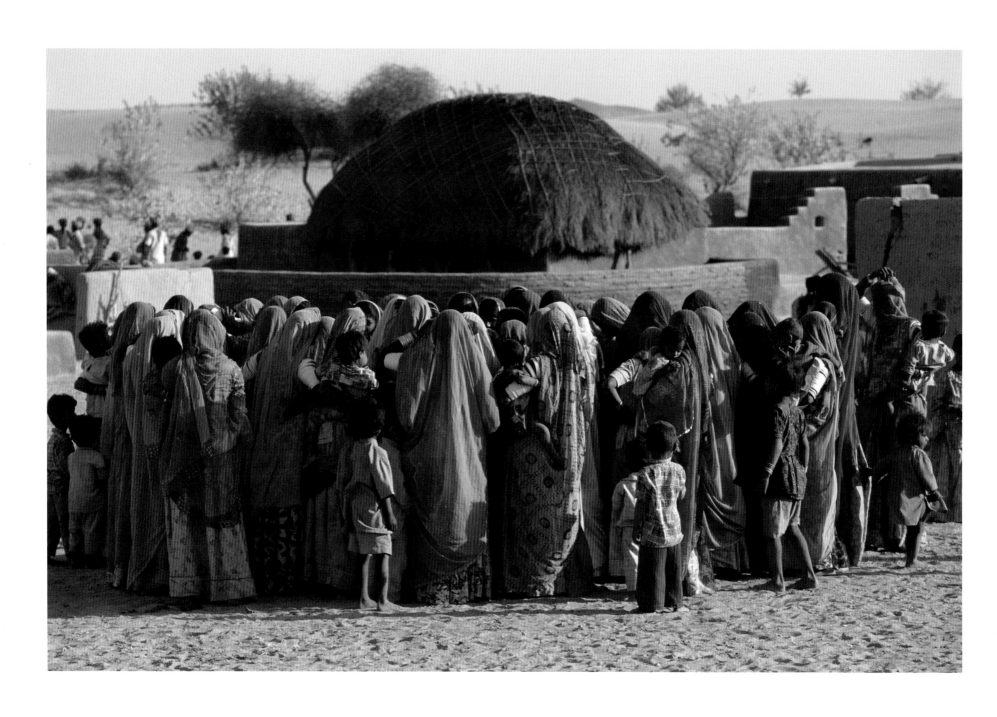

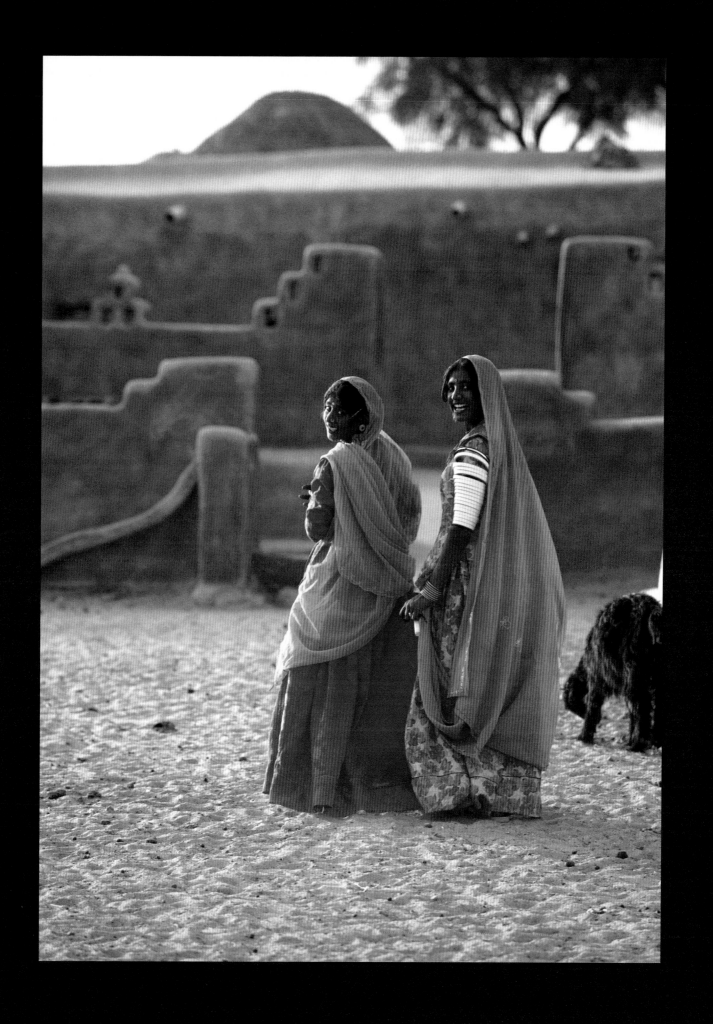

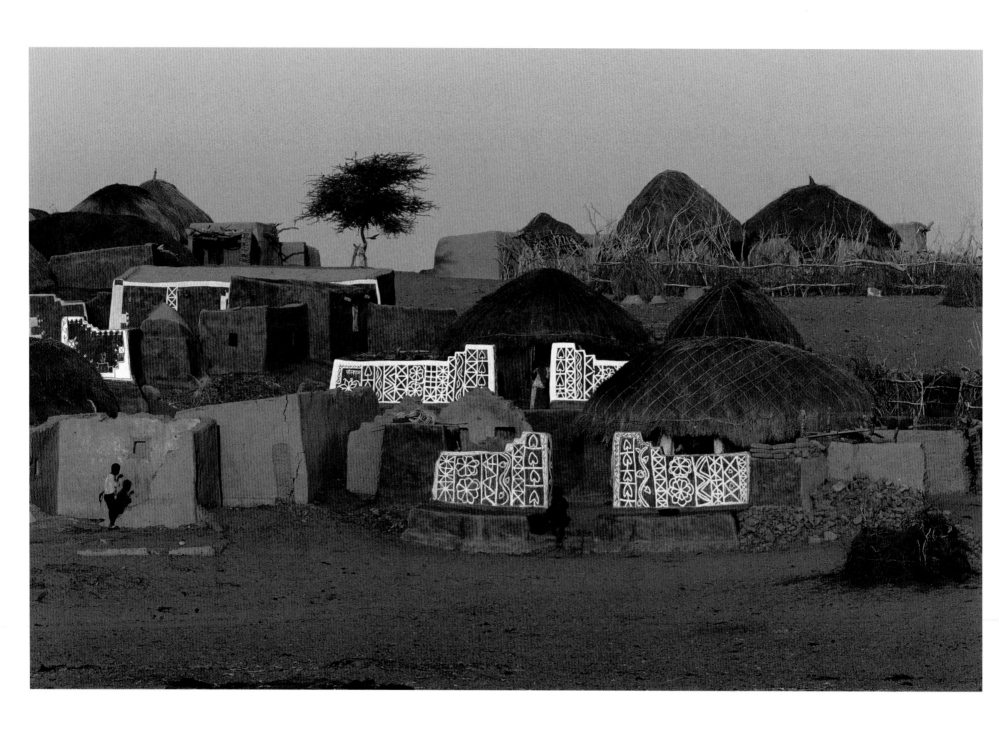

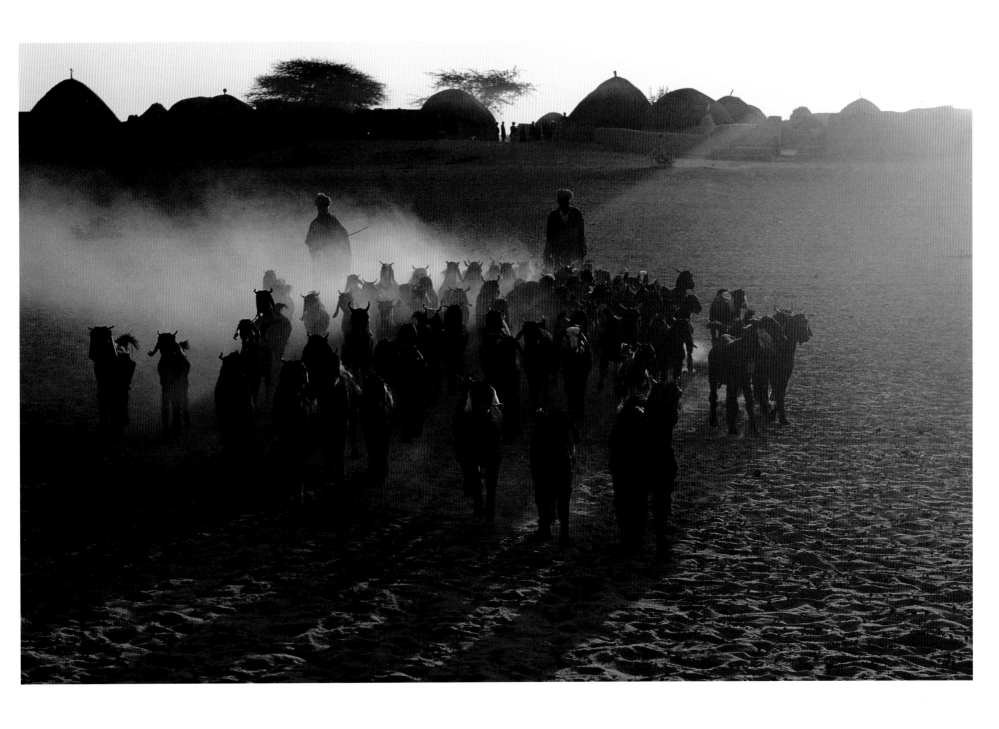

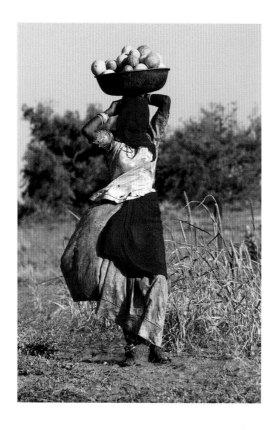

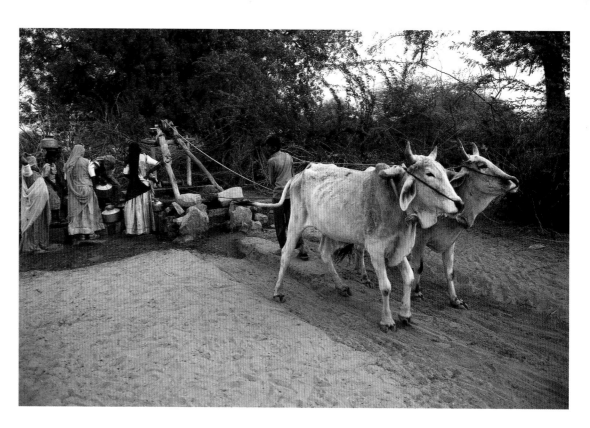

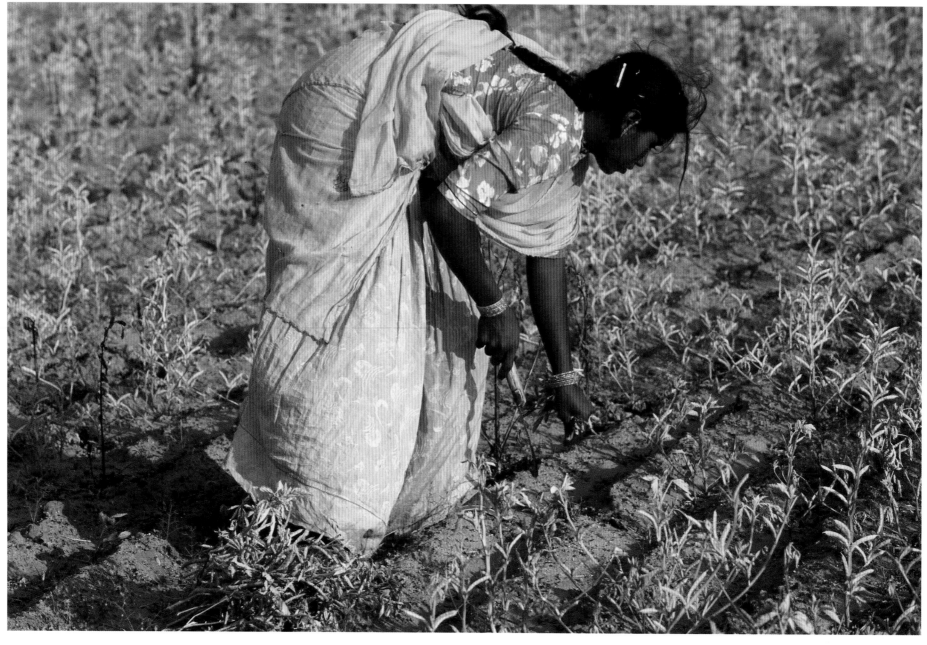

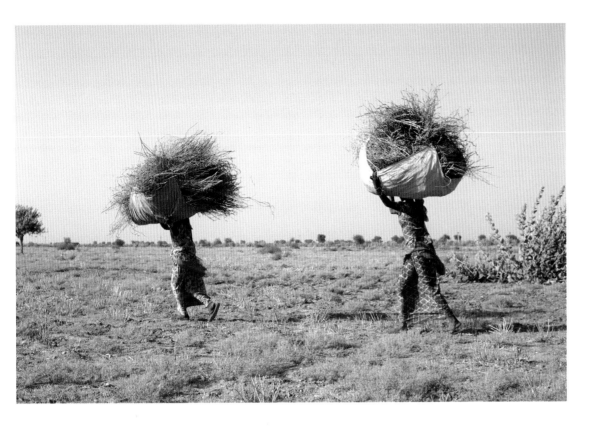

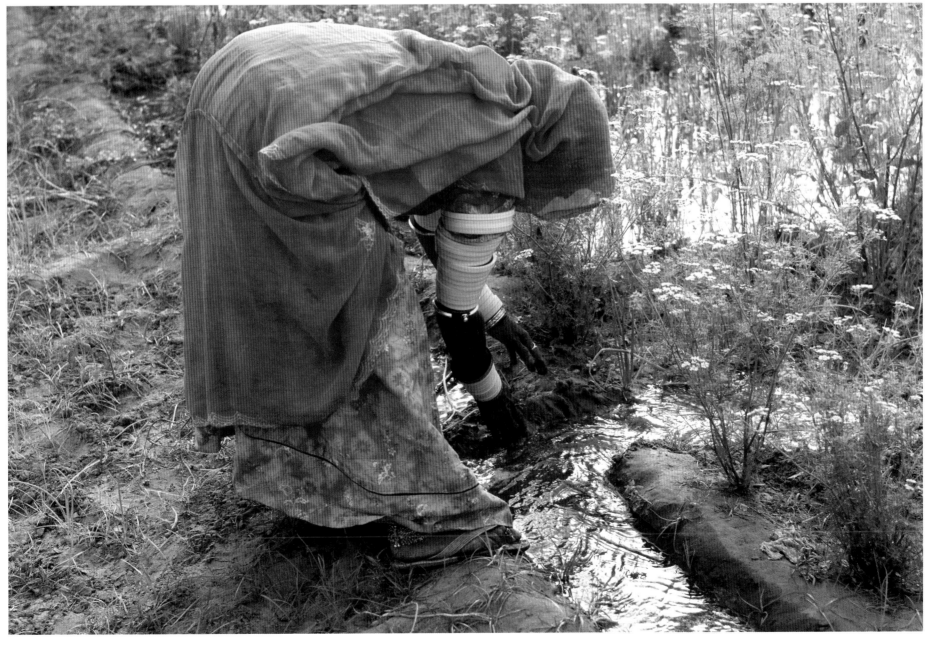

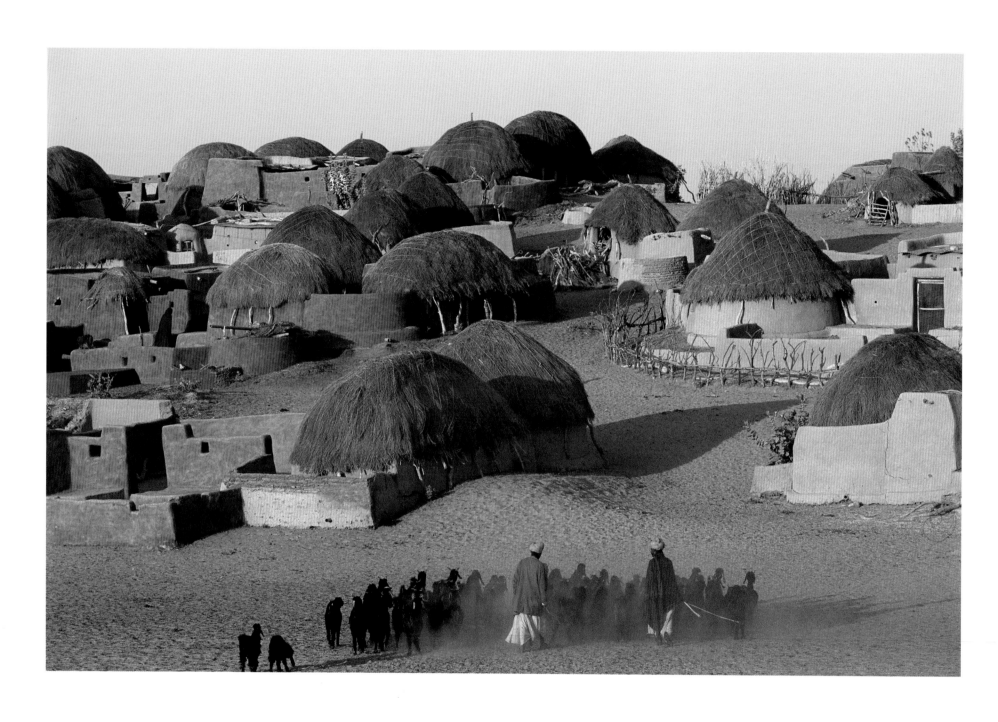

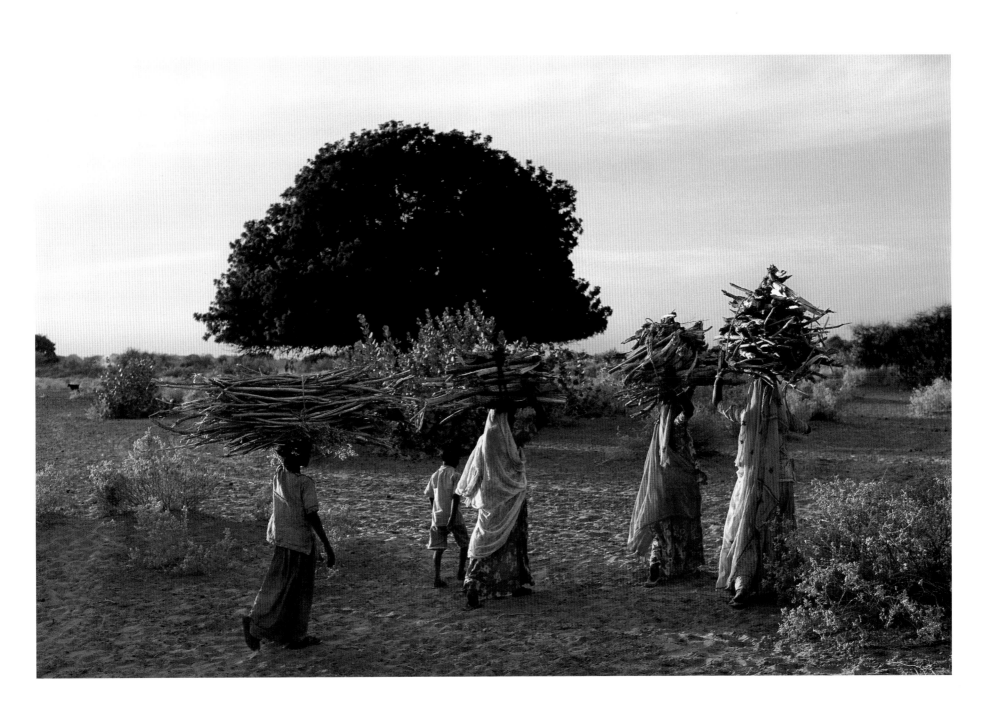

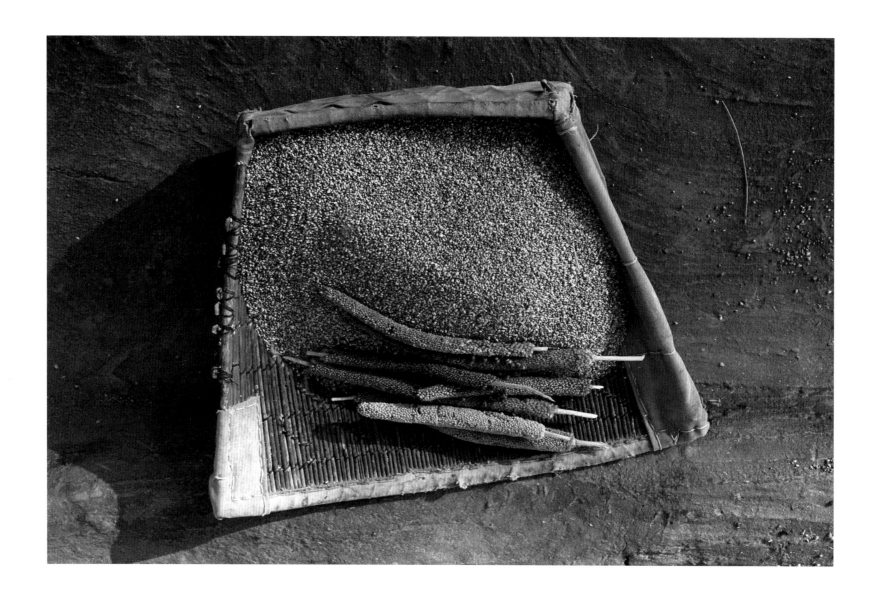

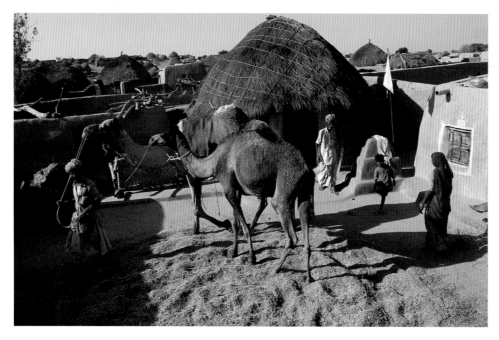

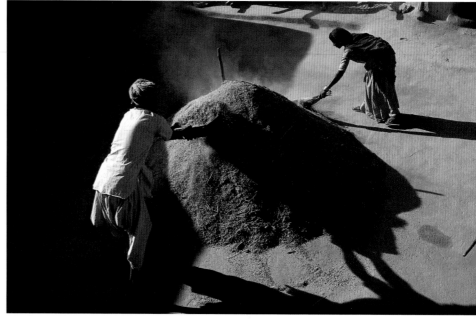

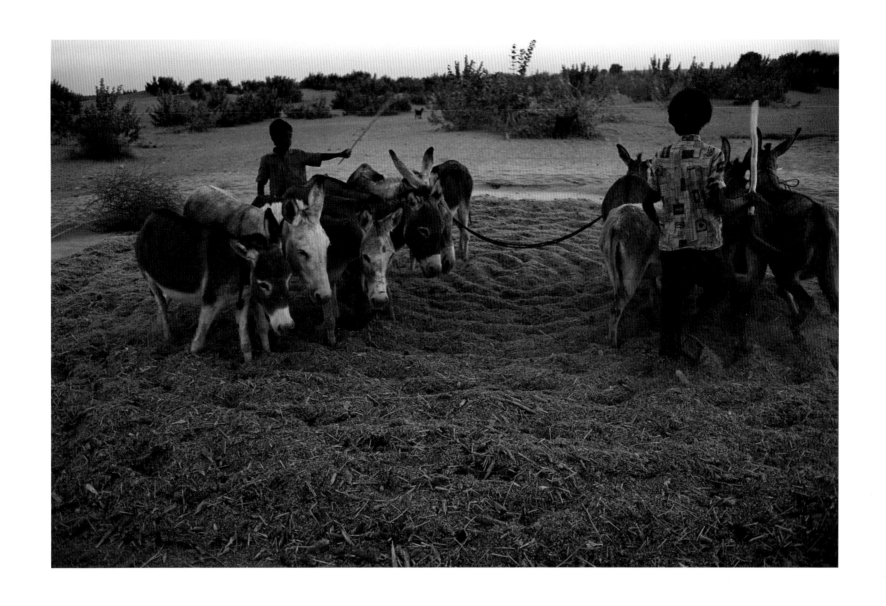

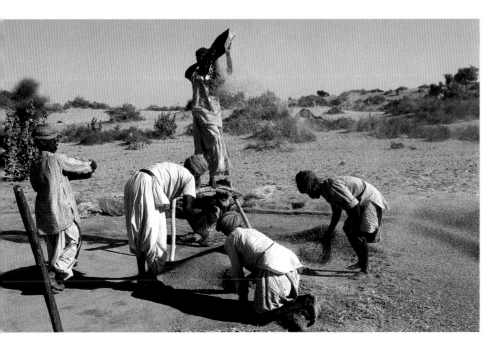

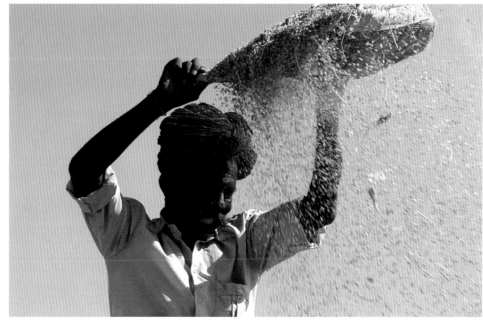

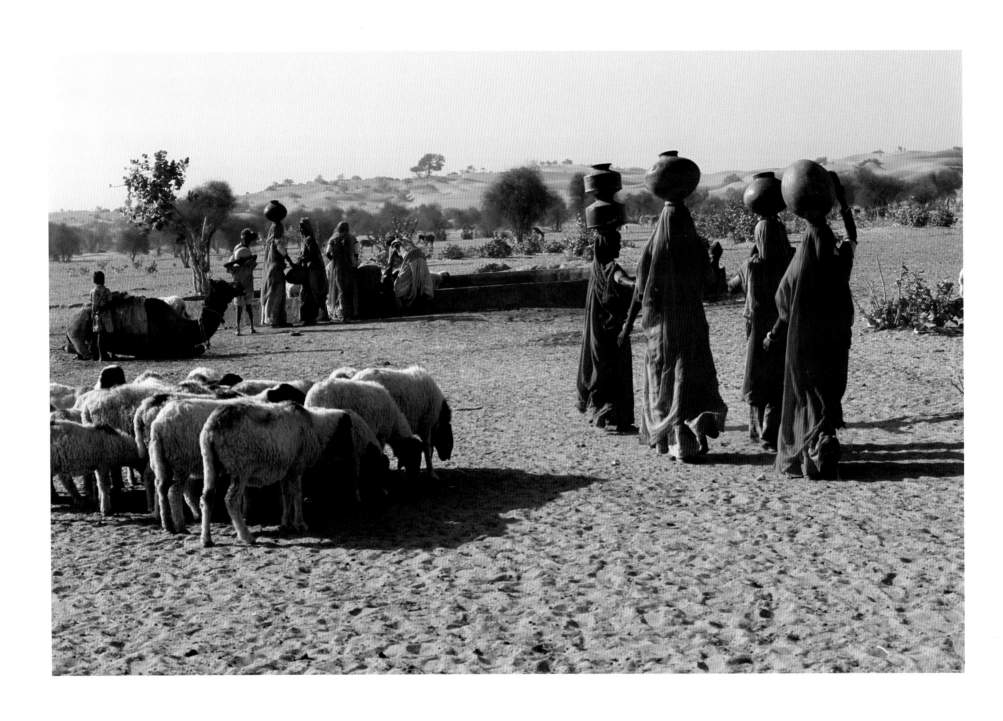

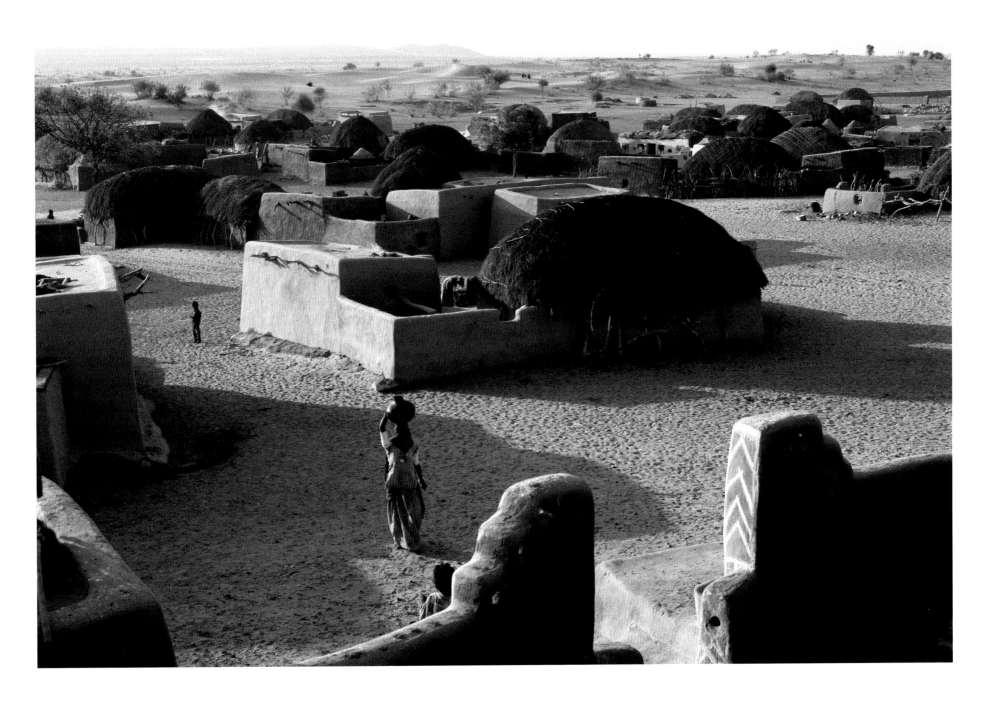

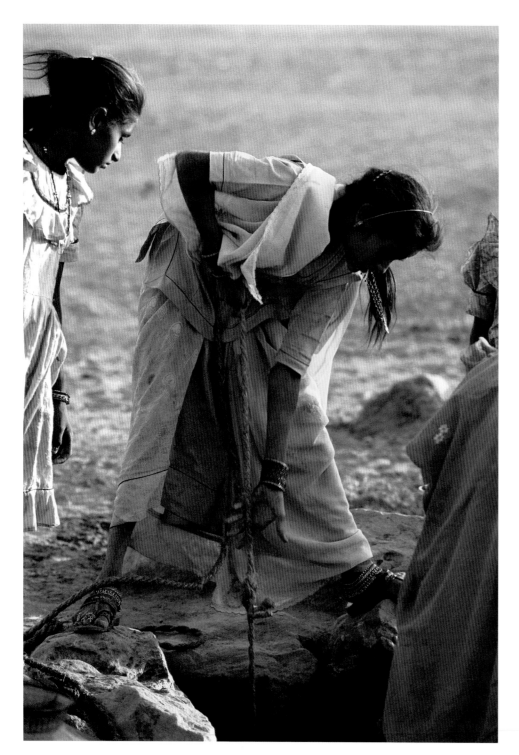

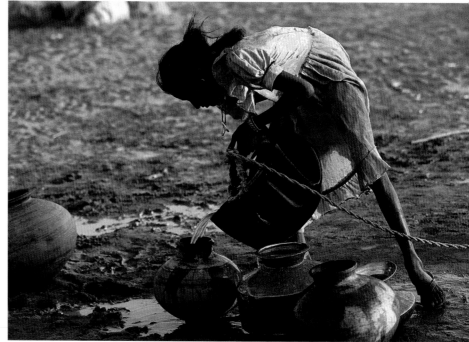

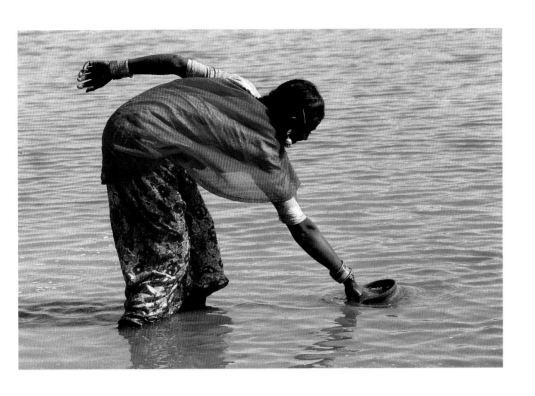

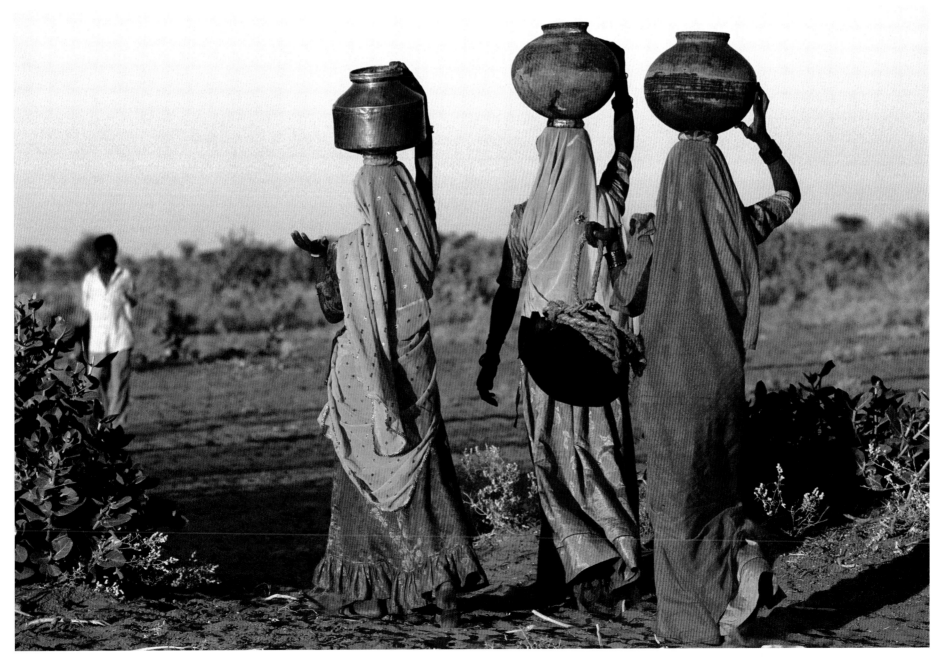

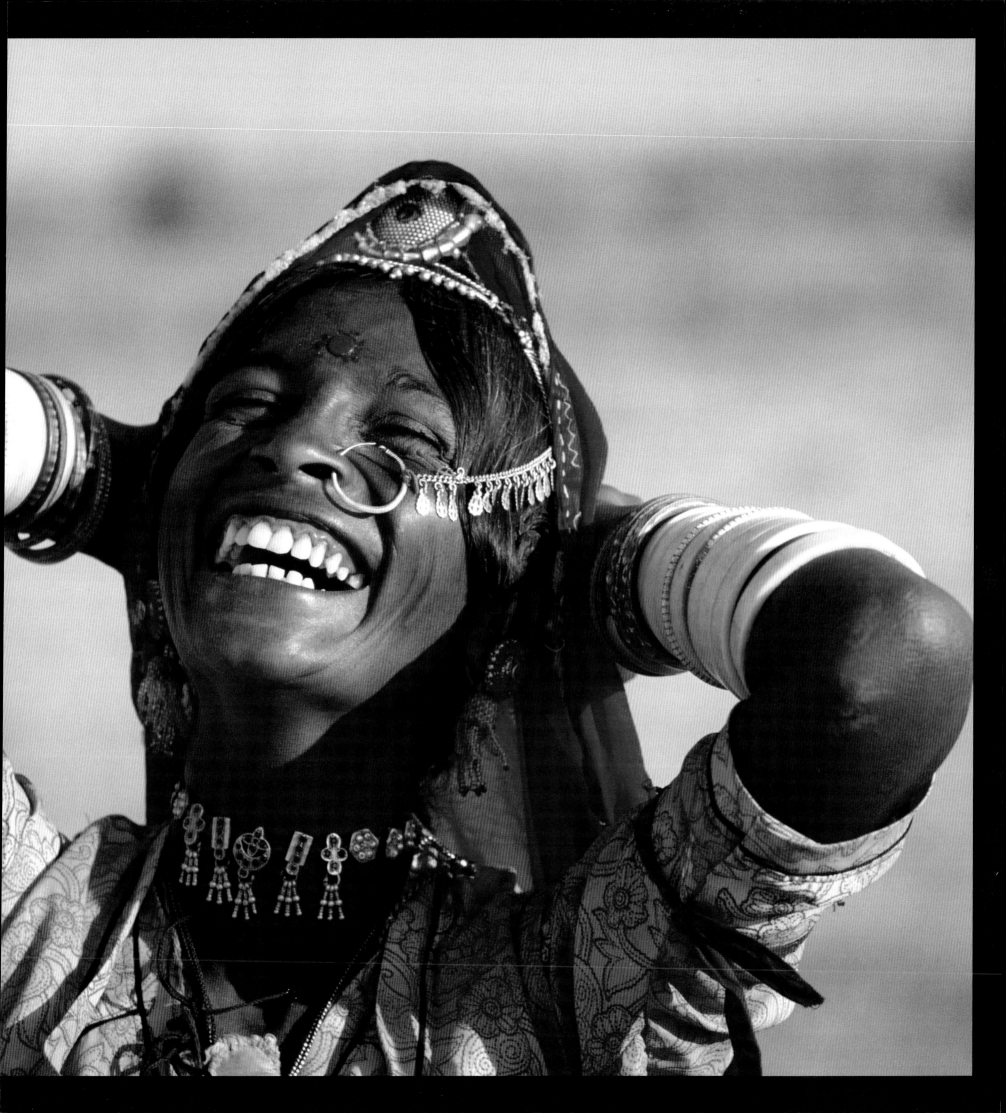

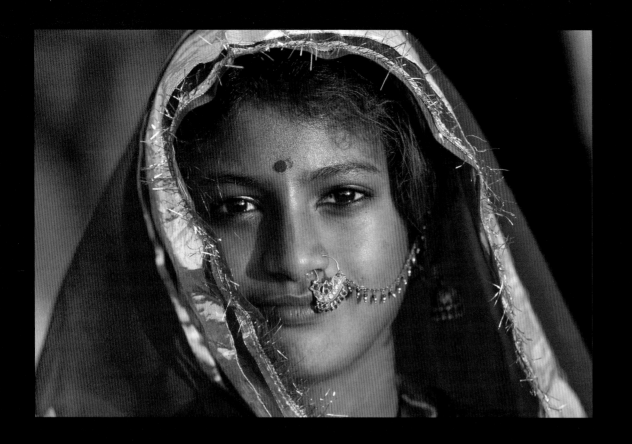
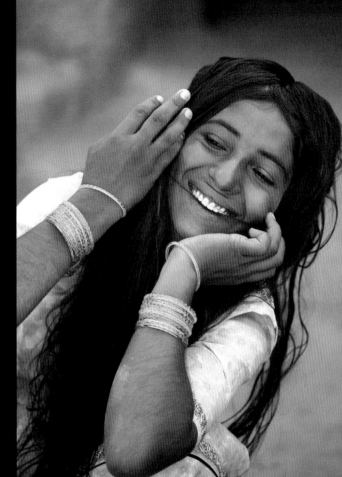
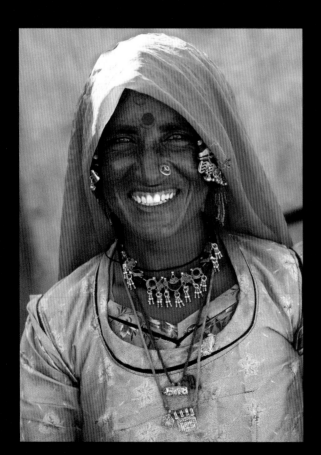
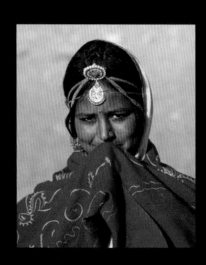
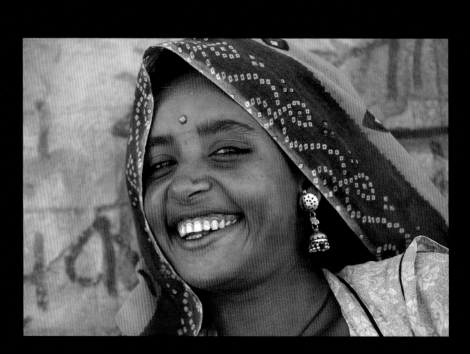

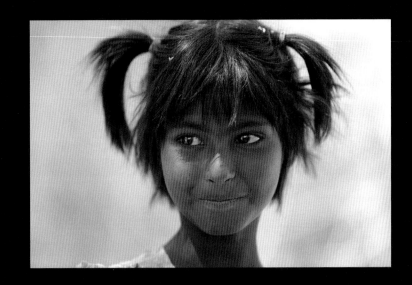
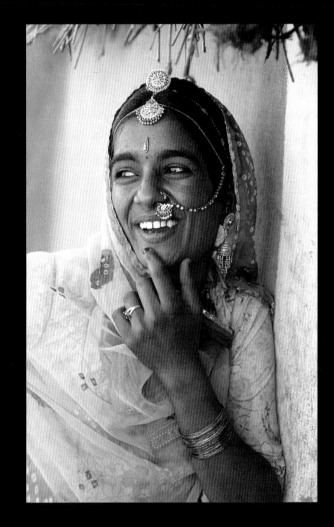
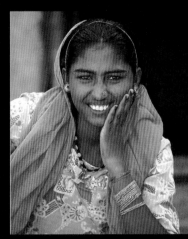
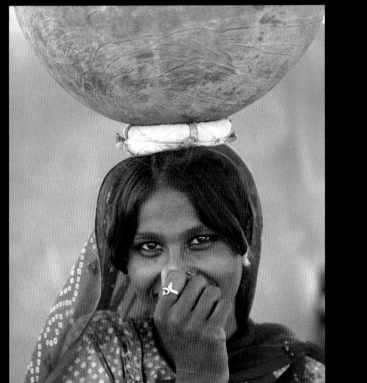
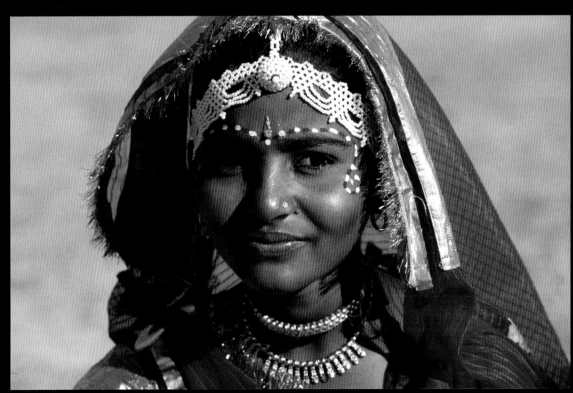

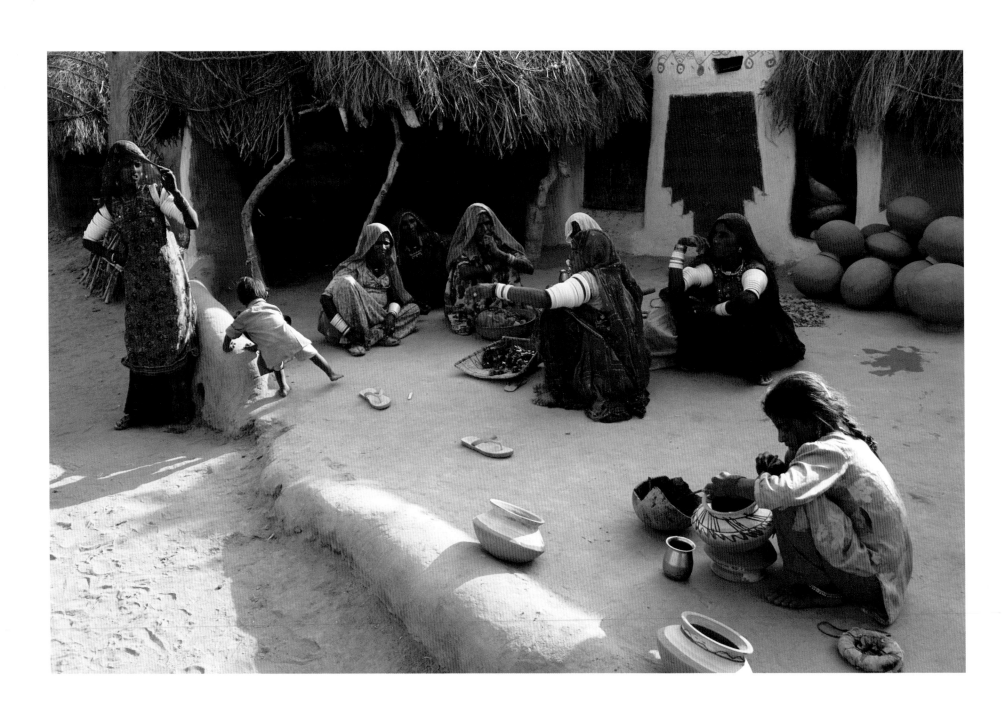

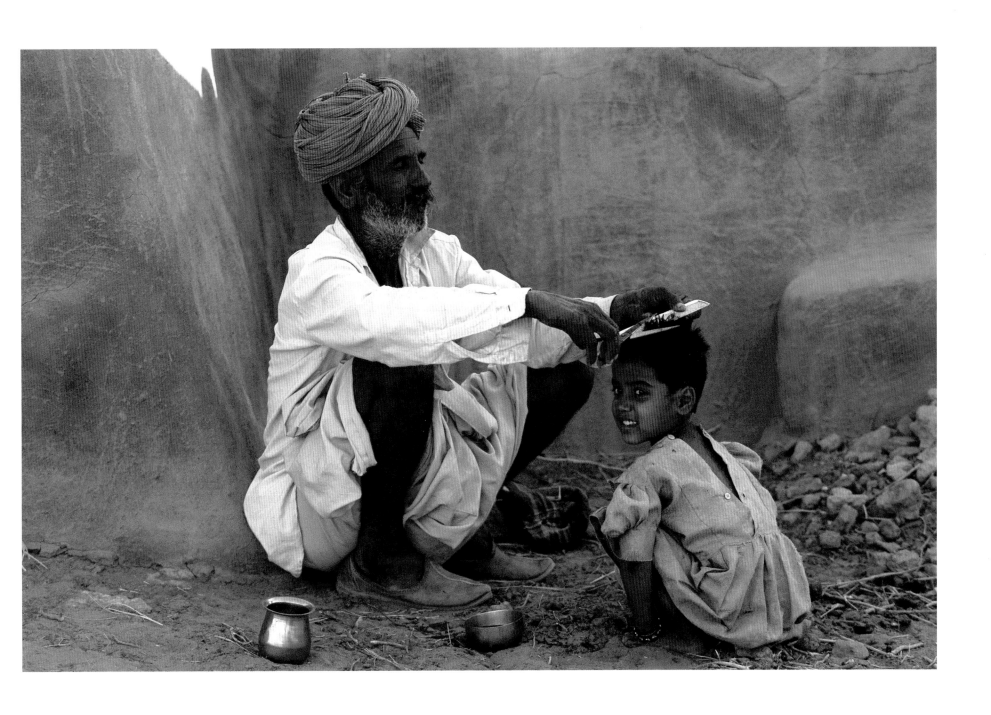

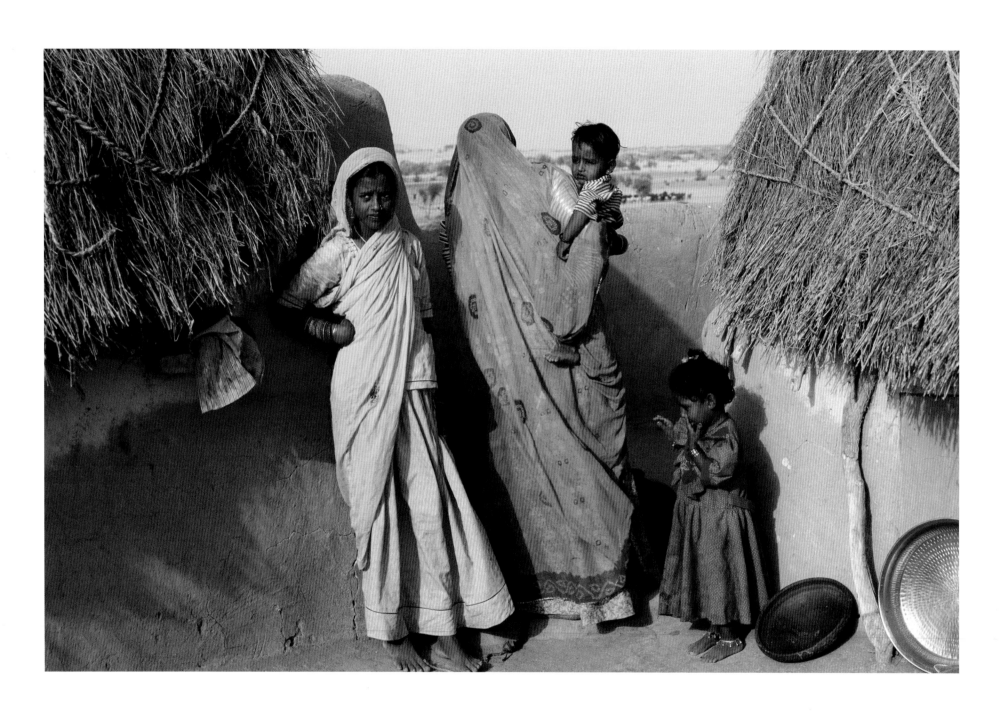

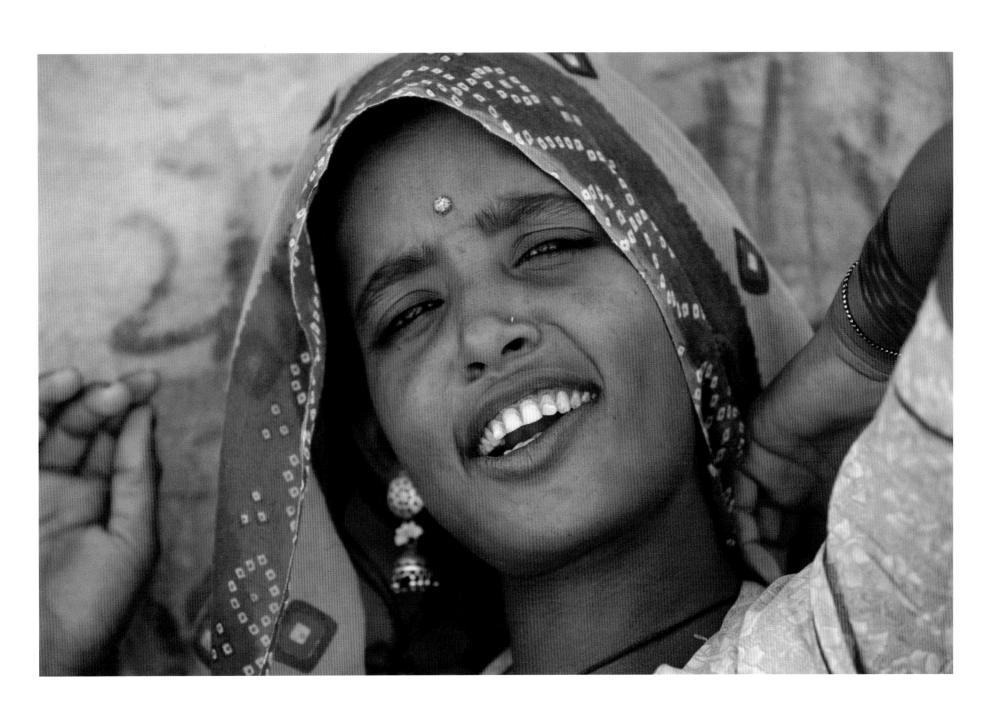

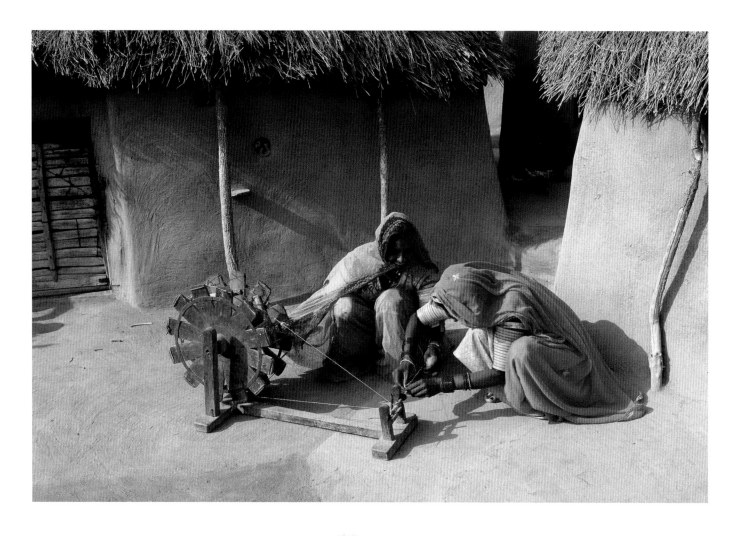

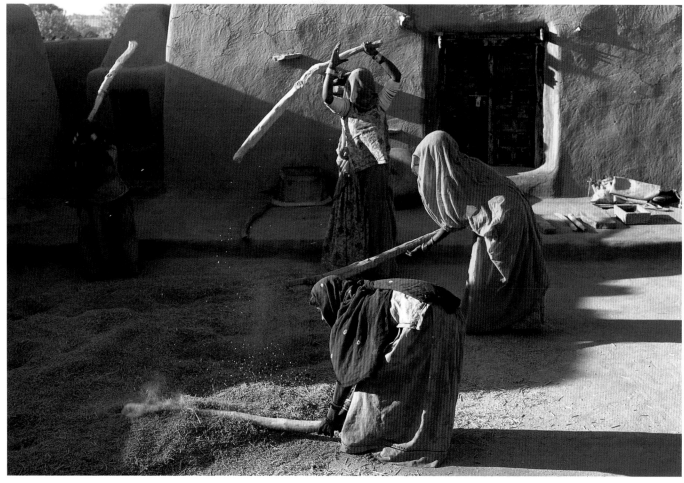

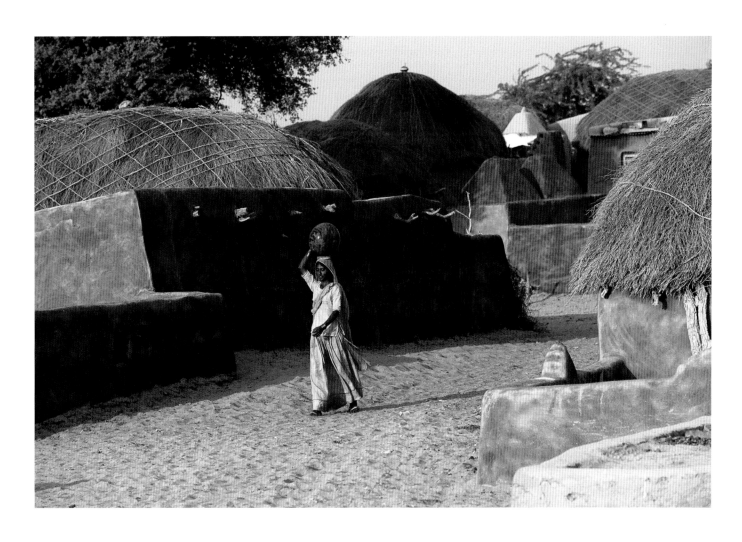

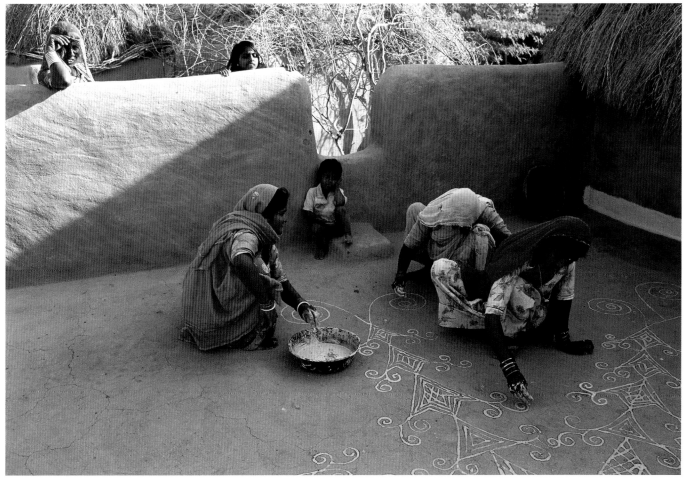

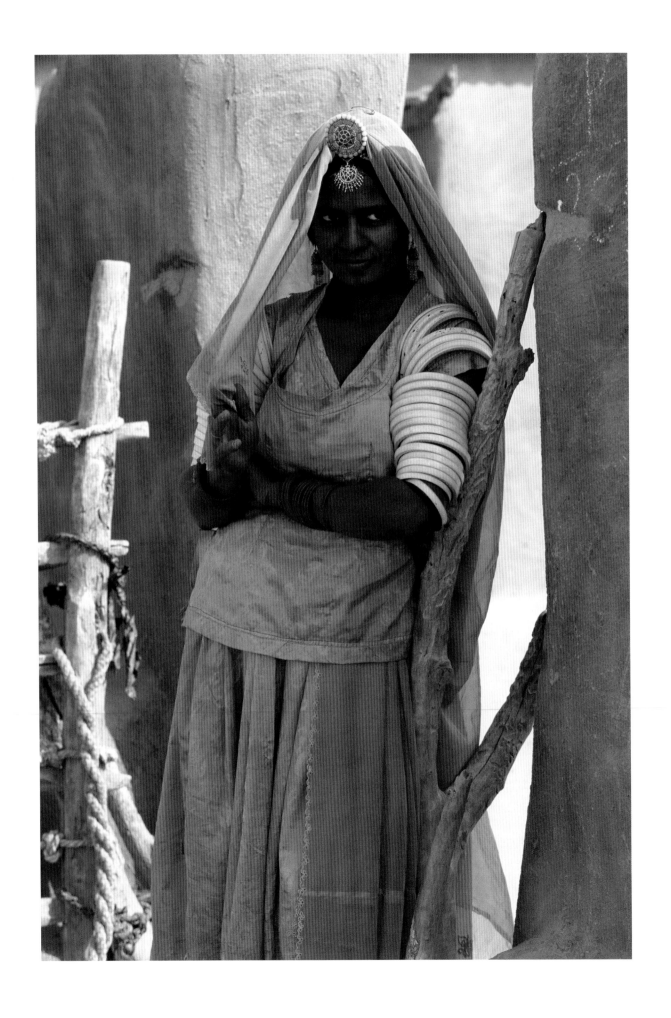

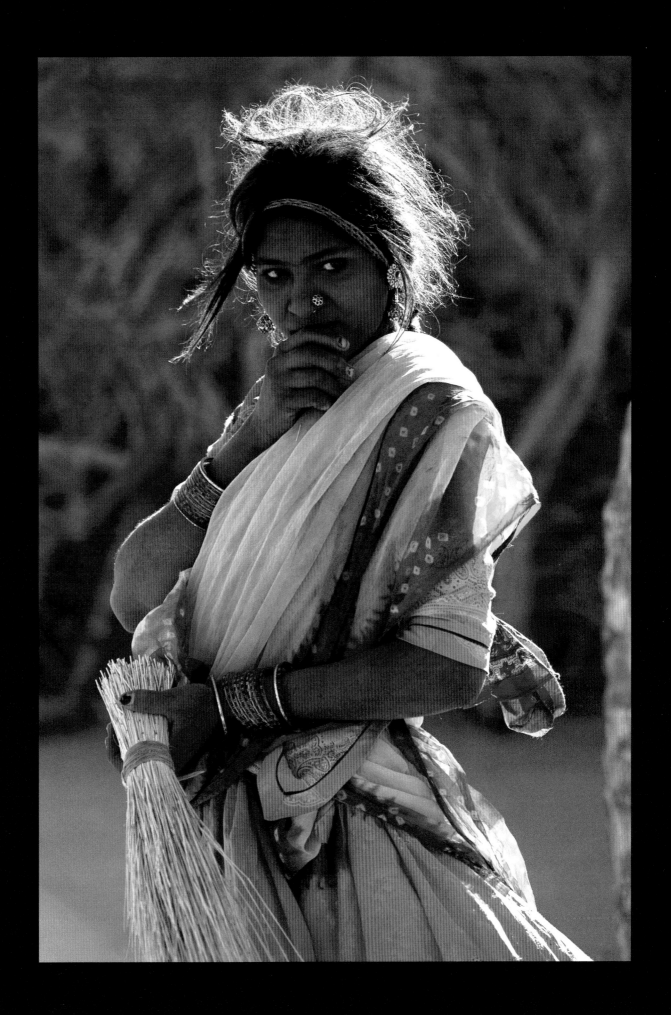

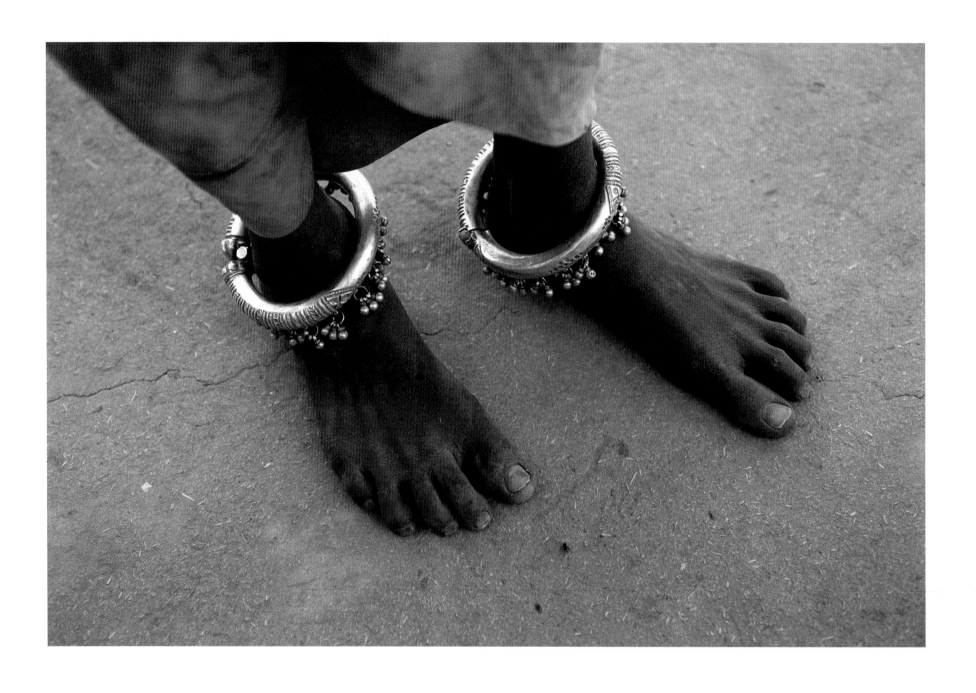

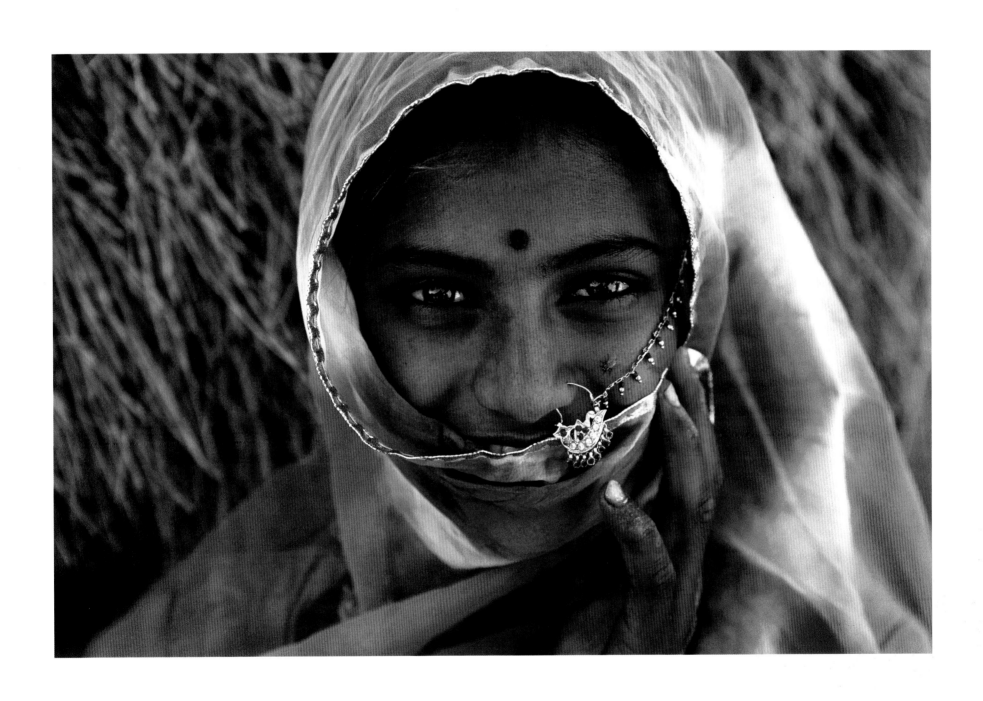

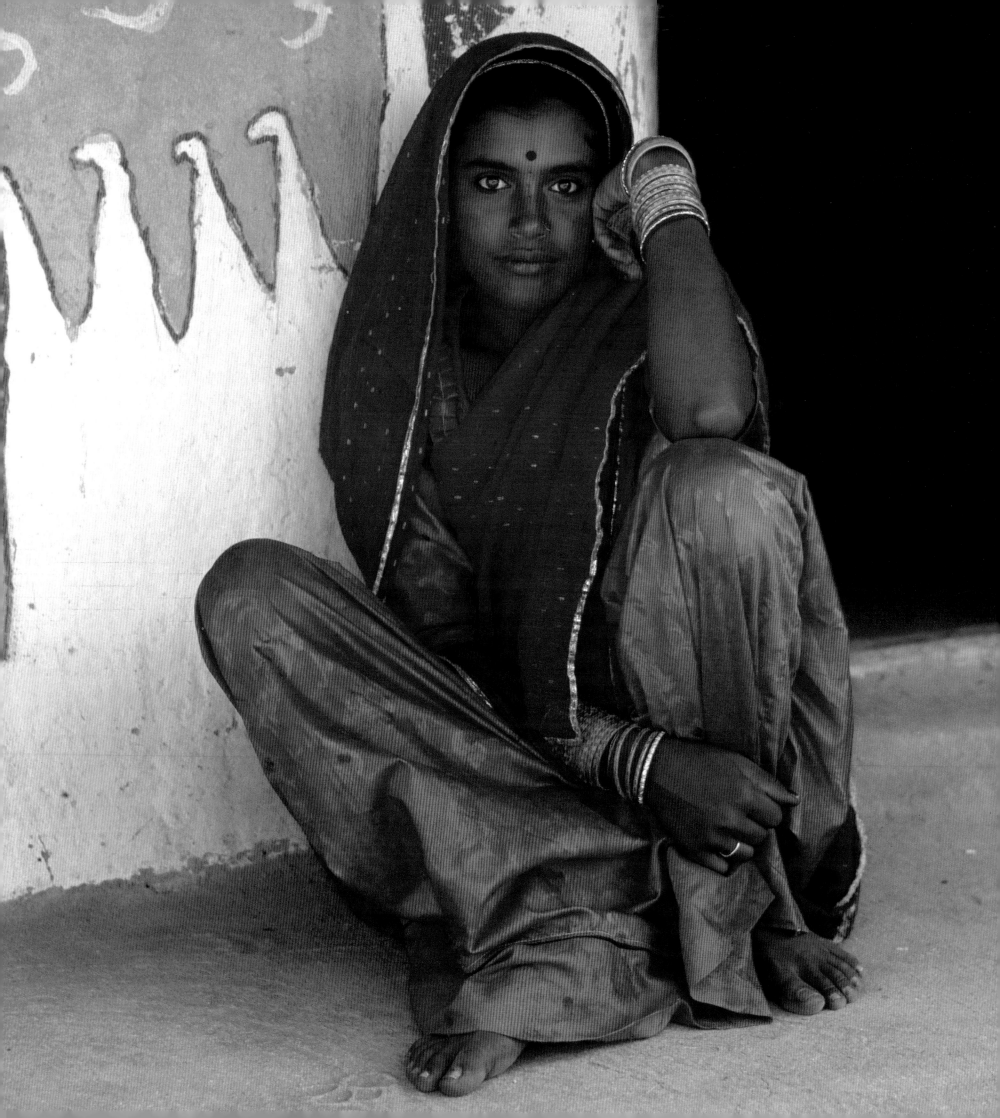

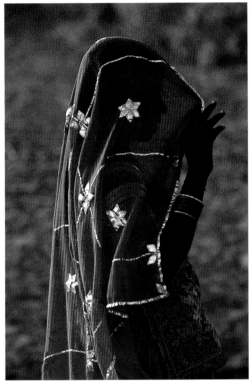
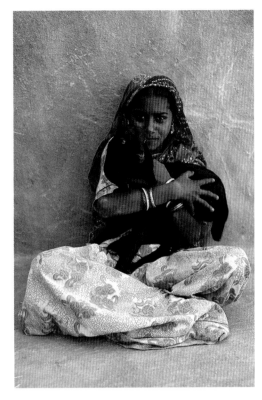
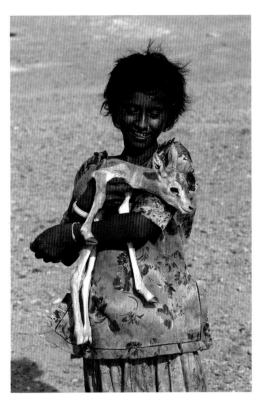
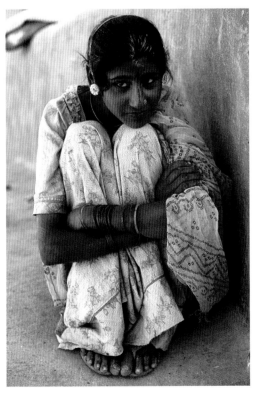
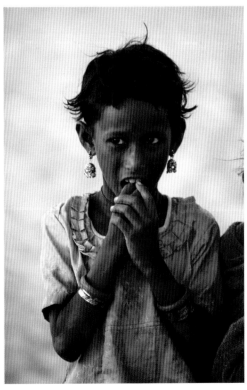
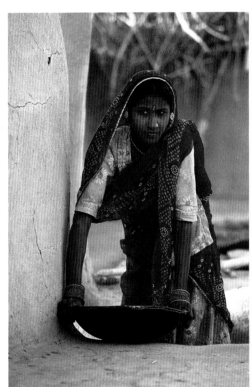

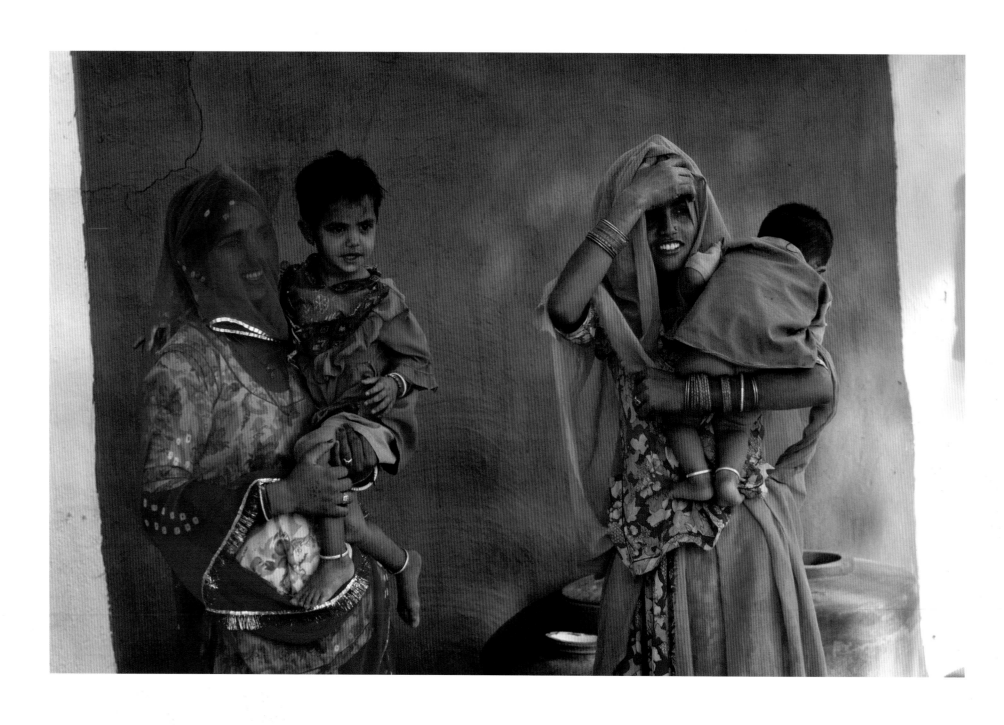

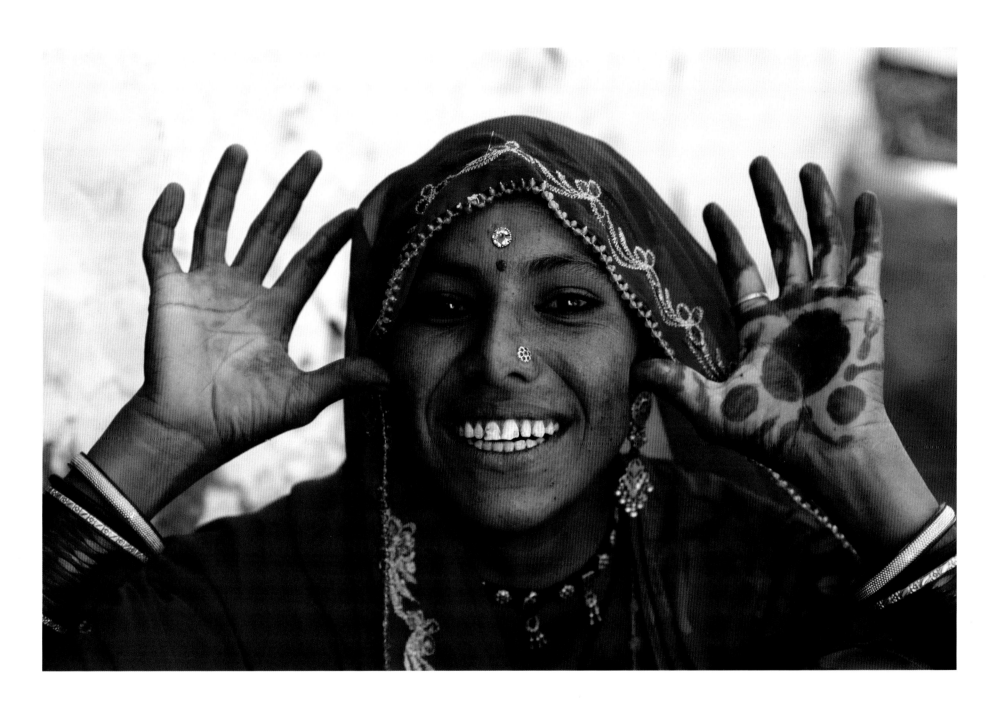

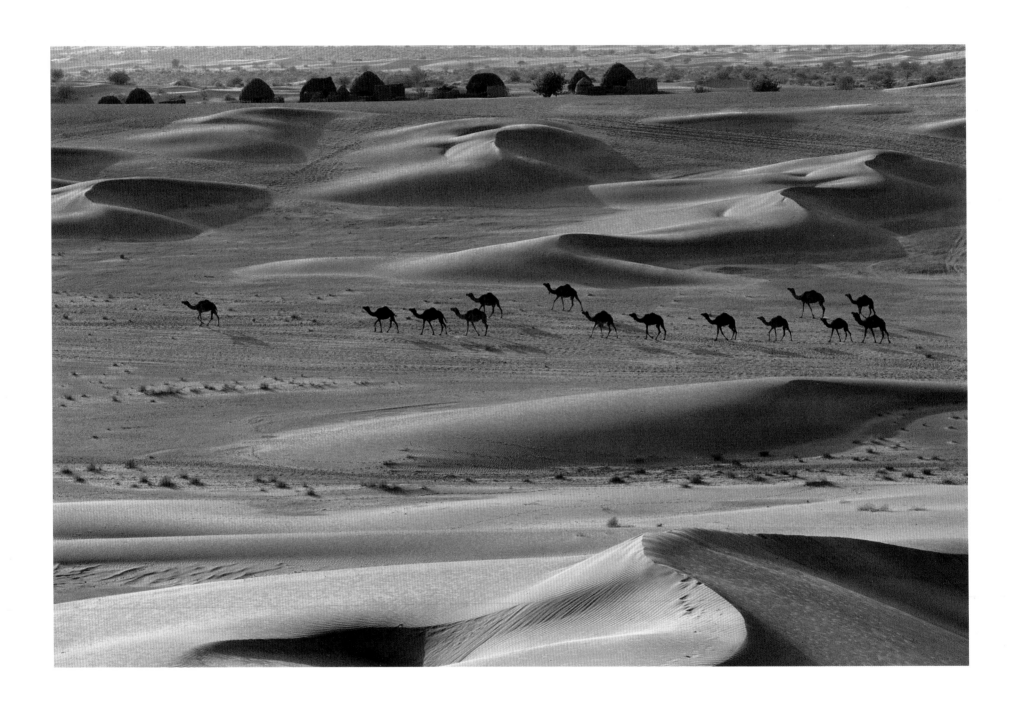

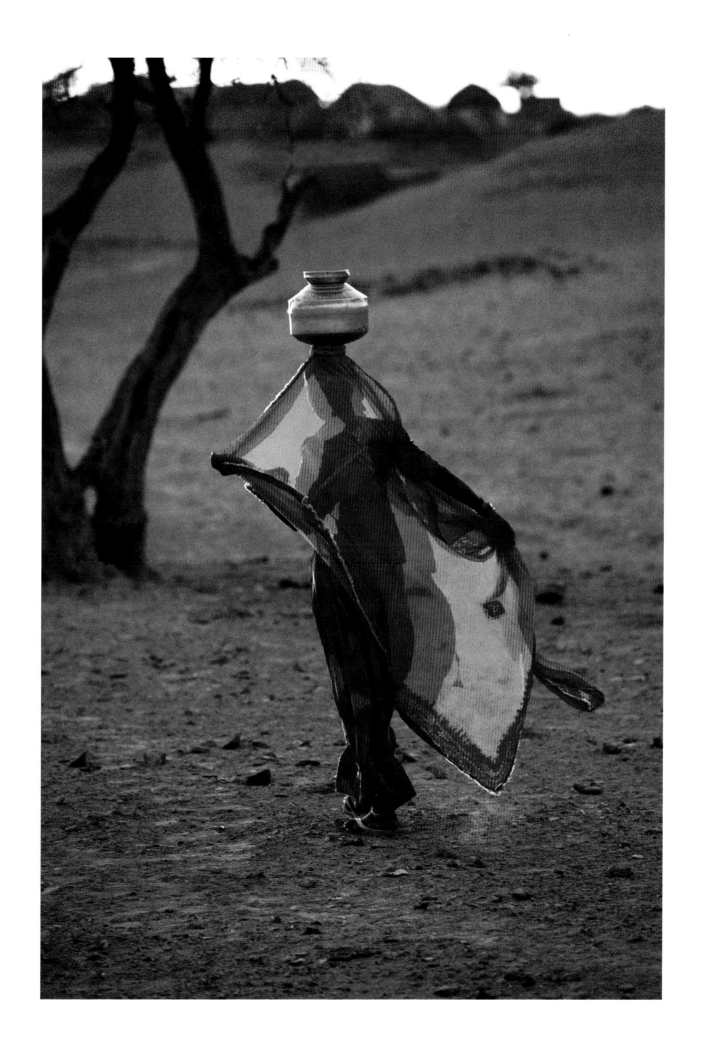

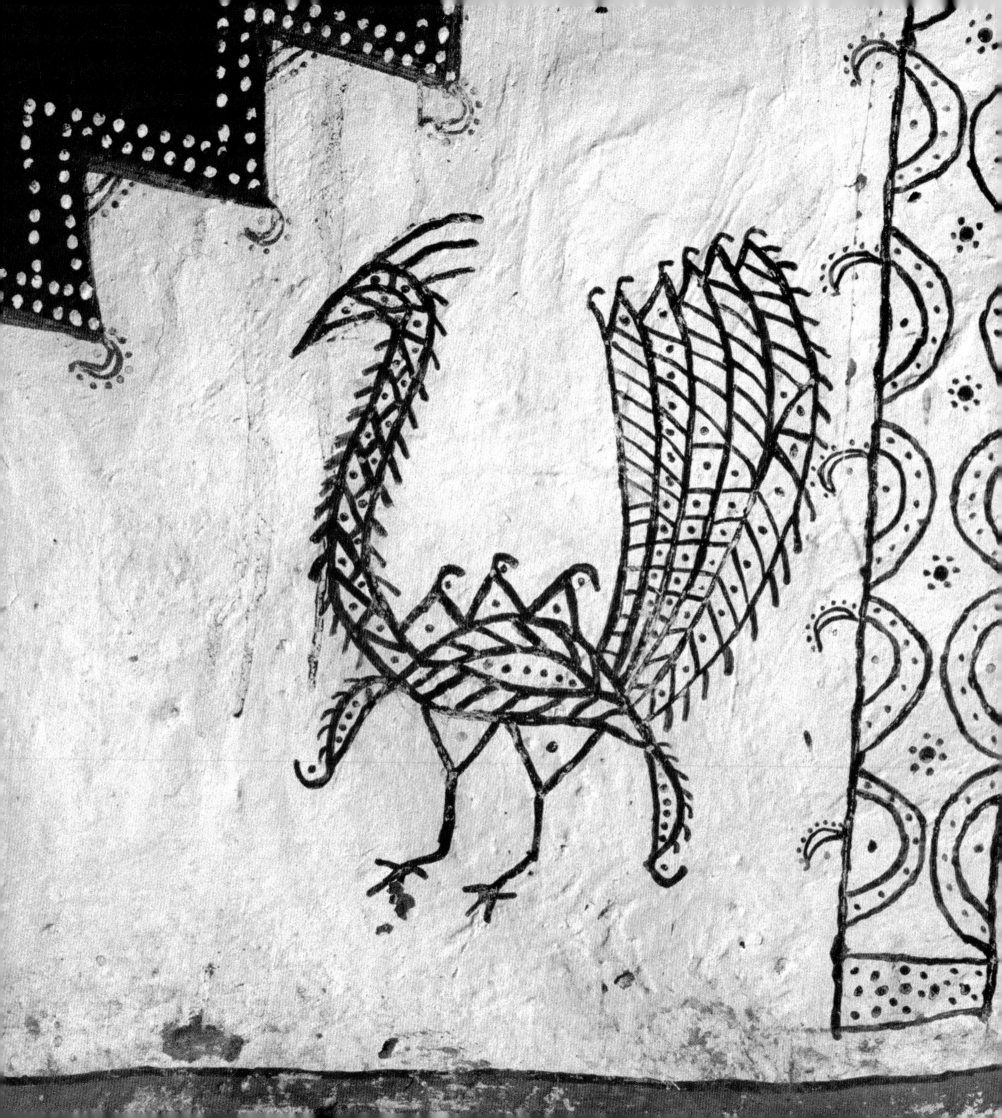